D1217852

# Women Artists in the Modern Era:

## A Documentary History

by
SUSAN WALLER

The Scarecrow Press, Inc.
Metuchen, N.J., & London
1991

British Library Cataloguing-in-Publication data available

**Library of Congress Cataloging-in-Publication Data**

Waller, Susan, 1948–
    Women artists in the modern era : a documentary history / by
Susan Waller.
        p.   cm.
    Includes bibliographical references and index.
    ISBN 0-8108-2405-1 (alk. paper)
    1. Women artists—Biography—History and criticism.
2. Art, Modern—History.
N43.W26      1991
709′.2′2—dc20                                                    91-17047
[B]

For my husband and my parents

# CONTENTS

*v*

# PREFACE

Women have worked as artists throughout the modern era, but their history has differed substantially from that of men. From the eighteenth century to the twentieth, women artists' opportunities to train and exhibit, their choices of media and subject, the critical and public reactions to their work—all have been affected by their sex. As artists they often explored the same aesthetic issues as their male contemporaries; as women their lives and careers have invariably been conditioned by society's assumptions about the ways in which men and women differ and what is appropriate to each.

The documents in this volume have been selected to illuminate the historical experience of women artists. They include the letters, journals, and memoirs of artists, critics' reviews of women's work at exhibitions and discussions of women's capabilities, and the minutes and reports of artists' societies and schools. They document the lives of individual women artists and the institutional and cultural parameters that conditioned what women artists attempted and what they accomplished.

The selections span the modern era—the period that begins in the mid-eighteenth century with the Enlightenment and ends in the twentieth century with the close of the Industrial age. Because of their sex and their profession, women artists were doubly affected by the social, political, and economic changes that shaped modern society over these two centuries. Their history had—as it continues to have—a double context: the history of art and artists and the history of women. Their participation in the institutions that shaped the public practice of art—art academies and schools, artists' societies and exhibitions—provides one context. The laws and conventions of femininity that regulated women's behavior throughout society provide another. The experi-

ence of women artists was as much affected by the changing institutions of the family, marriage, and motherhood as by academies and exhibitions.

Since, until late in the nineteenth century, women artists were virtually excluded from the institutions where men artists were trained, exhibited, and honored, they relied on private and informal resources for their education and shaped their careers largely outside of academies and artists' societies. Much of their history is documented not in institutional records but in personal papers, and a woman's "personal life" is inseparable from her "professional development." The selections from women artists' autobiographical accounts, therefore, focus particularly on the friendships and familial relationships that significantly affected their artistic development. They have also been chosen to document the lives of women whose work is largely unknown today as well as those of well-known artists. Though the careers of familiar figures like Elisabeth-Louise Vigée-Lebrun or Mary Cassatt attest to women's accomplishments, the experiences of less familiar individuals are equally revealing of the opportunities and constraints women faced and of the varied ways they negotiated the laws and conventions of feminine behavior.

As wives and daughters, many women artists worked as students of and assistants of men artists, as amateur painters and sculptors, and as embroiderers and designers. Much of their work as artists therefore occurred within the "private" sphere and was unrecognized within the public institutions of art. To maintain the customary dichotomy between public and private—or between amateur and professional and between the fine and the decorative arts—makes it difficult to see the links that join them and distorts and confuses our understanding of women's historical experience. By including documents relating to both public and private spheres, it is possible to see those links. There were women who moved between "assistant" or "amateur" and "professional" or between the "fine" to the "decorative" arts as need and opportunity allowed. The work done by "amateurs" established precedents for "professionals," and the criteria for

evaluating work from one context was freely applied to work in another.

Laws and institutional regulations are comparatively simple to document, and their effect on the work done by women artists is often easy to trace; cultural assumptions and conventions of femininity are harder to see, particularly when we share them, and their effects, though equally pervasive, are more subtle and complex. They may be resisted by some individuals, and supported by others—or they may be simultaneously resisted and internalized by the same individual. Cultural assumptions about the nature of femininity may be sharply illuminated by debate, as in the contrasting attitudes of critics writing for newspapers and those writing for the feminist press that are included here. They may also emerge as they are reiterated: the woman artist who questions to the institutional regulations that limit feminine participation in the public "professional" practice of art may reenact conventions of femininity in her own life or reassert them within her work.

Material has been drawn primarily from France, England, and the United States, although selections from twentieth-century Germany and Austria are included. In each country, the situation of women artists differed markedly, affected by the character of the art institutions and women's legal and political status. The documents are arranged in approximate chronological order and grouped into eight sections, each of which focuses on a particular aspect of women's experience. Just as there are chronological overlaps between sections, there are topical overlaps: issues that affect women throughout the period may become particularly significant during a given decade. The headnotes are intended to provide a broad contextual framework for each selection and to supplement the information found in standard histories of women artists. It is not possible in the headnotes to address all the questions and issues raised in these documents, but perhaps by bringing these documents together it will be possible for them to serve as the basis for future discussions of the history of women artists.

\*          \*          \*

The initial idea for this volume came from the late Elizabeth Gilmore Holt, whose documentary art histories set a standard for anthologies of primary source material. The suggestions and encouragement she offered as this volume developed were important, but the example of her indomitable commitment to scholarship was critical.

In identifying and interpreting many of the documents included in this volume, I am indebted to the work of feminist historians and art historians who, over the last two decades, have contributed to our knowledge of individual women artists and have formulated new theoretical approaches to women's art and history. This debt is acknowledged in the notes and the references.

I have deeply appreciated the assistance of the staffs and the privileges extended at the following libraries: Boston Public Library, MA; Bowdoin College Library, Brunswick, ME; Buffalo Public Library, NY; Center for Creative Studies, Detroit, MI; Cranbrook Academy of Art Library, Bloomfield Hills, MI; Detroit Institute of Art, MI; Detroit Public Library, MI; Harlan Hatcher Graduate Library and the Art History Library at the University of Michigan, Ann Arbor; Library of Congress, Washington, DC; Museum of Modern Art, New York; New York Public Library; Olin Library and the Steinberg Art and Architecture Library at Washington University, Saint Louis, MO; Richardson Library, Saint Louis Art Museum, MO; Saint Louis Public Library, MO. Those translations not credited in the notes are my own; in preparing them I received invaluable assistance from the staff at the International Language Center, Clayton, MO, and Geraldine Gambaye.

For advice and criticism and support, I am grateful to Mimi Weinberg, Diane Vogt-O'Connor, Michael Hall, Barbara Price, and the students in my seminar on women artists at Cranbrook Academy of Art.

My biggest debt, however, is to my husband, Ronald Leax, whose enthusiasm for this project never faltered.

Susan Waller
Portland School of Art
Portland, Maine

# I. WOMEN AND THE ACADEMIES

By the latter half of the eighteenth century, art academies structured the public and official practice of art in France and England. The Académie Royale de Peinture et de Sculpture, founded in 1648, and the Royal Academy, established in 1768, were self-regulating, hierarchical professional organizations. Their business, as English academician William Chambers explained, was "to establish schools for the Education of young artists, Premiums for their encouragement, Pensions to enable them to pursue their studies, an Exhibition wherein they may put their talents on public view, and honorary titles of distinction to be conferred on such as are deemed to deserve them" (quoted in Denvir 1983, 192). Academic schools, premiums, and pensions shaped the talents of young male artists, whose careers followed a pattern—from student to associate to full academician; teaching, exhibitions, and honors reinforced academic theory, which elevated history painting above all other genres.

Since women artists' place within academies was limited by social custom and institutional regulation, their careers followed a different pattern. Propriety barred them from academy schools, where male students, working from the nude model, learned to idealize the human form. Women learned to draw in the studio of another artist, usually their father or husband. By academic standards their education was incomplete, preparing them to work only in the lesser genres of portraiture and still life, which theoretically demanded little more than the ability to "copy" nature. But if portraiture and still life were looked down upon by academic theorists, they were sought after by private collectors and connoisseurs. A young woman who was talented, well-trained, and socially skilled—who was gracious and attractive, could converse intelligently, and play an instrument or sing—might find a welcome in the influential circles of aristocratic patrons.

At the close of the eighteenth century, increasing numbers of women established successful careers as professional artists, and for a few women official and public recognition in the form of

academic membership followed upon success in private circles. The Académie Royale, which had admitted nine women in its first century, accepted six women in the four decades preceding the French Revolution, while England's Royal Academy included two women among its first forty members. Their membership was largely honorary: since women did not participate in academic business and could not be appointed to office, they played no role in shaping academic theory or policy.

Critics and colleagues were often publicly skeptical of women's achievements, even after a woman was granted academic status. When she exhibited for the first time, the rumor that she had received assistance from a male colleague—usually he who had been her teacher and mentor—invariably was repeated in print. A significant number of the women who became academicians were not, however, content to maintain substantial reputations in lesser genres: the complex mythological and religious subjects that they submitted for exhibition directly challenged prevailing assumptions about feminine capabilities.

# Denis Diderot: Selections from the Salon of 1767

By 1767, the French Salon, which had become a biennial event in 1751, was a popular Parisian entertainment and attracted 500 to a 1,000 visitors each day. The connoisseurs, patrons, critics, and simply curious who crowded the exhibition in the weeks after it opened on the King's Name Day in August bought over 10,000 *livrets* or catalogues to identify the works that filled the Louvre's Salon Carré. Among the 185 works by forty-three academicians were 8 paintings by the two women who were members of the Académie Royale: Marie Thérèse Reboul Vien and Anna Dorothea Lisiewska-Therbusch.

Vien, a painter of gouaches and miniatures, had been admitted to the Académie in 1757, the same year she married Joseph-Marie Vien, a prominent academician and her teacher. It was not uncommon for academicians' wives to assist their husbands in the studio or exhibit their own work: Marie Anne Gérard Fragonard, married to Jean-Honoré Fragonard, painted miniatures that proved difficult to distinguish from her husband's

work, and Marie-Jeanne Buseau Boucher, the wife of François Boucher, not only was her husband's favorite model, but also engraved his paintings. When the Salon de la Correspondance, a private exhibition, was organized by Pahin de la Blancherie in 1779, Marie Thérèse Reboul Vien, Marie Anne Gérard Fragonard, and Marie-Jeanne Buseau Boucher all contributed work. Women were also active members of the Académie de Saint-Luc, the older, guild-derived artists' society. Marie Thérèse Reboul Vien's admission to the Académie Royale was unusual, however.

Dorothea Lisiewska-Therbusch had come to Paris from Prussia in the winter of 1766. She had been taught to paint by her father, had married an innkeeper and minor painter and established a substantial reputation at the courts of Stuttgart and Mannheim. Her arrival in France aroused the curiosity of the Marquis de Marigny, who as Director General of the King's Buildings was the government official in charge of the Académie Royale. When de Marigny asked Charles-Nicolas Cochin, Secretary of the Académie, about her, he was told:

> There appears to be more talent than one would expect to find in a person of her sex, and—what is more unusual—she paints history and the nude as a man would do. . . . In general her talents share the strengths and weaknesses of the German school: her drawing is not correct and her color is too red. (Hôtel de la Monnaie 1984, 359)

Lisiewska-Therbusch submitted a genre painting as her *morceau de réception* and was accepted into the Académie in February 1767. Melchior Grimm's *Correspondance littéraire*, a newsletter that reported on Parisian politics, society, literature, and art for subscribers in the courts of Eastern Europe, informed its readers that "the Académie Royale cannot be suspected of having deferred to the empire of beauty, which is so powerful in France, for the newest academician is neither young nor beautiful" (Hôtel de la Monnaie 1984, 359).

For the Salon of 1767 Lisiewska-Therbusch prepared *Jupiter and Antiope*, a classical subject with nude figures; when the Salon jury rejected it on moral grounds, she exhibited her *morceau de réception* and several portraits. Marie Thérèse Reboul Vien exhibited miniatures of birds and flowers. Denis Diderot (1713-1784), the philosopher and editor of the *Encyclopédie* who had reported on the Salon for Grimm since 1759, considered the work of both women in his review of the exhibition.

**Madame Vien***

No. 54: *A Crested Hen Watching over Its Young*. A very
handsome little canvas: a beautiful bird, a very beautiful hen
with a beautiful crest and a beautiful shaggy wattle, its beak
half open and menacing, its shining eye open and prominent,
its character worried, proud and quarrelsome. I can hear her
cry. Her wing hangs down and she crouches. Her young
gather beneath her, except for several which have escaped or
are about to escape. She is painted vigorously with true
color, and her young are painted very softly, with their down,
their innocence, and their chicken-coop giddiness. Every-
thing is well done, down to the blades of straw scattered
around the hen. These are the natural details that establish
the illusion. The artist failed to notice, however, that a
normal sized chicken becomes a very large bird when she
extends her ruffled feathers. Mme. Vien gives her animals
movement and life. Her chicken surprises me: I did not
believe the artist knew this much.

No. 55: *Golden Chinese Pheasant Cock*. The cock does
not have nearly as much life as the hen. The color is warm
enough, but the expression is cold and lifeless. The bird
is so smooth, stiff and monotonous that it almost looks
wooden. I prefer the small clump of flowers, shrubs, and
greenery in the background to the bird—but even that is not
wonderful.

Apologies to Mme. Vien. I said that the cock lacked
movement and life. I just learned that she worked from a
stuffed bird.

No. 56: *A Cage of Canaries with One Escaping to Chase
a Butterfly*. After seeing the *Crested Hen* one can hardly bear
to look at this. These birds are like little pieces of box wood
carved in the shape of canaries; they have no lightness, no
gentleness, no variety of tone, no life. Mme. Vien, you
painted these canaries yourself; as for your chicken, your
husband may well have trifled with it a little.

---

*   Translated from Denis Diderot, *Diderot Salons, Vol. 3: 1767*, edited by
    Jean Seznec and Jean Adhemar, Oxford: Clarendon, 1963, 173,
    249-53.

## Mme. [Lisiewska-]Therbusch

No. 113: *A Man, Glass in Hand, Lit by a Candle.* He is a merry old soul, seated before a table with a glass in his hand. He is illuminated by a candle which throws all its light on him. There is an eye shade on the table, between the viewer and this fellow: everything on this side of the shade is in half-light, while beyond it, on the half of the table that is not illuminated, one sees a pamphlet and an open snuff-box.

The painting is empty and dry, hard and red. The light is not that of a candle: it is the brick-red reflection from a large fire. There is none of the velvety darkness, the softness, the feeble harmony of an artificial light. There is no haze between the luminous bodies and the objects; there are none of those transition passages, none of those delicate half-tones which multiply infinitely in night paintings and whose imperceptible tonal variations are so difficult to capture, since they must both be there and not be there. The skin and the fabric are not their natural color: they were red before they were lit. I see here none of those visible shadows, which the light mingles in and makes almost luminous. The folds of the cloth are angular, small and stiff; I am not oblivious to the reason for this fault: the artist draped her model to paint it by daylight.

Nevertheless, for a woman the work is not without merit. Three-quarters of the members of the Académie could not do as well. She is self-taught, as her harsh and virile technique well shows. She had the fortitude to call upon nature and to study it. She said to herself, "I want to paint," and it was well said. Taking a just measure of the standards of modesty, she intrepidly placed herself before the nude model: she did not believe that only vice should have the privilege of undressing a man. She is so sensitive to opinions of her work that a great success drives her crazy or makes her die with pleasure; she is a child. She did not lack the talent necessary for great success in this country; she had enough of that. She lacked youth, beauty, modesty, coquetry. One must go into ecstasy over the talent of our great artists, take lessons from them, have good breasts and buttocks, and surrender to them. She arrived, she presented the Académie with a reasonably strong night painting. Artists are not

polite. They asked her point blank if it was her own work; she replied yes, and a bad wit added, "and that of your dyer." Someone explained the joke from Patelin's farce, which she did not know. She got angry, she painted this work, which was better, and she was accepted into the Académie.

This woman believes that one must imitate nature scrupulously, and I don't doubt that if her imitation were rigorous and strong and if she chose well in selecting from nature, this very servitude would give her work an unusual truth and originality. There is no middle ground when one limits oneself to nature as she occurs. One must take nature with her beauties and her faults, and one must scorn conventional rules in order to submit to a system in which, at the risk of seeming ridiculous and shocking, the necessity of nature's deformities is made clear. Either one is poor, dry, and flat or one is sublime, and Mme. Lisiewska-Therbusch is not sublime.

She prepared for this Salon a *Jupiter, Metamorphosed into Pan, Surprises the Sleeping Antiope.* I saw the canvas when it was almost completed. On the right Antiope is asleep, entirely nude; her left leg and thigh are bent, her right thigh and leg extended. The figure is coherent and the flesh well executed. It is something to have put together a large figure of a nude woman and it is something to have made it of flesh: I know more than one gentleman, proud of his talent, who could not do as much. But it is clear from her neck, her short fingers, her spindly legs, her feet with their deformed toes, her ignoble character, and an infinite number of other faults, that the model was a chamber maid or hotel servant. The head would not be bad if it weren't so vulgar. The arms, thighs, and legs are made of flesh, but the flesh is soft and flaccid—so soft and flaccid that if I were Jupiter I would be sorry that I had gone to the trouble of transforming myself. Next to this long, long, skinny Antiope there is a fat, chubby angel, twinkling and smiling, stupidly fine, altogether in the manner of Coypel, with all his little affectations. I observed to the artist that Cupid was one of those violent, slim, despotic and naughty characters and that hers reminded me of the fat healthy baby of a prosperous farmer. This fake Cupid, hidden in the half light, carefully lifts a gauze veil to

leave Antiope entirely exposed to Jupiter's gaze. This satyric Jupiter is nothing but a strong laborer with a flat face. The artist has lengthened his beard, given him split feet, and covered his thighs with fur. He feels passion, but it is an evil, hideous, lewd, improper and base passion. He is thrown into ecstasies, he stupidly admires, he smiles, has convulsions, licks his lips. . . .

She sent this painting to the Salon's committee, which rejected it. She fell into despair, and she felt ill. Fury followed weakness, she cried out, she pulled her hair, she rolled on the ground, she grabbed a knife, uncertain whether to use it on herself or her painting. She prayed to all the gods. I arrived in the middle of this scene; she clasped my knees, beseeching me in the names of Gellert, Gessner, and Clopstock, and all my German colleagues in Apollo, to assist her. I promised her, and in fact I went to see Chardin, Cochin, Le Moyne, Vernet, Boucher and La Grenée and I wrote to others. But all replied that the canvas was improper, and I understood that they judged it bad. If the nymph were beautiful, if the Cupid were charming, if the satyr had a strong character, she would have done what can be done for better or worse, and it would have been accepted until a public outcry retired it. Didn't we see at the Salon seven or eight years ago a nude woman lying on some pillows, her limbs outstretched, offering the most voluptuous head, the most beautiful back, the most beautiful buttocks—extending an invitation to pleasure and doing so by the most accommodating, easy, one might even say the most natural, or at least most advantageous pose? I am not suggesting that this painting should have been accepted, and that the jury should not have respected the public and outraged morals, I am only suggesting that these considerations are of little consequence when the work is good; I say that our Academicians care more about talent than about propriety. . . .

Along with her *morceau de réception*, Mme. Lisiewska-Therbusch sent a *Head of a Poet* in which there is verve and color. Her other portraits are cold, with no merit aside from the likeness—except for mine, which has a good likeness, in which I am nude to the waist, and which for dignity, flesh and

technique is well above the work of Roslin and every other member of the Académie. I placed it beside one by Van Loo, and it did Van Loo's a bad turn. It is so striking that my daughter said she would have kissed it a hundred times during my absence if she weren't afraid of spoiling it. The chest was painted very warmly, with transitions and flats altogether true.

When the head was finished and it was time to work on the neck, the height of my clothing hid my neck and annoyed the artist somewhat. To end her annoyance, I went behind a curtain, undressed, and appeared before her like a model at the Académie. "I would not have dared to suggest that to you," she said, "but you did well and I thank you." I was nude, entirely naked. While she painted me, we chatted with a simplicity and innocence worthy of the first centuries. . . .

If this woman walked a little through our Salon, she would have seen "our children with rhinoceros' noses" disdaining much better paintings than hers; she would have returned a little surprised at the severity of our judgments—and more sociable, more easy going, and less vain.

Dorothea Lisiewska-Therbusch returned to Berlin in 1768; neither she nor Marie Thérèse Reboul Vien exhibited at the Salon after 1767. Three years later the Académie Royale admitted two more women—Anne Vallayer-Coster, a still-life painter, and Marie Suzanne Giroust, who worked as a pastel portraitist—and at the same time enacted a regulation limiting the number of woman academicians to four.

# Angelica Kauffmann: Letters (1766, 1786, 1788)

Angelica Kauffmann (1741-1807) arrived in England in the spring of 1766. She came as the protégée of Lady Wentworth, wife of the British Ambassador to Venice, who was eager to introduce to London the young Swiss woman who had already captivated the international society of Rome. Sir Joshua Reynolds, England's most distinguished portrait painter, took an immediate interest in the young artist's career, and they arranged to paint each other's

portrait. The agreement may have persuaded patrons of the quality of Kauffmann's work; certainly it convinced gossips that the pair would marry. After Kauffmann established herself in rooms in a surgeon's house in Suffolk Street, Charing Cross, she wrote several letters to her father, a painter and her first teacher, to describe her success.

## To Joseph Johann Kauffmann, 1766*

I have been to visit several of the studios here, but there is none to compare with that of Mr. Reynolds. He is decidedly the first English painter. He has a peculiar method and his pictures are mostly historical. He has a light pencil or touch which produces a wonderful effect in light and shade. . . .

\*        \*        \*

I am in a private house with excellent people, old acquaintances of my lady, who has had the goodness to recommend me to them as if I were her own daughter. I have been here a month. The people of the house do everything for me. The handy-woman is a mother to me, and the two daughters love me as a sister.

The opportunity was so good, and everything suited me so well, that I did not hesitate to secure them, and have taken the apartments for the whole winter. I have four rooms; one where I paint, the other to show my portraits which are finished (it is the custom here for people to come and see the work without disturbing the artist). The other two rooms are very small, in the one that is my bedroom there is scarcely room for the bedstead to stand, the other serves to keep my clothes and trunks. For the rooms I pay two guineas a week, one guinea for the keep of the man servant, whom I have also to clothe; this is without washing and other small expenses, but I could not dispense with the servant.

These are my outgoings, which will appear to you very large, but it could not be less. Should you determine on coming

---

\*   Excerpted from Frances A. Gerard, *Angelica Kauffmann,* New York: Macmillan, 1893, 45-46, 54-58, 61, 227-31, 445-46.

this winter, we must take a house, which is very hard to find, and nothing could be had under a hundred guineas a year, unfurnished, and to furnish it would cost four hundred guineas. Consider how expensive all this would be; especially in the winter time, when everything is double in price, the days twice as short, so that little work can be done. You know very well that we must have a man and a maid. Decorum requires this, for I am known to everyone here, and I have to maintain a character for respectability for the sake of my standing in the profession, so that everything must be arranged on a proper footing from day to day, which is most necessary if one wants to be distinguished from the common herd. Ladies of quality come to the house to visit me or see my work. I dare not receive people of their rank in a mean place. My present apartment is very proper for the purpose at the same time as moderate as can be had here. . . .

*              *              *

Reynolds is one of my kindest friends and is never done praising me to everyone. As proof of his admiration for me, he has asked me to sit for my picture to him and in return I am to paint his!

*              *              *

There is nothing but applause for my work; even the papers are full of verses written in different languages, all in praise of me and my pictures. . . .

I have finished some portraits which meet great approval. Mr. Reynolds is more pleased than anyone. I have painted his portrait, which has succeeded wonderfully, and will do me credit. It will be engraved immediately. Lady Spenser has paid one hundred ducats for her picture. Lord Exeter is still in the country. This morning I had a visit from Mrs. Garrick. My lady Spenser was with me two days ago. My Lord Baltimore visits me sometimes. The Queen has only returned two days. As soon as she is better I am to be presented to her. Two days ago the Duchess of Lancaster came to see me; she is the first lady at Court.

By 1767 Kauffmann had earned enough money to purchase her own house in Golden Square, Soho, where her father joined her and royalty came to sit for their portraits. That same year she married, but she separated from her husband almost immediately when she discovered that not only was he not a count, as he had led her to believe, but that he was married already.

Official recognition of Kauffmann's achievements came in 1768 when she was asked to become a founding member of the Royal Academy. English artists and connoisseurs had long hoped that the crown might sponsor an organization similar to the French Académie Royale. Lacking royal support, artists themselves had organized a private drawing academy headed by George Moser and in 1760 initiated an annual exhibition. After one year, however, they had split and formed two organizations, which came to be known as the Free Society of Artists—in whose exhibitions Kauffmann had participated—and the Incorporated Society of Artists in Great Britain. Finally in 1768 King George III agreed to sponsor a Royal Academy: it immediately enjoyed greater prestige than either of the earlier societies.

The Royal Academy's articles of organization made no mention of women's membership, but the admission of two women—Kauffmann and Mary Moser, a flower painter and the daughter of George Moser—established a precedent. The Incorporated Society of Artists had included women in its exhibitions, but in 1769 it followed the example of the Royal Academy and admitted five women—Catherine Read, Mary Benwell, Mary Grace, Eliza Gardiner, and Mary Black—as "honorary members."

Although most of Kauffmann's income came from portraiture, she regularly sent history paintings to the Royal Academy's annual exhibitions. According to rumor she worked from the nude, but her models maintained that she always posed them decorously draped and her sketchbook contained no nude studies. Critics pointed out the discrepancy between her ambitions and her training. In 1781 the anonymous author of *The Earwig* noted slyly: "This lady seems in all her works to have copied pictures, prints, and plasters; perhaps she has been deterred by the delicacy of her sex from studying living models" (quoted Gerard 1893, 176). Nevertheless when the well-known print publisher John Boydell made plans to commission and exhibit a series of paintings illustrating Shakespeare's plays, Kauffmann was one of the first artists he asked to contribute, so highly did he regard her work. Responding to Boydell's request, Kauffmann stressed that her compositions owed nothing to any other artists' works.

**To John Boydell, 1786**

I greatly admire the idea you have to form so noble a gallery, and I shall certainly esteem it an honour to have my portrait placed amongst the respectable artists you name.

I likewise understand that you wish to have half a dozen historical pictures done by me, my engagements are very numerous—I am just now finishing two large historical pictures for His Majesty the Emperor, and though I have a great number of other commissions, I shall as soon as I can be mindful of yours, and choose such subjects which may be pleasing and interesting. I generally prefer to paint what I have not seen done by others.

Kauffmann returned to Italy in 1781 with her father and Antonio Zucchi, a painter whom she married after the death of her first husband and who, after the death of her father, assumed responsibility for her business matters. Kauffmann and Zucchi established their home on Rome's Via Sistina below Trinità de'Monti. Visitors to Casa Zucchi passed down a hall lined with statues and busts to enter Kauffmann's rooms, where she displayed her collection of paintings, carefully protected by silk curtains.

Their friends included many musicians, artists, and writers from Rome's German community; during the two years he spent in Italy Johann Wolfgang von Goethe became a frequent Sunday visitor. He found Kauffmann to be an invaluable guide to Roman collections; she, in turn, encouraged his attempts to draw, advised him against speculating on works of art, and listened to his works in progress. When Goethe returned to Germany, Kauffmann missed his companionship, as a letter she wrote him in 1788 shows.

**To Johann Wolfgang von Goethe, 1788**

I dreamt last night you had come back. I saw you a long way off, and hastened to the entrance door, seized both your hands, which I pressed so closely to my heart that with the pain I awoke. I was angry with myself that my joy in my dream should have been so great and that in consequence my happiness had been shortened. Still, today I am content, for I have your dear letter written July 19. . . .

You want to know what I am working at. I have the following pieces finished, I think: *Cardinal Rezzonico Before the Senate*. Today I am finishing *Virgil*; the subject you will remember. I am very well pleased with the effect of the chiaroscuro—this picture has a great deal of strength and the colors have become very brilliant. I have also commenced the two for the Shakespeare Gallery and a picture for the Duke of Courtland. Soon I must consider the subject for my large picture for Catherine of Russia. I have as yet done nothing, and I want to make it as good as possible. To do this, I must imagine it is Sunday and that you are coming to my studio. Ah! the dear past. It does not do to think of that.

My portrait, or it would be better to call it the painting, which I presented to the gallery in Florence, has been accepted. I received the letters a few days ago, and that they have placed me in a good light and beside a very famous man—no less than Michelangelo Buonarroti. I wish I could stand near him, not in effigy alone, but this is too ambitious. The Grand Duke, as proof of his kind acceptance of the portrait, has honored me with the gift of a large gold medal. Now it is time for me to stop speaking of myself; I have already said too much. . . .

# Elisabeth-Louise Vigée-Lebrun: Memoirs (1776-1789)

Elisabeth-Louise Vigée-Lebrun (1755-1842) was born in Paris, the daughter of Louis Vigée, a portrait painter, and Jeanne Maissin, a hairdresser. Like most middle-class girls, she attended a convent school, where she was sent at the age of six and remained until after her first communion at eleven. Vigée-Lebrun later recalled covering the margins of her notebooks with drawings: "As you can imagine, I was often punished" (Vigée-Lebrun 1879, 2). When she returned to live with her family, her father encouraged her interest in drawing and taught her to use his pastels; after his death in 1767, family friends and other artists offered her advice and lessons.

At fifteen Vigée-Lebrun was receiving portrait commissions that helped to support her family and educate her younger brother. Because French law required that professional artists be members

of a guild, she joined the Académie de Saint-Luc and participated in its exhibition of 1774. Two years later she married Pierre Lebrun, a picture dealer who lived in the same building as her family. Although Vigée-Lebrun profited from the access to important paintings that Lebrun's business gave her, she complained that her success supported her husband's fondness for gambling and women—but she probably had little recourse, since by law a husband controlled his wife's earnings.

Vigée-Lebrun's most important patron was Queen Marie Antoinette, from whom she received a number of portrait commissions. In 1783 the Queen supported Vigée-Lebrun's admission to the Académie—a position that had become increasingly important as the government tightened its regulation of exhibitions, but from which Vigée-Lebrun was barred by her marriage to a dealer. At her first Salon, the artist exhibited *Peace Bringing Back Abundance* and staked her claim to the title of history painter. The government never gave Vigée-Lebrun a commission for an historical subject, but in 1786 it did ask her for an official portrait of Marie Antoinette and her children that was intended to offset an unflattering portrait of the Queen exhibited the previous year.

Vigée-Lebrun's close association with Marie Antoinette was not, however, always an advantage. The Austrian princess had delighted Parisians with her grace when she came to the throne, but she soon appalled them with her taste for luxury and her impatience with court formality. Those who believed that the Queen would sell her favor for a diamond necklace were only too willing to credit gossip about the Queen's favorite painter and the Minister of Finance, the Comte de Calonne.

With the coming of the Revolution, Vigée-Lebrun's position became increasingly tenuous, so in October 1789, as the women of Paris marched to Versailles to demand bread, she and her daughter left France for Italy. She remained in exile until 1801, working in Italy and Russia, where her skills as a portraitist were sought after in aristocratic circles.

When Vigée-Lebrun began her memoirs in 1835, she promised to recount the facts of her life with "simplicity and truth." Her autobiography, however, is much like her portraits: just as she adjusted pose and proportion to show her sitters in the most flattering light, she omitted or embellished the details of her own story. She neglected, for example, the Queen's role in her admission to the Académie, but she included an account of the Queen's stooping to pick up her brushes—a story reminiscent of

one told of Titian and Charles V, but enriched by the painter's pregnancy, a detail that suggests a special feminine bond between artist and patron.

## Letter I*
My very good friend, you wish so very much for me to write my memoirs that I have decided to satisfy your desire. Imagine my heartfelt sensations as I remember the various events I have witnessed and the friends who exist no longer, save in my thoughts! Nevertheless, the task will be easy, for I remember them in my heart, and in my solitary hours those dear departed friends surround me still, so vivid are they in my imagination. . . .

## Letter IV
Dear friend, after my step-father retired from business, we went to lodge in the Hôtel Hubert, rue de Cléry. M. Lebrun had just bought this house and was living there, and as soon as we were settled, I went to see the splendid paintings of all schools that filled his apartment. I was delighted to have a neighbor who gave me the opportunity to consult so many masterpieces. M. Lebrun kindly lent me some very valuable and lovely paintings to copy. I owed, therefore, my best lessons to him; and at the end of six months he asked for my hand in marriage. I was not at all anxious to marry him, although he was well made and had a pleasant face. I was then twenty; I was not at all worried about my future, as I earned a good deal of money, so that I did not feel any desire to be married. But my mother, who fancied M. Lebrun was very rich, constantly urged me not to refuse such an advantageous match. I finally consented to this marriage, largely because I longed to escape living with my step-father, whose bad temper grew worse every day he was inactive. So little was I inclined to renounce my freedom that on the way to the church I kept saying to myself, "Shall

---

\*    Excerpts adapted from Elisabeth-Louise Vigée-Le Brun, *Souvenirs of Madame Vigée-Le Brun*, translator unidentified, New York: R. Worthington, 1879, 30, 32-33, 35-36, 40-46, 50, 52-55, 57, 60-64, 66-69.

I say 'yes'? Shall I say 'No'?" Alas! I said "Yes," and I exchanged my old troubles for new ones. . . .

I could not keep up with the requests for portraits that poured in from every side, and although M. Lebrun had already made a habit of pocketing my fees, he did not hesitate to make me take pupils in order to increase our income. I consented to what he wished without taking time to think about it, and soon several young ladies were coming to me for instructions in making eyes and noses and faces, which I constantly had to retouch and which took me away from my own work, to my great irritation. . . .

The obligation to leave my beloved brushes for a few hours increased, I believe, my fondness for my work. I never left my painting until night had completely fallen, and the number of portraits I finished at that time was simply prodigious. As I loathed the way women dressed in those days, I did my best to make it more picturesque, and was delighted when my models entrusted me to drape them as I pleased. Shawls were not worn then, but I used large scarfs and by lightly twining them around the body and arms, I tried to imitate the draperies of Raphael and Domenichino, as you perhaps have noticed in my Russian pictures, especially in the one of my daughter playing the guitar. I also loathed the use of hair powder. I persuaded the lovely Comtesse de Grammont-Caderousse not to wear any when she sat for her portrait. Her hair was as black as night, and I parted it and arranged it in careless locks over her forehead. After my sitting, which finished at dinner time, she went to the theater without changing her hairstyle. She was so pretty she was sure to set the fashion, and indeed this style gradually became generally popular. This reminds me that in 1786, when I was painting the Queen, I begged her not to wear powder and to part her hair in front. "I shall be the last to follow that fashion," said the Queen, laughing. "I do not wish it to be said that I invented it in order to hide my high forehead."

I tried as best I could to give to the ladies I painted the attitude and expression of their personality. Those that had none in particular, I painted with pensive looks, leaning nonchalantly against some object. I believe that they were

satisfied, for I could not keep up with the demand for my work. . . .

These personal triumphs—which I have related to you, dear friend, because you asked me to tell you everything—cannot be compared with the joy I felt when, after two years of marriage, I learned I would become a mother. But here you will see how my extreme love for my art made me careless about the small details of life, for, as happy as I felt, I let the nine months of my pregnancy pass without dreaming of making any preparations. The day my daughter was born I never left my studio, and worked at my *Venus Tying Cupid's Wings* in the intervals when I felt no pain.

Madame de Verdun, my oldest friend, came to see me in the morning. She sensed that I would be brought to bed that day and asked me if I was provided with all that was necessary, as she knew how giddy and careless I was. I answered her, with much surprise, that I did not know what was necessary. "Just like you!" she answered, "you are a regular tomboy. I am certain that you will have your baby tonight." "No! no!," said I, "I have a sitting tomorrow. I will not be brought to bed today." Without replying, Madame de Verdun left me a short time to send for a doctor, who arrived soon after. I sent him away, but he remained, unknown to me, till the evening, and at ten o'clock my daughter was born. . . .

**Letter V**

It was in the year 1779, my dear friend, that I painted the Queen's portrait for the first time; she was then in all the brilliance of her youth and beauty. . . .

At the first sitting the Queen's imposing bearing intimidated me extremely, but Her Majesty spoke to me so kindly that her charm soon dissipated this impression. It was then that I painted her with a large basket, dressed in a satin robe and holding a rose in her hand. This portrait was intended for her brother, the Emperor Joseph II. The Queen ordered two copies of it, one for the Empress of Russia, the other for her apartments at Versailles or Fontainebleau. . . .

As soon as Her Majesty heard that I had a pretty voice, she rarely gave me a sitting without making me sing several

of Grétry's duets with her, for she was very fond of music, although her voice was not always in tune. As for her conversation, it would be difficult to describe its affability and charm. I do not believe that Queen Marie Antoinette ever allowed an occasion to pass by without saying something pleasant to those who had the honor of approaching her, and the kindness which she always showed me is one of my most delightful memories.

One day it happened that I missed a sitting that was scheduled with her because I was well along in my second pregnancy and suddenly felt ill. The next day I hurried to Versailles to make my apologies. The Queen was not expecting me, and had called for her carriage, which was the first thing I saw when I entered the palace courtyard. All the same I went up and spoke to the gentlemen-in-waiting. One of them, M. Campan, received me very coldly and stiffly and said angrily in his stentorian voice, "It was yesterday, Madame, that Her Majesty expected you, and of course she is going for a drive and of course she will not give you a sitting." When I replied that I came merely to receive Her Majesty's orders for another day, he went to find the Queen, who immediately called me into her sitting room. She was finishing her toilette and held a book in her hand and was going over Madame Royale's lessons. My heart beat very fast, for I was as fearful as I was in the wrong. The Queen turned and said kindly, "I waited for you all yesterday morning, what happened to you?" "Alas! Madam," I replied, "I was so ill that I was unable to attend Your Majesty's commands. I have come today to receive them and will leave directly." "No! no! Do not leave," she replied. "I will not let you make your journey for nothing." She dismissed her carriage and gave me a sitting. I remember that in my eagerness to make amends for her goodness, I grabbed my box of colours so quickly that I upset them all; my brushes and paints fell to the floor, and I stooped down to collect them. "Let them alone, let them alone," said the Queen, "you are not in a condition to stoop." And not heeding what I said, she bent down and picked everything up herself. . . .

The last sitting I had with Her Majesty was at the

Trianon, where I painted her head for the large picture in which I depicted her with her children. . . .

After having finished the Queen's head, as well as separate studies for the first Dauphin, Madame Royale, and the Duc de Normandie, I immediately set to work, for I considered this painting very important, and I finished it for the Salon of 1788. The frame, which was taken there by itself, was enough to cause many unpleasant remarks. "There goes the deficit," they said, and many other things that were repeated to me and warned me to expect some harsh criticism. At last, I sent my painting, but I did not have the courage to follow it and learn my fate, so much did I dread it would meet with a bad reception from the public. My fear was so great that it made me feverish; I shut myself in my room, and was there praying to God for the success of *my* royal family, when my brother and a crowd of friends came to tell me I had won universal approval. . . .

## Letter VI

Dear friend, in 1782, M. Lebrun took me to Flanders, where he was going on business. The splendid collection of paintings belonging to Prince Charles was being sold in Brussels, and we went to see the exhibition. . . .

At that time [the paintings of Rubens] were better displayed than they have been since at the museum in Paris, for their effect in the old Flemish churches was beautiful. Other paintings by the same master decorated the private galleries: at Antwerp I saw the famous *Straw Hat* which was recently sold to an Englishman for a considerable sum of money. This wonderful painting represents one of Rubens' wives. Its chief effect consists of the different lights—sunlight and daylight: the bright light is sunlight and what I must call the shadow, for lack of a better word, is daylight. Perhaps only a painter can judge all the merits of Rubens' execution. I was enchanted with this picture, which inspired me so much that when I returned to Brussels I made a portrait of myself and tried to achieve the same effect. I wore a straw hat with a feather and held a garland of wildflowers and a palette in my hands. I may say that when the portrait was exhibited at

the Salon it added a good deal to my previous reputation. The celebrated Muller engraved it; but the dark shadows of an engraving take away from the effect of such a painting.

Shortly after my return from Flanders in 1783, on the strength of the portrait I have just mentioned and several other of my works, Joseph Vernet decided to propose me as a member of the Académie Royale de Peinture et Sculpture. M. [Jean Baptiste Marie] Pierre, then chief painter to the King, was strongly opposed to it, as he did not, he said, wish women to be received; and yet Mme. Vallayer-Coster, who painted flowers most beautifully, had already been received, and I believe Mme. Vien had been also. However that may be, M. Pierre (a very mediocre painter, for he saw nothing in painting but the art of handling the brush) was a clever man; and besides he was rich, which enabled him to entertain artists, who in those days were not as well off as they are now. His opposition would have been fatal for me, if at that time amateurs were not named as associates of the Académie and if they had not formed, in my favor, a cabal against that of M. Pierre. It was at this time that the following couplet was written:

To Madame Lebrun:

Au Salon ton art vainqueur,
Devrait être en lumière.
Pour te ravir cet honneur
Lise, il faut avoir le coeur
De Pierre, de Pierre, de Pierre.*

Finally I was admitted. M. Pierre then spread about a rumor that I had been received at the order of the Court. I really believe that the King and Queen were kind enough to wish me to enter the Académie, but that was all. For my *morceau de réception*, I presented *Peace Bringing Back Abundance*, which is now in the Ministry of the Interior. It should be

---

*   At the Salon thy victorious art / Should be brought to light. / To deprive thee of this honor, / Lise, would take a heart / of stone, of stone, of stone.

returned to me, since I am no longer a member of the Académie. . . .

After my marriage I still lived in the rue de Cléry, where M. Lebrun had a large and very richly furnished apartment where he kept his paintings by the great masters. As for me, I was reduced to occupying a little ante-room and bedroom which served me as a sitting-room. The walls of this room were covered with the same cretonne print that was used in my bed curtains. The furniture was extremely simple, too simple perhaps, but that did not prevent M. de Champcenetz (his mother-in-law was jealous of me) from writing that "Mme. Lebrun had splendid hangings in her rooms; she lit her fire with bank notes and only burnt aloe wood." But I will wait as long as possible, dear friend, to tell you of the thousands of slanders of which I was the victim; we shall return to them by and by. The explanation for them is that every evening in these modest, small apartments which I have described I received both courtiers and townsfolk: great ladies, noblemen and notable men in letters and art came to my receptions, and often the crowd was so great that, for lack of a chair, the marshals of France had to sit on the floor—I remember one night the Marshal de Noilles, who was very large and very old, had great difficulty in getting up again.

As you may believe, I was far from flattering myself that all these great people came for my sake; as happens where open house is kept, some came to meet their friends, and others, the majority, came to enjoy the best music which was to be had in Paris. The famous composers—Grétry, Martini, Sacchini—often tried out parts of their operas at my house before the first performance. Our usual singers were Garat, Azevedo, Richer, Mme. Todi, my sister-in-law, who had a very beautiful voice and could sight read music, which was very useful to us. . . .

It is impossible to imagine what society was like in France in those days when the business of the day was over and twelve or fifteen people would gather at a friend's house to finish the evening. The ease and laughter which prevailed at these entertainments gave them a charm which mere dinners can never have—friendliness and intimacy reigned among the guests, and since well-bred people are never

troubled with shyness, it was at these suppers that Parisian
society showed its superiority over that of all Europe. . . .

## Letter VII

Here, my dear friend, is an exact account of the most
brilliant supper I ever gave in the days when people were
always talking about my luxurious and magnificent manner
of living.

One evening I had invited twelve or fifteen friends to
hear a reading of the poet Le Brun; while I was resting before
they arrived, my brother read me some pages from the
*Travels of Anacharsis*. When he came to the passage
describing the way the Greeks made their different sauces,
he said, "We ought to try some of those things tonight." I
immediately called my cook and told her our plans, and we
decided she should make one sauce for the fowl and another
for the eels. As I was expecting some very pretty women, I
thought we might all dress up in Greek costumes to surprise
M. de Vaudreuil and M. Boutin, whom we knew could not
arrive before ten. My studio, full of the draperies I used for
my models, provided me with enough clothing, and the
Comte de Parois, who lodged in my house, had a fine
collection of Etruscan vases. By chance he came to see me
that day around four o'clock; I told him about my project and
he brought me a quantity of vases to choose from. I dusted
them carefully and placed them on a bare mahogany table. I
then placed behind the chairs a large screen, which I carefully
disguised by covering it with a cloth that I draped as in some
of Poussin's paintings. A hanging lamp threw a strong light
on the table. At last everything was prepared, even my
costumes; the first to arrive was a daughter of Joseph Vernet,
the charming Madame Chalgrin. Immediately I arranged her
hair and dressed her, then came Madame de Verneuil, who
was renowned for her beauty; Madame Vigée, my sister-in-
law, who though she was not very pretty had the loveliest
eyes; and there were all three transformed into *bona fide*
Athenians. Le Brun-Pindare came in; we took off his powder
and undid his side curls, and on his head I placed a wreath of
laurel with which I had painted the young prince Henry
Lubomirski. . . . The Comte de Parois had a large purple

mantle with which I draped my poet, and in a twinkling there was Pindare transformed into Anacreon. Then the Marquis de Cubières arrived. While they went to his house for his guitar, which he had mounted as a golden lyre, I costumed him also, as well as M. de Rivière (my sister-in-law's brother), Ginguené and Chaudet, the famous sculptor. . . .

At ten we heard the carriage of the Comte de Vaudreuil and de Boutin and when these two gentlemen entered the room, they found us singing the chorus from Gluck, the God of Paphos and Guido, with M. de Cubières accompanying us on his lyre.

I never in my life saw two such astonished faces as those of M. de Vaudreuil and his companion. They were surprised and delighted and could hardly tear themselves away from looking at us in order to sit down in the places reserved for them. Besides the two dishes I already mentioned, we had a cake made of honey and Corinthian grapes, and two plates of vegetables. That evening we did indeed drink a bottle of old Cyprian wine which had been given to me, but that was our only excess. We sat a long time at table, and Le Brun recited for us several odes that he had translated. We all spent a most amusing evening.

M. Boutin and de Vaudreuil were so enthusiastic about it, that the next day they talked about it among their friends. Some ladies of the court asked me to repeat this amusement, but I refused for several reasons, and several of them were annoyed with me as a result. Soon the rumor spread that this supper cost me twenty thousand francs. . . .

It is unfortunately only too true that since my first appearance in society I have been the victim of malice and stupidity. First it was said that my works were not my own, that M. Ménageot painted my pictures and even my portraits, even though the people who sat to me could naturally bear witness to the contrary. This absurd rumor did not stop until I had been received in the Académie Royale de Peinture et de Sculpture. Then, as I exhibited in the same Salon as the author of *Meleagro*, the truth came out, because Ménageot, whose talent and advice I fully appreciated, had a style of painting quite different from mine. . . .

Although I was, I believe, the most harmless person

there ever was, I had enemies. Not only did some women dislike my not being as plain as they were, but several could not forgive my being the vogue and my getting more money for my paintings than they did. The result was remarks of every kind, one of which distressed me very much. Shortly before the Revolution, I made a portrait of M. de Calonne and exhibited it at the Salon of 1785. I painted this Minister seated, a half-length picture, which led Mlle. Arnould to say when she saw it: "Mme. Lebrun has cut off his legs so that he may not run away." Unfortunately this witty remark was not the only one to which my painting gave rise; the most dreadful lies were invented about the picture. Some asserted that the Minister of Finance had given me a number of those bon-bons called *papillotes* wrapped in bank notes; others that I had received in a pasty a sum large enough to ruin the Treasury. The truth is that M. de Calonne had sent me four thousand francs in a box valued at twenty louis; several people are still alive who were present when I received it, and can testify to the truth of my statement. . . .

Besides, all those who surrounded me knew that M. Lebrun took possession of all the money I earned, telling me that he required it for his business; frequently I had only six francs in my purse. . . .

My indifference to money was no doubt due to the fact that I had little need to be rich. I lived very modestly and spent little on my clothes; I was often reproached with negligence on this point, for I wore generally nothing but white dresses, either muslin or linen, and I never wore full dress except for my sittings at Versailles. I spent nothing to have my hair dressed. I arranged my hair myself and generally twisted a muslin kerchief around my head, as can be seen in my self-portraits in Florence, St. Petersburg, and at M. de Laborde's residence in Paris. In all my portraits I am painted thus; the one exception is the painting which is at the Museum of the Louvre in which I am dressed as a Greek.

Certainly, a woman of this kind would not earn the title of Receiver-General of Finances, and besides, M. de Calonne had no attractions for me, for he wore a lawyer's wig. A wig! I always detested them, and imagine how, with my love for the picturesque, how I could have put up with a wig! . . .

This is a sad letter, enough to disgust one with fame, especially if one has the misfortune to be a woman. A gentleman said to me one day: "When I look at you and think of your renown, I seem to see rays of glory round your head." "Ah!" I replied, sighing, "There are many little serpents in rays of that kind." In fact, is there ever a great reputation in any field that does not excite envy? It is true that it also attracts to you all your most distinguished contemporaries, and this society is a great consolation. When I think of the many amiable, kind people whose acquaintance and friendship I owe to my art, I am happy that I made my name known; and to conclude in one word, dear friend, when I think of you I forget the wicked.

# Louis Petit de Bachaumont [Moufle d'Angerville]: Vigée-Lebrun at the Salon of 1783

When Elisabeth-Louise Vigée-Lebrun made her debut at the Salon of 1783, her paintings and pastels were the subject of public interest and critical attention. Art criticism was more common than it had been when Diderot began writing in 1859, but much of it, published anonymously or pseudonymously in pamphlets and small journals, was mediocre. At one extreme it included malicious satires of dilettantes, and at the other the considered criticism that appeared in the *Mémoires secrets* under the name of Bachaumont.

The *Mémoires secrets* had their origins in the seventeenth century *nouvelles à la main*, clandestine newsletters that kept Parisians and provincials informed about events at court and in the city despite government censorship of the press. In the 1730s Louis Petit de Bachaumont and Mme. Doublet had founded a salon that after 1742 became the source for the news included in one of the best known *nouvelles à la main*. While for many a positive response to the question "Is this from Mme. Doublet's salon?" was enough to confirm any information, others—including Voltaire—scorned the newsletter as drawing-room tattle. With the deaths of Bachaumont and Doublet in 1771, the newsletter was continued in book form as *Mémoires secrets* by Mathieu François Pidansat de Mairobert. In 1779 it was taken over by Moufle d'Angerville (birth date unknown-1794).

Since Bachaumont and Doublet had shared an interest in art and friendships with artists, a review of the Salon written by Bachaumont was added to the news in the 1760s. The later editors continued to include reviews which, presumably, they wrote themselves. Reporting on Salon of 1783, Moufle d'Angerville responded to the lively public interest in one of the newest academicians. His review of Vigée-Lebrun's paintings mingled aesthetic theory, explanations of the artist's allegorical subjects, and—in keeping with the tradition of *nouvelles à la main*—some gossip.

**Sir—**\*

Since the imitative arts, however perfect they seem, can never equal the inexhaustible fecundity, the infinite variety of nature, their model, one might fear that they would become boring and monotonous to the historian, since they return so often to the same subject. However, the Salon has always offered some unexpected incident, some new scheme, and especially some anecdote that adds zest and diversity to reports on this exhibition. Today, for instance, despite the number of history paintings gathered in this spot—more than have been previously seen—and despite the excellence of the many masters competing in the arena of the grand genre— who would have believed it? Would it not have seemed blasphemous even to suggest it? Apollo's scepter seems to have been turned into a spindle, and a woman carries off the palm of victory. . . .

When one announces that one has come from the Salon, one is asked: "Have you seen Mme. Lebrun? What do you think of Mme. Lebrun?" And immediately one's reply is suggested: "Isn't Mme. Lebrun truly a surprising woman?" That is the name, Sir, of the woman to whom I refer, who has become so famous in such a short time, because it was only a few months ago that she was named to the Académie, becoming a full member immediately in accordance with the

---

\*    Translated from Louis Petit de Bachaumont, *Mémoires secrets pour servir à l'histoire de la République des lettres en France, depuis MDCCLXII jusqu'à nos jours*, Vol. 24, 3-7, 9-11, London: John Adamson, 1785.

privilege granted to women and occupying one of the four seats reserved especially for women.

What has contributed not a little to the spread of Mme. Lebrun's reputation is that she is a young and pretty woman, full of wit and charm, very pleasant, who sees the best people of Paris and Versailles, who gives fine suppers for artists, writers, and people of quality. Her house is a sanctuary where the Polignacs, the Vaudreuils, and the Polastrons—the most refined and distinguished courtiers—seek a retreat from the boredom of court and find the pleasure that eludes them elsewhere. Such powerful patronage was necessary to overcome the Académie's barriers, for despite her merit, she would not have been accepted since her husband's mercantile practices are degrading to art and an essential reason for exclusion from the organization. But since I have described the artist, it is time to turn to her work.

I do not know in what class the Académie has placed Mme. Lebrun—history, genre or portraiture—but she is not unworthy of any, even the highest. I consider her *morceau de réception* very worthy of her admission. It is *Peace Bringing Back Abundance*, an allegory as natural as it is ingenious; no better choice could have been made under the circumstances. The former figure—noble, decorous, and modest like the Peace [of Versailles] that France has just concluded—is characterized by the olive, her favorite plant. In her right hand, she holds a branch which she softly entwines around the second figure, who looks at her obligingly and seems to yield easily to her prompting. The latter figure is characterized by the handful of ears of wheat that she holds in her left hand and is about to scatter on the ground. With her other hand, she pours out the varied fruits of the earth from a cornucopia. Goatskins full of wine complete the pleasures necessary to the people for whom the blessings of peace are invoked.

What is more, the person who plays the part of Abundance is a magnificent Rubenesque woman, whose large proportions mark her health, vigor and joy. Her flesh is firm and elastic, and her bust lifts itself from the canvas, so to speak. The freshness and brilliance of her complexion seem more beautiful than nature itself, because one compares her

to young Parisian women. But the model was on the contrary drawn—as she should have been—from what country folk prefer as healthy and sturdy; here it is appropriated by an art without falseness and embellished with the flourishes that belong to the *toilette* of a good city *bourgeoise*.

If one examines the figures as an artist would, one sees that they are grouped in a superior manner. The large forms, soft contours and picturesque and knowingly posed gesture of Abundance are admirable, while Peace, the daughter of Heaven, is drawn with a more precise line, and her face is suffused with the sweetness, calm and repose of Olympus' inhabitants. Her plain, severe dress forms a marvelous contrast to the sheen of the fabric that her completely terrestrial companion allows to float freely around her. The latter is more elegantly coiffed: a thousand flowers wreathe her head, while her companion is crowned only with olive leaves. These various contrasts produce a harmony within the painting that delights the viewer; its principal cause eludes the vulgar, but is soon grasped by connoisseurs. . . .

In addition, Mme. Lebrun is also exhibiting three portraits of the Royal Family: the Queen, Monsieur, and Madame. The two princesses are wearing shifts, a costume women have recently devised. Many consider it inappropriate to present these dignified personages to the public in a dress reserved the privacy of the palace; presumably the artist had permission to do so and would not have taken such a liberty on her own.* In any case, Her Majesty is well painted; she has the light and deliberate manner, the ease that she prefers to the bother of state display and that at home does not conflict with her noble role. Several critics have found her neck too slender—a small mistake in drawing; for the rest, the freshness of her face, the elegance of her carriage, and the naturalness of her pose all make this an appealing portrait. It is even of interest to those who at first glance do not recognize the Queen.

Madame is somehow more severe, more reserved,

---

* After this writing, the indecency of this costume—above all for the Queen—was noted and the removal of the paintings was ordered.

more sober—the attributes of her character prevail. The resemblance is striking. One wishes only that her arms were permitted to move and were not glued to her body, making her look like a mannequin. As for the prince, the gaiety of his expression is rarely seen in his portraits— apparently he was never bored while he was being drawn. One can easily believe it when one sees Mme. Lebrun's self-portrait. However, she made less of an effort to enhance her charms than to display her artistic talent. She wears a hat with a very large, turned-down brim, throwing a carefully arranged shadow onto her face and leaving more to be guessed at than to be seen—a small failure of common sense, since her actual occupation, which is suggested by the palette and brush she holds, would demand complete freedom of her eyes. The short mantle she wears is not consistent with the freedom of her arms and hands which, at this moment, she could not have too much of. Painters have explained to me that this is more picturesque, and once more, it is not a question of appropriateness but of an artistic *tour de force*. . . .

In concluding this article on Mme. Lebrun—on whom I would not have dwelt at such length if I did not know, Sir, your taste for the sex and if in fact she were not a phenomenon worthy of attention—I will not hide a rumor that is given credence by her colleagues: it is implied that she did not do her paintings, or at least that she did not finish them and that an artist in love with her gave her help.[*] I will admit that a comparison of her works with those of the other, which are exhibited in the same room, largely favors this suspicion, but it should be added as well that artists' jealousy is excessive and might at times extend to slander. It may have played a part in this story and its invention. However it may be, Mme. Lebrun's canvases are enough her own that the actual collaborator would not challenge her. It will be up to the artist, by sustaining herself with new masterpieces and by surpassing herself if possible, to justify her reputation and belie these shameful remarks.

---

[*]   M. Ménageot.

# Comte d'Angiviller and Jacques-Louis David: Letters (1787)

In 1785, the Comte d'Angiviller, whom Louis XVI had appointed Director General of the King's Buildings, announced that the King was concerned about maintaining moral standards within the Louvre and banned women art students from the palace. Since the late seventeenth century, the Louvre—left unfinished when Louis XIV moved his court from Paris to Versailles—had been home to the French academies and to the families of government officials, nobles, artists, and members of the royal household. Tenants adapted rooms to meet their needs, and by the late eighteenth century their partitions had turned the palace into a warren. Temporary walls divided the grand galleries and threw much of the interior into shadow. The courtyard had become the site of improvised latrines and the scrap heap of resident sculptors. On one occasion the king had ordered the gatekeeper to be more vigilant in turning prostitutes away from the door. Art critic Etienne Delécluze, who studied painting with Jacques-Louis David, recalled the palace with disgust:

> Today it is difficult to understand why the majority of artists, their wives and their daughters—as well as the wealthy amateurs who regularly visited the studios—why all these well-bred and genteel people lived there without any one of them expressing aloud the horror that the repulsive gloom of the Louvre must naturally have inspired in them. But their tolerance is explained by a single fact: the artists, their families and students all lived there rent-free. (Delécluze 1855, 16)

After 1747 the Académie Royale de Peinture et de Sculpture occupied a suite of rooms that included the Galerie d'Apollon and the Grande Galerie. Here, amid the *morceaux de réception* submitted by earlier academicians, students drew from the model and refined their skills in monthly competitions. They studied painting techniques in the studios of individual masters, which as often as not were elsewhere in the Louvre. The students' studios were rowdy: they were often unsupervised for extended periods, and older students teased and harassed the *rapins*, beginners who were still confined to working from prints and casts.

Although women were not admitted into the Académie's studios, they were accepted as students by several artists. The academicians who maintained studios for women included Jean-Baptiste Greuze, Jean-Baptiste Regnault, Jacques-Louis David,

and Joseph Benoît Suvée. Anne Vallayer-Coster, a painter of still lifes who had been elected to the Académie in 1770 and had received her studio in the Louvre in 1779 or 1780 at the request of Marie Antoinette, did not accept students. But Adélaïde Labille-Guiard, whose requests for space in the Louvre were rejected, and Vigée-Lebrun, whose studio was in the building owned by her husband on the rue de Cléry, did.

In 1787, while Vigée-Lebrun constructed a new studio, she sent her students to work with David. Learning of the young women's presence in the Louvre, d'Angiviller wrote the following letter to David and Suvée, in whose studio Constance Mayer was working. David's response and d'Angiviller's reply are also included; Suvée's response was similar to that of David.

### Comte d'Angiviller to Jacques-Louis David, 19 July 1787*

I have been informed, sir, that several young women are among the students who come to draw and work at your studio in the Louvre. This sort of mixture of young artists of different sexes may well result in improprieties which it is my duty to prevent. Would you please dismiss your girl or women students and limit yourself to receiving men in your studio. I am sorry to impose this constraint on you, but it is especially important to maintain propriety at the Louvre and it is impossible to ignore such an abuse.

I am, sir, your . . .

### David to d'Angiviller, 21 July 1787

The provisions included in the letter with which you honored me, concerning artists who mingle students of both sexes in their studios, seemed very strange with regards to me personally, though I particularly understood your purpose. I have received in my studio three young women, students of Mme. Lebrun, who will take them back as soon as her studio is completed. They are completely separated from the studio where my male students work and have absolutely no communication with them. Their morals are beyond reproach,

---

* Translated from Marie-Juliette Ballot, *Une élève de David: La Comtesse Benoist, l'Emilie de Demoustier, 1768-1826,* Paris: E. Plon-Nourrit, 1914, 255-60.

and I am convinced that whatever the slander, it cannot touch the justice their conduct deserves—I myself have too much self-respect to keep them for an instant if their conduct were otherwise. Their parents' reputations have been most honorably established, and that is the only condition I took into consideration when I agreed to a temporary favor without pay and insisted on making all auspicious arrangements. If there are abuses in the Louvre which are contrary to propriety, one can only applaud your watchfulness and the worthy motives which direct it, but it is undoubtedly not your wish that the fate of well born and very good young women be the same as that of those whose conduct has been represented to you as guilty. I have no interest in defending students who are with me only temporarily, but I know how dear honor is to the sex of which it is the principal ornament, and I consider it my duty to tell you the entire truth. If I do not enjoy the esteem with which you deign to honor me, it would be easy for me to destroy any doubts by having recourse to an accurate report that M. d'Hancarville can relate to you. He knows the place where I have placed the young ladies I am instructing and that they are virtually prisoners there.

Having done my duty in this situation by enlightening your justice and warning the parents, I await your final decision, which I will respect.

I have the honor of being, with the most respectful devotion, M. le Comte, your very humble and obedient servant, . . .

### d'Angiviller to David, 26 July 1787

I would be upset, sir, if you believed my letter to be the result of the bad impression given by the young ladies whom you are charged with instructing at the Louvre while waiting for Mme. Lebrun to take them back. My letter was motivated solely by improprieties which might result from the general practice of holding classes for young ladies in the King's palace, and I see that you have taken every precaution that prudence could suggest to prevent such an occurrence. But in general improprieties might nonetheless exist, and that forces me to forbid any school of this sort at the Louvre. Rest assured that there is nothing personal directed either at

you or the young ladies to whom you give your attention, and it is my pleasure to assure you that they have every justice in this regard.

    I am sir, your . . .

Postscript: I have no need of a testimonial, my dear David, to be sure all morality and honesty are respected in your studio. Reasons and motives of good order made the King decide in 1785 that there would be no young women going to take lessons with artists. By chance I learned that there were several young women in your studio, and I am very sure that neither you nor Mme. David would permit anything but purity in your home; the need to enforce a general law motivated my letter to you. If the young women were staying with you, it would be different, since they would be thought of as your children. You know how much I value you, both as an artist and as an upright man.

# Société Populaire et Républicaine des Arts: Minutes of 3 nivôse, Year II (1793)

*The Declaration of the Rights of Man* adopted by France's National Assembly in August 1789 at the start of the French Revolution did not address the rights of women. But the Enlightenment principle of "natural rights" on which it was based could be extended to all human beings, and soon some were suggesting that it should be applied to women as well as men. The Marquis de Condorcet in 1790 suggested that women should receive full civic equality, and Olympe de Gouges in 1791 addressed her *Rights of Women* to Queen Marie Antoinette. Women's rights and their role within public life became an issue for debate, and as the Revolution proceeded, changes in the government meant changes in women's status.

    When the Académie Royale de Peinture et de Sculpture, which was under pressure from the new government and non-academic artists to abandon its hierarchical structure, met in 1791 to consider reforms, women's membership was on the agenda. In the years before the Revolution d'Angiviller had supported the regulation stipulating that there would be no more than four female academicians; as he explained to Louis XVI:

This number is adequate to honor talent: women can never be useful
to the progress of the arts, since the modesty of their sex prevents
them from studying nude figures in the school established by your
majesty. (Montaiglon 1875-92, 9:157)

Now Adélaïde Labille-Guiard, who had been named to the
Académie on the same day in 1783 as Vigée-Lebrun, proposed
that women be admitted in unlimited numbers and given an
honorary, non-voting status. Her resolution passed, but since the
Académie's authority was eroding, there was no opportunity to put
it into effect.

In August 1791, responding to demands of non-academic
artists, the National Assembly decreed that the upcoming Salon
would for the first time be open to "all artists, French or Foreign,
members or not of the Académie" (quoted Holt 1979, 40). At the
Salon of 1791 there were 247 exhibitors; 19 were women.

Two years later the National Convention—which was elected
by universal male suffrage in 1792 to draft a republican
constitution and had abolished the monarchy and executed the
King—suppressed all French academies. The Commune Gé-
nérale des Arts was authorized to organize the next Salon.
Created in 1790 and led by Jacques-Louis David, the Commune
Générale des Arts was open to anyone who practiced an art
"based on drawing" and included at least twenty women
members. At the Salon of 1793 there were 28 women among the
358 exhibitors.

By the summer of 1793, the Convention turned over much of its
authority to Robespierre's Committee of Public Safety and radical
Jacobins, who instituted the programs known as "the terror" to
control the danger of counterrevolution. Marie Antoinette went to the
guillotine, as did Olympe de Gouges, who was reproached both for
supporting the monarchy and for having "wanted to be a statesman"
and forgetting "the virtues that suited her sex" (quoted Bell and
Offen 1983, 1:22). Newly formed government bodies suspected of
having too much power were dismantled: the Commune Générale
des Arts was dissolved in October 1793.

Two months later, some former members of the Commune
Générale des Arts created the Société Populaire et Républicaine
des Arts. Although the society never had any official power, some
of its members were appointed to official positions. One of the first
questions considered in its opening meeting was women's
membership. The debate and the policy that the society finally
adopted both reflect the growing reaction against women's public
role in French society.

**3 nivôse, Year II.**\*

A member of the organizational committee read a report on the admission of women to the society; it stated that since women are different from men in every physical and moral respect they should not be admitted.

Several members in succession spoke for and against the admission of women. Some maintained that since the society's sole purpose was the cultivation and perfection of the arts, not politics, women could not be admitted. Others asked that they be given a special place in the assembly.

The reader of the report again took the floor and maintained that women should be excluded because the law forbids them to assemble and deliberate on any subject.

A member cited the Jacobin Society, which admitted a woman. But another member, regardless of this exception, stated that among Republicans women should absolutely renounce work intended for men. Though he acknowledged that he himself would enjoy living with a woman who was talented in the arts, he argued that this would be contrary to the laws of nature. "Among savage peoples, who are closer to nature," he asked, "does one see women doing the work of men?" He thought that because a famous woman, Mme. Lebrun, had demonstrated great talent in painting, a crowd of others wanted to take up painting even though they should only be employed in embroidering the belts and hats of police uniforms.

It was proposed that only women of recognized talent and moral character be admitted.

Several members, including a deputy of the Société Populaire of the Arcis section, argued that the admission of women would displease the *sociétés populaires* and that they would cancel their affiliation to the society. This consideration seemed to unite the majority in favor of exclusion, in spite of the observation that the regulations did not rule on this question. At this moment a member who had asked that his daughter be admitted to the society withdrew his request,

---

\* Translated from Henry Lapauze, ed., *Procès-verbaux de la Commune Générale des Arts et de la Société Populaire et Républicaine des Arts*, Paris: J.-E. Bulloz, 1903, 183-84.

and after another member observed that since the law had already ruled on this question, the organizational committee's report was unnecessary, the assembly disregarded the committee's report and decreed simply that women could not be admitted into the society.

On July 27, 1794—9 thermidor, Year II by the Revolutionary calendar—the more moderate members of the National Convention reasserted their power, sent Robespierre to the guillotine, and began drafting the constitution that would last until Napoleon assumed power. Before the Convention turned over authority to the new government, it established the Institut de France to replace the academies of the *ancien régime*. Artists appointed to the Institut de France made up the faculty of the Ecole des Beaux-Arts and the jury for the Salon. Women could not attend the Ecole des Beaux-Arts and were not eligible for membership in the Institut, but they could submit work to the jury for the Salon, which—as decreed by the National Assembly three years before—remained open to all artists.

# II. WIVES AND ARTISTS

The American Declaration of Independence and the French Declaration of the Rights of Man gave political form to the Enlightenment philosophy of "natural rights." But even as citizenship was extended to a larger proportion of the male population, Mary Wollstonecraft's suggestion that women too "ought to have representatives instead of being arbitrarily governed" was ignored (quoted Rossi 1974, 68). In the opening years of the nineteenth century, the legal codes that defined women as extensions of male households were reaffirmed. In England the radical James Mill, whose theories contributed to the British Reform Bill of 1832, believed that women could be "struck off from political rights without inconvenience, since their interests were represented by their husbands or fathers" (quoted Bell and Offen 1983, 1:122). In France, Napoleon's Civil Code excluded women from citizenship and required that wives obey their husbands, whose control over children and familial assets was absolute. Over the next decades, the ideal of women's place within society was elaborated into what has been called "a cult of true womanhood": femininity was equated with piety, purity, submissiveness, and—especially—domesticity.

Within the private sphere, women's roles were in transition. In a pre-Industrial economy, a man's profession was often a part of his household: in many crafts and trades men routinely relied on their wives and daughters to assist them at the work bench, keep accounts, wait on customers or supervise employees and apprentices, and women were admitted to guild membership. As industrialization gradually transformed production methods, some women were lifted into the parlors of the prosperous middle classes, while others left home to seek employment in new factories. But throughout these changes, a large proportion of European and English women, whether they were middle or working class, remained single until their late twenties, and over twelve percent never married at all. Daughters, spinsters, and widows who in earlier times would have contributed to the "family

business" needed the means to earn a livelihood that would support them or augment the family income.

Women who were trained as artists usually learned their skills within the family. Some continued to work within the family, assisting their husbands or fathers, but their opportunities to market their works independently were growing. During the Empire and Restoration twelve percent of the exhibitors at the French Salon, which remained open to all artists, were women. In England women made up from five to ten percent of the participants at the exhibitions of the Royal Academy and such newer organizations as the British Institution and the Society of British Artists.

In keeping with laws and policies that increasingly relegated women to the domestic sphere, however, women's active participation in the institutions that structured the public practice of art decreased. Women were completely excluded from membership in the Académie des Beaux-Arts of the Institut de France, and they were now limited to "honorary" membership in England's Royal Academy. Of the societies established by English artists dissatisfied with the Academy, only the Society of Painters in Watercolours, formed in 1804, admitted women to full membership.

Art critics tended to consider certain media and subjects— portraiture and genre, miniatures and watercolors, the decorative arts and copying—compatible with what they thought of as woman's character and capabilities, but since these media and subjects were at the bottom of the academic hierarchy, exhibition reviews devoted little attention to the women who specialized in these areas. Women artists had to reconcile their professional aspirations with prevailing attitudes about what constituted "feminine" media and genres, but within these parameters they were able to achieve limited recognition.

# Ellen Wallace Sharples: Journal (1796-1804)

In artists' studios of the late eighteenth and early nineteenth centuries, a close working relationship between husband and wife or father and daughter was commonplace. Most artists were essentially artisans. Studios were workshops: there were not only paintings to complete but pigments to grind, portrait sittings to

schedule, engraved or miniature copies to make, and accounts to record. Like other craftsmen, artists valued their wives' and daughters' contributions to the family business. Even the Secretary of the Académie Royale, Charles-Nicolas Cochin, relied on the assistance of his widowed mother and a spinster sister, both trained engravers. He spoke with authority when he advised his nephew, a painter who had fallen in love with his Roman landlady's daughter, that it would be folly to marry a young woman who had not proved she could be useful in the studio. William Blake, less pragmatic, married a farmer's daughter and then taught her to print his plates.

The number of artists who, like Joseph-Marie Vien, Jean-Honoré Fragonard, Jean-Baptiste Oudry, and Antoine Denis Chaudet, married their students confirms that artists considered their wife's artistic training an asset. The skills that Pauline Châtillon, Mary Thornycroft, Fanny Moreau Vernet, Cornelia Lamme Scheffer, and other women learned in their fathers' studios must have been a sort of dowry they brought to their marriage to an artist. If some women, like Anna Geneviève Greuze, were content to remain as assistants to a male artist, others, like Jane Stuart, were frustrated in that role.

Ellen Wallace Sharples (1769-1849) began as her husband's assistant and worked professionally to insure her family's financial stability. The daughter of wealthy English Quakers, she married her drawing instructor in 1787. Eight years later Ellen and James Sharples and their three children left England for America, where they hoped that James would be able to support the family as an itinerant portrait artist. They settled in Philadelphia, and the fashion for portraiture soon brought dignitaries to James' studio. Their livelihood, however, remained precarious, in part because of James' fascination with inventing. Ellen Sharples, who had continued to paint as an amateur after her marriage, was fearful for her family's financial security and gradually began accepting payment for her works. As she recorded in her diary, she started by copying her husband's pastels to meet the demand for copies of his popular portrait of George Washington. By 1803, when the family had returned to England, she was receiving independent commissions as well as making copies in miniature—and needlework. Ellen Sharples encouraged her sons and her daughter, Rolinda, to become artists, and after her husband's death in 1811 she supported herself for almost forty years as a miniaturist.

*[Philadelphia, United States] 1796.*[*] I had frequently thought that every well educated female, particularly those who had only small fortunes, should at least have the power, (even if they did not exercise it) by the cultivation of some available talent, of obtaining the conveniences and some of the elegances of life and be enabled always to preserve that respectable position in society to which they had been accustomed. Many circumstances had led to the formation of this opinion, not only the French Revolution, which occasioned the entire loss of fortune to the great number of ladies and gentlemen who sought refuge in this and other countries. The reverse of fortune had been frequently observed in married and single ladies, a few the loss of their whole income, others of a part, obliging them to observe the strictest economy. In mercantile and various other concerns, men of abilities once affluent had become poor, others by thoughtlessness and extravagance. . . . The continual fluctuation of the funds and other property in which our money had been invested, the uncertainty in mechanical pursuits in which Mr. Sharples delighted—all had an influence in deciding me, soon after our arrival in Philadelphia where Congress then assembled, to make my drawing which had been learnt and practiced as an ornamental art for amusement, available to a useful purpose. Mr. Sharples was generally engaged in drawing in crayons the portraits of the most distinguished Americans, foreign ministers and other distinguished visitants from Europe. Copies were frequently required; these I undertook and was so far successful as to have as many commissions as I could execute; they were thought equal to the originals, price the same; we lived in good style associating in the first society.

*[Bath, England] May 1803.* Still engaged in copying heads in pencil. . . . Rolinda in various kinds of drawing according as inclination prompts, a flower, any single

*    Excerpted from Katharine McCook Knox, *The Sharples: Their Portraits of George Washington and His Contemporaries,* New Haven, CT: Yale University Press, 1930, 12-13, 117-18. Copyright © 1930 by Yale University Press; © 1957 by Katharine McCook Knox.

object from nature, a figure or a small group from imagination.

*June 20, 1803.* My first attempt at miniature painting on ivory, copy of Dr. Darwin. Applied every day with attention and pleasure, succeeded better than I expected.

*June 29, 1803.* Commenced a miniature of Mr. Sharples. Should I excel in this style of drawing it will be a great satisfaction to me. I shall then consider myself independent of the smiles or frowns of fortune, so far as the fluctuating and precarious nature of property is concerned.

*October 1803.* Miss Sergeant introduced her cousin Mr. Brown, Prime Serjeant of Ireland, to sit to my son for his portrait. James had just left home, for a few days, a great disappointment, as Mr. B.'s stay in Bath is to be very short. Miss S. prevailed on me to undertake it, and although excessively nervous I succeeded much beyond my expectations. Mrs. and Miss S . . . pronouncing it an excellent likeness. . . . I made a copy for our collection, and then resumed miniature painting, copying of Sir Joseph Banks.

*February 1804.* Thinking the etching of Caius Marius sitting on the ruins of Carthage a good subject for needle work, purchased a piece of white Gros de Naples, framed it and begun the outlines. . . . Finished the outlines and commenced the work in which I have been greatly interested to the end of the month, devoting a small portion of time to miniature painting.

*April 1804.* Commenced a new piece of work from another Etching of Mortimers, *The Fishermen*, in which after previously each day applying to miniature painting, I have been equally interested as in the former, C. Marius.

*December 1804.* During the year 1804 copied in miniature Mr. Adams, President of the United States, Mr. Jefferson, President, General Hamilton, Commander in Chief of the Forces of the U.S., Chancellor Livingston, Mr. B. Livingston, Mr. Galletin, Dr. Priestly, 2nd of General Washington, executed in a very superior style to the one done of him last year, as are all the latest pictures. This manifest improvement as I persevere is very pleasing to me.

## An Admirer of Genius and Lover of the Arts: The Linwood Gallery of Pictures in Needlework (c. 1809)

Needlework was considered essential to the education of middle- and upper-class English women in the late eighteenth and early nineteenth centuries. Following the example of Elizabethan amateur embroiderers, who executed complex pictorial hangings and carpets, Queen Charlotte and the ladies of her court worked from flower designs provided by academician Mary Moser. Students in boarding schools embroidered silk copies after book illustrations or prints. A few more ambitious women, including Mrs. Lloyd and Miss Morritt, Mary Knowles and Mary Linwood (1755-1845), used wool to make full-scale copies after paintings.

Although pictorial embroideries were usually framed to decorate the family drawing room, several artists' societies included needlepictures—as well as other media favored by lady amateurs—alongside paintings and sculpture in their annual exhibitions. Linwood exhibited at the Incorported Society of Artists in Great Britain and was awarded a medal by the Society for the Encouragement of Arts, Commerce, and Manufacture. The Royal Academy, however, made a firm distinction between "amateur" and "professional" media: though it accepted amateur paintings for exhibition, its regulations stipulated that it would not exhibit "needlework, artificial flowers, cut paper, shell work, models in colored wax, or any such performances" (quoted Sandby 1862, 1:437).

Following the example of John Boydell's Shakespeare Gallery, Henry Fuseli's Milton Gallery, and the private exhibitions opened by other entrepreneurs and artists, Mary Linwood determined to exhibit her needlepictures independently. After sending her collection on a tour of provincial cities, she established the Linwood Gallery of Pictures in Needlework in Leicester Square in 1809. Visitors paid a fee to see over a hundred needlework copies after old and contemporary masters that were displayed in rooms decorated like a private collector's gallery.

Connoisseurs, who were accustomed to seeing paintings by artists like François Boucher or Jacques-Louis David reproduced as tapestries, admired Linwood's woolwork copies. The *Ladies Monthly Museum* considered her "unrivalled as an artist in needlework" (quoted Ingram 1917, 145). *The Times* compared her work favorably with the originals: "The forms and expression of the

figures discover the power of Michael Angelo, and the whole effect of the piece is almost magical and beyond the power of the pencil" (quoted Wardle 1970, 21). This opinion was shared by the anonymous "Admirer of Genius and Lover of the Arts" who wrote the introduction to the catalogue for Linwood's gallery.

Mary Linwood was the daughter of an unsuccessful thread manufacturer and never married. Though she resolutely refused to sell her needlepictures, she continued to embroider until her eyesight weakened and kept the gallery open until her death in 1845.

**The circumstance to which the public** are indebted for the admirable exhibition, whose rise and progressive increase to its present astonishing magnitude we propose briefly to consider, was a law of the Royal Academy, absolute as that of the Medes and Persians, which forbids the admission of any species of needlework; could the original institutors and makers of this law have foreseen how wonderful a collection of pictures in needlework was destined to grow beneath the touch of their inimitable and indefatigable countrywoman, that her collection would become, as it richly deserves to be, the wonder of the age, and the finest exhibition of which Europe can boast, we presume no such law had been made.* Her works exhibit, also, in a moral point of view, how much may be accomplished by unremitting industry, and how satisfactory and laudable it is always to be usefully employed.

The first idea, we understand, presented itself in the form of amusement, stimulated, no doubt, by genius hitherto dormant, but which was afterwards to awake into unrivalled invigoration, without any intention of extending the pursuit beyond one or two pictures, still less expecting to swell them to their present extent; she has, however, shown everything that industry, activity, and perseverance could accomplish. The growth of this art, and formation of this incomparable

---

* Excerpted from *The Linwood Gallery of Pictures in Needlework with a Biographical Sketch of the Painter by an Admirer of Genius and Lover of the Arts*, London: Rider and Weed, [c.1809].

Gallery, cannot be better made known to our readers than by
an elegant poem by Miss Aickin, which we have transcribed.

When Egypt's sons, a rude untutor'd race,
Learn'd with wild forms the obelisk to grace,
And mould the idol god in ductile earth,
The loom and polish'd needle took their birth.

When, doom'd to dull obscurity no more,
Fair science reign'd on each surrounding shore,
And stretch'd her arm o'er Greece and early Rome,
Still in her train appear'd the labours of the loom.

When Gothic night o'erwhelm'd the cheerful day,
And sculpture, painting, all neglected lay,
And furious man, creation's savage lord,
Knew but the hunter's spear, the murd'rer's sword.

Our softer sex emboss'd the 'broider'd vest,
In flow'ry robe the blooming hero drest,
Or rang'd in tap'stry's glowing colours bright,
The mimic crests, and long embattled fight.

Now Learning's better sun-beam shone anew,
And Gothic horrors, gloomy night, withdrew;
Again Prometheus wak'd the senseless clay;
Grace, beauty, order, leapt to second day.

Most did the manly arts its influence feel,
The pencil chas'd the housewife's humbler steel;
Rent was the aged tap'stry from the wall,
Exulting genius gloried in its fall.

To monstrous shapes, and hydra forms uncouth,
Succeeded nature fair, the angelic truth;
The artist man awak'd the victor's lay,
And woman's labours crumbled in decay.

Then Linwood rose, inspir'd at once to give
The matchless grace that bids the picture live;
With the bold air, the lovely, lasting dye,
That fills at once and charms the wond'ring eye.

Hail! Better Amazon, to thee belong
The critic's plaudits, and the poet's song;
To thee may fame no barren laurels bring,
But flow'ry wreaths, which bud each rising spring!

This novel style of needlework, brought to so high a pitch of excellence by this ingenious lady, consists of great numbers of beautiful copies from the most celebrated artists, both foreign and English, possessing, to the full, every property and effect of their originals.

Ascending a magnificent staircase, the spectator enters a noble gallery, 100 feet in length, hung with scarlet broad cloth, terminated with fringe of gold bullion; sofas, etc., are placed in every appropriate situation, and a superb canopy, of corresponding elegance, graces the extremity.

The Pictures are hung to the left of the entrance-door; at the end, a gloomy passage leads the inquiring mind to search for further beauties. Miss Linwood's correct taste here exhibits itself in the happy adaptation of the decorations to the subject: such as placing the Lady Jane Grey in an imitative prison; Lions in dens; Gainsborough's Woodman, and the Woman shielding her Infant from the Storm, under convenient places of shelter; and the little cottagers in scenic rusticity. . . .

## Charles Paul Landon: Selections from the Salons of 1806, 1808, and 1810

Throughout the years when Napoleon ruled France, the work of women artists was increasingly seen at public exhibition and rewarded by public patronage. Women made up from twelve to fifteen percent of the exhibitors at the Salon. In 1804 there were 42 women among 328 exhibitors; in 1808—when the *Moniteur* dubbed the exhibition a "Salon des Dames"—there were 52 women among 404 exhibitors; in 1812 there were 78 women among 559 exhibitors. Women artists were regularly recognized by the Imperial government. The names of Marguérite Gérard, Marie Guillemine Benoist, Pauline Auzou, and Angélique Mongez appeared on the lists of medalists at the close of the Salon, and

official commissions for portraits or depictions of official events were given to Benoist, Jeanne-Elisabeth Chaudet, and Marie Eléonore Godefroid. Members of the Imperial family purchased women's paintings for their personal collections.

Most of the women who participated in the Salon exhibited portraits and sentimental genre scenes, which had become increasingly popular. Those women who turned to historical subjects tended to concentrate on incidents from the private lives of famous women which embodied traditional "feminine virtues": piety, conjugal loyalty, and familial devotion. Many observers thought that women's capabilities were particularly adapted to the depiction of sentimental genre scenes. Speaking at the opening of the Ecole Gratuite de Dessin pour les Jeunes Filles, which was established to educate young women in the decorative arts, the Mayor of Paris' 11th *arrondissement* predicted that women would affect art's development:

> Painting will acquire a more touching and moral character in hands. With pencil and brush women will depict domestic scenes where the soul, tired of the shock of passions, will rest; they will depict for us the cares that they lavish on childhood and age in particular; and because . . . women's sensibility is more lively, they will recreate beautiful actions that will stimulate us all to noble emulation. (quoted Yeldham 1984, 1:43)

The critic Charles Paul Landon (1760-1826) shared this opinion. As a student in the Ecole des Beaux-Arts, Landon had studied painting in the studios of François-André Vincent and Jean-Baptiste Regnault. He continued to exhibit at the Salon until 1812, but his real success was as an art critic. His first pamphlets on the Salons appeared in the 1790s, and in 1801 he began publishing *Annales du Musée et de l'Ecole Moderne des Beaux-Arts*. These elaborately produced volumes of engraved reproductions and descriptive commentary documented the Salon and the collections in the Louvre, which Napoleon had filled with works brought from all over Europe.

Just as the critics' encouragement of women who worked with portraiture and sentimental genre reinforced women artists' tendency to concentrate in these areas, so the artists' depictions of devoted wives and caring mothers reinforced the growing identification of femininity and domesticity. Their paintings confirmed the ideas expressed by Napoleon, who told Germaine de Staël that the greatest woman in history was "she who had the most children" (quoted Bell and Offen 1983, 1:37).

## Salon of 1806*

Mme. [Elisabeth] Harvey: *Malvina Mourning Oscar*

The large number of women who successfully practice
painting today is astonishing. Over fifty women exhibited at
the last Salon; certainly they did not all offer works worthy of
the public's approval, but there were many whose works
could only honor our school. If the French were as
enthusiastic about their developing talents as the Italians are
about those that honor their native land, we could mention
more than one French woman artist whose reputation would
eclipse that of the famous Rosalba.

Some unfair critics maintain that generally it is only
when an art form is decadent that women devote themselves
to it, because the timid sex cannot compete with men of
superior genius. In France, however, the art of painting has
reached a very high degree of perfection of late, and never
before have there been so many women artists. While it is
true that most paint only for their own amusement, one must
always be grateful to those who are willing and eager to
compete for the glory of our school during one of its best
periods, and one must do justice to those whose good works
increase the public's pleasure. Mme. Harvey deserves to be
included in this group. Her pretty painting of Malvina
exhibited at the last Salon earned her the right to connois-
seurs' attention.

Malvina is shown mourning the death of her young
husband Oscar, treasonously slain; her companions play
their doleful harps to ease her grief. The location of the scene
recalls Ossian's descriptions of the wild places where he sung
of Caledonian heroes.

---

\*  Translated from Charles Paul Landon, *Annales du Musée et de l'Ecole
   Moderne des Beaux-Arts,* Paris: C.P. Landon, Imprimerie des Annales
   du Musée, 1807, vol. 13, 113; vol. 14, 61; vol. 15, 35; *Annales du Musée
   et de l'Ecole Moderne des Beaux-Arts: Salon de 1808,* Paris: C.P.
   Landon, Imprimerie des Annales du Musée, 1808, vol.1, 91-92;
   *Annales du Musée et de l'Ecole Moderne des Beaux-Arts: Salon de
   1810,* Paris: C.P. Landon, Imprimerie des Annales du Musée, 1810,
   23, 73.

This small painting is remarkable for its light and harmonious color, its fluent drawing, and above all, its charming expression—a precious quality that does a good deal to compensate for several faults and imperfections.

## Mlle. [Henriette] Lorimier: *Jeanne de Navarre*

Jeanne de Navarre leads her son Arthur to the tomb that she had built to the memory of her husband, Jean V, duc de Bretagne, and tells him of his father's virtues and misfortunes. . . .

If the subject of this painting cannot be considered an historic episode in the strict sense, it is nonetheless a clever idea that the artist has presented. History furnished Mlle. Lorimier the motif for a sentimental scene glowing with maternal and conjugal love, premonitions of filial piety, a sweet melancholy, and a touching ingenuousness. The painting's execution is equal to the idea. The composition is simple; the poses are gracious and expressive; the costumes and accessories are well chosen; the drawing is noble and correct; a smooth tonality and lively harmony succeed in endowing the subject with all its potential interest. Her Majesty the Empress purchased this work for her study.

## Mlle. [Constance] Mayer: *Sleeping Venus and Cupid Are Awakened and Caressed by the Zephyrs*

The subject of this painting is gracious and pleasant. This type of composition suits feminine talent better than the strong, pathetic, and often terrible subjects that are often too much for the strength of a trained masculine talent, but how many young women dare to attempt such subjects, nevertheless. In fact, many have given proof of their talent, but—exhausted by too lengthy efforts—rarely have they achieved the elevation that their subjects demand. Mlle. Mayer has prudently taken her strength into account, and her efforts augur well for the future. She possesses a fluent line and a facile brush. A student of Prud'hon, she has benefited from the advice and example of this pleasant painter and has identified so closely with his principles that her painting is an exact imitation of her master's manner. But as soon as she becomes

more confident and devotes herself to the study of nature rather than other works of art, she will doubtless not delay in developing an individual manner and an original style.

**Salon of 1808**

Mme. [Angélique Lavol] Mongez: *Orpheus in Hades*

. . . In the foreign schools, from their beginning to the present, one could count barely a dozen women who made their names as painters. But for several years, due to the sudden change in their education, women have asserted their right to cultivate art, and several have shown themselves worthy rivals even of those who wanted to forbid them this kind of fame. This year alone, fifty French women have contributed to the Salon, embellishing it with a variety of genres. Since they are now permitted to receive awards alongside men, it is likely that the list of competitors will grow with every public exhibition. Like new Amazons, they will compete in the future for the victor's palm in a field sown with laurel and everlastings.

If it is appropriate to begin with the woman who has attempted the most difficult and audacious work, Mme. Mongez must be noted first. Her painting of *Orpheus in Hades*, in which the figures are at least life size, is substantial (12' x 15'). The subject calls for all the richness of a poetic inspiration; a feeling for ideal beauty should determine the forms and the appropriate expression and allows no weakness or exaggeration. Mme. Mongez has satisfied most of these conditions; her work would be noteworthy with much less. If the execution is somewhat uneven, the spirit is cultivated and the style is pure; above all the masterful drawing of the contours of the nude figures proclaim her excellent training. The figures of Cupid, of one of the Fates, and of Pluto and Proserpine would not be disclaimed by a skillful teacher. The flesh tones tend to grey or violet, and perhaps the color is generally a little cold. But in the work as a whole as in the details, there is an unusual sense of three-dimensional relief. Unfortunately although Orpheus is the principal figure, he is not also the most successful. . . .

The Emperor has ordered the purchase of this painting.

**Salon of 1810**

Mlle. [Constance] Mayer: *The Unhappy Mother*

A young woman who has lost her child has raised a
monument to him in a lonely valley. A rock covered with
grass and moss and surmounted by a cross and a crown of
roses forms the modest monument to maternal love. With
tears in her eyes and a mournful expression, the unhappy
mother contemplates the spot where the cherished remains
rest. Beside her is a vase of water to freshen the flowers that
grow on the tomb.

More than once we have publicly voiced our regard for
Mlle. Mayer's work. They always mix sweet and graceful ideas
with very fresh color, harmony, and a soft and light touch,
but—although these are precious qualities—Mlle. Mayer's
work leaves a little variety to be desired. Her paintings tend to
be much alike, which is hardly surprising, but they are also too
similar to those by the skillful master who directs her. She must
stop imitating since she is able to create. Consideration is
always extended to a new and original talent, however bizarre,
but an imitative talent is generally valued far below its model
and often below even its own worth.

Mme. [Pauline] Auzou: *Arrival of Her Majesty the Empress
[Marie Louise] in the Gallery at the Château de Compeigne*

At the moment when Their Majesties arrive in the
gallery at Compeigne, young girls come before the Empress
to offer her garlands and crowns of flowers. This painting,
with half life-size figures, is one of the most pleasant in the
exhibition. It is notable not only for the picturesque
arrangement of the numerous and animated group, but also
for the grace and naïveté of the poses, the variety and
sweetness of the faces. The young women all wear white, but
the effect is not monotonous—it is even quite lively—and the
eye rests here with pleasure.

One might wish for a quicker and lighter touch in Mme.
Auzou's painting, but at least one finds in this work a
harmonious and unified execution; the entire painting is
unquestionably by the same hand, and we do not think that

even the most experienced eye could find any trace of another hand. Mme. Auzou will never be reproached—as have several other women who have been accused (perhaps unjustly) of not having made the effort to complete by themselves the works exhibited under their names—with offering a work in which there are varied and often incoherent manners that cannot escape the connoisseurs' eyes.

# Marie Guillemine Benoist: Letters (1804, 1808, 1814)

The success that Marie Guillemine Benoist (née Leroulx de la Ville, 1768-1826) enjoyed during Napoleon's reign justified her parents' decision of 1783 to send her and her sister to study with Elisabeth Vigée-Lebrun. Their father, who was a minor government official, explained that after twenty-three years of official service he had made the decision because "changes in circumstance destroyed rather than expanded my fortune, so I was pleased to find that my children's interest in the fine arts might make up for the dowry which I would not have been able to preserve for them without neglecting my duties" (quoted Ballot 1914, ix).

Marie Guillemine Benoist's career began auspiciously in the summer of 1784, when she sent several portraits to the Exposition de la Jeunesse, the annual open-air exhibition mounted for one day in celebration of the feast of Petite Fête-Dieu. Two years later she and her sister were working with David in the Louvre, and the *Mercure de France* noted that her contribution to the Exposition de la Jeunesse was "much stronger than those she previously exhibited and she should soon acquire a reputation" (quoted Ballot 1914, 38). By 1791, when the Salon opened to non-academicians for the first time, she exhibited two large, elaborate historical compositions: *Psyche's Farewell to Her Family* and *Innocence Between Virtue and Vice*.

In 1793 Marie Guillemine married Pierre Vincent Benoist, a lawyer with literary tastes and royalist sympathies. Ironically—since she had been one of the young women forced to quit Jacques-Louis David's studio in 1787—she was given a studio in the Louvre by the revolutionary government, and it was here that the young couple lived. During the uncertainties of the Revolution, they collaborated to support themselves: he translated and she

illustrated several English books, including Mary Wollstonecraft's autobiographical novel, *Maria*.

When Napoleon came to power, Pierre Vincent Benoist was appointed to the Ministry of the Interior, and Marie Guillemine Benoist continued to work as a professional artist. She maintained a close relationship with David, who had become First Painter to the Emperor, turning to him for advice on her Salon entries and listing herself as his student in the catalogues. She had given up sending historical compositions to the Salon and now submitted portraits and sentimental genre scenes. At the Salon of 1804, she received a gold medal and an official commission for a portrait of the Emperor, which she probably painted from existing portraits rather than sittings. This was followed by orders for portraits of other members of the Imperial family. All this was accomplished as her family grew: when she opened a studio where she taught younger women, her sister took care of her children. Marie Guillemine Benoist's pride in her success is reflected in her letters to her husband and her family.

### [To her brother-in-law, 20 June 1804]*

I was to travel this spring, but the portrait of the Emperor I was asked to do—a commission I was given with the favor that makes one believe in one's talent and satisfies one's self-esteem—took the time I had set aside for traveling. The Salon, which opens in six weeks, the portraits of Mme. Maret and others—all this has left me free only for the grape harvest, which I will spend at Anjou. My large painting is finished and has been successful. It is for the village of Ghent and will earn me 1,000 *écus*, the price for portraits of this size; but since fame is still more valuable to me than money, I have put many details into this portrait, which measures seven by six feet. The Emperor is dressed in the Consuls' uniform. I did a portrait of the Minister of the Interior's mother and received from him a very handsome diamond worth 1,500 francs. My affairs are going very well and I am pleased with the success, which adds to our domestic happiness.

---

*   Translated from Marie-Juliette Ballot, *Une élève de David: La Comtesse Benoist, l'Emilie de Demoustier, 1768-1826*, Paris: E. Plon-Nourrit, 1914, pp. 157, 188-89, 190-91, 212.

**[To her husband, early September 1808, shortly after the death of her father-in-law]**

What a letter you received yesterday, dear friend; it added to my unhappiness not to be able to be beside you in this awful time. If you had seen the state of your father's health, you would have longed for his death, for his suffering made it necessary. . . .

We left immediately [after the funeral] and I swear that nothing has been more difficult for me than to sleep in that house. Here, I breathe more easily and my poor maternal heart is less anxious for my children's health. . . .

I would like you to try to see [Dominique Vivant] Denon [General Director of Museums], to explain my situation to him and ask whether I can send Gall's portrait after the Salon opens. . . .

**[To her husband, mid-September 1808]**

I am waiting for David's opinion; for me it is the highest judgment. . . . I would like to be completely reassured about the Salon, but would Denon do that? I am angry that you have not seen him; it is different, even if one is rejected in writing, often the difficulties are smoothed out in conversation. I am very worried about the outcome; if you possibly can, call on him; I do not want to bother you, but I am very preoccupied about this. . . .

**[To her husband, late September 1808]**

I hope I still have time to finish the painting of Gall. Have you seen David? Ask him to come and find out if he is satisfied with the head, because if there is a great deal to retouch, I won't have time and it would be useless for me to hurry. Visit him in the morning at eight o'clock and tell him the whole story—the trip I had to take—and if he says, "She must return. Two or three days are all it would take," write me immediately. Ask him to see if the glaze has lifted. Finally, you must judge from his remarks whether I can ignore this Salon or whether it is important that I be represented.

If Gall's portrait is not very, *very* good, and if it would take too much time to finish it, I give it up—and you know

how it pains me when I say, "It is necessary; my decision is made without complaint."

Marie Guillemine Benoist's public career was cut short when Napoleon's defeat returned the Bourbons to the throne of France and Pierre Vincent Benoist received a significant promotion. At her husband's request, she no longer participated in the Salon nor accepted commissions. It was a decision she made with difficulty, as the following letter shows. In later years, her son remembered that her children had always respected her: "Today, we continue to respect her, for she gave us a taste for work and a sense of duty" (quoted Ballot 1914, 213).

### [To her husband, 1 October 1814]

I would seem resentful towards you, my friend, if I did not write you today. The thought that I might be an obstacle to your career would be a bitter blow for me. Do not be angry if at first my heart bled in making this decision—a decision demanded by a social prejudice to which one must submit, after all. But so much study, effort, a life of hard work, and after the long trials, the success, and to see them almost an object of humiliation—I could not bear that idea. Let us speak no more about it; I am reasonable and it was necessary to knock on that door, and my self-respect was wounded too sharply. Let us speak no more about it, for the wound will open again.

Adieu, I embrace you as your tenderest friend in the world, who is not at all resentful.

## Alexandrine Aragon: Women Artists at the Salon of 1833

In the early years of France's July Monarchy the number of women active as artists and writers increased so dramatically that critic Théophile Thoré called it an "invasion" (Thoré 1834, 42). At the Salon, the percentage of women participants remained the same,

but their numbers rose as the exhibition grew in size, and the number of women who received government awards increased as well.

Journals published by and for women proliferated. Some were largely fashion magazines; others emphasized women's literature; and still others, influenced by the utopian socialist ideals of the Saint-Simonians and Fourierists, addressed political and social questions. These magazines were a forum where women reexamined every aspect of their lives from their place in the home, as defined by marriage and property laws, to their place in the Salon, as defined by the juries and the critics.

The *Journal des femmes*, a biweekly that was founded by Fanny Richomme in 1832 and sold for the comparatively high price of sixty francs a year, emphasized women's education and "moral emancipation." This, the editor believed, would better prepare the *bourgeoise* for marriage and motherhood. Women contributed most of the articles on science, law, literature, and the arts that were interspersed with recipes, fashion plates, and fiction. Encouraged by her readers' letters, Richomme devoted more and more space to such issues as the reintroduction of civil divorce, the suppression of the dowry system, and improvements in women's educational and employment opportunities. She argued that women should be able to become doctors, lawyers, and even priests. "One day," she told her readers, "you will attend the Ecole Polytechnique rather than the convent" (quoted Adler 1979, 88).

Articles on art appeared regularly and ranged from lessons for amateurs to a satire on "ladies' day" at the Salon. Alexandrine Aragon (dates unknown) contributed a series of articles on the Salon of 1833. Her first five articles followed the standard format for Salon reviews and concentrated on the work of male artists, but in her final section, she took up the work of women exhibitors. Her report on their work is prefaced by an impassioned discussion of women's employment: the fine arts, she believed, offered women a unique opportunity to earn an independent and respectable livelihood.

In 1835 the *Journal des femmes* was sold. Though Fanny Richomme continued as editor until the journal folded later in 1835, the magazine's contents changed. Political and social questions gave way to society gossip, and articles on theater and art devoted less attention to women's work and more to the fashions worn by the audience.

**Never before, perhaps, have women given** better proof
that for several years they, too, have possessed the genius
that makes artists and writers and that they, too, can obtain
the most glorious and desirable kind of independence
through study, persistence, and love of art.* This year the
number of women artists is so much larger than in the past
that it cannot be passed over in silence. Anyone fortunate
enough to be endowed with the kind of philosophical and
observant spirit that is charmed by the spectacle of life and
society must take a lively interest in the striking progress in
the education and art of the sex that, though it is equally
endowed intellectually, always finds in the social laws
instituted by men so many shackles, prejudices, and chains
that it is forced to remain long, too long, short of the degree
of moral perfection that it might attain.

This year 191 [*sic*; see below] women exhibited. One
must make particular note of the 111 unmarried women who,
if they do not have as a dowry a large portion of the metal
that is valued above all else in this country, do on the other
hand have talents that enrich life and that honor and preserve
a woman from the sad and usually fatal necessity of owing
her existence to a man and of placing herself in a dependent
position that all too often becomes trying and humiliating.

The women artists can be divided into thirty-seven
painters of genre and easel paintings, sixty who paint
portraits in oil, forty-eight painters of landscapes and
flowers, twenty seven miniaturists and watercolorists, and
fourteen painters on porcelain; total: 191 [*sic*].

Among these women are a small number whose only
goal in working is their own amusement and who desire to fill
in a reasonable manner the precious time that others devote
to worldly frivolity and squander so deplorably. This
undoubtedly is beneficial, but much of the work has a more
realistic significance: other women—and they are the most
numerous—find an assured income in their brushes.
Through their talent and their persistent studies they can

---

* Translated from Mme. Alexandrine Aragon, "Des femmes sous le
rapport des arts, de l'industrie et sous celui de l'exposition de 1833,"
*Journal des femmes* 5 (1833), 7-10.

insure themselves of an honorable existence. Our vicious social system either refuses or grudgingly grants them such an existence anywhere else. Except for a career in the fine arts—which all too often their ungenerous rivals in the brush dispute them, and in which they generally win their initial success only at enormous cost—what are the lucrative professions that women can practice in the world? I do not claim to speak about the two classes of women who are placed at the social extremes and cannot commit themselves to work: those women overwhelmed with riches and those overwhelmed with misery. The former, dazzled and absorbed by the pleasures and prestige of wealth, have barely enough time to solve the important problems of their wardrobes and their trivial social duties; the latter, crushed by the weight of the difficulties of supporting households, are devoted exclusively to the cares of a young family and can only accomplish their arduous duties at the expense of fatigue and late nights in a world where all is bitterness to them. I want to consider the intermediate class, so numerous and so interesting. Why are they deprived of so many means of existence that should be theirs? Why are they excluded from certain lucrative occupations that they would be perfectly capable of filling? Why are the only resources left to them so feeble and inadequate? Isn't almost all of the work that women do an absurdly minimal means of escaping misery? . . . Industry and business are wrongly deprived of women's intelligence and industrious efforts: in a host of factories uselessly populated by men, women could be employed to the benefit of the shop foreman and themselves. Why is it necessary to condemn men's faculties to the making of pins, button molds, and a thousand other paltry tasks that require neither masculine strength nor intelligence?

But why are you complaining, you women? Don't you have dressmaking, embroidery, illumination, and all the baubles of industry that men consider too inadequate for themselves, but sufficient for you? *Twelve hours* of work will earn you one franc and even some additional centimes! And if this miserable amount is not enough to keep you from horrible misery, you poor young girls still pure and innocent of all thought of vice, don't worry: the man who plunders you

and is jealous even of the scraps he leaves you is not so pitiless that he does not leave you one other resource! He is ready to extend a helping hand to you, if you are young and pretty! He is setting aside for you, once you are corrupted, gold—a single percentage of which he would refuse you if you remain virtuous. . . .

Fortunately, there remains one noble career which women can successfully pursue and in which they can even compete with men for glory. This year they have proved it brilliantly. Thanks to the noble love of art that they are constituted to feel enthusiastically, thanks to the sacred fire of genius that Heaven endows them with also, and thanks finally to their eagerness and persistence in their studies (the cost of which now more than ever they have begun to learn), in the exhibition of 1833 they occupy a place more remarkable than any they have yet struggled to fill. Undoubtedly this glorious first step will be followed by still more glorious success.

Women have particularly distinguished themselves in genre painting, which demands a light touch, a precious finish, and a certain sensibility in execution and composition. This kind of painting suits them so well that they have eagerly surrendered themselves to it. First among the genre painters, we place Mlle. [Aimée] Pagès, Mme. [Hermine Lerminier] Dehérain, Mlle. [Marie Amélie] Cogniet, and Mme. [Sophie] Rude-Frémiet. Mlle. Pagès' most remarkable works are *Ann Boleyn's Farewell to her Family* and her *Prediction* with its delicious heads of young girls. Her portrait of M. Giroud de l'Ain is a good likeness, well modeled. . . .

Mme. [Antoinette Cécile Hortense] Haudebourt-Lescot, whose vigorous brush is so remarkable, must be mentioned first among the women who devote themselves with brilliant success to oil portraits and miniatures. . . .

As for miniature painters, let us first note two women who are models in this genre: Mmes. [Lizinka] de Mirbel and [Félicie] de Watteville. The perfect finish of their works demonstrates the studies they have had the courage and the persistence to pursue—studies without which one can achieve only a small talent, a mongrel, degenerate, and shabby talent. See how the heads are posed, how they

animate the bust; the eyes are brilliant and sparkling, the mouth seems ready to speak, the flesh has natural color, the hair waves or curls gracefully, the blood circulates beneath this rosy skin and beneath this darkened complexion; all is truth. And if one examines the artists' technique—what a delicate, conscientious brush: the effort is evident, and how beautiful and perfect it is!

In Mme. de Watteville one sees the pure correct drawing and the talent for illuminating the figures with a brilliant, life-giving flash of a student of Ingres; in Mme. de Mirbel, one sees the friend and advisor of Champmartin, the artist who seemed so bizarre and extraordinary at his debut and is today so remarkable, so truthful in his poses and colors. Examine Mme. de Mirbel's portraits; you will recognize in miniature the same qualities found in the work of this young painter. Happy is the man wise enough to follow friendly advice and to moderate the fire of a delirious talent! Happy is the women who is well enough educated and well enough informed to direct the brush that was going astray and lead it back to the path of truth and beauty! . . .

Among the many landscapes from women's brushes, we will mention only those of Mlle. Fanny Lecomte, who truthfully depicted the entrance to a village near Denain and an effect of rain in the neighborhood of Paris; those of Mlle. [Eulalie] Caillet, who exhibited two views of Switzerland and one of Normandy which were done with a breadth and audacity rarely found in a woman's brush; those of Mlle. [Linna] Jaunez, whose works are full of freshness and harmony; and finally those of Mlle. Sarrazin de Belmont, Mme. [Adèle] Clerget-Melling, and Mme. [Catherine Edmée Simonis] Empis, who was encouraged by receiving a medal at the last exhibition.

Regretfully I must forgo the pleasure of mentioning the crowd of other women who should find a place here beside these distinguished women. Unfortunately this article must remain incomplete in many respects; the limits proscribed for me do not allow me to examine all the developments of a subject as interesting as this. I hope that this article at least will serve to record women's work and successes; that it will encourage them to pursue steadily and enthusiastically the

true route to well-being and independence; that it will inspire in others the ambition to see their own work in an honorable place at the Salon; and finally that I can contribute to proving how many women are worthy of being admitted to a more equal share of the goods of this world and the glory to be acquired in the practice of the fine arts!

## Anonymous, *L'artiste*: Lady Artists in France (1835)

Many critics who reviewed the Salon for general newspapers and magazines in the 1830s noted the presence of more works by women artists, but usually the only women's works they discussed were the fashionable miniatures of Lizinka de Mirbel. Lengthy consideration of women's paintings appeared only in journals that catered to specialized audiences, like the *Journal des femmes*, which was read by women, or *L'artiste*, which was directed to connoisseurs.

When Linna Jaunez, a painter of landscapes and portraits, reviewed the Salon of 1834 for the *Journal des femmes*, she noted that 156 women were represented, some by more than one type of painting: 19 artists contributed genre paintings, 45 sent portraits in oil, 41 portraits in pastel or miniature, 20 landscapes, animals, or interior views, 22 still lifes, 17 porcelain paintings, and 3 women exhibited lithographs. Noting that no women exhibited large-scale history paintings, Jaunez questioned whether the violent subjects and painterly techniques made fashionable by the romantics were appropriate to women's sensibilities:

> If you want to see bloody scenes of odious assassins or beasts devouring each other, pass by the women's paintings. If you seek some trivial or base subject in which humanity spreads the most disgusting miseries, pass by quickly. Women will never lose their dignity to that extent. If you seek some new manner of painting, pretentious and bizarre, full of lies, exaggerations and extravagance, the strange product of a false and proud system, pass by again. Women paint as they feel: they may sometimes lack energy, knowledge, talent or happiness, but never a conscience. (Jaunez 1834a, 115)

Jaunez noted that women's contributions to the Salon tended to be characterized by their "pathetic or gracious subjects, their feeling

for decency, and their charm of execution." And if some efforts
were "feeble or mannered" and some figures were "inaccurate or
stiff," Jaunez nevertheless maintained that "considering the
particular difficulties which women face in their studies and the
prizes and awards that are denied them, one must praise their
courageous efforts and applaud their success."

Jaunez' encouragement to women artists was not echoed in
the coverage of women's painting that appeared in *L'artiste*, the
weekly magazine devoted to the arts founded by Achille Ricourt in
1831. Ricourt was the friend of romantic artists and writers, and the
work of Eugène Delacroix, Honoré de Balzac, George Sand,
Alexandre Gabriel Decamps, and other brilliant figures regularly
appeared in the journal's pages. Their opinions were sometimes
controversial, but the publisher welcomed their vitality and
conviction and proudly proclaimed his editorial policy: "We allow
attack, but without forbidding defense" (quoted Damiron 1954,
22). The policy would make *L'artiste* the first successful arts
magazine.

Late in 1835, between the Salons of 1835 and 1836, Ricourt
published the following article on women artists. Though the
anonymous author was clearly aware of the arguments favoring
women's rights put forward by followers of Fourier and Saint-
Simon, he had little sympathy for them. For women artists he ruled
out not only history painting, but also genre painting. Instead, he
emphasized miniatures—a medium that even Lizinka de Mirbel
considered inferior, since it could "only address private interests"
(Mirbel 1830, 92).

**While awaiting the great Emancipation Day** that is
promised them, women continue to demonstrate in the arts
that they can emancipate themselves.* Their intellectual
territory—formerly confined to light poetry and the novel—
has expanded to the wide fields of music and painting. Music,
the preferred and most powerful art today, has magnificent
and inexhaustible potential for the women who devote their
talents to its service: music gives them reputations that spread,
if not as fast as light, almost as fast as sound, and that echo
throughout the kingdoms and capitals of Europe. And that is
not all: every so often it bestows on them riches that are the

---

* Translated from "Les dames artistes," *L'artiste* 10 (1835), 454-56.

envy of financiers, rewards that make those of the stock exchange pale in comparison. In short—since one must invoke the word that is so influential today—the quickest and greatest fortunes in the arts are made in music. But these benefits have disadvantages also: the musician must put up with the publicity of the theater or at least the concert hall; she must parade her face and gestures before the curiosity of the crowd, bow her head and curtsy for all the applause she receives; she must shed some of the reserve that so enhances the woman it surrounds. Not everyone can, wants, or dares to run the risks of such trials. The fame and fortune that painting offers to women are slower and less brilliant, but on the other hand, they are in keeping with family responsibilities and modest, retiring tendencies. We are not speaking of those who, scorning the vocation of their sex, aspire to become painters after the manner of men. Even when the too familiar and boisterous studies of the studio are no longer fundamentally distasteful to all the proprieties prescribed for women, their weak arms and their tender and timid imaginations would still be over-whelmed by the large canvases and the too liberal or too austere subjects of painting in the grand manner. The same limits restrict women's territory in all the arts. Women musicians, whether they sing or whether they play the harp or piano, can at most express their heartfelt sensations in love songs; they should not exhaust their talents in the difficulties of historical composition. Mozart and Beethoven were never, in the present or the past, exposed to rivalry from feminine genius. As for painting, artists who fear comparison with the opposite sex are more often from the family of Petitot than that of Rubens.

The history of literature by women shows us the same thing: in the arts women must follow a path parallel to that travelled by literary women from the time of Mlle. de Lafayette and Mme. de Sévigné to that of Mme. Cottin. To earn the right to be called an exception to their sex, they must lose too many of the graces that nature has given them, and while one cannot prevent them from taking that avenue, those who want to give their works the masculine character with which Mme. de Staël stamped her work will always run the risk that others will wonder at the extent to which they

have lost their femininity. In painting woman's only indisput-
able share, therefore, is landscape, interiors, pastels, water-
colors, portraits, and—above all—miniatures, which should
perhaps be considered their particular monopoly. It is clearly
a large portion with room for many great efforts.

We must not forget, however, painting on porcelain;
though not a genre in and of itself, it is invaluable because it
offers women their only opportunity to work in every genre.
Painting in the grand manner, which we forbid them, can be
brought back within their reach by copying on porcelain. It
demands careful, delicate and intelligent work and is entirely
suitable to their nature; and the example of Mme. [Marie
Victoire] Jaqotot, who has made such beautiful copies of
Raphael's paintings, demonstrates that they can achieve real
art in this area. But it is a profession that the poor taste of our
century has curtailed. Except for some exceptional copies
made at Sèvres and some vases covered with fruit and flowers
for private industry, porcelain painting produces nothing. All
that remains is coloring printed fabrics or wallpapers that are
inferior in taste and execution. . . .

Another artist with an established reputation, Mlle.
[Clotilde] Gérard annually exhibits at the Louvre pastel
portraits which prove how suitable this medium, revived by
Henriquel-Dupont and Giraud, is to women's talent. Since
we have mentioned the exhibition, shall we mention, if not
all the women whose work appears there, all those worthy of
notice? No, we do not want to initiate a critique which will be
more timely when the Salon is open, but let us note that each
year the number of women artists increases. It is easy to
believe, therefore, that from now on women will share with
men in all the genres which suit them, painting still-lifes as
well as landscapes and portraits; as for miniatures, consider-
ing the ardor and success with which women tackle it, it
seems possible that it will shortly belong to them entirely. We
willingly support them in this effort because, as we said,
miniature painting seems more their province than ours. And
since we are inclined to applaud every successful effort, we
will back every venture beyond the limits we assign them that
they have the strength to make. Without calling for
exceptions, we will always recognize them. . . .

# Anna Brownell Jameson: Reflections on Women Artists (1834)

As a daughter and wife, a governess and a writer, Anna Brownell Jameson (née Murphy, 1794-1860) was acutely aware of the contradictions between the roles that society prescribed for women and the realities of their experience. She was the eldest daughter of a miniature painter, Dennis Murphy, who taught her to draw and encouraged her love of reading. Her family employed a governess for a time, but she owed her real education to the family library and her own self-discipline. She, in turn, educated her three younger sisters and, when her father lacked commissions, made plans to take them to Brussels to learn lacemaking to augment the family income. Her parents put a quick stop to this project, but at the age of sixteen Anna Brownell Murphy accepted a position as a governess.

She left teaching in 1825 to marry Robert Jameson, a barrister four years her senior who shared her literary and artistic interests. Although the marriage failed—in 1829 the couple separated—it did introduce Anna Jameson to a literary career. Her husband encouraged her to publish *The Diary of an Ennuyée* (1826), a romanticized account of a young woman's travels through Europe that was based on a journal Jameson had kept on her first trip to the continent and was influenced by Mme. de Staël's *Corinne*. It soon became a fashionable success.

In her later books, like *The Loves of the Poets* (1829), *Memoirs of Celebrated Female Sovereigns* (1831), and *Characteristics of Women: Moral, Political and Historical* (1832), Anna Jameson found an audience among middle-class women, whom she called "the fair, pure-hearted, delicate-minded, unclassical reader" (quoted Thomas 1967, 49). She made no claims to scholarship, but in the lives of historical figures and literary characters, she found many lessons for modern women. She believed, as did most of her contemporaries, that women's intellect was "inferior in power and different in kind" from men's. But she also believed that it was "dangerous" to educate women only for marriage and motherhood:

> We know that hundreds, that thousands of women are not happy wives and mothers—are never either wives or mothers at all. The cultivation of the moral strength and the active energies of a woman's mind, together with the intellectual faculties and tastes, will not make a woman a less good, less happy wife and mother, and will enable her to find content and independence when denied love and happiness. (Jameson 1888, 3:63)

In 1834, Jameson collected her notes from two German trips into *Visits and Sketches at Home and Abroad* (1834), which combined descriptions of her travels with her observations on German literature, history, art, opera, and personalities. Drawing on her growing familiarity with the history of art, she turned an account of the Dresden gallery into an opportunity to consider the lives and work of women artists. By focusing on the artists' characters as well as their work and by distinguishing between "masculine" and "feminine" art, she implied that a professional career was not necessarily destructive of feminine virtue.

**There is one room [at the Dresden Gallery]** entirely filled with the crayon paintings of Rosalba, including a few by Liotard. . . .*

Rosalba Carriera, perhaps the finest crayon painter who ever existed, was a Venetian, born at Chiozza in 1675. She was an admirable creature in every respect, possessing many accomplishments, besides the beautiful art in which she excelled. Several anecdotes are preserved which prove the sweetness of her disposition, and the clear simplicity of her mind. Spence, who knew her personally, calls her "the most modest of painters"; yet she used to say playfully, "I am charmed with everything I do for eight hours after it is done!" This was natural while the excitement of conception was fresh upon the mind. No one, however, could be more fastidious and difficult about their own works than Rosalba. She was not only an observer of countenance by profession, but a most acute observer of character, as revealed in all its external indications. . . .

Thinking of Rosalba, reminds me that there are some pretty stories told of women, who have excelled as professional artists. In general the conscious power of maintaining themselves, habits of attention and manual industry, the application of our feminine superfluity of sensibility and imagination to a tangible result—have produced fine charac-

---

* Excerpted from Anna Jameson, *Sketches of Art, Literature and Character,* Boston and New York: Houghton Mifflin, 1890, 359-68. First published in *Visits and Sketches at Home and Abroad,* 4 vols., London: Saunders and Otley, 1834.

ters. The daughter of Tintoretto, when invited to the courts of Maximilian and Philip II, refused to leave her father. Violante Siries of Florence gave a similar proof of filial affection; and when the grand duke commanded her to paint her own portrait for the Florentine gallery, where it now hangs, she introduced the portrait of her father, because he has been her first instructor in art. When Henrietta Walters, the famous Dutch miniature painter, was invited by Peter the Great and Frederic to their respective courts, with magnificent promises of favor and patronage, she steadily refused; and when Peter, who had no idea of giving way to obstacles, particularly in the female form, pressed upon her in person the most splendid offers, and demanded the reason of her refusal, she replied, that she was contented with her lot, and could not bear the idea of living out of a free country.

Maria von Osterwyck, one of the most admirable flower painters, had a lover, to whom she was a little partial, but his idleness and dissipation distressed her. At length she promised to give him her hand on condition that during one year he would work regularly ten hours a day, observing that it was only what she had done herself from a very early age. He agreed; and took a house opposite her that she might witness his industry; but habit was too strong, his love or his resolution failed, and he broke the compact. She refused to be his wife; and no entreaties could afterwards alter her determination never to accept the man who had shown so little strength of character, and so little real love. She was a wise woman, and the event showed, not a heartless one. She died unmarried, though surrounded by suitors.

It was the fate of Elisabetta Sirani, one of the most beautiful women, as well as one of the most exquisite painters of her time, to live in the midst of those deadly feuds between the pupils of Guido and those of Domenichino, and she was poisoned at the age of twenty-six. She left behind her one hundred and fifty pictures, an astonishing number if we consider the age at which the world was deprived of this wonderful creature, for they are finished with the utmost care in every part. Madonnas and Magdalenes were her favorite subjects. She died in 1526. Her best pictures are at Florence.

Sofonisba Anguissola had two sisters, Lucia and Europa, almost as gifted, though not so celebrated as herself; these three "virtuous gentlewomen," as Vasari calls them, lived together in the most delightful sisterly union. One of Sofonisba's most beautiful pictures represents her two sisters playing at chess, attended by the old duenna, who accompanied them everywhere. . . .

It is worth remarking, that almost all the women who have attained celebrity in painting, have excelled in portraiture. The characteristic of Rosalba is exceeding elegance; of Angelica Kauffmann exceeding grace; but she wants nerve. Lavinia Fontana threw a look of sensibility into her most masculine heads—she died broken-hearted for the loss of an only son, whose portrait is her masterpiece. The Sofonisba had the most dignity, and in her own portrait a certain dignified simplicity in the air and attitude that strikes us immediately. [Artemisia] Gentileschi has most power; she was a gifted but a profligate woman. All those whom I have mentioned were women of undoubted genius; for they have each a style apart, peculiar, and tinted by their individual character: but all, except Gentileschi, were *feminine* painters. They succeeded best in feminine portraits, and when they painted history they were only admirable in that class of subjects that came within the boundary of their sex; beyond that boundary they became fade, insipid, or exaggerated: thus Elisabetta Sirani's *Annunciation* is exquisite, and her *Crucifixion* is feeble; Angelica Kauffmann's nymphs and Madonnas are lovely; but her picture of the warrior Herman, returning home after the defeat of the Roman legions, is cold and ineffective. The result of these reflections is, that there is a walk of art in which women may attain perfection, and excel the other sex; as there is another department from which they are excluded. You must change the physical organization of the race of women before we produce a Rubens or a Michelangelo. Then, on the other hand, I fancy no *man* could paint like Louisa Sharpe, any more than write like Mrs. [Felicia Dorothea] Hemans. Louisa Sharpe, and her sister, are, in painting, just what Mrs. Hemans is in poetry; we see in their works the same characteristics—no feebleness, no littleness of design or manner, nothing vapid,

trivial, or affected—and nothing masculine; all is super-
eminently, essentially feminine, in subject, style, and
sentiment. I wish to combat in every way that oft-repeated,
but most false compliment unthinkingly paid to women, that
genius is of no sex; there may be equality of power, but in its
quality and application there will and must be difference and
distinction. If men would but remember this truth, they
would cease to treat with ridicule and jealousy the at-
tainments and aspirations of women, knowing that there
could never be real competition or rivalry. If women would
admit this truth; they would not presume out of their
sphere—but then we come to the necessity for some key to
the knowledge of ourselves and others—some scale for the
just estimate of our own qualities and powers, compared with
those of others—the great secret of self-regulation and
happiness—the beginning, middle, and end of all education.

# III. LADY AMATEURS

In the first half of the nineteenth century, the association between femininity and domesticity was elaborated by word and image into a doctrine of separate spheres. The feminine ideal was woman as daughter, wife and mother, at home and removed from what John Ruskin called "the anxieties of the outer life . . . and the inconsistently-minded, unknown, unloved, or hostile society of the outer world" (Ruskin 1905, 18:122). Within the home, woman's business, in the words of Jules Michelet, was "to be loved, to give birth, then to give moral birth, to raise man up" (quoted Bell and Offen 1983, 1:173). Alfred, Lord Tennyson reiterated the idea poetically:

> Man for the field and woman for the hearth:
> Man for the sword and for the needle she;
> Man with the head and woman with the heart:
> Man to command and woman to obey:
> All else confusion. (*The Princess* 5:427)

The ideal was unattainable for many working-class women, but it structured the lives of most middle-class women.

Whether they studied at home or at a boarding or day school, middle-class daughters were not expected to develop the knowledge demanded by business or politics, but to acquire the gentility that would grace the home. Needlework and drawing each had their place: *The Young Ladies Treasure Book* explained that "girls who are clever with their fingers can do very much towards making the home beautiful . . . by needlework, painting, drawing, and the various kinds of fancywork" (*Young Ladies Treasure Book*, n.d., 37). Needlework, along with reading, writing and arithmetic, was among the rudiments young girls learned from their mothers or sisters. Drawing was an "accomplishment"—one of the *arts d'agrément* as they were called in France—that girls studied along with piano, dancing, and modern languages to finish their education.

Their schooling complete, young women remained in their

parents' home until they married. Although it was assumed they would learn to manage a household, most labor in the home was left to servants. Middle-class wives and daughters increasingly adopted the habits of the upper classes and spent their days making social calls, reading, writing letters, studying the piano, sketching, and doing fancy needlework. All these feminine activities signified a family's gentility: they reflected a private leisure that was paid for by husbands' and fathers' earnings in the public sphere. The drawing and needlework of lady amateurs further reinforced the connection between femininity and domesticity: a man's embroidered slippers or suspenders were signs of his wife's or daughter's devotion, and the portraits and landscapes that an amateur collected into albums provided a record of the family's history.

Amateur work was welcomed in the drawing room, but it was less and less tolerated in public galleries. As Minister of Fine Arts, La Rochefoucauld was adamant that "the work of those amateurs and women which does not merit exhibition must be turned away without pity" from the French Salon (quoted Whitley 1981, 76). The art critic for *Fraser's Magazine* explained that he didn't object to lady amateurs—as long as he was not asked to comment on their albums, which "reverse the ancient mythos of the Hesperian gardens, for there golden fruit was guarded by dragons, while here the vilest rubbish is frequently hoarded up by blooming nymphs and angels" ([Leeds] 1830, 94). The amateurs themselves, however, were often frustrated by restrictions that custom and propriety placed on their ambitions.

# Sarah Stickney Ellis: Advice on Drawing for the Daughters of England (1842)

Many young women who were between school and marriage turned to books of advice and etiquette to guide them in the transition from daughter to wife. Among the most popular volumes in England and America were those of Sarah Stickney Ellis (1810-1872), who encouraged her readers to practice needlework, music, and drawing not for their own merits, but because they contributed to the formation of character and the quality of domestic life.

Raised as a Quaker, Ellis' first book, *The Poetry of Life*, was published in 1835. Two years later, she married the Reverend William Ellis, who was eighteen years her senior and the editor of

*The Christian Keepsake*. They shared a commitment to improving society through religion: together they promoted temperance by providing a home for reformed alcoholics; then, while he travelled to the south seas as a missionary, she founded Rawdon House, a school for young women. When the school was well established, Sarah Ellis withdrew from active participation to devote herself to writing. Ultimately she published twenty-six works, but the best known were her series of books of advice for the women of England, which were widely read on both sides of the Atlantic.

*The Daughters of England*, published in 1842, was the second in the series. As in all her volumes, Ellis advised young women to cultivate an attitude of self-sacrifice—what she called "personal disinterestedness"—as the "essential characteristic of women's genius and the basis of domestic happiness" (quoted Hale 1870, 650). Ellis encouraged daughters and wives to put their family's needs before personal considerations and warned against the development of any skill or talent that would draw a young woman's thoughts "away from others and fix them on herself."

A young woman's drawings of the people and events of Victorian private life helped to shape the family's sense of itself. Collected into albums, the images functioned much as snapshots do today: amateur portraits provided a visual record of family and friends, and landscape drawings made while a family travelled served as a reminder of shared experiences. As one young woman asked: "What is a trip without memories and memories without an album and an album without drawings?" (Jaunez 1834b, 168-69).

Ellis' advice was based on her own experience as an amateur artist. She made a practice of rising each day at five, writing for several hours before breakfast, and then returning to her desk or taking out her watercolors. She completed several series of drawings, including one of her favorite mountain views in the Pyrenees, where the family lived for several years, and another documenting the orchids she and her husband collected.

**As a picture which presents to the eye** of the beholder those continuous masses of light and shade usually recognized under the characteristic of breadth, though it may be striking, and sometimes even sublime in its effect, yet, without the more delicate touches of art, must ever be defective in the pleasure it affords, so the female character, though invested with high intellectual endowments, must

ever fail to charm, without at least a taste for music, painting,
or poetry.* . . .

With regard to the application and use of the art of
painting, or perhaps we ought to say drawing, there is a very
serious mistake generally prevailing among young persons, as
well as among some who are more advanced in life. Drawing,
as well as music, is not only considered as something to
entertain company with, but its desirableness as an art is
judged of precisely by the estimate which is formed of those
pieces of polished pasteboard brought from school and
exhibited as specimens of genius in the delineation of gothic
arches, ruined cottages, and flowers as flat and dry as the paper
on which they are painted. The use of drawing, in short, is
almost universally judged of among young ladies, by what it
enables them to produce; and no wonder, when such are the
productions, that its value should be held rather cheap.

There are many very important reasons why drawing
should be especially recommended to the attention of young
persons, and I am the more anxious to point them out,
because, among the higher circles of society, it appears to be
sinking into disrepute, in comparison with music. Among
such persons, it is beginning to be considered as a sort of
handicraft, or as something which artists can do better than
ladies. In this they are perfectly right; but how then are they
to reap the advantage to themselves, which I am about to
describe as resulting from an attentive cultivation of the
graphic art?

Among these advantages, I will begin with the least. It is
quiet. It disturbs no one; for, however defective the
performance may be, it does not necessarily, like music, jar
upon the sense. It is true, it may when seen offend the
practiced eye; but we can always draw in private, and keep
our productions to ourselves. In addition to this, it is an
employment which beguiles the mind of many cares, because
it never can be merely mechanical. The thoughts must go
along with it, for the moment the attention wanders, the

---

*    Excerpted from Sarah Stickney Ellis, *The Daughters of England, Their
     Position in Society, Character and Responsibilities*, New York:
     Appleton, 1843, 35-41. First published London: Fisher, 1842.

hand ceases from its operations, owing to the necessity there is that each stroke should be different from any which has been previously made. Under the pressure of anxiety, in seasons of protracted suspense, or when no effort can be made to meet an expected calamity, especially when that calamity is exclusively our own, drawing is of all other occupations the one most calculated to keep the mind from brooding upon self, and to maintain that general cheerfulness which is a part of social and domestic duty. . . .

But the great, the wonder-working power of the graphic art, is that by which it enables us to behold, as by a new sense of vision, the beauty and the harmony of the creation. Many have this faculty of perception in their nature, who never have been taught; perhaps not allowed, to touch a pencil, and who remain to the end of their lives unacquainted with the rules of painting as an art. To them this faculty affords but glimpses of the ideal, in connection with the real; but to such as have begun to practice the art, by first learning to *see*, each succeeding day unfolds some new scene in that vast picture, which the ever-varying aspect of nature presents. . . .

In every object, however familiar in itself, or unattractive in other points of view, the painter perceives at once what is striking, characteristic, harmonious, or graceful; and thus, while associating in the ordinary affairs of life, he feels himself the inhabitant of a world of beauty, from which others are shut out.

Would that we could dwell with more satisfaction upon this ideal existence, as it affects the morals of the artist's real life! Whatever there may be defective here, however, as regards the true foundation of happiness, is surely not attributable to the art itself; but to the necessity under which too many labor, of courting public favor, and sometimes sacrificing the dignity of their profession to its pecuniary success.

Nor is it an object of desirable attainment to women in general, that they should study the art of painting to this extent. Amply sufficient for all their purposes, is the habit of drawing from natural objects with correctness and facility. Copying from other drawings, though absolutely necessary to the learner, is but the first step towards those innumerable

advantages which arise from an easy and habitual use of the
pencil. Yet here how many stop, and think their education in
the graphic art is complete! They think also, what is most
unjust of drawing, that it is only the amusement of an idle
hour, incapable of producing any happier result than an exact
*fac-simile* of the master's lesson. No wonder, that with such
ideas, they should evince so little inclination to continue this
pursuit on leaving school. For though it is a common thing to
hear young ladies exclaim, how much they should like to take
likenesses, it is very rarely that we find one really willing to
take a hundredth part of the pains which are necessary to the
attainment even of mediocrity in either of these depart-
ments. That it is in reality easier, and far more pleasant, to
sketch from nature, than from another drawing, is allowed by
all who have made the experiment on right principles; which,
however, few young persons are able to do, because they are
so seldom instructed in what, if I might be allowed the
expression, I should call the *philosophy* of picture making,
or, in other words, the relation of cause and effect in the
grouping and general management of objects, so as to unite
a number of parts into a perfect and pleasing whole. . . .

Nor ought we by any means to overlook the value of that
which the pencil actually produces. Sketches of scenery,
however defective as works of art, are among the precious
memorials which time, the great destroyer, is unable to
deprive us. In them the traveller lives again, through all the
joys and sorrows of his distant wanderings. He breathes
again the atmosphere of that far world which his eye will
never more behold. He treads again the mountain-path
where his step was never weary. He sees the sunshine on the
snowy peaks which rise no more to him. He hears again the
shout of joyous exultation, when it bursts from hearts as
young and buoyant as his own; and he remembers, at the
same time, how it was with him in those by-gone days, when,
for the moment, he was lifted up above the groveling cares of
every-day existence.

But, above all, the art which preserves to us the features
of the loved and lost, ought to be cultivated as a means of

natural and enduring gratification. It is curious to look back to the portrait of infancy, or even youth, when the same countenance is stamped with the deep traces of experience, when the venerable brow is ploughed with furrows, and the temples are shaded with scattered locks of silvery hair. It is interesting—deeply interesting, to behold the likeness of some distinguished character, with whose mind we have long been acquainted, through the medium of his works; but the beloved countenance, whose every line of beauty was mingled with our young affections, when this can be made to live before us, after death has done his fearful work, and the grave has claimed its own—we may well say, in the language of the poet, of that magic skill which has such power over the past, as to call up buried images, and clothe them again in beauty and in youth,

> Blessed be the art that can immortalize,
> The art that baffles Time's tyrannic claim
> To quench it.

Beyond these, however, there are uses in the art of drawing so well worthy the consideration of every young woman of enlightened mind, that we cannot too earnestly recommend this occupation to their attention, even although it should be at some sacrifice of that labyrinthine toil of endless worsted-work, with which, in the case of young ladies, both hand and head appear to be so perseveringly employed. I freely grant the charm there is in weaving together the many tints of *German wool*, but what does this amusement do for the mind, except to keep it quiet, and not always that?

# Elizabeth Stone: The Art of Needlework (1841)

In the first half of the nineteenth century, needlework remained an important practical skill for many women, including the seamstresses who assembled shirts as sweated laborers, the dressmakers who created intricate Victorian fashions, and the young

women in rural America whose quilts were their dowries. For middle-class women who could pay a seamstress and a dress-maker and lavished their leisure on decorative fancywork, needlework had a more symbolic significance. Beyond providing clothing for the family and linen for the home, needlework had come to embody feminine virtue. In magazines and handbooks like Elizabeth Stone's (dates unknown) *The Art of Needlework* (1841), women found not only designs to follow, but justifications for their work.

In urban Europe, needlework had long been considered a useful protection against what was perceived as the potential dangers of feminine idleness. In 1712 Joseph Addison explained in the *Spectator* that one reason for "busying good women in works of fancy is because it takes them off from scandal, the usual attendant of tea tables and all unactive scenes of life" (quoted Parker and Pollock 1981, 62). Because embroidery was associated with aristocratic ladies of the past—and the Middle Ages in particular—it had a particular appeal for middle-class women who aspired to upper-class manners. Stone, whose book was edited by the Vicountess Wilton and dedicated to Queen Adelaide, lavished attention on the Bayeux tapestry, attributed at that time to Mathilda, wife of William the Conqueror. Even in the democratic United States the aristocratic precedent was important. In her American hand-book, Lydia Sigourney singled out the wife of Louis XI of France, Marie d'Anjou, as a model of feminine prudence and modesty because she embroidered for the church: "She considered industry a remedy for a disordered imagination and a shield against the temptations of a fashionable life" (Sigourney 1838, 78-9).

The pictorial embroideries done in silk that had been popular among young ladies at the end of the eighteenth century gave way by the 1830s to German or Berlin wool work. Using worsted wool and a cross-stitch, women executed patterns that were printed on mesh canvas in Berlin, imported to America and England by printsellers, and sold by dealers like Wilks Warehouse on London's Regent Street. Complex designs based on well-known contemporary paintings mimicked the illusionistic techniques of oil paint. Scenes from the Old Testament and the novels of Walter Scott sold well, as did portraits of such public personalities as England's royal family and American statesmen. Decorative patterns were adapted to every possible surface in Victorian middle-class homes: flowers blossomed on upholstery and handbags; exotic birds perched on firescreens; and dogs and cats settled on footstools.

## Introduction*

In all ages woman may lament the ungallant silence of the historian. His pen is the record of sterner actions than are usually the vocation of the gentler sex, and it is only when fair individuals have been by extraneous circumstances thrown out, as it were, on the canvas of human affairs—when they have been forced into a publicity little consistent with their natural sphere—that they have become his theme. Consequently those domestic virtues which are woman's greatest pride, those retiring characteristics which are her most becoming ornament, those gentle occupations which are her best employment, find no record on pages whose chief aim and end is the blazoning of manly heroism, of royal disputations, or of trumpet-stirring records. And if this is the case even with historians of enlightened times, who have the gallantry to allow woman to be a component part of creation, we can hardly wonder that in darker days she should be utterly and entirely overlooked. . . .

Still, though in our happy country it is now pretty generally allowed that women are "des créatures humaines," it is no new remark that they are comparatively lightly thought of by the "nobler" gender. This is absolutely the case even in those countries where civilization and refinement have elevated the sex to a higher grade in society than they ever before reached. Women are courted, flattered, caressed, extolled; but still the difference is there, and the "lords of the creation" take care that it shall be understood. Their own pursuits—public, are the theme of the historian—private of the biographer; nay, the every-day circumstances of life—their dinners—their speeches—their toasts—and their *post coenam* eloquence, are noted down for immortality; whilst a woman with as much sense, with more eloquence, with lofty principles, enthusiastic feelings, and pure conduct—with sterling virtues to command respect, and the self-denying conduct of a martyr—steals noiselessly through her appointed path in life; and if she excites a passing

* Excerpted from Elizabeth Stone, *The Art of Needlework from the Earliest Ages,* London: Henry Colburn, 1841, 1, 5, 7, 84-116, 397-99.

comment during her pilgrimage, is quickly lost in oblivion
when that pilgrimage hath reached its appointed end.

And this is but as it should be. Woe to that nation whose
women, as a habit, as a custom, as a matter of course, seek to
intrude on the attributes of the other sex, and in a vain, a
foolish, and surely a most unsuccessful pursuit of publicity or
power, or fame, forget the distinguishing, the high, the
noble, the lofty, the pure and unearthly vocation of their sex.
Every earthly charity, every unearthly virtue, are the
legitimate object of woman's pursuit. It is hers to soothe
pain, to alleviate suffering, to soften discord, to solace the
time-worn spirit on earth, to train the youthful one for
heaven. Such is woman's magnificent vocation; and in the
peaceful discharge of such duties as these she may be content
to steal noiselessly on to her appointed bourne, "the world
forgetting, by the world forgot." . . .

And if we look for that feminine employment which
adds most absolutely to the comforts and elegancies of life, to
what other shall we refer than to *needlework*? The hemming
of a pocket-handkerchief is a trivial thing in itself, yet it is a
branch of an art which furnishes a useful, a graceful, and an
agreeable occupation to one-half of the human race, and
adds very materially to the comforts of the other half. . . .

**The Bayeux Tapestry**
Great discussion has taken place amongst the learned
with regard to the exact time at which the Bayeux tapestry
was wrought. The question, except as a matter of curiosity,
is, perhaps of little account—fifty years earlier or later,
nearly eight hundred years ago. It had always been
considered as the work of Mathilda, the wife of the
conquering Duke of Normandy, until a few years ago, when
the Abbé de la Rue started and endeavoured to maintain the
hypothesis that it was worked by or under the direction of the
Empress Mathilda, the daughter of Henry the First. But his
positions, as Dibdin observes, are all of a negative character,
and "according to the strict rules of logic, it must not be
admitted, that because such and such writers have not
noticed a circumstance, therefore that circumstance or event
cannot have taken place." Hudson Gurney, Charles A.

Stothard, and Thomas Amyott, Esqrs. have all published essays on the subject, which establish almost to certainty the fact of the production of this tapestry at the earlier of the two periods contended for, viz. from 1066 to 1068.

In this we rejoice, because this Herculean labour has a halo of deep interest thrown around it, from the circumstance of its being the proud tribute of a fond and affectionate wife, glorying in her husband's glory, and proud of emblazoning his deeds. As the work of the Empress Mathilda it would still be a magnificent production of industry and skill; as the work of "Duke William's" wife these qualities merge in others of a more interesting character. . . .

This excellent and amiable princess was a most highly accomplished woman, and remarkable for her learning; she was the affectionate mother of a large family, the faithful wife of an enterprising monarch, with whom she lived for thirty-three years so harmoniously that her death had such an effect on her husband as to cause him to relinquish, never again to resume, his usual amusements.

Little did the affectionate wife think, whilst employed over this task, that her domestic tribute of regard should become an historical memento of her country, and blazon forth her illustrious husband's deeds, and her own unwearying affection, to ages upon ages hereafter to be born.

This magnificent piece of work is 227 feet in length by 20 inches in width, is now usually kept at the Town-hall in Rouen, and is treasured as the most precious relic. . . .

The tapestry is coiled around a machine like that which lets down the buckets to a well, and a female unrolls and explains it. It is worked in different coloured worsteds on white cloth, to which time has given the tinge of brown holland; the parts intended to represent flesh are left untouched by the needle. The colours are somewhat faded, and not very multitudinous. Perhaps it is the little variety of colours which Mathilda and her ladies had at their disposal which has caused them to depict the horses of any colour—"blue, green, red, or yellow." The outline, too, is of course stiff and rude.

Ages have rolled away; and the fair hands that wrought

this work have mouldered away into dust; and the gentle and affectionate spirit that suggested this elaborate memorial has long since passed from the scene which it adorned and dignified.

These may be deemed trite reflections: still it is worthy of remark, that many of the turbulent spirits who then made earth echo with their fame would have been literally and altogether as though they never had been—for historians make little or no mention of them—were it not for the lasting monument raised to them in this tapestry by woman's industry and skill.

## Modern Embroidery

The style of modern embroidery, now so fashionable, from the Berlin patterns, dates from the commencement of the present century. About the year 1804-5, a print-seller in Berlin, named Philipson, published the first coloured design, on checked paper, for needlework. In 1810, Madame Wittich, who, being a very accomplished embroideress, perceived the great extension of which this branch of trade was capable, induced her husband, a book and print-seller of Berlin, to engage in it with spirit. From that period the trade has gone on rapidly increasing, though within the last six years the progression has been infinitely more rapid than it had previously been, owing to the number of new publishers who have engaged in the trade. By leading houses up to the commencement of the year 1840, there have been no less than fourteen thousand copper-plate designs published.

Of the fourteen thousand Berlin patterns which have been published, scarcely one-half are moderately good; and all the best which they have produced latterly are copied from English and French prints. Contemplating the improvement that will probably ere long take place in these patterns, needlework may be said to be yet in its infancy.

The improvement, however, must not be confined to the Berlin designers: the taste of the consumer, the public taste must also advance before needlework shall assume that approximation to art which is so desirable, and not perhaps now, with modern facilities, difficult of attainment. Hitherto the chief anxiety seems to have been to produce a glare of

colour rather than that subdued but beautiful effect which makes of every piece issuing from the Gobelins a perfect picture, wrought by different means, it is true, but with the very same materials. . . .

## Ary Scheffer: Princess Marie Christine Caroline d'Orléans (c. 1839)

Princess Marie Christine Caroline d'Orléans, born in 1813, was the second daughter of Louis Philippe, who was crowned "King of the French" following the Revolution of 1830. As the duc de Chartres, Louis Philippe's republican sympathies had led him to support the Revolution of 1789; in years of exile following the Revolution, he educated his children *en bourgeois* and sent them to public schools. After the family was permitted to return to France in 1826, Princess Marie was educated by private instructors and watched over by a governess.

Her drawing master was Ary Scheffer (1795-1858), a distinguished painter, a family friend, and a member of the delegation that summoned Louis Philippe to the throne in 1830. Scheffer owed much of his own early education to the efforts and influence of his mother, Cornelia Lamme Scheffer. Trained as an artist and widowed at an early age, she had moved to Paris to enable her sons to study at the Ecole des Beaux-Arts. Perhaps his early experience explains the sympathy Ary Scheffer felt for Princess Marie's ambitions and frustrations.

When the princess became bored by the stringent restrictions that hedged amateur work, Scheffer encouraged her to take up sculpture. Women sculptors, professional or amateur, were unusual but not unknown. In eighteenth century England, Anne Seymour Damer, granddaughter of a duke and the cousin to Horace Walpole, was "entitled to a life of ease and luxury" but chose, as a later critic put it, to "dedicate the golden hours of her youth to the task of raising a name by working in wet clay, plaster of Paris, stubborn marble, and still more intractable bronze" (quoted Fine 1978, 76). Walpole considered her work equal to antique sculpture, but others criticized her reliance on assistants. In France, Félicie de Fauveau, an aristocratic young woman several years older than Princess Marie, first pursued sculpture as an amateur, but when her father lost his fortune, she began accepting payment for her work.

Princess Marie's most ambitious project was a monument to Joan of Arc undertaken at her father's request. Louis Philippe, unhappy with the sculptor James Pradier's proposal, asked his daughter to make another version. She agreed—but stipulated that if the model satisfied her father, she would be allowed to execute the monument. With Scheffer's guidance, the work was completed and installed at Versailles.

Not long after, Princess Marie married the Duke of Wurtemburg. Following the birth of their son in 1837, she was found to have a heart condition. At her death two years later, she left her drawings and models to her teacher, who wrote the following memoir of her.

**She was brought up after the manner** of all princesses, by Madame de Malet, a person of education and religiously disposed, but having exceedingly narrow and restricted ideas of things.\* The Princess was, as a child, impertinent, heedless, and wild to a degree; yet she learned what she was taught—languages, history, and so forth—though habitually indulging in saucy sallies at the expense of her instructors. . . .

Such lessons as, from the age of twelve years and onwards, I had been in the habit of giving her, were never much else than an amusing pastime, either for master or pupil. The Princess made but slight progress, and could at no time draw a head correctly from the plaster model. Upon the marriage of her elder sister, this young girl, till now careless and unreflecting, became all at once serious and pensive. She entreated me earnestly to afford her instruction of a nature to occupy and interest her mind, and to distract her attention from the loss she had sustained; but she added that, "as to setting about to *copy*, it was too tiresome an affair by half for her to attempt it."

So she took to composing historical subjects, washing them in with watercolor. The very first trials which she made revealed to me the existence of undoubted talent, and of her imaginative faculty. Within the space of two years she

---

\*    Excerpted from Harriet Lewis Grote, *Memoir of the Life of Ary Scheffer,* London: John Murray, 1860, 51-63.

executed more than fifty drawings, all of them showing a certain power of design, carried out with originality and good general effect, though faulty in drawing and but indifferently colored. The contracted notions of Madame de Malet, the scruples of the Queen, and the reverential feeling in my own breast as towards maidenly purity and reserve—all these offered serious impediments to regular artistic instruction; so that, being restricted to the copying of draped figures (and these *abundantly* draped) the Princess remained of necessity unacquainted with the structure of the human body.

At length weary of composing cleverly, and executing unskillfully, she became out of humour with her drawing; and one day she inquired of me "whether I could not find something for her to do less dull and monotonous, and less like what other people did?" To say the truth, I was myself somewhat tired of having continually to correct her bad drawing of legs and arms, often distorted and out of shape. I suggested then to the Princess the idea of trying her hand at modeling and sculpture: a walk of art wherein I was equally unpracticed with herself and which therefore offered to both of us the attraction of novelty.

Our first essay was the small bas-relief of *Gaez and Martin*, very simply designed, and executed with the imperfect skill of mere novices. This was not a very encouraging beginning certainly, but it happened that on the day when the plaster cast of the clay model was sent home, M. Quinet's book *Ahasuerus* fell into the hands of the Princess. She began a group forthwith of *Ahasuerus refused admittance within the abode of the angel Gabriel*. In this bas-relief was now disclosed the indubitable instinct of a sculptor. Along with the perception of distances (by a diversity of surface), and quite an original style of arranging the figures, there was joined so much of expression that the whole thing bore evidence of a true vocation in art.

From this moment a passion for sculpture took deep hold of the Princess, and I must own that I felt scarcely less pleasure in giving her lessons in it. Whilst *she* was at work, *I* sought out suitable subjects for her to execute. . . . Her first choice fell upon *Le réveil du poète*; from which she "composed" the whole of a bas-relief, my aid being rendered

by drawing heads for her on paper. Viewed as an ideal piece
of sculpture, and, furthermore, as a triumph over recognized
difficulties, this performance must be regarded as something
extraordinary in itself; but as the production of a young girl,
who was actually only at her third attempt in modeling, and
who had read works of poetry and fiction under the sober
influence of a *gouvernante* of strict piety, this work is truly
surprising. The gradations of the ground plan, and the
characteristic indications of the various personages intro-
duced, being managed with singular and happy ingenuity.

After completing this bas-relief, she modeled the *Joan
of Arc on Horseback*, of which the conception is entirely due
to herself. The figure of Joan has much merit, but in the
manipulation of this model, I gave the Princess a good deal of
help. . . .

The occupation had, indeed, taken such a hold upon her
that unknown to her parents she would actually sit up at night
to pursue it. Her settled dream was to lead the life of an
elevated, conscientious artist and thus to exercise a beneficial
influence over high art in France. She chose for her studies
books calculated to ripen and develop her intellectual
faculties. Scientific treatises, in imaginative works, every-
thing was read, and read with profit, by her.

## Marie-Elisabeth [Boulanger] Cavé: Drawing Without a Master (1850)

Middle-class wives in nineteenth-century France were encour-
aged to become "mother-teachers," who gave their younger
children lessons in reading and writing and supervised the tutors
who instructed their older daughters while their sons were sent
away to school. Ladies' magazines and books regularly offered
mothers lessons and advice they could use as they educated their
children. *Drawing Without a Master* was written for the woman
who could not hire a drawing master or who preferred to educate
her daughters herself.

The author, Marie-Elisabeth [Boulanger] Cavé (née Blavot,
born 1810, death date unknown), was herself an artist and a

mother. Today she has the reputation of a charming, lively flirt, because as a young woman she had an affair with Eugène Delacroix, whom she met at a masked ball in 1833. She was studying with the landscape painter Camille Joseph Etienne Roqueplan and was married to her cousin, Clément Boulanger, a student of Dominique Ingres. Delacroix, whose paintings had outraged many in the twenties, was now enjoying government favor. While Boulanger was visiting England in 1839, Cavé and Delacroix travelled together to the low countries, where they studied the works of Peter Paul Rubens. They remained lifelong friends and their brief adventure, as recorded by Delacroix, became a matter of history.

The balance of Cavé's life was quiet and hardworking. She exhibited regularly in the Salon after her debut in 1835, received awards and commissions, and became known for her watercolors of sentimental genre scenes. Two years after Boulanger died in 1842, she married Hygin-Auguste Cavé, a government arts administrator under whose name she exhibited for the rest of her life. It was perhaps through her influence that Delacroix was awarded the title of Officer in the Legion of Honor in 1846.

Marie-Elisabeth Cavé's first book, *Drawing Without a Master*, consisted of a series of letters to a friend explaining her method for teaching drawing. Published in 1850, it was very likely undertaken to offset her husband's career reverses: following the Revolution of 1848 he had lost his government post. Delacroix reviewed the book so enthusiastically in the *Journal des deux mondes* that it is often assumed that her methods reflect his ideas. While some of Marie-Elisabeth Cavé's emphasis on the importance of "inspiration" may reflect Delacroix's influence, only a close comparison of her book and his very scattered writings on art would show precisely the intellectual debt she owed him. Cavé's method, based on copying engravings, was adapted from traditional studio methods, but her emphasis on memory was similar to the experimental techniques advocated in the 1840s by Lecoq de Boisbaudran and adopted later by Edgar Degas, Auguste Rodin, and others.

*Drawing Without a Master*—which went through at least four editions in French and seven in English—was more than a simple instruction book, however, for Cavé also addressed the purpose of an artistic education for women. Beyond suggesting that women be responsible for educating their children, she advocated that they use their skills to supplement the family income and become

their husband's economic partner, a proposal that may reflect her familiarity with the ideas of French feminists and Saint Simonians of the 1830s. In 1863, her suggestion led to the establishment of Notre Dame des Arts, a school which prepared young girls from poor families for careers in the decorative arts.

Certainly Cavé's own experience demonstrated the usefulness of educating women: after the death of her second husband in 1852, she began to write regularly. Such works as *Religion in the World* (1852), *The Woman of Today and the Woman of Yesterday* (1863), and *Color* (1863) probably helped to support her financially during these years.

### First Letter: Dedication*

You are correct, my dear Julia. If you do not compel me to put my method in writing it will remain only a project of my brain, and will never see the light. You have presented a motive for overcoming my indolence: "I wish my daughters to have a profession, if reverses should overtake them. Their fate is in your hands. Write to me and I will interpret your lessons to them. Hereafter, other mothers will thank you with me, when your letters shall be given to the press." . . .

I wished to dedicate my method to you, but my son counsels me to inscribe it to Mary your eldest daughter. Mary is the name for all young girls, yours will represent them all for me. I intend to play the part of a mother, not of a professor.

Without any pretension, and by conversation, I will begin then to teach drawing from memory.

Remember these words and repeat them to your daughters. Drawing from memory, is to have one's thought, the expression of that thought, at the point of his pencil, as the writer has his at the tip of his pen. All the artistic careers are open to those who acquire this talent. Instinct, genius, will impel them in different directions; but everywhere and always, they will find useful occupation. . . .

---

* Excerpted from Marie-Elisabeth Cavé, *Drawing from Memory,* New York and London: G. P. Putnam's Sons, 1886, 25-31, 53-55, 59, 76-80, 106-10. First published as *Le dessin sans maître,* Paris: Susse Frères, 1850.

## Second Letter: Lesson—The True Teacher—Drawing from Memory

You are not in so wild a country, my dear Julia, as to be unable to procure a veil of white gauze and four pieces of wood shaped like flat rules.

You will adjust these rules in the form of a square slightly elongated, and stretch the gauze upon it. Thus you will obtain a kind of frame, the glass of which will be gauze; then purchase common drawing-paper and charcoal. . .

The pupil should be in a good position, properly seated with her feet firmly on the floor; she should have the back of the chair before her to support the board upon which she is to draw; a pasteboard never affords a perfectly plane surface.

The pupil will place the gauze on the chair before her, so that she can take it up and lay it down with ease.

When she has sharpened two or three sticks of charcoal very fine, she will fasten her sheet of paper upon the board with four paper tacks—carpet tacks or wafers will answer—so that it will be perpendicular.

This properly done, you will hand your pupil the first series of models, heads of men and animals, feet, hands, trees, and she will select the one which appears most simple.

The model chosen, and placed on the board before the pupil, you will say to her:

Pat your gauze over this model and trace with the charcoal. Trace until the tracery is perfect, and pay careful attention to what you are doing, for presently you are to copy the model.

The tracing finished, you call it the proof; this serves as the professor. Then you replace it on the chair. The model is then placed perpendicularly before the pupil.

We come now to the second operation: drawing from the model. The pupil copies her model.

While thus occupied she may, whenever she wishes, apply the proof to the outlines already executed, either to correct them or to verify their accuracy; this proof is her faithful instructor, not a prating professor filling the ear of his pupil with unintelligible phrases, but a silent teacher responding to the earnest eyes which consult him only by presenting the truth. Such instructors are always heard and understood.

With the proof applied to the drawing, how can the pupil help seeing her faults? And she will realize and correct them so much the better for having recognized them herself. She will thus in time produce a drawing similar to the proof and therefore to the model. . . .

While your pupil is thus employed, do not fail to repeat: Pay attention to what you are doing, for when you have finished your drawing, I shall take away the model and you must reproduce it from memory.

"That is impossible!" the pupil will respond. But you will be firm, you will require some expression of her idea and you will obtain it. . . .

You will number the first two drawings thus: "No. 1 Drawing with Proof. No. 2 Drawing from Memory." and preserve them as a starting point. Thus with the others to the last. I pledge myself you will not wait for the last to express your surprise at the progress of your pupil, either in what she can accomplish with the model or from memory.

## Seventh Letter: Observations—Woman Truly Woman

You ask, my dear friend, if you shall permit your daughters to copy the lithographs of [Paul] Gavarni: they take great pleasure in doing so, you say. I must compliment their taste in selecting the works of this artist; it is a proof that they have already studied nature, and are charmed at seeing her thoroughly understood and expressed.

Gavarni will leave to posterity a very correct idea of the manners and the style of his contemporaries. That is a desirable attainment for woman, whose mind possesses such tact in observing the details of familiar life, and whose delicate raillery could so well bring them out in relief. Gavarni, however, will still be the master. . . .

One thing I would recommend, and it is to improve every opportunity of becoming acquainted with our modern masters.

Their names recur so often in the journals that it is scarcely necessary to give a list of them. I will mention only Rosa Bonheur, because she is a woman, and because she paints animals with wonderful skill.

As I look at the admirable works of this artist, I congratulate myself for having said, "We have no conception

of what our sex can do." When woman shall learn how to possess talent without ignoring her womanhood, she will astonish man; and what is still better, she will charm him. What original and pleasing illustrations she can give; that of Berquin, for instance! Could any man have delineated it with such grace and expression?

But when a woman desires to paint large-sized pictures, and mounts the ladder, she is lost—lost as a painter—lost as a woman. As a painter, she will fail in force; as a woman in grace. Why descend from the pedestal upon which the Creator has placed us, giving us that happy feebleness which is irresistible! It is such an admirable combination—the strength of man with the delicacy of woman! And though I cannot tell how, without arms, powder, or ball, we move the world and place her mighty conquerors at our feet. . . .

P. S.   Drawing is an art which renders woman truly feminine. It increases her love of home, by teaching her to render it attractive. It imparts taste in ornamenting her house, and in designing the dresses and hats she orders, and which she may make herself, if she knows how to draw. Drawing and painting do not oblige a woman to show herself in public in order to call attention to her talent. It is, in a word, an art which lends modesty and wisdom, which subdues imagination to the control of reason. . . .

### Eleventh Letter: Observations—Nude Figures

You write, my dear Julia: "There is one thing that alarms me in seeing my daughters become artists. An amateur talent no longer satisfies them. After three months of study they speak of composing, and have attempted it already. This drawing from memory excites their imagination, and impassions them, even, to such a degree that they deny themselves the pleasures of the ball, because the preparations consume time, while their highest delight is to hoard up drawing after drawing in their portfolios."

What joy I experience in reading this passage in your last letter! I see that, far or near, all my pupils are the same.

Eliza, you tell me, prefers to compose jewels, vases, ornaments. We have done well, then, in teaching her all

varieties of drawing. Nothing is an obstacle to her; she follows her vocation. . . .

Mary collects engravings. She wishes to be a painter. If I remember right, she has an eye for color. It is wonderful. Each of your daughters pursues a different path. Their work will possess a two-fold interest for their mother, and there will be no rivalry between them.

It is needful that I calm your apprehensions; your fear that your daughters will become real artists only by drawing nude figures from nature.

Have I not said, that a woman should never, under any pretext, forget her womanhood; that to be woman is her first condition in life? Woman possesses a nobility which she should preserve before all things else. Courage, will, devotion, perseverance, delicacy of sentiment, self-respect, or in other words, dignity—these are her titles. These virtues constitute woman, and give her as much control over herself as she naturally maintains over others.

I cannot, with this high estimate of our sex, desire anything that would depreciate or dishonor her. I wish, on the contrary, to reinstate the name of woman-artist.

I am well aware how it is regarded at the present day; it suggests a woman who assumes masculine manners and habits, an amphibious being who is neither a man, nor yet a woman.

I have never been able to see the necessity of that in acquiring talent. On the contrary, the prime requisite of originality is to be always perfectly one's self, and to represent that self in one's works. Why am I devoted to painting children? Because I love them supremely. To see them move about in my studio charms me; all their motions are beautiful. I shall never have time to execute all they inspire within me. It is because they are natural, and this naturalness is God's style, His work.

If a woman would be thoroughly herself, she cannot well represent a Hercules, nor a battle. She must confine herself to those subjects which are allied to her sphere, which possess, in some degree, her qualities, and to which she can assimilate. It seems to me her domain is large enough and beautiful enough. As I have said elsewhere, with women,

children, animals, fruits, flowers, etc., one may create master-pieces for a lifetime.

Man, then, who cannot be properly represented by woman, ought to be excluded from our studies for this reason, and for a much stronger one, which it is not necessary to explain.

Children and partially nude women; these are the extreme limit for us. Yet these half-nude figures are necessary only for ornamental sculpture, for clocks, vases, jewels, etc., and you will agree with me that for these, they are not at all inappropriate. The subject is always mythological, and they are not colored.

As to figures in costume, it is perfectly useless to paint them nude at first, for the purpose of dressing them afterward; worse than that, it is destructive. It is impossible for a nude person to take the "movement" of one in costume. The dress gives the action. . . .

You see, my dear friend, that there is no necessity for my pupils compromising their womanly dignity, in order to become great artists; that, on the contrary, they will attain an exalted position in art, only by retaining in its highest sense their womanhood. . . .

There may, perhaps, be some giddy young girls who will say, "It is wearisome! The boys are free, but we are not."

That is true, the girls are like white satin dresses, which are not free to display themselves in the street. Of what do they complain? That they have the best of the bargain and that the bride is too pretty.

## Twentieth Letter: Serious Women—Trifling Women

One more word, my dear Julia, before closing this correspondence, which has put me to some trouble, but which, nevertheless, I shall not leave off without a certain feeling of regret; for the labor that we have undertaken for our friends has about it a charm, which grows in attractiveness. But what could I say further? Besides, I have found for myself occupations which consume all my leisure; and, as you know, I am not a writer; I do not even like the art in woman, who has no motive for publishing her thoughts and senti-

ments; who should, on the contrary, sacredly seclude her life
in that mystery of intimacy for which she is born. . . .

I like painting above all things. I like it better than
music, because it permits a woman to remain at home,
because it does not require a public and a theater. The
woman who is a musician must have a little of the audacity of
the comedienne; she must expose herself, like the actress.
With painting, however, we need never emerge from that
modesty which is one of the virtues and charms of our sex.

Still, we must not misuse the word modesty as the word
equality is used. There is, in certain circles, a tendency to
wish that woman should not be anything more than a doll,
pleasing her husband and taking the part of mother for his
children. This is not my understanding of it. I desire for her
a more useful part, one worthier of her, more respectable.
Woman should be the intelligent companion of man, that is
to say, his associate in the ofttimes painful struggles of life,
his supporter, his counsellor, his consoler. She should be for
his children not merely a well-dressed idol that they are to
come and kiss evenings and mornings, not a box of
sugar-plums, but a vigilant guardian and an attentive
physician, the professor of all that is learned at the homeside.
I wish her to be like the gardener who raises a choice shrub,
protecting it from the frost and the heat of the sun, pruning
it, cleaning it of weeds, straightening it, giving it, in short all
the vigor and all the beauty it can acquire.

I wish still more; I wish her to take pride in this noble
mission on earth. How can an idle and useless woman respect
herself and be respected? And who would not dare to respect
the woman and other as I have just described her? . . .

People generally say: "Women are trifling." They
should have limited themselves to saying, "There are trifling
women." How many women, how many mothers of families,
could smile with pity at this word. . . .

If a pretty young person, adorned with her natural
beauty, and all that fashion knows how to add to it, enters a
parlor gracefully; if she sits down with a smile and enters into
a lively interchange of those thousand little nothings that
make up the substance of conversation in society; if, at the
first tap of the bow, she flies away like a bird, whirling on the

arm of a cavalier with that expression of pleasure which is so becoming to youth, without which we might say there was no youth, you exclaim: "A trifling woman!" . . .

But, on the morrow of the ball, get access to her home, come and sit down by her fireside. You will find her up early, having already laid aside the flowers of the night before, and given her first attention to her beautiful children. She receives you in a toilette that is simple and elegant, like the apartments in which she resides. Speak to her on serious matters, she listens to you with attention, and you are not a little surprised at the good sense of her answers. Is this not enough to make you blush for your prejudice? Well, look around you: do you not see, off there, near the window, a palette and brushes? That watercolor is our work. An amateur bought it, and it paid for our last night's toilette, for we are not rich. That other one will give our husband a handsome pony that he regrets not being able to buy. As to that pastel, it is going to enrich a lottery for the benefit of the poor mothers of the ward.

I do not say all I might, for I do not wish to be accused of vaunting my sex and soliciting *Montyon* prizes for it. But how many cruel sufferings I could cite, borne without murmur and with a smiling face! What long, unrecognized devotion, without any other prospect than ingratitude! Oh! women are trifling!

Let us be on our guard, however, my Julia, against presuming too much on ourselves, and let us be what we can be, and keep our places. Men really love us only for what we are worth.

# Anonymous, *Arnold's Library of the Fine Arts*: **The Miseries of the Lady Amateur (1834)**

Although as late as the 1830s the "man of rank" was warned that painting was considered "a mechanical art" and he would "lose caste" by becoming a professional artist, the amateur artist—male or female—had an accepted place in the public practice of art in England ([Lister] 1834, 64). Not only did the Royal Academy routinely exhibit amateur work, but the Society for the Encouragement of Arts, Commerce, and Manufacture—known as the Society

of Arts—and other groups sponsored exhibitions specifically for amateur artists.

When it was founded in 1754 by the drawing master and landscape painter William Shipley, the Society of Arts initiated annual exhibitions in the fine arts and "the arts as applied to manufacture" for artists under twenty-five. Initially prize winners were presented with money, but "to encourage a Love of the Polite Arts and excite an Emulation among persons of rank and condition," medals were introduced in 1758, when the first was given to Lady Louisa Augusta Greville (quoted Wood 1913, 156). Other medals created later included the Honorary Palette, the Society's or Large Medal, and the Isis or Small Medal. In the nineteenth century, competitors entered as "honoraries"—as the amateur category was called—or "artists": by the 1820s most of the awards to "artists" went to men, while the preponderance of "honoraries" were women. Towards the middle of the century, the society's role in organizing the Crystal Palace exhibition of 1851 diverted its resources, and the last awards for young artists were presented in 1853.

In 1851, however, an Amateur Society was founded. Watercolor was the favorite medium and landscape the favorite genre of the men and women who participated in its annual exhibitions in London. But the standards for work at public exhibitions had been set by professional artists. As the critic for the *Art Journal* warned the amateurs in 1851, "Although many of the paintings exhibit much power, yet not of the kind which shows that art can be cultivated with any degree of success as a mere amusement; . . . it will be understood that there can be little hope of any amount of excellence, except from assiduous study" ("Amateur Exhibition" 1851, 199). The society discontinued its exhibitions after a few years.

Women were well aware that the rituals of genteel family life imposed on them consumed the time and concentration necessary to paint well. As Florence Nightingale wrote in 1852:

> Look at the poor lives we lead. It is a wonder that we are so good as we are, not that we are so bad. . . . Mrs. A. has the imagination, the poetry of a Murillo, and has sufficient power of execution to show that she might have had a great deal more. Why is she not a Murillo? From a material difficulty, not a mental one. If she has a knife and fork in her hands, she cannot have a pencil or brush. Dinner is the great ceremony of the day, the great sacrament. To be absent from dinner is equivalent to being ill. Nothing else will excuse us from it. Bodily incapacity is the only apology valid. If she has a pen and ink in her hands during the other three hours, writing answers for the penny post, again, she cannot have her pencil, and so on *ad infinitum* through life. (quoted Strachey 1978, 399)

Twenty years earlier, the problems faced by female amateurs were explored in the following article, which appeared in *Arnold's Library of the Fine Arts*. Its description of the practical difficulties faced by lady amateurs is so pointed that it seems likely that the anonymous author, though purportedly male, may well have been a woman who, like Currer, Ellis, and Acton Bell and George Eliot, adopted a masculine identity for publication.

> **Oh, why did God,**
> Creator wise, that peopled highest heaven
> With spirits masculine, create at last
> This novelty on earth, this fair defect
> of nature, and not fill the world at once
> With men, as angels, without feminine?

<div align="center"><em>Paradise Lost</em>, Book 10</div>

Thus spake in anger our father Adam, and thus probably responds in sorrow many a daughter of mother Eve, as with characteristic curiosity and hereditary hardihood she would fain stretch forth the hand to pluck from the forbidden tree of knowledge, and—she may not.*

I allude to those restless spirits, which, lodged in a casket of nature's frailest workmanship, are, like the invisible tenant of Otranto, grown too large for their habitation.

An artistical friend once said to me, "I really compassionate ladies who are so unfortunate as to have a taste for drawing and painting, the impediments to their progress are so numerous and so insurmountable!" I had not then had sufficient intercourse with this species of the *genus graphicum* to appreciate his remark, but, from subsequent observation, I can readily imagine those ladies, whom circumstances prohibit from professional embracing the study of the fine arts, ruminating on the ensuing catalogue of discouragements:

To be taught drawing as a matter of business, and because it is the fashion, with the proviso, however, that you are to practise that, like your other multifarious accomplishments, "only a little."

---

\* Excerpted from "The Miseries of the Lady Amateur," *Arnold's Library of the Fine Arts* 4 (June 1834), 131-33.

To be hampered and restricted in your pursuit, even of what you are permitted to attempt, by genteel friends, who, in the apprehension of your emancipating yourself from appropriate insipidity, confine you to shadowless miniatures, incomprehensible landscapes, moon-struck *vegetables*, or dog-star butterflies.

To be haunted, immediately on an exhorted admission that you can hold a pencil, by a host of album-makers, repositarians, bazaar-belles, and "charitables" of both sexes.

To be expected to supply your private friends with illustrated card-racks, illuminated card-screens, ornamental chess-boards, and flower-wreathed work-tables.

To be left to chew the cud of jealousy and mortification (on the relinquishment of your art in disgust) arising from some significant observation on the ingratitude of throwing away the advantages your parents have secured for you, and the afflicting intelligence that one rival school-fellow has gained the silver Isis Medal for a head in chalks, and that another had appeared at the Royal Academy as an honorary exhibitor of a landscape in oils.

To be called from your re-vivified exertions, in the anticipation of similar distinction, by the importunate summons of domestic duty—to resign the fleeting visions of artistic honors for the sad realities of every day necessity— and to exchange the ambrosia and nectar of celestial banquets, and the prismatic vestiture of spiritual inspira- tions, for the gastronomic achievements of the victualling office on the one hand, or the labyrinthian details of the clothing department on the other, although you may in "sober sadness" acknowledge them to be indispensable to the vulgar exigencies of un-etherealized mortals.

To be consigned by fate to a virtual interment in the country, or to the demi-mortual monotony of a provincial town, and to know that unless you shall be relieved by the discovery of a super-human ear-trumpet, the interposition of a preter-natural telescope, or the temporary possession of Fortunatus's Wishing Cap, you must never hope for the enjoyment of a personal intercourse with the world of art.

To be hurried from a delicious ramble among the flowers and sweets of a metropolitan exhibition, or an

enchanting reverie on an imaginary "Graphic Conversazi-one," by the wearisome attentions of a dandified acquain-tance, or the harrowing interruptions of trifling disputators on the latest ball or the newest fashion.

To be allowed to possess a wonderful talent for portrai-ture, and to be proclaimed by one sex a *bore,* by the other a bear, for certain staring delinquencies of which you are perpetually guilty, in your uncontrollable avidity for subjects—your own relatives and acquaintances being too busy or too un-accommodating to oblige you with a sitting, or, having prevailed on a sturdy vagrant or two to "give you the benefit of their countenance," to be consoled by the announcement that they had amply compensated themselves for their loss of time by pocketing a dozen or so of silver spoons in their way to and from your studio, leaving behind them, however, as the *quid pro quo,* a portion of their late adherents—a sacrifice "more honored in the breach than the observance."

To be inspired with a rage for the beauties of landscape, and having with difficulty obtained an escort, to the romantic and the picturesque, to be snatched by his or her impatience from a scarcely indicated sketch; or to sit on thorns while your companion chooses to sit upon the damp grass, superinducing an ague by fretting over the detention, or to encounter alone the terrors of a solitary walk through unfrequented paths, and to be scared from your studies and your propriety together by the apparition of an insolent beggar, or the intrusion of an infuriate bull.

To be dragged forward as show-woman to your own performances, and to stand the running fire of praise undeserved, or sarcasm unmerited, and while thus burning with the febrile tortures of the torrid zone—while your mental quicksilver indicates the point at which spirits boil, on perceiving at length the approach of one (a gentleman of course) to whose dictum you appeal as the guarantee of your fame, to experience the excruciating revulsion of a fall below Zero, and the agonizing effect of a submersion in the frozen ocean—a result which must necessarily await you in the intimation that your best, and really meritoriously executed production, is only—"very well for a lady."

# IV. STRONG-MINDED ARTISTS

Not all women artists in the middle of the nineteenth century accepted the conventional wisdom that—in the words of an anonymous writer for *Blackwoods' Magazine*—their work was invariably "less courageous, magnificent and sublime . . . and more beautiful, delicate and affecting" than that of men (Omega 1824, 390). They resisted subordinating their talents to familial responsibilities and restricting their audience to the private sphere, but when they began their careers in the 1830s and '40s, women's opportunities to acquire professional skills remained severely limited.

Many women artists were still trained by family members; others attended women's classes that were being introduced by art schools. As early as the 1830s, women in England studied at Henry Sass' school in Bloomsbury, where young men prepared to enter the Royal Academy schools. In the United States, women entered the Pennsylvania Academy of Fine Arts after 1844 and the National Academy of Design after 1848. In France several artists—notably Alexandre Abel de Pujol and Léon Cogniet—established teaching studios for women. Even at well-established schools, however, women's classes were separate from and less rigorous than men's classes.

Women who were frustrated by the inadequacies of such training ventured beyond women's usual classrooms: they sought out slaughterhouses and medical schools to learn anatomy and travelled far to work with artists whose skills or sensibility they admired. Despite Marie-Elisabeth Cavé's predictions that when a woman artist "mounts the ladder, she is lost—lost as a woman and as an artist," they completed works monumental in scale. Despite the *Art Journal*'s assertion that "the chisel and mallet are not the most pleasant tools, we should imagine, for a lady to use or stone or marble the most subservient materials to yield to the efforts of her will," they turned to sculpture as well as painting ("Beatrice Cenci" 1857, 124). Confronted with the convention that equated femininity with domesticity, some women artists deliberately chose

to remain single, while others, though married, refused to conform to prevailing marital customs.

After the middle of the century, however, academies and artists' societies were increasingly reluctant to recognize women artists. In France, the Salon juries of the Second Empire consistently limited the proportion of women who participated to under ten percent. In England the Royal Academy and the Society of British Artists abolished the "honorary" membership category for women in the 1850s and 1860s, while the watercolor societies—which had formerly admitted women as full members—relegated them to a separate "ladies" category. But if recognition from their professional colleagues was slow in coming, the middle-class audience was growing and private art dealers were ready to cultivate purchasers for the work of successful women. Surprisingly, most art critics ignored the question of these artists' sex in discussing their work. However, for those who at mid-century were beginning to address the "woman question"—those who in England were called "strong-minded"—the issue remained significant. The careers of these women demonstrated that, despite prevailing opinion, women could meet the criteria for achievement that had been established by their male colleagues.

# Rosa Bonheur: Fragments of My Autobiography and Conversations (c. 1898)

Raymond Bonheur taught his daughter, Rosa Bonheur (1822-99), both to paint and to question convention. Raymond Bonheur was a provincial portrait painter and drawing instructor who married one of his students, Sophie Marquis. In 1828 he left Bordeaux for Paris with the hope of finding better opportunities, but instead of commissions, he discovered the utopian theories of Claude Henri, Comte de Saint-Simon. By the time his wife and four children joined him in the capital in 1829, he was closely involved with Barthelémy-Prosper Enfantin. In 1832 Raymond again left his family, joining Enfantin in a Saint-Simonian community at Ménilmontant. The community was short-lived; in a matter of months Enfantin, whose theories of sexual equality led him to advocate free love, was jailed on charges of immorality and Raymond returned to his family. The experience left Rosa Bonheur with a lifelong ambivalence about her father's ideals: she shared and admired his commitment to equality between the sexes, but she always remembered the hardships that his

absence forced on her mother, who had been left in Paris to struggle to keep the family together.

Exhausted and ill, Sophie died in 1833, and Raymond attempted to educate his eldest daughter in a conventional manner. First he apprenticed Rosa to a dressmaker, but she was unhappy there. He placed her in a school where he taught drawing, but Rosa, a tomboy, was soon asked to leave. She persuaded her father to teach her to paint, and his studio became her classroom. She started by copying prints and casts, progressed to copying paintings at the Louvre, and—because Raymond stressed the importance of working directly from nature—crowded birds, rabbits, and even a goat into the studio. By the 1840s Rosa, who had determined to become an *animalier*, sought out the slaughter-houses of Paris to study anatomy.

It was perhaps while visiting the slaughterhouses that Rosa Bonheur first adopted male clothing, though she did not obtain official permission to wear pants in public until 1853. George Sand had scandalized Paris when she wore a suit and great-coat to the theater in the early 1830s; Bonheur, who admired Sand's politics and books, but not her notoriety, avoided wearing pants on public occasions. Though her eccentric dress was soon common knowledge, it did not seem to hurt her growing reputation. It may, in fact, have helped to distance Bonheur from the prevailing stereotype of the lady artist.

Rosa Bonheur first contributed to the Salon in 1841. By the late 1840s, her success enabled her to establish her own studio, and in 1853 she moved to a building on the rue d'Assas with courtyard for her menagerie. Bonheur shared this home with Nathalie Micas, a childhood friend who became her lifelong companion, and Nathalie's mother, who organized their house-hold. They moved in 1859 to an estate at By, near the forest of Fontainebleau, where Bonheur had room for ever-larger animals, including lions.

Bonheur's paintings sold well in England and America: virtually everything she painted was placed by her dealers— Ernest Gambart and the Tedesco brothers. After 1855, she had no need or desire to participate in the Salon. She was not unrecognized in France: in 1865 the Empress Eugénie, temporar-ily appointed regent, named Bonheur to the Légion d'Honneur. Bonheur was the first woman artist so decorated.

After Nathalie Micas' death in 1889, Bonheur led a life of seclusion and hard work, visited by a few friends and surrounded by her animals. Among her visitors and correspondents were

younger women artists like Virginie Demont-Breton, who had been
inspired by her example. In 1895, Bonheur was visited by a young
American artist, Anna Klumpke, who returned three years later to
paint her portrait. Klumpke remained as Bonheur's companion and
in Bonheur's final years helped the older woman assemble her
memoirs.

### Fragments of My Autobiography*

I was born in Bordeaux, in the rue Sainte-Catherine, on
the 16th of March, 1822, and was the eldest of four children.
My father, a drawing master, was only twenty-two years old
then, and we lived with my mother's parents, *pépé* and
*mémé*, as they are called in the Bordelais. I was allowed to
run about everywhere, and I have kept the sweetest
recollection of that happy time of freedom. Once, I ventured
so far from home that a neighbor, finding me in the Square
des Quinconces, brought me back to my house, where
everyone was in despair. We used to spend our Sundays in
the country, not far away. I was ungovernable. I positively
refused to learn my alphabet, but had already a great passion
for drawing before I was four years old. I covered the white
walls with my shapeless sketches as high as I could reach, and
also enjoyed myself very much in cutting out paper models.
They were invariably the same; first I made long strips of
paper, then with my scissors I cut out the shepherd, then the
dog, then the cow, the sheep, and finally the tree, always in
the same order. I remember spending many a day in that
way.

Towards the year 1830, the family of Rosa Bonheur went to Paris,
where her father hoped to find more teaching. . . .

I was growing fast; my father did not want me to remain
altogether ignorant, and he sent me to Madame Gilbert's

---

* Excerpted from Rosa Bonheur, "Fragments of My Autobiography,"
translated by Lucie Ponsart, *The Magazine of Art* 26 (1902), 531-36.

school, rue de Neuilly. They found me a troublesome
inmate; my romping habits had a deplorable influence on my
school fellows, who became turbulent like me. Once, at
playtime, I suggested a game of war. Our arms were wooden
swords, and I gave the order for a charge. It was such a
disaster for the flower garden! Beautiful roses, the pride of
M. Gilbert, were soon scattered on the ground; but this
outrageous frolic was the last. M. and Mme. Gilbert refused
to keep any longer such a tomboy as me, and sent me home.
My parents had now removed to the rue de Tournelles. The
first floor of their house had been converted into a studio.
There I worked alone, as best I could, whilst my father went
into every quarter of Paris to give lessons. One evening,
coming home after a trying day of work, he found me putting
the finishing touches to my first picture from nature, *A
Bunch of Cherries*. "This is very good indeed," he exclaimed.
"You must work seriously now." And I did. From that day I
began to copy from casts and from engravings, without,
however, neglecting to paint from nature. How much more
fascinating it was to me, than to learn grammar and
arithmetic!

It was also at about that time that I went to study at the
Louvre, where, owing to my dress and manners, the
gallery-keepers gave me the name of *le petit hussard*. My
lunch consisted of a half-penny loaf of bread and one
penny-worth of fried potatoes, with a mug full of the clear
water from the fountain in the Cour du Louvre. I copied a
few pictures by great masters, such as *Henry IV*, by Purbus,
which I immediately sold; *Les Bergers d'Arcadie*, by Poussin,
which my father gave to the Minister of the Interior; *Les
Moissonneurs*, by Léopold Robert, and some others. But it
was in the Sculpture Gallery that I chiefly distinguished
myself by a copy of *Saint Jérôme*. The students came to
watch me working, no longer with contempt. I do not know
for certain what became of my *Saint Jérôme*; it was probably
bought for a church. I was so fascinated by the pictures of the
old masters that I spent many hours in the vast galleries
crowded with their *chefs d'oeuvre* and copied many of them.
I strongly advise beginners who wish to give themselves up to
the difficult and arduous career of art, to follow my example

and get thoroughly acquainted with the old masters. It is the true foundation of art, and time, thus spent, brings forth fruit sooner or later.

In 1845 we moved to the rue Romfort. My father had married again, and I went on working harder than ever in our new quarters, situated at the back of the beautiful Parc Monceau, near which there were at that time, mostly open fields, farms and dairies. What an opportunity for me to watch the cows, sheep and goats! I had found out a delightful corner at Villiers, near the Parc de Neuilly. For a few months I boarded and lodged with a kind peasant woman. To recount all my experiences there would be telling you over again the story of all beginners.

I had to catch the rapid motion of the animals, the reflection of light and colours on their coats, their different characteristics (for every animal has its individual physiognomy). Therefore, before undertaking the study of a dog, a horse, a sheep, I tried to become familiar with the anatomy, osteology, myology of each of them. I acquired even a certain knowledge of dissection; and, by the way, I must strongly advise all animal painters to do the same. Another excellent practice is to observe the aspect of plaster models of animals, especially to copy them by lamp light, which gives more distinctness and vibration to the shadows. I can assure those who do not doubt my sincerity as an artist, that I owe all that I know to those patient and conscientious exercises.

In 1846 I travelled through the Auvergne, and made sketches which I used for my Salon picture of 1847: *Boeufs rouges du Cantal*. A medal of the third class was awarded to it, the first which I received. Years later, I had the honor of being invited to Chantilly by the duc d'Aumale. After dinner, when we were smoking and conversing, I showed him the innocent little medal, bearing the effigy of his father, King Louis Philippe. "It brought you good luck," he said to me. And it was true.

In 1847 medals were not solemnly given away as now; those to whom they were awarded had to call for them at the Director's office. My father sent me there alone, wishing me to get used to relying entirely on myself, and I went with all the courage of my twenty-three years. The Director of Fine

Arts delivered to me a medal, in the name of the King, and addressed to me a few flattering words. Great was his surprise when I replied, "Pray, give my thanks to the King, and kindly tell him that I will try to do something better another time." It was success, but not yet fortune. I had to go on working hard, and sometimes to suffer also.

Our studio was a confusion of all sorts of odds and ends, and you would never guess how my father took advantage of that disorder. When he received money for his work, he would take a handful and throw it at random about the room, and then, when we had not a farthing left at home, we searched in all the corners of the room and sometimes found a five-franc piece which saved us from starvation.

To perfect myself in the study of nature, I spent whole days in the Roule slaughterhouse. One must be greatly devoted to art to stand the sight of such horrors, in the midst of the coarsest people. They wondered at seeing a young woman taking interest in their work, and made themselves as disagreeable to me as they possibly could. But when our aims are right we always find help. Providence sent me a protector in the good M. Emile, a butcher of great physical strength. He declared that whoever failed to be polite to me would have to reckon with him. I was thus enabled to work undisturbed. His occupation was to boil and trim calves' heads. Having noticed how frugal my meals were, he sometimes offered to let me share his own. I then went to his house, where his wife, as kind as he, made room for me at their table and gave me a good dinner. And what a sight the place was, with all the curious implements of his calling! At last Fortune smiled on me. . . . Of course, I mean that I sold my pictures at a good price!

In 1858 I bought the country seat of By, in the forest of Fontainebleau, which is my home now. I gave two thousand pounds for it, and my first step was to build a large studio. The Emperor granted me the right of shooting and hunting in the forest, which stretches round my own park. Here I lead a happy life, retired from the world, only receiving a few intimate friends now and then, and working my very best.

In the year 1865 I was one afternoon busy as usual, surrounded by my pictures, on my easel stood *The Stags in*

*the Long Rocher*, when I heard the rolling of wheels and the cracking of a postillion's whip, and my little maid, Olive, entered the studio greatly upset.

"Mademoiselle, mademoiselle! Her Majesty the Empress!"

I had hardly time to slip a skirt over my flannel knickerbockers, to take off my long blue blouse and put on a velvet jacket, before the Empress appeared.

"I bring you," she said, "a little jewel from the Emperor. He allowed me to avail myself of my last day as Regent, to bring you the news of your promotion to the Légion d'Honneur," and kissing the new *chevalier*, she attached the cross to my black velvet jacket. . . .

A few more words about my home life. I live as a simple peasant woman, rising early, but retiring late. In the morning I take a walk round my garden with my dog, and afterwards a drive in my pony-cart in the forest of Fontainebleau. From 9 til 11:30, sitting at my easel, I work steadily at my painting. Then I take a very simple lunch, and when it is over, smoke a cigarette and take a glance at the papers. At one o'clock I take up my brushes again, and at five I go out. I love to watch the sun slowly disappearing behind the lofty trees of the forest. My dinner is as simple as my lunch, and I spend my evening in reading, giving the preference to books on travelling, hunting, or history.

## Conversations

If physical force is stronger in a man, it is because he is the natural defender of woman against the material dangers of life.* But in all that is moral and intellectual, she contributes as well as he to the security and happiness of the family. Consequently, there is no reason why her judgment, thought, in a word, her moral strength should be inferior. Is not intelligence, especially as regards the artistic sense, to be found first of all in the heart?

Circumstances do not allow all women to combine the

---

* Excerpted from Theodore Stanton, *Reminiscences of Rosa Bonheur*, New York: D. Appleton, 1910, 63, 374-75. (Reprinted New York: Hacker Art Books, 1976.)

various necessary elements of happiness. In my case, it has been art that monopolized my existence. I owe to it my greatest enjoyments and the consolations of the troubles I have had to endure. I have always been happy with my lot. But no one more than I better comprehends that to be a wife and mother as well as an artist must be complete bliss. To have been able to bind one's heart in love and yet to preserve the liberty of thought and of mental creation are the realization here below of the fairest dream. . . .

I heartily disapprove of women who give up their customary dress in their eagerness to pass for men.* If I had found that pants suited my sex, I would have given up skirts completely, but this is not the case, and I would never advise my sister painters to wear men's clothes in the ordinary course of life.

If, however, you see me in pants, it is not at all because I want to appear original, as is the case with too many women, but simply because it makes my work easier. Remember that there were times when I spent whole days at the Paris slaughterhouses. Oh, one must be devoted to art to live in the seas of blood amid the butchers of animals. I also loved horses, and how better to study these animals than at the fairs or among the horse traders? It was clear that feminine dress was inconvenient in these circumstances. That is why I decided to ask the police for permission to wear men's clothing. . . .

My pants were a great protection for me. Often I have congratulated myself on having dared to break with the tradition that would have forced me, by making me drag my skirts everywhere, to give up certain kinds of work. As for my feminine outfits, when I began to be famous, Nathalie Micas gave me some very intelligent advice: "You can never aspire to wearing the latest fashions, so you have to create a costume that will never undergo any of the changes that elegant women are subjected to. You can keep it all your life,

---

*   Translated from Anna Klumpke, *Rosa Bonheur: sa vie, son oeuvre*, Paris: Flammarion, 1908, 308-12, by permission of Flammarion et Cie., Paris.

and it will belong to you.'' Nathalie was right, I followed her suggestion and adopted the Breton dress, modifying it to my taste. I must admit that I often appeared silly dressed in my narrow sleeves, my vest, and my full, pleated skirt. But Nathalie comforted me by saying, "Enough! Enough! Rosa Bonheur will stand out in a crowd because of her petticoats, just as Napoleon was known by his small hat." . . .

Two years ago, in October 1896, when the Russian rulers visited Paris, the Minister of Fine Arts wanted to present the leading French artists to their Highnesses when they visited the Louvre. Invitations were sent, and I was honored with one.

According to my custom in such occasions, I put on my handsome black velvet dress and my small feathered hat, which—since my hair was cut short—could only be held on by a chin strap going from one ear to another. . . .

The moment I arrived at the Louvre, I would have given anything to have been wearing my grey felt hat. I was the only woman in a crowd of men, each one wearing more decorations than the next, because only members of the Légion d'Honneur were invited. Every eye turned to me; I did not know where to hide. It was a hard experience, and on that day I missed my masculine dress, I can assure you. Seeing my embarrassment, M. Carolus-Duran came forward and offered me his arm, which I accepted gratefully and clung to in desperation. . . .

Despite my dress, no daughter of Eve ever appreciated the niceties more than myself. My brusque and perhaps a little wild manner did not mean that my heart didn't remain completely feminine. If I had loved jewels, I would certainly have worn them; Nathalie wore them well, and I have never reproached her on this subject.

Why shouldn't I be proud to be a woman? My father, the enthusiastic apostle of humanity, frequently told me that woman's mission was to elevate humanity, that she was the Messiah of future centuries. It is to his doctrines that I owe my great and proud ambitions for the sex to which I am proud to belong and whose independence I will support to my dying day. Furthermore, I am convinced that the future belongs to us. I would note two proofs: if Americans lead

modern civilization, it is because of the admirably intelligent
way they raise their daughters and the respect they have for
their wives. On the other hand, if the Orientals are sunk in a
barbarism from which they cannot free themselves, it is
because husbands do not value their wives enough and as a
result their children are not inclined to feel affection for their
mothers.

Our timid beauties of old Europe are too willing to allow
themselves to be led to the altar like the lambs who were
once led to sacrifice in pagan temples.

I believe that when she wears the crown of orange
blossoms, the young girl is subordinating herself. She is no
longer but the pale reflection of what she was before. She
becomes forever the companion of the leader of the family,
not to be his equal, but to help him in his work; however
valuable she may be, she will always remain in the shadow.

The memory of my mother's devoted silence reminds
me that it is man's nature to express opinions without
worrying about their effect on his companion's feelings.

I know, to be sure, that the noble type of husband who
is the first to bring forward his wife's merits does exist; you
know some examples. But for myself, I have never dared to
take the risk of going before the Mayor [to marry].
Nevertheless, despite Saint-Simonian opinion, I hold mar-
riage to be a sacrament indispensable to society. What a
grand idea to give to human law the power to establish a
contract so powerful, so awesome, that even death cannot
dissolve it. . . .

## Critics on Rosa Bonheur's *The Horse Fair*

In 1851 Rosa Bonheur began regular visits to the Paris horse
market to study the horses and their handlers. Two years later, her
work culminated in *The Horse Fair*, a huge—over 8 by 16
feet—canvas that served to consolidate her growing reputation
when she sent it to the Salon of 1853.

Like the artists of the Barbizon group who emerged in the
Salons of the 1840s, Bonheur was known as a painter of the
French countryside. By the early fifties, however, critics were

contrasting her painstaking technique with the painterly manner of Barbizon painters like Constant Troyon. Her studied approach pleased the conservative critic Etienne Delécluze, who objected to the "facile, careless" painting that "inundated" the Salon: "Her brush has followed the conception so religiously that the artist's touch and laborious efforts assist rather than hinder the spectator's attention. That is art!" (quoted Holt 1981, 28). On the other hand, Louis Clément de Ris, whose articles for *L'artiste* supported the Barbizon artists, objected that her "excessive detail" pandered to popular taste.

## Louis Clément de Ris:
## Rosa Bonheur at the Salon of 1853*

Despite the unquestionable merit of *The Horse Fair*, Mlle. Rosa Bonheur cannot sustain comparison with M. Troyon, and if I announce what is obvious, it is only because the comparison has been made by the public and it is a natural one. However, to anyone who reflects seriously for several minutes after examining these works, to anyone who remembers the advice of the masters of genre painting and can separate his judgments from the impressions of the crowd, it is clear that Mlle. Bonheur cannot for an instant pretend to compete with M. Troyon. If one compares this famous artist with herself, however, one can only admire Rosa Bonheur's Salon entry for 1853. Mlle. Bonheur's work is remarkable neither for knowledge or life, nor for frank or vigorous touch, nor for powerful color, nor for general effect. A narrow interpretation of nature, a prosaic translation that brings everything down to her level—those are her qualities. Certainly in her painting this year she has glossed over some of her faults and rid herself of others. The composition at least is very remarkable. The eye takes in the subject and the details at one glance, and the harmony of the color immediately aids the harmony of line by stopping one's glance at the center before leading it by well-graduated tints

---

*   Translated from Louis Clément de Ris, "Salon de 1853: II," *L'artiste*, 5e ser., 10 (15 June 1853), 148-49.

to the edges. This is the painting's principal strength. But it is not the only one. All those who know horses know the difficulties faced by anyone who would paint them, and we admit that Mlle. Bonheur has handled these difficulties like an artist who thoroughly knows her subject. In the cantering horses and in the men who spur them on or stop them, there is a preoccupation with Géricault's lithographs—always admirable in an artist who studies the same subjects. Finally, as just mentioned, the artist's touch has been broadened and strengthened, the color has been given body, the effect has been grasped and rendered with a felicity which we always hope for with the painter.

But if one judges this composition in an absolute manner, without considering Mlle. Bonheur's earlier works, one must mute this praise. One recognizes that in order to emphasize the horses, she has ignored the accessories, that the ground lacks solidity, that the rows of trees have neither organization nor depth, and finally that the sky—this element that is so important and so neglected by Mlle. Rosa Bonheur—has been no more generously treated than in her previous works. In sum, one would be struck by I don't know what vulgarity reminiscent of—but unquestionably with other qualities—the facile sleight of hand of a Horace Vernet.

The Horse Fair was indeed a popular success. The public eagerly bought lithographs after the painting. The French government did not purchase the work—apparently because of its large size—but it did create a special award for Bonheur, who was declared *hors-concours* and granted the privilege—usually reserved for members of the Académie des Beaux-Arts of the Institut de France and the Légion d'Honneur—of exhibiting whatever she chose in future Salons. Bonheur exhibited *The Horse Fair* in Bordeaux and Ghent, but it remained unsold until Ernest Gambart, who had established himself in London as a dealer of prints and paintings and was initiating a series of exhibitions of French artists in the English capital, visited the artist. Gambart agreed to a price over three times what Bonheur had asked previously, exhibited the painting at his Pall Mall gallery, and introduced Bonheur to British artists, patrons, and press. Queen Victoria arranged for a private

viewing. Charles Eastlake, President of the Royal Academy, invited Bonheur to dinner with John Ruskin. Elizabeth Rigby, a discerning art critic married to Eastlake, accompanied Bonheur on a visit to the studio of *animalier* Edwin Landseer and found the artist to be "a real, and truly interesting, simple woman—quite above all compliments and flattery. . . . I expected a remarkable woman, but she far exceeds my expectation: indeed, she is one of those earnest, true creatures whom one can meet but very seldom in this world" (Rigby 1895, 2:42-3). Bonheur's work made a strong impression on the British public as well, as can be seen from the following review that appeared in *The Morning Post.*

## Anonymous, *The Morning Post*: Rosa Bonheur at the French Gallery, Pall Mall (1855)*

A soirée was given at this gallery, last evening, to inaugurate the exhibition of the great painting entitled *The Horse Fair,* by Mademoiselle Rosa Bonheur, and to introduce that highly gifted lady to the leading artists and amateurs of Art in this country. This picture is one of the few efforts of human genius which the trumpet of fame and the workings of individual imagination have failed, by their usual exaggeration to render a source of disappointment to the most devoted of their believers. On standing before it, all preconceived ideas vanish, and we have a splendidly luminous effect—an unquestionably truthful resemblance to reality—presented by a mind evidently imbued with an elevated feeling for Nature, and a well-practised and an obedient hand of masculine power. . . .

The subject, as the title gives us to understand, is a troop or string of horses going to a fair. . . . The portion of the road over which the horses are moving is nearly the segment of a circle. The legs of the horses are rendered less striking to the eye by being partially concealed by dust, and this arrangement fixes the attention upon the middle of the canvas, where the motion of the heads of the animals and the upper

---

\*   Excerpted from "Rosa Bonheur: French Gallery, Pall Mall, *Morning Post,*" *The Crayon* 11 (29 August 1855), 137.

parts of their riders are seen. . . . Of the principal light it may be said that it is broadly massed upon the two grey cart-horses, and is distributed by flashing along upon the heads of the horses and their flying manes, dying away gradually until it is revived on the head of the old grey horse on the extreme left of the spectator. . . .

To this we may add that the drawing is admirable, the action of the horses spirited and natural, the anatomy both vigorously and accurately expressed, with a touch as firm as it is masterly. The eye of the spectator rests where the artist intends it shall, and there is not one obtrusive light to draw it from that spot, which it never quits until interest and curiosity exert their sway, and the mind seeks to know more of the subject. It is then led gradually over the whole until it is satisfied with contemplating the most powerful, natural, and truly elegant picture which has been seen in this country for many years past.

## Anna Mary Howitt [Watts]: An Art Student in Munich (1850)

Anna Mary Howitt (1824-1884) was interested in art from an early age, and her parents encouraged her efforts. William and Mary Botham Howitt, who had been raised as Quakers, were both successful and prolific writers of poetry, children's stories, and natural history. Mary gave her eldest daughter stories to illustrate, and William proudly showed the results to his artist friends. In 1840, the Howitts left England for Germany, where there were professional opportunities for William and Mary and educational opportunities for their children. During their three-year stay, Anna Mary visited galleries, museums, and the studio of painter Wilhelm von Kaulbach, who made a profound impression on the young woman.

Returning to England in 1843, the Howitts settled on the outskirts of London. Anna Mary, who had grown into a nervous and diffident young woman, was given the best room in the house as a studio and attended classes taught by Francis Cary at Henry Sass' Bloomsbury school. In 1850 with money she earned from translating German and some help from her mother, who believed strongly that girls should have the skills to be financially

independent, Anna Mary left for Germany with her friend Jane Benham. This time Anna Mary spent two years in Munich, studying with von Kaulbach, recording her experiences in a journal, and sending descriptions of "Bits of Life in Munich" for publication in Charles Dickens' magazine, *Household Words*.

Among Anna Mary Howitt's visitors in Germany was Barbara Leigh Smith, whom she had known since childhood. Bright, blond and confident, the daughter of a wealthy radical politician, Smith had also studied at Sass' school, but her attention was turning to women's rights. Together, the young women dreamt of an "art sisterhood." Their idea may have been inspired by the recently formed Pre-Raphaelite Brotherhood: the group was mentioned regularly in the letters Howitt received from her mother, for Mary and William Howitt had befriended a number of the young artists. Smith's and Howitt's sisterhood—unlike the Pre-Raphaelites— was to provide practical as well as philosophical and aesthetic support for its members.

After Howitt returned to England in 1852, she and her mother settled in a cottage in Highgate while her father and brothers travelled to Australia. Howitt began a series of ambitious figure compositions that concentrated on women: her *Gretchen at the Fountain* was rejected by the British Institution in 1854, but attracted interest when it was exhibited at the Portland Galleries. She also edited her German journal, which was expanded and republished in 1853 as *An Art Student in Munich*. Barbara Leigh Smith appears disguised as "Justina."

Howitt and Smith became friendly with the Pre-Raphaelite artists. Dante Gabriel Rossetti and Elizabeth Siddal visited them at Smith's country home, and when Howitt attempted outdoor painting, Rossetti offered advice. With Dante Gabriel and Christina Rossetti, Frederic Stephens, and John Everett Millais, they formed a Portfolio Club: each member was to contribute a poem or drawing to the collection. Howitt's contribution was a study for *The Castaways*, a painting she exhibited in 1855 at the Royal Academy. Dante Gabriel called it "strong-minded" and described it as "a dejected female, mud with lilies lying in it, a dust heap, and other details symbolical of something improper" (Rossetti 1965, 1:214). Howitt was surely aware of Rossetti's and William Holman Hunt's paintings on the theme of the fallen woman, but her treatment of the "castaway" must also have been informed by her involvement in women's rights. By 1856 she was assisting Smith, who had formed a committee that included Mary Howitt, Anna

Jameson, Bessie Rayner Parkes and others in an effort to reform the married women's property laws.

In 1856, Howitt also began a painting of *Boadicea*, the ancient British Queen who had led a revolt against Roman rule. Smith posed for the Queen, and Mary Howitt called the painting "very fine, truly sublime" (quoted Lee 1955, 216). But Anna Mary Howitt was also anxious for the opinion of John Ruskin, who had given important critical support to the Pre-Raphaelites. She arranged for him to see the painting. Family members later remembered that they were sitting together in the Howitts' garden when Ruskin's response was delivered. Opening the envelope, Howitt read his letter aloud: "What do you know of Boadicea? Leave such subjects alone and paint me a pheasant's wing" (quoted Lee 1955, 216). Stricken, her ambitions crushed, Howitt destroyed her paintings and avoided her artist friends.

Anna Mary Howitt turned to spiritualism and three years later married Alfred Alaric Watts, a kind and patient friend from childhood who shared her new interest. Although in 1857 one of her works was included in the inaugural exhibition of the Society of Female Artists, she never painted again except to reproduce the images that came to her from the spirit world.

## Settling Down, A Great Painter's Studio*

*Munich, June 1, 1850.* Here we are in Munich. These last several days have been such a confusion of excitement, delight, disappointment, joy, fatigue, and disgust, that I scarcely know where to begin my narrative. I will, however, begin with prosaic lodging-hunting. Today, all yesterday, and part of Saturday, have we been hunting for our little home that is to be; and as yet we have not found it. . . . At present we remain at the Inn.

You will naturally wish to know what we have done about the most important thing of all—our artistic arrangements: scarcely anything as yet, for all requires time and consideration. I have not yet been even to Kaulbach's atelier. I asked advice from B——, and he recommended that I should become a pupil, for the first three months at

---

* Excerpted from Anna Mary Howitt [Watts], *An Art Student in Munich*, Boston: Ticknor, Reed and Fields, 1854, 1, 2, 3-6, 39-41, 91-96, 450-51, 452, 453-55.

least, of a friend of his, a rising artist and pupil of De la Roche's. I, of course, was therefore anxious to see this gentleman and his works; but I am disappointed—and in fact, we for the present remain in a state of the greatest uncertainty. Admission into the Academy, as we had hoped, we find is impossible for women; the higher class of artists receive no pupils. . . .

*June 12.* Rejoice with us: on Monday we become pupils of ———! yes, next Monday we are to begin our studies in that identical little atelier where, seven years ago, when almost a child, I saw that group of young artists resting themselves at noon, and playing on the guitar—a group which has haunted me ever since, like a glimpse into a new world of poetry, or the old world of Italian art. Yes! that little room, with its glorious cartoons, its figures sketched on the walls, its quaint window festooned with creepers—that is to be our especial studio. There we stood this morning; there we showed ——— our sketches; there I talked to him in the German tongue, being the mouth-piece for us both, as though he had been a grand benevolent angel.

I told him how earnestly we longed really to study; how we had long loved and revered his works; how we had come to him for his advice, believing that he would give us that, if not his instruction, which we heard was impossible. I know not how it was, but I felt no fear—only a reverence, a faith in him unspeakable. And what did he do? He looked at us with his clear keen eyes, and his beautiful smile, and said, "Come and draw here; this room is entirely at your disposal." "But," said we, "How often and when?" He said, "Every day, and as early as you like, and stay as long as there is daylight."

We knew not how to thank him; we scarcely believed our ears: but he must have read our joy, our astonishment, in our countenances.

The amount of our joy may be estimated by considering exactly our position the evening before—nay, indeed, at the very time when we entered the studio. The evening before, we were discouraged and disheartened to an extreme degree; our path in study seemed beset by obstacles on every hand: in fact, we asked ourselves for what had we come—how were we better off here than in England? We talked and talked,

and walked into that lovely English garden, along the banks
of the Isar; the trees rose up calmly in their rich summer
foliage; all was silent in the approaching twilight; long gleams
of pale flesh-colored sky gleamed through the clumps of trees
in the distance; acres of rich summer grass and flowers
stretched away from our feet. The peace of Nature seemed so
holy and beautiful to us, I believe. We talked of a thousand
things; a certain cloud, a certain barrier which seemed to
have existed between our hearts, melted away; for after all,
our hearts had been strangers to each other until that night.

On our return home, we still thought and thought what
was to be done; we talked till it was morning, and by that
time we had arranged a grand ideal plan of work, which, as
far as it went, was good. We determined, if we could find no
really first-rate master, to have models at our own rooms,
and work from them most carefully with our anatomical
books and studies beside us; that we would do all as
thoroughly as we could, and help and criticize each other;
that we would work out some designs in this way, studying
the grand works around us, going daily to the Basilica, to the
Glyptothek, to drink in strength and inspiration and
knowledge; that we would draw also from the antique, and
would take our drawings to be corrected by ———, as he had
already offered. This was the scheme of the night.

The first thing, therefore, this morning was our setting
off boldly to him with our sketches, to ask his advice. The
rest is told.

**Passing Sketches**

At half past six we breakfast, and then, as early as we
can, set off to our work. It is a pleasant walk along the quaint
old streets, now passing beneath the Falcon Tower, a heavy
round mass of stone, which tells well from different points
against the deep blue sky. . . . And so, crossing another
bridge, a stone-mason's yard, and another busy mill, we
reach the gate close to the house where live the people who
look after the studio. Here we are already recognized by the
old dog as belonging to the place. If we are early we ascend
the steps and ask for the keys of the studio, or perhaps a little

brown-eyed girl, with her hair in a net, runs to meet us with them.

Two minutes more, and we unlock the heavy door and stand in our art temple. The high priest as yet is not there, and we have a quiet, earnest studying of his pictures, endeavouring through them to discover how he looks at nature—endeavoring to see only the beautiful, the strong, and the tender. This union of the strong and the tender seems to me the great characteristic of his mind. But is not that the great and difficult union which we are all striving for, whether in life or in art? . . .

We drew last week, as a refreshment when weary with harder work, a lovely branch of white lily, and became so enamored of our work that we determined to make another study of plants. We resolved to make a drawing of the most beautiful flowers growing the beloved wilderness-field in which the studio stands, and to keep them as memories of this beautiful place, and this beautiful passage in our lives. . . .

### Justina's Visit: A Group of Art-Sisters

*September 2.* How delicious was my meeting with Justina yesterday! At the moment when I was sitting at a solitary breakfast—for Clare was yet asleep—with my mind full of Justina, and after having arranged and dusted everything in our rooms, to be ready for her, I heard the outer door open, and she entered.

Of course the first thing we did was to cry for joy, and then to gaze at each other, to see whether really she were Justina and I were Anna. It seemed strange, dream-like, impossible, that we two could be in Munich together.

Before long we set off to Kaulbach's studio—Justina, Clare, and I. . . . We walked through the light and shadow of the English garden—and I pointed out to her those particular spots that had always reminded me of her landscapes; and across the timber-field and the bridge over the mill-stream, and along the side of the rushing water, till we came to the grey, wooden door opening into the studio field, and so along the narrow path between the thick grass and the flowers, in the pleasant sunshine across the field. But I was obliged to

hold Justina's hand in mine, else nothing could have persuaded me that this was not one of my many dreams. We passed through the bushes; we stood under the vine; we opened the heavy grey door: we were in the little room. The clock ticked as loudly as usual; there stood the two sister easels, and a sister painting-blouse hung on each; the casts, the books, the green jug with flowers, all looked so familiar, that to set to work at once and fancy that I had only dreamed of Justina, seemed the most natural thing. But there she really stood in the body!

And having now seen what we were beginning, and having taken into her memory all the features of the beloved little room, so that she could picture our lives when she should have again vanished, we went into the other studio. . . . We three, as it happened, had the studio all to ourselves; and we stood and sat before those grand works, in the most perfect repose and silence, and drank in the whole spirit of the place.

Justina looked grandly beautiful, with that golden hair of hers crowning her as with a halo of glory, and her whole soul looking through her eyes, and quivering on her lips as she gazed at the pictures. I longed for Kaulbach to quietly enter, and see her standing before them like a creature worthy to be immortalized by him—an exception to the puny prosaic race of modern days, who are unworthy to live in art—who only deserve to pass away and be forgotten.

But the sublimest intellectual emotion can, after all, last only for a time, seeing that we all, the most spiritual even, are possessed of a double nature—body and soul! It was now half-past eleven o'clock, and we were grown very hungry, for our joy at meeting had prevented our eating much breakfast. . . .

What a pleasant dinner was ours at the Meyerischen Garden! What joy we had in all three going into the kitchen and ordering three portions! What a delight to see Justina's amusement at the odd look of everything! What merriment in our little bower over our dinner when it arrived! The flock of turkeys came round us as usual; all the external was the same, but the spirit was very unusual which reigned at our little dinner-table. No more "grinding." Flexors and exten-

sors were forgotten; such things as anatomy, or work, or fatigue, or home-sickness, no longer existed. All was the joyous, blessed present! . . .

After this dinner, which Justina enjoyed with all the keener relish from the contrast it made to the life she was leading—a life of the highest respectability, a life of first-class traveling, of couriers, of the grandest hotels, of English solemnity, and aristocratic propriety. She declared again and again that there never was such a delicious, free, poetical life as ours; and she was perfectly right. . . .

<p align="center">*         *         *</p>

Justina is gone! I am alone this evening, as Clare is out with some English friends.

Thank God she has been here! We all agree that three such gay delightful days never before were spent by three such accordant spirits; days which we shall never forget, and out of which Justina declares that something great and good must come. . . .

What schemes of life have not been worked out whilst we have been together! as though this, our meeting here, were to be the germ of a beautiful sisterhood of Art, of which we have all dreamed long, and which by association we might be enabled to do noble things.

Justina, with her expansive views, and her strong feelings in favor of associated homes, talked now of an Associated Home, at some future day, for such "sisters" as had no home of their own. She had a large scheme of what she calls the Outer and Inner Sisterhood. The Inner, to consist of the Art-sisters bound together by their one object, and which she fears may never number many in their band; the Outer Sisterhood to consist of women, all workers and all striving after a pure moral life, but belonging to any profession, any pursuit. All should be accordant with their natures and their characters. Among these would be needle-women—good Elizabeth ——s, whose real pleasure is needle-work, whose genius lies in shaping and sewing, and whose sewing never comes undone—the good Elizabeth! How unspeakably useful would such as thou be to the poor

Art-sisters, whose stockings must be mended! Perhaps, too, there would be some one sister whose turn was preserving, and pickling, and cooking; she, too, would be a treasure every day, and very ornamental and agreeable would be her preparation of cakes and good things for the evening meetings once or twice a month. And what beautiful meetings those were to be, as we pictured them in the different studios! In fact, all has been present so clearly to my imagination, that I can hardly believe them mere castles in the air. . . .

**Spring Pictures**

*April.* There is no denying now that Spring is at hand; yet as I am still far from ready to bid adieu to Munich, I am inclined to close my eyes to her signals, which each day greet me on my walks through the English garden. Dog's mercury and the lovely glossy arum leaves are rapidly revealing their vernal beauty. I see pale oxlips nodding here and there upon mossy banks, and bunches of them lie withering upon the pathways, gathered farther on in the garden by children's hands, and then dropped. . . .

Smiling to myself I passed a group of gardeneresses, and crossing the rustic bridge, which spans a second branch of the Isar flowing through the garden, I behold approaching the bridge over which I leaned a small raft, formed of a few huge pine-tree stems, come rushing along with the current. The water dashed over the little raft, swilkering between the mighty stems, and drenching the great leathern boots of the men who guided the raft. . . .

Baron H, I recollect, once described to me an excursion which some students he knew had made to Vienna on a raft. In description, at all events, it sounded very delightful. The floating so dreamily along the solemn Danube—the peculiar life among the raftsmen—the pausing for the night with the raft at old-world villages upon the banks—villages far away from the beaten path of ordinary travellers—the glimpse of a quaint, fresh, peasant life, opening out before you in the talk of the raftsmen and of the villagers—all this, I well remember, most pleasantly affected my imagination. I

remember, also, that a sort of little sigh for a moment heaved itself up in my heart as he described it—"Oh, if I were but a man, then would I voyage with a raft!"

But, thank God! such silly sighs as this do not often heave themselves up in my heart; for the longer I live the less grows my sympathy with women who are always wishing themselves men. I cannot but believe that all in life that is truly noble, truly good, truly desirable, God bestows upon us women in as unsparing measure as upon men. He only desires us, in His great benevolence, to stretch forth our hands and to gather for ourselves the rich joys of intellect, of nature, of study, of action, of love, and of usefulness, which He has poured forth around us. Let us only cast aside the false, silly veils of prejudice and fashion, which ignorance has bound about our eyes; let us bare our souls to God's sunshine of truth and love; let us exercise the intelligence which He has bestowed on us upon worthy and noble objects, and this intelligence may become keen as that of men; and the paltry high heels and whalebone supports of mere drawing-room conventionality and young ladyhood withering up, we shall stand in humility before God, but proudly and rejoicingly at the side of man! Different always, but not less noble, less richly endowed!

And all this we may do, without losing one jot or one tittle of our womanly spirit, but rather attain solely to those good, those blessed gifts, through a prayerful and earnest development of those germs of peculiar purity, of tenderest delicacy and refinement, with which our Heavenly Father has so specially endowed the woman. . . .

The assumption of masculine airs or of masculine attire or the absence of tenderness and womanhood in a mistaken struggle after strength, can never sit more gracefully upon us than do the men's old hats, and great coats, and boots, upon the poor old gardeneresses of the English garden. Let such of us as have devoted ourselves to the study of an art—the interpreter to mankind at large of God's beauty—especially remember this, that the highest ideal in life as well as in art has ever been the blending of the beautiful and the tender with the strong and the intellectual. . . .

# Harriet Hosmer: Letters (1851-1860)

Harriet Hosmer (1830-1908) was born in Watertown, Massachusetts. After her mother, two brothers and a sister died of tuberculosis, her physician father encouraged Hatty, as she was called, to participate in the kind of outdoor activities usually frowned on for ladies. She skated and shot, rowed and swam, and grew into a vigorous but undisciplined young woman. When she was seventeen, Lydia Maria Child, a family friend, recommended a school in the Berkshires run by Elizabeth and Catharine Sedgwick. Hosmer spent two years at the school and learned to discipline her energy—and that ambition was not inappropriate for women. Catharine Sedgwick was a highly respected novelist, whose friends and visitors included Swedish novelist and women's rights advocate Fredrika Bremer, English sociologist Harriet Martineau, and American transcendentalist Ralph Waldo Emerson. The Sedgwicks' neighbor was the English actress Fanny Kemble, said to be the first woman to wear bloomers, who entertained the school girls with readings of Shakespeare and accounts of donning pants to go fishing.

By 1849, when Hosmer returned to Boston, she had determined to become a sculptor. She studied drawing and modeling under Paul Stephenson, but when she wanted to study anatomy she was refused admittance to classes in Boston's medical schools. In the fall of 1850, Wayman Crow, the father of Hosmer's schoolmate Cornelia Crow and an art collector and Missouri state senator, invited Hosmer to St. Louis and arranged for her to study under Professor Joseph MacDowell.

When she returned to Boston, Hosmer began a life-size bust entitled *Hesper* and made visits to the Boston Athenaeum, which housed one of America's first collections of casts of sculpture. Lydia Maria Child brought Hosmer's efforts to the attention of actress Charlotte Cushman, who advised Hosmer to go to Rome and persuaded the young woman's father to allow her to leave Boston.

Hosmer arrived in Rome in 1852. Her works impressed the English sculptor John Gibson, who—though he rarely took students—permitted her to work in his studio. She lived alone on the via Fontanella, rode horseback alone, and quickly developed a reputation as an "emancipated female." Her energy, enthusiasm, and directness won over Rome's Anglo-American community. When Nathaniel Hawthorne visited her studio he was startled by her unconventional dress—"a sort of man's sack of purple or plum

colored broadcloth, into the side pockets of which her hands were thrust as she came forward to greet us"—and charmed by her manner: "She was very peculiar, but she seemed to be her actual self, and nothing affected or made up, so that for my part, I gave her full leave to wear what may suit her best and to behave as the inner woman prompts" (quoted Taft 1903, 206). She became a favorite of Robert and Elizabeth Browning, toured the Roman galleries under the guidance of Anna Jameson, and was introduced to Barbara Leigh Smith and Lady Marian Alford, who became one of her patrons.

In 1853 Wayman Crow commissioned Hosmer's first full-length figure, *Oenone*, which she finished two years later. For a number of years Crow was her most important patron, but as her reputation grew, American and English collectors readily bought her neo-classical busts and figures, many of which depicted historical or mythological women like *Beatrice Cenci* and *Medusa*. The regulars at the Caffè Greco, where artists in Rome had gathered for gossip and coffee since the eighteenth century, were less willing to accept Hosmer, but her example was important to other American women sculptors, including Edmonia Lewis, Margaret Foley, and Anne Whitney. To an American journalist who visited her studio in the 1870s, she represented "the new womanhood of our time. . . . She gives the impression that the coming woman is on the way, and men must have something more than their sex to boast of if they would keep the track of honor and wealth to themselves" (quoted Rensselaer 1963, 424).

**Watertown, November 1851***
To Cornelia Crow:

You can't imagine how delightful are the musical rehearsals in Boston every Friday afternoon—once a week, at least, I am raised to a higher humanity. There is something in fine music that makes one feel nobler and certainly happier. Fridays are my Sabbaths, really my days of rest, for I go first to the Athenaeum and fill my eyes and mind with beauty then to Tremont Temple and fill my ears and soul

---

\* Excerpts from Cornelia Crow Carr, ed., *Harriet Hosmer: Letters and Memories*, New York: Moffat Yard, 1912, 14-15, 25, 26-27, 35-36, 140-41.

with beauty of another kind, so am I not then literally "drunk with beauty"?

And now I am moved to say a word in favor of sculpture being a far higher art than painting. There is something in the purity of the marble, in the perfect calmness, if one may say so, of a beautiful statue, which cannot be found in a painting. I mean if you have the same figure copied in marble and also on the canvas. People talk of the want of expression in marble, when it is capable of a thousand times more than canvas. If color is wanting, you have form, and there is dignity with its rigidity. One thing is certain, that it requires a longer practice and truer study, to be able to appreciate sculpture as well as one may painting. I grant that the painter must be as scientific as the sculptor, and in general must possess a greater variety of knowledge, and what he produces is more easily understood by the mass, because what they see on canvas is most frequently to be observed in nature. In high sculpture it is not so. A great thought must be embodied in a great manner, and such greatness is not to find its counterpart in everyday things. That is the reason why Michael Angelo is so little understood, and will account for a remark which I heard a lady make, a short time since, that she "wondered [why] they had those two awful looking things in the Athenaeum, of *Day* and *Night*; why don't they take them away and put up something decent." Oh, shades of the departed! . . .

### Rome, April 1853
To Wayman Crow:

Had it not been for my God-like faith in human nature and for my very natural supposition that others were as busy as myself, I should have begun to fear that you had forgotten H.H. And now, how can I thank you for your letter? I must thank you for many things therein expressed or understood, for your kindness and your interest in me, for the confidence you have shown in my future, and for your leading me so quickly out of the apron strings of art, and in reality for "setting me up" as an artist.

When an artist has received the first order, and such an order, he considers himself (or herself) placed, at least, on

one artistic leg. As Mr. Gibson remarked, there are very few who can say the first benefit conferred on them was of such a princely nature. But now, my dear sir, I want to tell you that it will be some time before I can make anything which I should feel that I could send you as compensation, either in justice to yourself or as worthy of myself. Therefore for the present I shall derive no other good from your generosity than that which will arise from the possession of this "artistic leg" of which I speak, but which, I assure you, is a great thing. When I told Mr. Gibson the news, he said, "*Brava, brava*, more splendid encouragement nobody ever received"; which is indeed true, and when I told Mrs. Kemble, she wouldn't believe it. I have received many congratulations on the strength of it, and every day feel more and more that I must strive to deserve the confidence you feel in me, and that by faithful study· and devoted labor I must justify the interest expressed by my many friends.

## April 1853
To Cornelia Crow:

I have not the least idea that I shall see America for five years at the inside. I have determined that, unless recalled by accident, I will stay until I shall have accomplished certain things, be that time three, five, or ten years. . . .

You ask me what I am doing, and in reply I can say that I am as busy as a hornet. First, I am working on your *Daphne*, and then making some designs for *bassi relievi*. I reign like a queen in my little room in Mr. Gibson's studio, and I love my master dearly. He is as kind as it is possible for you to imagine, and he is, after Rauch, the first sculptor of the age.

Don't ask me if I was ever happy before, don't ask me if I am happy now, but ask me if my constant state of mind is felicitous, beatific, and I will reply "Yes." It never entered into my head that anybody could be so content on this earth, as I am here. I wouldn't live anywhere else but in Rome, if you would give me the Gates of Paradise and all the Apostles thrown in. I can learn more and do more here, in one year, than I could in America in ten. America is a grand and glorious country in some respects, but this is a better place for an artist. . . .

**August 1854**
To Wayman Crow:

By this time Bessie S. is Mrs. R. You see, everybody is being married but myself. I am the only faithful worshipper of Celibacy, and her service becomes more fascinating the longer I remain in it. Even if so inclined, an artist has no business to marry. For a man, it may be well enough, but for a woman, on whom matrimonial duties and cares weigh more heavily, it is a moral wrong, I think, for she must either neglect her profession or her family, becoming neither a good and wise mother nor a good artist. My ambition is to become the latter, so I wage eternal feud with the consolidating knot. . . .

You ask if I have commissions. I have made several copies of the busts I have modelled, but hitherto have not been so desirous of making original things as of studying composition and modelling. I have been here less than three years, during which time I have not been idle, and have received the approbation of my master. Now I am ready to execute original works and shall be glad of any commissions for such. I shall have more to show in my studio this winter. Your figure [of *Oenone*], for instance, and a small figure I am modelling now. . .

**December 1858**
To Wayman Crow:

I wish you could raise your eyes from this paper and see what at this particular moment of writing I can see. It would be a huge, magnificent room, not in Mr. Gibson's studio, but close by, with a monstrous lump of clay, which will be, as Combe would have said, "when her system is sufficiently consolidated," *Zenobia*. The resources of my quondam studio being unequal to the demands upon it this year, I have been forced to seek more spacious quarters, and here I am ready to receive you in regal style.

So the *Beatrice Cenci* is finally at rest. I hope the light is good and that her critics will deal leniently with her. As mothers say, Beatrice has her good points and she has her faults. Nobody knows it better than the parent who brought

her forth, but I will leave it to others, to find out what they are.

**Lucerne, Switzerland, August 1859***
To Anna Jameson:

Just ten months ago this very day, as I find by the date of your letter lying now before me, you were good enough to write me the kindest of letters, containing a little criticism, more praise, and still more encouragement. . . . How far I have availed myself of these and what the result of ten months of study has been, you may already have an opportunity of judging for yourself, for before coming away from Rome I committed to the tender mercies of Mr. Boardman two photographs of different views of *Zenobia* and destined for you via Bessie and Princes St., so if you have not already received them they will soon be forthcoming and I shall leave them to speak for themselves: the only remark I have to make is that the round folds in the torso (thigh) do not please me and shall change them in plaster; they are harsh and jagged and must be made more *dolce*; as for the rest, though I wish them better, yet I don't see the way to make them so and as my master is content, I suppose I must be, finding encouragement in his verdict that I "have given some of the artists a twist." . . . So after all my doubts and queries, here is my daughter for what she is worth and what that is still remains to be seen. When the Prince of Wales was in Rome he bought your favorite *Puck* and asked me to enclose a photograph of *Zenobia* to show to the Queen which I have done accordingly. . . . Wouldn't it warm the cockles of my heart if she would take it into her royal head to have a copy! Well so much for art! . . . You give me a great deal of good advice regarding the myrmidons of the Caffè Greco, which I receive and remember. I think I do and have always attached to their kind insinuations all the weight they merit, which is none whatsoever. I mean to silence them, though not with my tongue in return, but with my fingers. I consider

*   Excerpted from Beatrice (Mrs. Steuart) Erskine, ed., *Anna Jameson:
    Letters and Friendships 1812-60,* London: T. Fisher Unwin, 1915,
    243-45. Reprinted by permission from Unwin Hyman Ltd.

their remarks, malicious and ungenerous as they are, the highest compliment they can bestow, because, if I were not a little in their way, they wouldn't give themselves the trouble to talk about me. That is my easy and contented way of viewing the matter. . . .

## Watertown, Massachusetts, June 1860*

To Committee—Messrs. J. B. Brant, Wayman Crow, M. L. Linton, M.D.:

I have had the honor to receive your letter of the 15th inst., informing me that the execution of the bronze statue in memory of the late Colonel [Thomas Hart] Benton, for the city of St. Louis, is entrusted to me. Such a tribute to his merit would demand the best acknowledgments of any artist, but in the present instance my most cordial thanks will but insufficiently convey to you a sense of the obligation under which I feel you have placed me.

I have reason to be grateful to you for this distinction, because I am a young artist, and though I may have given some evidence of skill in those of my statues which are now in your city, I could scarcely have hoped that their merit, whatever it may be, should have inspired the citizens of St. Louis to entrust me with a work whose chief characteristic must be the union of great intellectual power with manly strength.

But I have also reason to be grateful to you, because I am a woman, and knowing what barriers must in the outset oppose all womanly efforts, I am indebted to the chivalry of the West, which has first overleaped them. I am not unmindful of the kind indulgence with which my works have been received, but I have sometimes thought that the critics might be more courteous than just, remembering from what hand they proceeded. Your kindness will now afford me opportunity of proving to what rank I am entitled as an artist, unsheltered by the broad wings of compassion for the sex; for this work must be, as we understand the term, a manly work,

---

*   Excerpted from Cornelia Crow Carr, ed., *Harriet Hosmer: Letters and Memories*, New York: Moffat Yard, 1912, 362-63.

and hence its merit alone must be my defence against the attacks of those who stand ready to resist any encroachment upon their self-appropriated sphere.

I utter these sentiments only to assure you that I am fully aware of the important results which to me, as an artist, wait on the issue of my labours and hence that I shall spare no pains to produce a monument worthy of your city and worthy of the statesman. . . .

## Harriet Hosmer's *Zenobia* at Exhibition

In 1858, as she shipped her sculpture of *Beatrice Cenci* to St. Louis, Harriet Hosmer was already planning her next major work. According to her friend Lydia Maria Child, Hosmer's "whole soul was filled with Zenobia" and her notebooks were crowded with studies of the ancient queen of Palmyra who was defeated in battle by the Roman emperor (quoted Carr 1912, 192). Over the next few years, Hosmer talked with Anna Jameson and read ancient histories to determine the queen's pose and costume, and she moved to a new, larger studio to work on the full-scale model. In 1862 she sent the finished over-life-size marble to England's international exposition to be exhibited for the first time.

*Zenobia* was placed, along with John Gibson's controversial tinted *Venus* and several other sculptures, in a small octagonal "temple" lined with niches painted Pompeiian red at the center of the main exhibition hall. The response of the press was lukewarm. Several English critics ignored the figure altogether and devoted their attention to another figure of an ancient queen by another American—William Wetmore Story's *Cleopatra*. One writer for the *Art Journal* thought Hosmer among the best artists in the New World, but another writer for the same magazine dismissed her sculpture as "a figure of command with an elaborate cast of classical drapery" (Atkinson 1862, 320).

In the fall of 1863, a more serious criticism appeared in an article that was published simultaneously in the *Art Journal* and the *Queen*: an anonymous writer complained that the *Zenobia*, which was "said to be by Miss Hosmer, was really executed by an Italian workman in Rome" ("Alfred Gatley" 1863, 181). Hosmer had ignored such gossip in the past, but when the story appeared in print, she and Gibson responded with a lawsuit and the following letter to the *Art Journal*.

## Harriet Hosmer and John Gibson: Letter to the Editor of the *Art Journal* (1864)*

### January 1864

In the September number of the *Art Journal*, an article entitled "Mr. Alfred Gatley," contains a statement so highly injurious to myself as an artist, that I cannot allow it to pass unnoticed.

I have been for a long time aware of the report that I employ a professional modeler to model my statues; and while this report was circulated through private mediums, I treated it with the contempt and silence which I felt it deserved; but now that it has assumed the form of a serious charge in public print, silence on my part would be equivalent to an admission of its truth, and I therefore place you in possession of facts, which I beg you to insert in your columns.

All artists are well aware, but the public may be ignorant, of the fact, that when a statue is to be made, a small model is first prepared by the artist, and that the professional modeler then enlarges the model, by scale, to any size the sculptor may require. This was the practice constantly pursued by Canova, and by Thorwaldsen, and is still continued by Mr. Gibson, by Tenerani, and by most of the sculptors of the present day. The charge now brought against me is, that this professional modeler does all my work, and to refute that charge I here state, that after the statue of *Zenobia* was set up for me, from a small model, four feet high, which I had previously carefully studied, I worked with my own hands upon the full-sized clay model during a period of eight months, and therefore feel that if there is any merit in the figure, I may be entitled to at least a portion of it. Nor is this all; the man who undertook to prepare the work for me was not a professional modeler in clay, but one of the marble workmen in Mr. Gibson's studio.

For seven years I worked in Mr. Gibson's own studio, and I am authorized by him to state that during that time I had no more assistance in my work than every artist

---

*   Excerpted from Harriet Hosmer and John Gibson, "Correspondence: Miss Hosmer's *Zenobia*," *Art Journal*, January 1864, 27.

considers legitimate, nor, to use his own words, "would he have permitted me to send forth works from his studio which were not honestly my own."

We all know that few artists who have been in any degree successful enjoy the truly friendly regard of their professional brethren; but a *woman* artist, who has been honoured by frequent commissions, is an object of peculiar odium. . . .

Hosmer and Gibson settled for a printed retraction in the *Art Journal* and the *Queen*, and Hosmer wrote a long article for the *Atlantic Monthly* that explained the processes used by contemporary sculptors. *Zenobia* went on to the United States, where it was exhibited at private galleries in New York and Boston. Visitors flocked to see it—one Boston observer noted that "no single work of art ever attracted so much attention here" (quoted Carr 1912, 201-2). For American journalists, Hosmer's accomplishment was noteworthy both because she was an American and because she was a woman. The *New York Post* predicted that the work "would give new ideas as to woman's ability," and several newspapers quoted Hiram Powers' observation that "if it were the work of a man, it would be considered as more than clever, but as it is from the chisel of a woman, why it is an innovation" (quoted Waller 1983, 28). The following anonymous review from the *Atlantic Monthly* reflects the American confidence in Hosmer's work as a confirmation of the new world's artistic promise.

Hosmer, who said she didn't "approve of bloomerism and that view of woman's rights, but [did believe that] every woman should have the opportunity of cultivating her talents to the fullest extent . . . and those chances will be given first in America," could not have been surprised at the warm reception *Zenobia* received from her countrymen (quoted Carr 1912, 171-72).

### Anonymous, *The Atlantic Monthly*: ### Harriet Hosmer's *Zenobia* (1865)*

There now stands on exhibition in this country one of the finest examples of the spirit which animates our best

---

*   Excerpted from "Art: Harriet Hosmer's *Zenobia*," *The Atlantic Monthly*, February 1865, 248-50.

American artists in their selection of ideals, and their execution of them on the catholic principle.

Miss Hosmer has not thought it necessary to color her statue, because she knew that the utmost capability of sculpture is the expression of form—that, had she colored it, she would have brought it into competition with a Nature entirely beyond her in mere details, and made it a doll instead of a statue. Neither has she made it a travel-stained woman with a carpet-bag, because in history all mean details melt away, and we see its actors at great distances like the Athene, and because our whole idea of Zenobia is this:—

*A Queen Led in Chains.*

Neither has she made her Zenobia a Greek woman, because she was a Palmyrene. What she has made her is this:

*Our idea of Zenobia won from Romance and History.*

This Zenobia is a queen. She is proud as she was when she sat in pillared state, under gorgeous canopies, with a hundred slaves at her beck, and a devoted people within reach of her couriers. She does not tremble or swerve though she has her head down. That head is bowed only because she is a woman, and she will not give the look of love to the man who has forced her after him. Her lip has no weakness in it. She is a lady, and knows that there is something higher than joy or pain. Miss Hosmer has evidently believed nothing of the legends to the effect that she did swerve afterward, else she could not have put that noble soul in her heroine's mouth. . . .

As for the figure, none of those who from Roman studios have hitherto sent us their work have ever given a juster idea of their advancement in the understanding of the human anatomy. The bones of the right metatarsus show as they would under the flesh of a queenly foot. The right foot is the one flexed in Zenobia's walking, and that foot has never been used to support the weight of burdens; it has gone bare without being soiled. The shoulders perfectly carry the head, and no anatomist could suggest a place where they might be bent or erected in truer relative proportion to either of the feet. The dejection of the right arm is a wonderful

compromise between the valor of a queen who has fought her last and best, and the grief of a woman who has no further resource left to her womanliness. . . .

In many respects, we regard Miss Hosmer's *Zenobia* as one of the very highest honors paid by American Art to our earliest assertions of its dominant destiny.

# Henrietta Ward: Memories of Ninety Years (c. 1841-1924)

The only child of two artists, Henrietta Ward (1832-1924) was precocious, indulged, and encouraged to follow her family's profession. She received her first drawing lessons from her mother, Mary Webb, a miniaturist. She copied prints of the well-known animal paintings by her grandfather, James Ward. She went with her father, George Raphael Ward, a miniaturist and engraver, when he called on friends who included such artists as Edwin Landseer and Charles Leslie. Later she attended Henry Sass' school in Bloomsbury and, when she was old enough to work on her own, was given her own studio at home. By 1846, at the age of fourteen, she had exhibited a drawing at the Royal Academy.

Two years later, ignoring her parents' disapproval, she secretly married Edward Matthew Ward, who was also an artist but not, despite the name, a relation. Edward Ward was "a tall man, inclined to stoutness . . . indifferent to personal appearance, of a most genial and tender disposition, full of kindness, a good mimic, and a most amusing companion," who shared Henrietta's love of music as well as art (Redgrave and Redgrave 1981, 474). The marriage—although Mary Webb Ward never reconciled herself to it—was a success.

Henrietta Ward devoted as much time to her studio as to their household. Edward had given Henrietta drawing lessons before their marriage, and he encouraged her to continue working after. The first oil painting she sent to the Royal Academy, *Results of Antwerp Marketing*, was based on a sketch completed on their honeymoon. After their return to England, Henrietta continued to study for several years at Sass' and then attended the Royal Academy lectures on anatomy—despite the disapproval of Academicians. When she became a mother—the Wards had eight children—Henrietta simply adapted the family's routine to the

demands of her studio. Her paint became her childrens' toys; they served as her models. Three of the Wards' daughters and their eldest son became artists.

By the late 1850s, Henrietta regularly exhibited genre and historical drama paintings at the Royal Academy. In addition, she sent smaller or previously exhibited works to the Society of Female Artists or provincial exhibitions. Many of her paintings had a domestic emphasis, and in depictions of the lives of highborn and famous, like Mary, Queen of Scots, her concentration on touching incidents won her a substantial success. Her work convinced some observers of "the justice and necessity of admitting female artists within the ranks of members of the Royal Academy," but Henrietta had to content herself with seeing Edward elected in 1857 (quoted Nunn 1978, 300).

If the Academy did not honor Henrietta Ward, Queen Victoria did. The Wards' association with the Royal Family began in 1854, when Edward was asked to contribute to the decoration of the new Houses of Parliament. Queen Victoria and Prince Albert, who made studio visits to all the participating artists, came to know both Wards and appreciate their work. Victoria not only gave Henrietta several commissions for portraits of her children, but showed the painter her own sketchbook.

After Edward's death in 1879, Henrietta established a drawing school for young women. Her students were not aspiring artists, but wealthy amateurs; her respectable status and royal friendships assured her of numerous applicants and a secure livelihood. She continued to work in the studio, exhibiting landscape paintings at the Royal Academy as late as 1921 and 1923, and completed her memoirs, which were first published in 1924.

## Childhood*

With such an artistic record as my family possessed, it would have been strange if I had not inherited a love of art; my mother taught me drawing, but no one encouraged me so much to develop my gift as my old grandfather, James Ward, R.A., who used to come every day to see me, his favorite grandchild. He watched over my budding intelligence,

---

* Excerpted from Henrietta Mary Ada Ward, *Memories of Ninety Years,* New York: Henry Holt and Co., 1925, 22, 32-34, 41, 52-53, 58-59, 119, 121, 124-26. First published London: Hutchinson and Co., 1924.

fortified and directed me towards an artistic goal, and I always regarded him as the first influence I had in shaping my career. I could draw and paint before I could read. My father used to cut out pictures from periodicals and bring them to me to color, and one day in 1841 he threw over to me the first number of *Punch*, with the suggestion that I should paint the pictures throughout. I greatly enjoyed doing it, and only wish that I had kept that first number. . . .

Edward Matthew Ward lived with his father and mother in an adjoining street to Fitzroy Square, and the postman unconsciously played the part of Cupid in the romance of my life by leaving Edward's letters at our house and vice versa. At last my father decided to call on the man with the same name as ours to make some arrangement to avoid a series of irritating blunders. I recall the incident, because, for once, he refused to take me with him, and being a very spoilt child I literally screamed the house down with disappointment. On his return, after a long time, he told us that Edward Ward was a handsome and accomplished young man, a rising genius, and that he had greatly enjoyed his conversation. . . . Edward returned his call, and I, a child of eleven or ten, took a great fancy to him at once. . . .

Finding that I was interested in Art, Edward Ward became my critic, my drawings were shown, and he even gave me many valuable casts to help me in my studies. He taught me much that was helpful in drawing, and we soon became fast friends. My mother seeing my attachment to him, little dreaming of what the future would bring forth, used to say that if I did my lessons well she would ask him to spend the evening in our house. Thus time went on, and when Edward wanted me to pose as a model for his picture *Temptation* I was taken to his house, where I would stand most patiently holding a basket of fruit, whilst Edward painted as if his life depended on it, and threw himself so entirely into his work that he became oblivious of all else. At first I wondered why he never offered me one of those delicious pears or some grapes, but his mother was very fond of me, and used to give me a selection to choose from when the sitting ended. . . .

I worked very hard, beginning each day at six in the

morning, every hour being mapped out till afternoon, when Edward would arrive to criticize my work and set me fresh tasks. Black-and-white work used to be accepted at the Royal Academy, and to my joy and pride I found my picture *Elizabeth Woodville Parting from the Duke of York* had actually secured a place, in 1846, when I was only fourteen. The next year two studies of still-life were accepted and hung, but I fully realized that I was indebted very largely to Edward Ward for this honour, seeing that it was due to his sound teaching. . . .

## Marriage

[After our marriage in 1848] Edward and I settled down to our home life very quickly; he had missed his mother very much, and was delighted to have a home of his own. I understood the artistic temperament, and I don't think there were two happier persons in the whole kingdom than my husband and myself. The joy of following a profession entirely to one's satisfaction is a privilege known only to a few. Art never bores, but offers always fresh vistas of delight and fascination. My husband was a rising man, broad-minded enough to take pleasure in the fact that I too was an artist. I worked on my own lines, but found him always the kindest teacher, the most unfailing friend I have ever known. . . .

We often entertained in those early days of married life, and saw a great deal of the Collins family, who lived, as far as I can recollect, in Dorset Square, near us. Mrs. Collins was the widow of William Collins, R.A. Her son Wilkie was a writer of great fame, and Charles inherited his father's gifts, and was one of the first members of the Pre-Raphaelite Brotherhood. . . .

Later [after our children were born] I received a lecture from old Mrs. Collins on my maternal duties, which I was foolish enough to take to heart for a time. She told me I was very wrong not to make my child's clothes and give all my time to domestic matters, and that if I did my duty to my husband and home there would be no time left to paint. I listened to her, and said: "If you think so, I will do it for a year." And a very miserable time it proved to be without my art. At the end of the year my husband insisted on my taking

apartments in Bloomsbury to be close to the Art School, as we then lived at Slough, and he came up to town each week from Saturday to Monday, and so I studied anatomy and drawing for six months assiduously. How I enjoyed it! Soon after this, I exhibited two pictures at the Royal Academy, *The Pet Hawk* and *Rowena,* and the following year, 1852, *The Antwerp Market,* [my son] Leslie being my model for the baby. . . .

## Study and Work

The Royal Academy lectures for students have always been held in high esteem, but women were disqualified on account of their sex when I was young. Edward, ever mindful of my success and anxious that I should share his privileges, encouraged me to be a pioneer in breaking through a hard and fast convention, but he warned me that I should be separated from him, as he had his place among the Royal Academicians. It was distinctly an ordeal to find myself the only woman present, but I enjoyed the first lecture so much that I determined to go regularly, in spite of very determined opposition from Mr. Jones, R.A., who was Keeper of the Royal Academy Schools. With an utter absence of chivalry, he actually convened a special meeting to exclude women, and me incidentally.

He was not successful, however, and the next lecture I attended had five women present, and the following one had thirty of the fair sex. After this triumph I went regularly and gained great advantages. Jones and his followers were nonplussed; they had hoped for a whole-hearted resistance against the encroachments of women in the field of art, and they found only the reverse. There was a St. Paul-like feeling about women's achievements at the Royal Academy. Miss Starr, who afterwards became Mme. Cunziani, was exceedingly talented, and she made a design signed with her initials; the voting was unanimous, and she gained the highest honor to a woman, and since it may appear in present times that they should not have thought it probable, it must be remembered that woman was almost unknown in the artistic profession. Personally, I feel that the R.A.-ship should be open to women equally with men, for there is no sex in Art,

and it is pure selfishness that has excluded women from this honour, with the exception of Mary Moser and Angelica Kauffmann. . . .

A picture I painted, exhibited in 1866, was one of the most popular, and certainly one of my best efforts—*Palissy the Potter*. Palissy was a French potter who was so keen an artist that he plunged his family into abject poverty in trying to discover the secret of a certain kind of china called "Majolica." He was in sight of success, for which he and his wife had waited many months, when the furnace, which had been lighted, ceased to work, and the result of all his toil and genius showed deformed pieces of clay, quite valueless.

In my picture the unhappy potter is gazing at his ruined works on the floor, whilst his daughter tries to comfort him. His wife is angrily glaring at him, and his children look on in wonder. It was sold at the Academy exhibition, and . . . the Leicester Art Gallery bought it on the death of the purchaser. . . .

Mrs. Fry, the great Quaker philanthropist, accomplished her life's work before my time, but her fame was still ringing when I was young. I was impressed by her mission of mercy to unfortunates, and I painted a picture called *Mrs. Fry Visiting Newgate, 1818*.

Prison life today is a very different thing from what it was in 1818. Sad and grim and severe it must always be, or it would fail as a deterrent to criminals. But in 1818 it presented an aspect which was nothing short of terrible. People were herded together under dreadfully insanitary conditions, irrespective of the different degrees of crime—in fact, many who were merely the innocent victims of circumstances were there, and many who had never deserved such a cruel fate.

All these facts crowded into my mind and induced me to depict as realistic a presentment as I could gather. Mrs. Fry was the forerunner of the woman of today who champions liberty and hope for herself and for everyone. She ran the gauntlet of much criticism, and received scant praise at the time for her merciful actions. She was a woman of strong principles, possessing a fine brain, a great heart, with the independence of mind that ignores all opinions. . . .

In my young days most people would have agreed with

Mrs. Collins that a wife and mother had no right to be a practitioner in paint, and I think in most households it would have been rendered impossible by the husband's and relations' combined antagonism to the idea. Edward was greatly in advance of his age in broadmindedness, and this fact spurred me on to success. My work required great concentration, and orders were strictly enforced that I was not to be disturbed during certain hours of the day. And Edward observed the rule, being also immersed in his own artistic problems quite to the exclusion of the whole world. But there were exceptions: I was occasionally confronted by an alarmed servant coming to tell me of a domestic tragedy; some knotty point that could only be solved by the mistress of the house. . . .

My husband was always a strenuous worker, and a long day's work had been completed before he allowed himself the necessary recreation at the close of the day. He would be in his studio at 6 A.M., where he would concentrate so fully on what he was engaged upon as to forget everything else. At half-past eight we breakfasted, after which he scanned the newspaper, whilst I went to the kitchen and nursery in turn before settling down to my painting till lunch, which used to be served in our respective studios. After the children's dinner in the nursery Edward would spend half an hour playing with them, and when I went in I would find him drawing pictures for their amusement or playing bears. Great would have been their grief if he had failed to appear, as it was their great time.

To encourage them in a love of art I used to allow my two elder daughters to paint on the lower corners of my canvas, and the three of us would solemnly and silently work away on my picture for the next Academy. Then, as my work grew, theirs had to disappear, but they felt very important while doing it, and as they grew older I provided them with canvas and easels, with the result that both exhibited later at the Royal Academy.

I had one tragic result through allowing my children in my studio. I was painting a picture called *The Birthday*, and Enid, then two and a half, was the model catching hold of a box of sweets lying on a table, on which was also the

"birthday present." I crossed the studio to look out of the window, hearing a carriage drive up, and on my return to my easel found, to my dismay, that she had industriously removed all my painting, having vigorously rubbed it all over with a paint rag, besides having decorated herself and her pinafore very thoroughly in her efforts. . . .

# Frances Power Cobbe: On Women's Creative Artistic Power (1862)

The lives and works of Harriet Hosmer and Rosa Bonheur were very different from what was expected of women artists at the middle of the century. Their paintings and sculpture were ambitious in scale, more serious than sentimental, and directed as much to a public as to a private audience. They did not marry. In the studio, their dress was determined by efficiency and comfort, rather than fashion. To many critics and journalists, they seemed more masculine than feminine. In 1855, French art critic Théophile Gautier observed that with Bonheur "there is no need to be gallant; she pursues art seriously and one can treat her as one would treat a man. For her, painting is not a kind of *petit point* embroidery" (quoted Boime 1981, 384). An anonymous reporter for the *New York Times* described Hosmer during her 1858 trip to the United States: "Her style of dress is slightly on the masculine order, but neat and peculiarly in keeping with her profession. In manner and conversation she is the furthest possible removed from the conventional fine lady, yet neither is she coarse nor unwomanly" ("Harriet Hosmer: Personal Sketch" 1858, 2).

The ambition, the independence—and the success—of these two artists was not lost on other women, particularly those concerned with what was beginning to be known as "the woman question." As a journalist, Lydia Maria Child was known for her unqualified commitment to the abolition of slavery, but she had also written *A Brief History of the Condition of Women in Various Ages and Nations* (1835). As a friend of the Hosmer family, she had watched Harriet Hosmer grow up and was encouraged by the young artist's ambitions: "Here was a woman, who, at the very outset of her life, refused to have her feet cramped by the little Chinese shoes, which society places on us all, and then misnames our feeble tottering feminine grace. If she walked forward with vigorous freedom, and kept her balance in slippery places, she

would do much toward putting those crippling little shoes out of fashion" (Child 1858, 697).

Frances Power Cobbe (1822-1904) voiced similar hopes. The daughter of strict Evangelical Protestants, she was educated at home before being sent for two years to a fashionable girl's school in Brighton. Frustrated by the school's emphasis on accomplishments rather than learning, she returned home and educated herself, reading widely and studying Greek and geometry with a clergyman. At her father's death in 1856, Cobbe inherited an income of £200 a year and the independence to devote herself to writing, travel, and social reform. She visited Italy and Greece and became the Italian correspondent for the *London Daily News*. She worked to improve the care of the incurably sick and insane, supported Mary Carpenter's "ragged schools" for the children of poor urban families, and was an ardent anti-vivisectionist. In the 1850s she had joined Barbara Leigh Smith's campaign to reform the married women's property laws.

By the 1860s Cobbe's lectures and articles advocated admitting women to universities and extending the franchise to them. "What Shall We Do with Our Old Maids?" appeared in the liberal *Fraser's Magazine* in November 1862 and addressed reforms in women's education. If Cobbe believed that the female character was inherently different from that of the male, she also believed that for those individual women for whom "the pursuit of the True and the Beautiful" was a real passion, educational opportunities should be available. In support of her arguments, she turned to the example set by contemporary women: the careers of Rosa Bonheur and Harriet Hosmer established for Cobbe that women artists were indeed capable of success within the terms set by established institutions.

**Till of very late years it was,** we think, perfectly justifiable to doubt the possibility of women possessing any creative artistic power.* Receptive faculties they have always had, ready and vivid perception of the beautiful in both nature and art, delicate discrimination and refined taste, nay,

---

\*   Excerpted from Frances Power Cobbe, "What Shall We Do with Our Old Maids?" *Fraser's Magazine* 66 (November 1862), 594-610. Reprinted in Candida Ann Lacey, ed., *Barbara Leigh Smith Bodichon and the Langham Place Group,* New York and London: Routledge and Kegan Paul, 1986, 365-70.

the power (especially in music and drama) of reproducing
what the genius of man had created. But to originate any
work of even second-rate merit was what no woman had
done. Sappho was a mere name, and between her and even
such a feeble poetess as Mrs. Hemans, there was hardly
another to fill up the gap of the whole cycle of history. No
woman has written the epics, nor the dramas, nay, nor even
the national songs of her country, if we may not except
Miriam's and Deborah's chants of victory. In music, nothing.
In architecture, nothing. In sculpture, nothing. In painting,
an Elisabetta Sirani, a Rosalba, an Angelica Kauffmann—
hardly exceptions enough to prove the rule. Such works as
women did accomplish were all stamped with the same
impress of feebleness and prettiness. As Mrs. Hemans and
Joanna Baillie and Mrs. [Mary] Tighe wrote poetry, so
Angelica Kauffmann painted pictures, and other ladies
composed washy music and Minerva-press romances. If
Tennyson had spoken of woman's *Art*, instead of woman's
passions, he would have been as right for the one as he was
wrong as regards the other. It *was*

> As moonlight is to sunlight
> And as water is to wine.

To coin an epithet from a good type of the school—it was all
"Angelical," no flesh and blood at all, but super-refined
sentiments and super-elongated limbs.

But there seem symptoms extant that this state of things
is to undergo a change, and the works of women become
remarkable for other things beside softness and weakness. It
may be a mere chance conjunction, but it is at least
remarkable, that the same age has given us in the three
greatest departments of art—poetry, painting, and sculp-
ture—women who, whatever their faults or merits, are
pre-eminently distinguished for one quality above all oth-
ers—namely, strength. [Elizabeth Barrett Browning's] *Au-
rora Leigh* is perhaps the least "Angelical" poem in the
language, and bears the relation to *Psyche* that a chiselled
steel corselet does to a silk bodice with lace trimmings. The
very hardness of its rhythm, its sturdy wrestlings and
grapplings, one after another, with all the sternest problems

of our social life—its forked-lightning revelations of charac-
ter—and finally, the storm of glorified passion with which it
closes in darkness (like nothing else we ever read since the
mountain-tempest scene in *Childe Harold*)—all this takes us
miles away from the received notion of a woman's poetry.

And for painting, let us look at Rosa Bonheur's canvas.
Those droves of wild Highland black cattle, those teams of
tramping Norman horses—do they belong to the same school
of female art as all the washed-out saints, and pensive ladies,
and graceful bouquets of Mesdemoiselles and Signorine
Rosee, and Rosalba, and [Maria Elena] Panzacchi, and
[Maria de] Grebber, and [Maria Sibylla] Mérian, and
Kauffmann? We seem to have passed a frontier, and entered
a new realm wherein Rosa Bonheurs are to be found.

Then for Sculpture. Will woman's genius ever triumph
here? We confess we look to this point as to the touchstone
of the whole question. Sculpture is in many respects at once
the noblest art and the one which tasks highest both creative
power and scientific skill. A really good and great statue is an
achievement to which there must contribute more elements
of power and patience than in almost any other human work,
and it is, when perfected one of the most sublime. . . . If she
succeed here, if a school of real sculptresses ever arise, then
we think that in effect the problem is solved. The greater
includes the less. They may still fall below male composers in
music, though we have seen some (inedited) music of
wonderful power from a female hand. They may produce no
great drama—perhaps no great historical picture. Yet if
really good statues come from their studios, statues showing
at once a power of conception and science of execution, then
we say, women can be artists. It is no longer a question of
whether the creative faculty be granted to them.

Now we venture to believe that there are distinct tokens
that this solution is really to be given to the problem. For
long centuries women never seem to have attempted
sculpture at all: perhaps because it was then customary for
the artist to perform much of the mechanical labor of the
marble-cutter himself; perhaps because women could rarely
command either the large outlay or the anatomical instruc-
tions. But in our time things are changed. The Princesse

Marie d'Orléans, in her well-known *Joan of Arc*, accomplished a really noble work of sculpture. Others have followed and are following her path, but most marked of all by power and skill comes Harriet Hosmer, whose *Zenobia* (now standing in the International Exhibition, in the same temple with Gibson's *Venus*) is a definite proof that a woman can make a statue of the very highest order. Whether we consider the noble conception of this majestic figure, or the science displayed in every part of it, from the perfect pose and accurate anatomy, to the admirable truth and finish of the drapery, we are equally satisfied. Here is what we wanted. A woman—aye, a woman with all the charms of youthful womanhood—can be a sculptor, and a great one.

Now we have arrived at a conclusion worthy of some little attention. Women a few years ago could only show a few weak and washy female poets and painters, and no sculptors at all. They can now boast of such true and powerful artists in these lines as Mrs. Browning, Rosa Bonheur, and Harriet Hosmer. What account can we give of the rise of such a new constellation? We confess ourselves unable to offer any solution, save that proposed by a gifted lady to whom we propounded our query. Female artists hitherto always started on a wrong track; being persuaded beforehand that they ought only to compose sweet verses and soft pictures, they set themselves to make them accordingly, and left us Mrs. Hemans' *Works* and Angelica's paintings. *Now*, women who possess any real genius, apply it to the creation of what they (and not society for them) really admire. A woman naturally admires power, force, grandeur. It is these qualities, then, which we shall see more and more appearing as the spontaneous genius of woman asserts herself.

We know not how this may be. It is at all events a curious speculation. One remark we must make before leaving this subject. This new element of *strength* in female art seems to impress spectators very differently. It cannot be concealed that while all true artists recognize it with delight, there is no inconsiderable number of men to whom it is obviously distasteful, and who turn away more or less decidedly in feeling from the display of this or any other

power in women, exercised never so inoffensively. There is a feeling (tacit or expressed) "Yes, it is very clever, but somehow it is not quite feminine." Now we do not wish to use sarcastic words about sentiments of this kind, or demonstrate all their unworthiness and ungenerousness. We would rather make an appeal to a better judgment, and entreat for a resolute stop to expressions ever so remotely founded on them. The origin of them all has perhaps been the old error that clipping and fettering every faculty of body and mind was the sole method of making a woman—that as the Chinese make a lady's foot, so we should make a lady's mind; and that, in a word, the old alehouse sign was not so far wrong in depicting "The Good Woman" as a woman without any head whatsoever. Earnestly would we enforce the opposite doctrine, that as God means a woman to *be* a woman and not a man, every faculty he has given her is a woman's faculty, and the more each of them can be drawn out, trained, and perfected, the more *womanly* she will become. She will be a larger, richer, nobler woman for art, for learning, for every grace and gift she can acquire. It must indeed be a mean and miserable man who would prefer that a woman's nature should be pinched, and starved, and dwarfed to keep on his level, rather than be nurtured and trained to its loftiest capacity, to meet worthily his highest also.

That we quit the subject of woman's pursuit of the Beautiful, rejoicing in the new promise of its success, and wishing all prosperity to the efforts to afford female students of art that sound and solid training, the lack of which has been their greatest stumbling block hitherto. The School of Art and Design in London is a good augury with its eight hundred and sixty-three lady pupils!

# V. WOMEN AND THE DECORATIVE ARTS

In 1829 it seemed to Thomas Carlyle that society was being transformed by what he called "the machine age":

> On every hand the living artisan is driven from his workshop, to make room for a speedier inanimate one. The shuttle drops from the fingers of the weaver and falls into iron fingers that ply it faster. For all earthly, and some unearthly purpose, we have machines and mechanical furtherances. (quoted Callen 1979, 2)

In Europe and America the process of mechanization was shifting the kind of work done by women—their paid and unpaid contributions to household economy—and women who were skilled in the decorative arts were among those profoundly affected. Those whose specialized skills catered to a small, luxury market were least affected initially. Others—particularly those who worked in the textile industries—saw skilled crafts broken down into semi- or unskilled components. Lacemaking, weaving, and other cottage industries were moved to factories or turned into "slop trades."

For many working-class women the changes meant laboring long hours in harsh conditions for minimal wages. In France the *Journal des demoiselles* described the sweated labor of a laceworker: "Without raising her head from her work, thirteen hours of work a day allowed her . . . to obtain bread and charcoal for herself and her child" (quoted Moses 1984, 25). Reformers worried that working-class women, whether they were employed in factories, did "outwork" at home, or turned to prostitution to supplement low wages, were being forced to forsake woman's "natural sphere"—domestic work.

For middle-class women, the gradual separation of home from workplace meant that single women who could not rely on male protection had fewer ways to earn a livelihood and maintain their genteel status. Most widows or spinsters turned to teaching and sewing, which afforded them only a marginal existence.

Reformers worried that the single middle-class woman was becoming, as the English put it, "redundant."

In this context the decorative arts seemed to offer women needed opportunities. Unlike painting or sculpture, designing textiles or ceramics did not require study from the nude model, and feminine modesty was protected. In many cases the products were destined for use in the home, so the link between femininity and domesticity was respected. Schools were established to teach women the skills demanded by new production methods. One of the earliest was the Ecole Gratuite de Dessin pour les Jeunes Filles, established in Paris in 1803 to train young girls from poor families in fabric and wallpaper design, lacemaking, flowermaking, and "all the arts and trades that demanded neither bodily strength nor a public display of their persons" (quoted Yeldham 1984, 1:42). Similar schools were founded in England and the United States, where classes in wood engraving, china painting, illustration, and pattern design attracted middle-class students. Graduates of these schools often met with hostility, however, when they tried to find employment: men already employed in the industries feared that women would work for lower wages and take their jobs.

English and American women's opportunities improved with the rise of the Arts and Crafts Movement after the middle of the century. Although William Morris was not directly concerned with women's particular needs, his belief that "as a condition of life, production by machinery is altogether an evil" contributed to a new appreciation for traditional feminine skills (quoted Pevsner 1968, 21). The demand for the work of artist-craftsmen which was stimulated by Morris and his followers enabled many women to earn a livelihood and enabled a few women to become well known as ceramists or textile designers.

# Anonymous [Henry Cole]: Wood Engraving as an Occupation for Gentlewomen (1838)

According to England's census figures, the Napoleonic Wars had left the country's population with a disproportionately high number of women. In the following decades, as young men emigrated to the colonies or simply chose to remain bachelors, the number of "redundant" or "surplus" women grew: by 1851 thirty percent of all English women between the ages of 20 and 40 were unmarried. The socially acceptable role for the middle-class spinster was to become a governess, who remained in the privacy of a home,

even if it wasn't her own, as she attended to another woman's children. It was by no means a comfortable life: the pay was usually low and the conditions often humiliating. Nevertheless, by the 1840s there were far more applicants than positions. Reformers searching for alternatives looked to the artistic skills that already formed a part of many middle-class women's accomplishments.

Wood engraving, which was becoming the most common medium for illustrating books, magazines, and newspapers, seemed to offer new opportunities for women. Three of engraver William Byrne's daughters—Elizabeth, Letitia, and Anne Francis— were already known not only for the watercolors they exhibited at the Royal Academy and Old Watercolour Society, but also for their engraved book illustrations. Metal engravings were exacting to execute and expensive to print, but wooden blocks were easier to work and wood engravings could be printed easily by steam-powered presses. Because the wood engraver usually copied onto wooden blocks drawings that were provided by other artists, the training was more technical than creative. M. S. R. (Maria Susan Rye?) noted with irony in the *English Woman's Journal* that it was well within what were considered to be women's capabilities: "Woodengraving requires no artistic skill; it is simply a matter of patience and perseverance, and everyone knows that women are not as a body deficient in these two qualities" (M. S. R. 1858, 175).

Woodengraving was first recommended to women in the August 1838 issue of the *Westminster Review*. "Modern Wood Engraving" was published anonymously, but many years later Henry Cole (1808-1882), who had been introduced to wood engraving when he served on a committee working to improve the postal system, took credit for the ideas it contained. An energetic reformer, Cole did not make his recommendation idly: in 1841 when he published the first of a series of guidebooks to English monuments, *A Handbook for the Architecture, Sculpture, Tombs and Decorations of Westminster Abbey*, under the pseudonym Felix Summerly, the volume included "fifty-six embellishments on wood engraved by ladies" (quoted D. 1842, 216). According to Cole, the women who engraved David Cox's drawings—Laura and Charlotte Bond, İsabel and Augusta Thompson, Anne Water-house, Harriet Clarke, and Juliet Dudley—had turned to wood engraving as a direct result of his suggestion. Wood engraving was also incorporated into the curriculum of the Female Class of the School of Design when it was established in the following decade, despite the protests of established wood engravers who

considered the course was "a violation of the principles of free trade" ("Our Weekly Gossip" 1843, 1048).

The demands of engraving plates for newspapers and weekly journals made large workshops and long hours a necessity, however, and the number of English women who actually found employment as wood engravers was probably limited. The census of 1851 listed 327 women employed "about pictures and engravings," but this number probably included the many women who hand-colored prints; the census of 1871 listed only 40 female engravers. The foremost reproductive wood engravers in England at mid-century were the Dalziel brothers, whose firm was established in 1839. The four brothers were in 1851 joined by their sister, Margaret, a spinster who worked with the firm for the rest of her life and was remembered by George Dalziel as "the essence of kindness and generosity, a sister-mother to us all" (Dalziel 1901, 19). The pupils and apprentices she mothered, however, were all male.

**To that large portion of educated gentlewomen** of the middle classes who now earn a subsistence chiefly as governesses, we wished to point out this art as an honourable, elegant, and lucrative employment, easily acquired, and every way becoming their sex and habits.* We have already done honour to the exquisite delicacy and elegance of the engravings of Mary Ann Williams; we venture to say that few women of taste, whatever their rank in life, can look on *Le Jardin du Paria au Levée de l'Aurore* without envying the artist her power of producing a scene so beautiful, and of exciting in thousands the pleasing emotions inseparable from it. Apart from all pecuniary considerations, to be able to do it is an elegant accomplishment, and the study of the principles and details of taste which it implies, is a cultivating and refining process to every mind. All that can be taught of the art may be learnt in a few lessons, and thus an acquirement made, which will afford no slight protection against misfortune to which, in this commercial country, even the richest are exposed—and a

---

\* Excerpted from [Henry Cole,] "Modern Wood Engraving," *The Westminster Review* 7/29 (August 1838), 265-78.

means of livelihood obtained, which, without severing from home, without breaking up family assemblies, is at once more happy, healthy, tasteful, and profitable than almost any other of the pursuits at present practised by women. The lady we have named is not alone in the practice of this art: we might name also Eliza Thompson, and Mary and Elizabeth Clint, who have furnished excellent engravings for the *Paul et Virginie*; and we have heard of several daughters of professional and mercantile men, not likely to be dependent on their own exertions for support, who have wisely, by learning this art, acquired both an accomplishment and a profession. The occupations, we may also add, are few indeed to which gentlewomen of this class can more worthily devote themselves than to an art which peculiarly aims and is peculiarly fitted to enhance the enjoyments and refinements of the people, by scattering through all the homes of the land the most beautiful delineations of scenery, of historic incidents, and of distinguished persons.

# Fanny McIan: Report to the Council of the Government School of Design on Visits to Paris and Staffordshire Potteries (1845)

In 1842 England's School of Design, which had been established five years earlier to train designers for British manufacturers, introduced a class for women. The school's Council hoped that female students would learn skills that would enable them to become self-supporting. It set aside space on the third floor of its Somerset House quarters for classrooms and appointed Fanny McIan, who was well known as a private drawing instructor and an exhibitor at the Royal Academy, as instructor.

There were immediate objections. When a class in woodengraving was introduced, wood engravers feared that women graduates would take their jobs. Others, as Anna Jameson remembered a few years later, were concerned for the students' morals: "One would have thought that half of London was to be demoralised because a class of thirty or fifty girls were taught to use a lead pencil under the same roof with a class of boys, though the two schools were separated by three stories" (Jameson 1846, 150). Nevertheless, by 1845 the Female School of Design had

over fifty students who met weekday mornings from eleven until two, and twenty to thirty applicants were turned away each semester for lack of room.

Searching for appropriate fields for her students, Fanny McIan turned to porcelain painting. The report she submitted to the Council of the School of Design in 1845 describes her visits to the potteries of France and England. For some time, women had worked in the porcelain works sponsored by the French government at Sèvres. In the late eighteenth century, quite a few women—usually from families of artisans long associated with Sèvres—worked as flower painters. Although their numbers had dropped in the nineteenth century, several women—notably Marie Victoire Jaquotot—had established reputations by exhibiting decorated porcelain at the Salon. In England, McIan found a very different situation. The Cambrian and Glamorgan potteries of Swansea, Wales—which McIan did not visit—regularly employed women as decorators, but in most potteries women were restricted to the simplest tasks. As a result of Fanny McIan's initiative, porcelain decoration was introduced to the curriculum at the Female School and into women's classes at the provincial "branch" schools of the School of Design.

By 1850 students in the Female School were selling designs for wallpapers, carpets and fabrics to manufacturers, and the program was noted in the French press and imitated in America. In 1844 Sarah Worthington King Peter founded the Philadelphia School of Design for Women—which later became Moore College of Art—to educate women in pattern making, lithography, and wood engraving. The New York School of Design for Women—which was later incorporated into the Cooper Union—was founded in 1852 and after a few years had fifty-odd students, "some learning to draw, some learning to engrave, and others practising the art of wood-engraving" ("New York School of Design for Women" 1856, 123).

**Having been taught to advert to France** as the great School of Ornamental Art, and being desirous to render myself more competent to give instructions in the Female School of Design, in order to carry out fully the intentions of the Council in establishing it, I visited, during the summer vacation of 1843, the institutions and manufactories in Paris, with the view of acquiring, by personal inspection of processes and productions of Ornamental Art, such informa-

tion as might be serviceable in promoting this object: and porcelain painting being a branch of art enumerated in the prospectus, as affording an employment especially adapted to females, and one for instruction in which applications had been made by several of my pupils, I was particularly anxious to obtain such a knowledge of it as would fully qualify me to direct the exercises of a class for this purpose.* I therefore obtained an introduction to M. Robert, the chief conductor of the porcelain manufactory at Sèvres, and by his permission every part of that celebrated establishment was shown to me. I saw the artists at work, observed their methods of using colours, and obtained a knowledge of their technical means of proceeding, and of the media which they employ in the process. The result of my observations at that time, was a conviction that I could readily learn this art, and could easily teach it. With this impression, I again visited Paris in the course of the last vacation, and having placed myself under the instruction of Madame [Clémence] Turgan, one of the principal *artistes* engaged in the porcelain manufacture at Sèvres, I assiduously painted daily under her direction during the period of my visit, and copied on porcelain an original picture of my own.

On my return from Paris, I proceeded at once to, and remained some time in, Staffordshire, in order to visit the district of the Potteries, and by carefully examining the work of our best English porcelain painters, to be enabled to form a just estimate of their productions, compared with those of the artists of France. For the prosecution of this object, I obtained introduction to some of the principal manufacturers, and was shown whatever related to my inquiries in the several large establishments of the Messrs. Wedgwoods, Copeland, Minton, Ridgeway, and others. The effect of this comparison of the finest examples of the art in France and England, was an impression by no means unfavorable to English ability; so that with regard, at least, to this branch of

---

* Excerpted from Fanny McIan, "On Porcelain Painting: Report to the Council of the Government School of Design, of Proceedings and Observations of Mrs. McIan during Visits to Paris and Staffordshire Potteries," *The Athenaeum*, no. 906 (8 March 1845), 249-50.

ornamental art, I am happy to feel warranted in dissenting from those who indiscriminately decry the productions of British art. At Messrs. Copeland's manufactory, I saw specimens of flower painting in porcelain by an English artist which I have no hesitation in declaring to be in every respect equal to the best productions of M. Jacobert, one of the best artists in this department at Sèvres, where flower painting is most admirably executed. . . . As to the question of originality of Design in this department of painting, I may state, with regard as well to the French as English artists engaged in it—the remark being applicable to each—that, with the exception of flowers and miniatures, no original pictures are introduced; the artistical labour consisting merely in a continual process of copying.

In visiting the manufactories of the Staffordshire potteries, I was much gratified to find employment afforded to numerous females, although they perform merely the inferior kinds of work. Indeed, it is only the cheapest and commonest description of wares that can be committed to their hands; for, as they do not possess the slightest knowledge of drawing, their work consists simply in filling up with certain colours, according to a given pattern, certain spaces formed by outlines which are previously painted on the wares. They are thus confined to the mere mechanical labour of an art in which excellence in its highest department is undoubtedly fully as much attainable by women as by men. In this country, unfortunately, the employments obtainable by females are very limited in number and variety, so that it becomes highly desirable not only to provide the means of developing and cultivating talent in females, but to increase the number of subjects, to which such ability, when so cultivated, may with propriety and profit be applied. To this class of subjects belong with peculiar fitness, not only the arts of painting on porcelain and glass, but those of designing for every branch of our pottery manufactures: and with respect to the practicability and expediency of at once acting on these considerations, I would state that I have been assured by the chief artists of one of the principal porcelain establishments in Staffordshire, that if, in the Female School at Somerset House a class were formed for studying the art of painting

porcelain in a superior manner, the more skillful pupils might
readily obtain from the manufacturers transmissions of work
to be executed at home; so that without any injurious
interference with the uneducated female artists, or rather
artisans, in the Potteries, a constant and beneficial employ-
ment might be procured.

# Léon Lagrange: On Woman's Position in the Fine Arts (1860)

Although French feminists were active during the Revolution of
1848, in the following years the government of the Second Empire
restricted their activities. Feminist leaders went into exile, and
women's participation in the press and political clubs was
curtailed. Even critics of the government, like the republican
historian Jules Michelet and the anarchist philosopher Pierre-
Joseph Proudhon, shared the official attitude towards women's
roles in public life.

Proudhon had suggested in 1846 that women had a choice
between becoming a housewife or a harlot. Refining his ideas in
De la justice (1858), he assigned numerical values to the
characteristics of physical strength, beauty, intellect, and morality
and added them to determine "the total value of men and women,
their relationship and consequently their share of influence": men
won by 27 to 8 (quoted Bell and Offen 1983, 1:330). Women's
subordination, Proudhon concluded, was inevitable and the
household their proper sphere.

Proudhon's theories angered Juliette Lambert La Messine, a
member of Saint-Simonian literary circles who later became
famous as Juliette Adam. She quickly responded with Idées
anti-proudhoniennes sur l'amour, la femme et le mariage (1858).
Arguing that women were "functionally equal" to men because
they were superior in certain respects, she suggested that women
should be educated to work in those fields appropriate to their
nature. "There are," she wrote, "some [duties] that suit women, as
there are some that suit men. So those professions that demand
strength should remain the lot of the stronger sex and those that
demand taste, tact and dexterity should be as much as possible
attributed to the weaker sex" (quoted Moses 1984, 164).

Art and design demanded "taste, tact and dexterity," but
professional training was difficult for French women to acquire in

1858. The Ecole Gratuite de Dessin pour les Jeunes Filles, established in 1803 and headed by Rosa Bonheur after 1849, was the only French school that trained women in design. In 1860, however, the city of Dijon—the site of a branch of the state-sponsored design school, the Ecole Gratuite de Dessin, which was open only to men—considered introducing a school for young women. Art critic Léon Marius Lagrange (1828-1868) was among those who supported the idea, and he reviewed the proposal for the *Gazette des beaux-arts*, an art magazine founded by Charles Blanc only the year before. Lagrange's rationale for supporting the idea—that design offered a career in keeping with women's innate character and capabilities—echoes arguments from earlier in the century and develops La Messine's ideas of two years before.

In the following decade women's educational opportunities in design increased in France. In part this improvement may have been stimulated by concerns voiced by La Messine, Lagrange, and others, but it probably also reflected the widespread effort to improve French design education that followed London's international exposition of 1862. At the suggestion of Marie-Elisabeth Cavé, Notre Dame des Arts was established in 1863 in a small building on the rue de Rocher to educate "women artists for artistic industries and teachers for girls' primary schools of practical art." By the late 1860s it had moved to Neuilly and was reported to have 18 teachers, 15 assistants, and 140 students. Students learned academic subjects and a "useful art, most often one that relates to drawing, such as ornament, tapestry, embroidery, the making of artificial flowers, and sometimes painting—particularly painting on porcelain, enamel and ceramic—and engraving on wood and metal" (Henriet 1868, 210). Similar programs were offered in the schools sponsored by the Société pour l'Enseignement Professionnelle des Femmes, founded in 1862 by Elisa Lemonnier. By 1868 the *Revue des deux mondes* reported that there were twenty schools in Paris offering free design instruction for young women.

**It is often said today that dance is an art** whose time has passed.* "Our country no longer produces dancers. If the

---

* Translated from Léon Lagrange, "Du rang des femmes dans les arts," *Gazette des beaux-arts* 8 (October 1860), 30-43. Excerpted and translated as "Woman's Position in Art," *The Crayon* 8 (February 1861), 25-28.

government does not do something, France will have to import yet another item from foreigners."

"And what would you have the government do?"

"Don't you know that in Italy there are conservatories of dance that have trained most of the celebrities applauded on our stage? Apparently the administration is concerned about the wretchedness of our *corps de ballet* and dreams of importing to France this useful institution, which will have the benefit of opening a new and lucrative career for women."

Very well—after conservatories of music, conservatories of dance. Women have been well cared for. . . .

At this point a woman speaks up: "To hear you debate the matter, gentlemen, it seems we are only qualified for singing and dancing. If a poor girl shows any talent for the arts, she is quickly directed to the stage. The government invites her there and becomes her teacher. Yet for the few leading figures who emerge occasionally from these classes, how many shipwrecked talents are condemned to the boards of a *café chantant* or the lowest provincial theater? How many misplaced callings end in poverty, shame and disgrace! . . . More than one who has entered a theatrical career under government sponsorship sees too late that she is on the wrong road and asks herself if the feeling for art which nature gave her does not entitle her to a more reliable livelihood, a more respected career, a more lasting fame."

The answer to this question is easily given. What remains of [the dancer] Guimard? A reputation, and not the most honorable one. Malibran and Pasta charmed our fathers [at the opera]. Where are the marvelous notes that warbled from their throats? Borne away by the wind. But this wind of forgetfulness could not scatter all the pages on which Claudine Stella put her name along side that of Poussin. Go to the Louvre, go to Florence, and you will find Mme. Vigée-Lebrun still alive in her gracious portraits. At Versailles the statue of Joan of Arc sustains the memory of a king's daughter who would have died unknown if she had not demanded of an art more noble than the dance and a glory as solid as the marble that she worked with her hands. . . .

Music and dancing are not the only arts that lead women

to fame and fortune. Painting, engraving, and sculpture itself promise easier success; they provide a freedom that is more secure in that it is better acquired; a fame that is less fragile, and especially a calmer and more virtuous existence. . . .

While still on the benches of the Conservatory, the dramatic artist meets offensive glances; the day she passes its threshold, a life of risk opens before her, and risk is synonymous with disorder. Driven from city to city in search of precarious engagements, exposed to the questionable attentions of those who think that everything is permissible, vulnerable to the wiles of infamous agents, ever struggling with cupidity and ignorance in a duel with honor and fame, she all too often loses one without gaining the other and, forced to descend from the stage on which she has fruitlessly paraded, she dies in the arms of misery, ashamed of having lived. . . .

Very different is the situation of women who devote themselves to the arts of design. Painter, engraver, or sculptor, only her work claims the public eye. Her person is sacred; no one will lift the veil that hides her face; no one presumes to ask her to acknowledge feeble applause. As a chaste and pure young girl, she may sit by the lonely hearthside; as a wife—because she can become a wife without scorn—she will not see her smiles and caresses disputed as the seal of a purchased right; as a mother—because she can become a mother without dishonor—she may educate her children under a name they will never be tempted to despise. Exhibitions, open to all, will allow the public the opportunity to measure her talent or genius; the attacks of critics will be confined to her works; and praise, if deserved, will be made in a form she can read without blushing.

This is the main point which separates such an artist from musicians and singers: the female painter or engraver may pursue her profession in the shadow of privacy, never publicly advertised, and never summoned to appear before the curious and heartless world; in art she finds ample resources for maintaining her honor whatever her place in society. . . . If a drawing conservatory for women existed, it would produce not only artists, but also honest, accomplished laborers.

The plastic arts are great and beautiful in that they are not restricted to the highest excellence, but descend by gentle steps into the minute, familiar details of ordinary life. . . . The female painter, even if she does not cover grand canvases, can still paint. What more delicate hand can better decorate the fragile porcelains we love to see around us? Who can reproduce on ivory, with the most exquisite feeling of maternal tenderness, the features of a cherished infant? And to descend to handicraft, where shall we find, except among women, the patience and care required in coloring botanical plates, religious prints, and every other kind of illustration? Publishers already employ hundreds of women to color books. To feminine hands, incapable of erecting massive stone monuments, is given the task of building the cardboard structures that provide children with such great joy. In addition to the industrial arts in which woman is already active, how many others are there to which she could usefully devote herself? Isn't it ridiculous to see a broad shouldered man with whiskers tracing designs for lace and embroidery. At Lyons, the hands of thousands of men and women are occupied in the manufacture of various fabrics— but only men enjoy the privilege of inventing the forms and colors destined to entice the eyes of feminine coquetry. Is there not a contradiction in this? If feminine taste were developed by artistic education, would it embroider the shawls, carpets, and ribbons with more brilliant fantasies?

The carpets of Smyrna and Caramania, so widely valued, demonstrate what women's genius can produce. They are all woven by feminine hands. . . . Is it necessary to cite another illustration, nearer to our own time and country? At Mans, in France, there is a stained-glass factory that has already provided beautiful windows of various churches, among others the chapel on the avenue de Saxe, Paris, and, more recently, the church of Notre Dame de Passy. Does the public know who painted them? Women. . . .

Women's taste would produce other marvels if, directed and sustained by good education, it could replace men's taste in certain branches of industrial art. Jewelry offers them a vast field, one in which they might accomplish most of the work. In wood sculpture, a simple ornament might receive a

special grace from their inspiration. Those who could provide our richest fabrics would also know how to invent the most elegant forms for upholstered furniture. Lithography, engraving, and especially wood engraving would gain if they passed from men's to women's hands. Man is not made for an exclusively sedentary life; woman, however, conforms to it without inconvenience. She is better able to maintain the close, unceasing attention, the motionless activity demanded by engraving. Her nimble fingers, accustomed to wielding the needle, lend themselves more easily to minute operations, to the use of small instruments, to the almost imperceptible shades of manipulation demanded by wood engraving. Engraving on copper and steel also demand a patience and minuteness more compatible with woman's nature than man's. It is only by feminizing himself to some degree that man succeeds in developing these faculties so contrary to his physical constitution, and inevitably he does so at the expense of his strength.

It would thus benefit both art and women if women were more generally devoted to the practice of the fine arts. This would happen if our civilized society offered them educational resources in art which equaled those offered men.

That is not all. Not only are there no drawing conservatories in France, but there is only one free public drawing school for women—that established in Paris and directed so ably by Rosa Bonheur. "One cannot imagine," says the directress herself, "the services this single, small school renders to porcelain and enamel painters, to flower painters, engravers, lithographers, etc." But the services are limited and the instruction inadequate. Community drawing schools exist in all the capitals of the Departments and the other important cities in France. Can someone explain why women are excluded from these schools? Is this intentional or simply inadvertent? We would willingly believe the latter, since the former does not seem likely. Given that music schools educate equally young people of either sex, what serious motive could oppose the teaching of drawing equally to young girls and young boys? . . .

The Society of Friends of Art of Dijon has taken a praiseworthy initiative in this regard. In a report which we

have before us, the above considerations are developed with more authority. It demands that the prefect of the Cote d'Or region establish a free drawing school for women. But here, I fear, the society is mistaken. To ask the administration to create something new—what are they thinking of? To innovate, when the status quo is so comfortable? To innovate! That would mean a deluge of paperwork and reworking budgets. It would create a revolution that would involve not only the Mayoralty and the Prefecture, but two or three Ministers. Ultimately, it would mean relegating to the back file a question that is worthwhile and easy to resolve.

It would be enough, it seems to us, to admit young women on the same basis as young men to the community drawing schools that already exist. The only cost would be a few additional benches. No more teachers would be necessary. Leave it to the learned—or better yet to the simple good sense of the school authorities—to determine what measures are necessary to maintain order. . . . To adopt the principle, it is clear, is always the first step; the practical questions will be resolved in their own time and place. . . .

The longer one examines this question, the more important it becomes. In addition to the moral issue we initially raised, there is a question that might be called social. Modern economists customarily call the invasion of the cities by the rural worker one of the plagues of our time, a serious social peril for the future. The workers are drawn to the city both by the prospect of a higher salary and by the attraction of easy work that demands more agility than strength. The greater part of this work could be done by women. To furnish them, by means of free drawing instruction, with the means to take up these tasks would both improve the work itself and restrict the professions that increasingly draw dangerous and useless men to the cities. The undue development of dexterity in men is as abnormal as the development of strength in women, and whenever it occurs masculine strength becomes frustrated and seeks an outlet denied by work. . . .

Thus the major objection that social scientists raise against such simple ideas is destroyed: the problem of competition. History proves that competition will never become a serious danger for male artists: masculine genius has

nothing to fear from feminine taste. To the former belong the elevated concepts of architecture, sculpture, and painting; the engraving of works that demand the highest comprehension of the ideal—in a word, great art. To women, the genres they have always preferred: portraiture, so pleasant under the hand of Mme. Vigée-LeBrun; pastel, in which Rosalba showed herself the equal of LaTour; the miniature, which seems to demand the delicate fingers of a Mme. [Lizinka] de Mirbel or a Mme. [Jeanne Mathilde] Herbelin; flowers, those wonders of grace and freshness that can be equaled only by feminine freshness and grace; genre in all its varieties, from the poetic dreams of a Mlle. [Constance] Mayer or the familiar scenes dear to the brush of Mlle. [Marguérite] Gérard to the animals of which Mlle. Rosa Bonheur has made beloved pets. Above all, engraving will remain for women—engraving, this art of sacrifice which corresponds so well to the roles of abnegation and devotion that the honest woman happily fills on earth and that is her religion. Finally, to women will remain the secondary arts that have already been listed and that are so well suited to their nature and their character. The masculine genius suffers if it is restricted by too narrow a genre; a secret ambition devours him and forces him to rise. "Woman's spirit"—and a woman (Mlle. Bonheur) said this—"is more supple, more delicate, less proud, and easier to direct." Woman is content with a secondary rank, if the salary of the inferior work is sufficient for her to procure the means for her pleasure.

A more serious objection might be addressed to us on behalf of women themselves. "What," you may say, "do you dare dangle before families the deceptive mirage of a career in the fine arts?" Count the large number of young men who compete unsuccessfully against the privations and· frustrations of the artistic life. Even with government aid, how many vegetate in the depths of an illusory profession that will never earn them a living? And you want to open the same abyss of misery to young women? Are there not already enough women painters; are there not already *too* many? Go to the Louvre one day when it is open to students: all you see are skirts perched on ladders, feminine hands eagerly working at immense canvases whose least indecency is to

popularize the insipidities of Guido and Mignard at the expense of the healthy beauties of Raphael and Poussin.

Without a doubt, if it were only a matter of doubling the number of *rapins* in skirts, we would consider ourselves guilty towards art and society. . . .

But that is not the question. The government is not being asked to open the Ecole des Beaux-Arts or the school in Rome to women; it is only asked to admit young women on the same basis as young men to the benefits of instruction in drawing that is freely offered in the community schools. . . .

Women's aptitude for the fine arts is a fact. Their right to become artists cannot be challenged. The services they would perform rise before us; logic and justice support their interests; art itself could only gain by this diffusion of the rules of taste. Without mentioning industrial art, in which so many young working-class women earn their living, it is clear that if the women who today aim too high in painting, engraving and sculpture were free to choose, they would soon prefer the easiest and most familiar genres and would leave the highest and most glorious ones to men. That reduces the question of competition to its proper place.

This competition, after all, would only be appropriate in a country and a century when there are men selling fashionable goods or fitting boots. Who knows if this competition would not be beneficial? The development of a free artistic talent in women, opening to them lucrative careers that would not endanger their moral position, would perhaps have the unanticipated result of provoking among the men of our generation a return to those masculine virtues which their pride so willingly cheapens.

# Lady Marian Alford: The Report for 1875 of the Vice-President of the Royal School of Art Needlework

In the 1830s and 1840s a revival of church needlework began to turn English women away from the elaborate illusionistic patterns

of Berlin woolwork. Augustus Welby Pugin, who collaborated with architect Charles Barry to rebuild and redecorate the Houses of Parliament in a Gothic style, encouraged embroiderers to imitate the stylizations of medieval prototypes. The needlework that architect George Street designed for his Anglican churches was executed by the amateurs of the Ladies' Ecclesiastical Embroidery Society, which his sister and Agnes Blencowe founded in 1854.

In the following decades, embroidery was transformed into "art needlework" under the influence of William Morris, who had worked with Street and had absorbed John Ruskin's idealization of medieval craft from *The Stones of Venice* (1853). Morris began working with textiles in 1860, when he planned the decoration for his home. With his wife Jane Burden, he picked apart old needlework to study its construction. In 1861 Morris founded "the firm" with seven architects and artists—including Edward Burne-Jones, Philip Webb, Dante Gabriel Rossetti and Ford Madox Brown—who were intent on devoting themselves to the decorative arts. Needlework was soon an important part of the group's commissions: elaborate figural embroideries were designed by the partners and worked by Jane Burden and other women associated with the group, and linen was printed with Morris' designs, which were often adapted from his wallpapers or printed fabrics, and sold to amateur needleworkers.

Inspired by Morris' example and women's continuing need to find employment, Lady Marian Alford and a group of accomplished and aristocratic needlewomen founded the Royal School of Art Needlework in 1872. Their purpose was to "restore ornamental needlework for secular purposes to the high place it once held among decorative arts and to supply suitable employment for poor gentlewomen" (quoted Morris 1963, 113). Rooms were taken in Sloane Street, where young women whose "claims were poverty, gentle birth, and sufficient capacity to enable them to support themselves and be educated to teach others" came to study and work (quoted Callen 1979, 99). At the Royal School of Art Needlework women learned technical skills, executed designs by leading artists, and transferred patterns to linen for amateurs to work at home. Lady Marian Alford's Annual Report of 1875, the year the school's success enabled it to expand into new quarters on Exhibition Road in South Kensington, described the school's facilities and activities.

Other societies where women could learn embroidery skills and market their work were founded in the following decade: by 1883 there were over fifteen such societies in London alone and

others in provincial cities. But May Morris, who managed the embroidery section of her father's firm after 1885, did not think art needlework offered much of an opportunity for women. She believed that the century's "infatuated admiration for and subjugation by machinery" had destroyed the public's ability to distinguish between good and bad work and created a market for "cheap hand-embroidered household linen." She warned that "until the love and taste for rich and delicate needlework becomes more widely spread, I shall not take a very hopeful view of the art as an employment for women; that is, at a reasonable remuneration" (Morris 1900, 191).

**It is due to those who have befriended** the Royal School of Art Needlework, that they should receive a report of the progress it has made, and the increase of the work it has done, since its removal into its present home in Exhibition Road, in the month of June.*

The great extension in space, and the necessary outlay, were at once justified by the increase of business. For us there has been no dead season. During the past year there have been 403 orders received in the Executive Department. In the Prepared Work Department, 1,065; and we have sold in the Show-Room to the amount of £1,382. . . .

In the beginning of 1875 our numbers amounted to 100: 88 Workers and 12 Staff. Now, in December 1875, there are 110 Workers and 20 Staff—130 in all. The Staff consists of the Head of each Department, and a Forewoman, or Assistant to each.

The necessity of new designs was evident, and many eminent Artists, besides our Committee of Taste, have promised us drawings. [Edward] Burne-Jones, [Edward] Poynter, [William] Morris, Atcheson, Pollen, Walter Crane, Armstrong, Miss [Gertrude] Jekyll—all these have been applied to and some have already granted us the benefit of their invaluable assistance. A Design Fund has been opened, to which subscriptions have been given, in order to pay for

---

* Excerpted from Lady Marian Alford, "Vice-President's Report of the Royal School of Art Needlework for 1875," *The New Century for Women,* no. 1 (13 May 1876), 3.

these drawings. It is intended that a percentage shall be charged, every time the design is worked, and either be paid to the Artist himself, or repaid to the Fund, if the original expense has been placed upon it.

First in order comes the large general Work-Room, in which an accomplished lady overlooks the execution of varied work in all materials and styles, from the most delicate to the most effective. In the second room appliqué and gold work are especially carried out under the superintendence of a lady who has learned her craft in the best Foreign Schools. Thirdly an Artistic room is set apart for working in crewels, from the designs of Messrs. Morris, Walter Crane, and others. The lady who teaches in this room is supposed to be the finest worker in the style in England, where crewels have always been a favorite material since the days of Elizabeth.

The next room is that in which work is prepared for amateurs to embroider at home. And we would here remark that we do this at a lower rate than in the shops—and yet find it one of the most remunerative parts of our scheme. To be able to judge of how much care and time is needed in our business, it is only necessary to look into the adjoining Studio, where twenty ladies are busy altering, tracing, and pricking designs to be worked.

The Show-Room furnishes specimens of all the styles we can carry out, our best and finest works being made to order, can only be seen in the Work-Room, but are exhibited for a day before being sent home. The Work-Rooms cannot be visited without the permission of the Manager, who exercises her own discretion as to admitting strangers behind the curtain which hangs across the Show-Room door—as too large a public would impede business. The Store-Rooms are well filled, and the Upholstery Department in constant activity.

The work is now divided into four classes in each room. . . . The value of the highest class, No. 1, is judged by the work being set, and so many square inches done, by an experienced Worker. What she can do well in an hour, not hurrying herself, but at a steady pace, is valued at 10 d., and so measured out, to the embroideress employed on that piece of work. At seven hours a day, it is easily calculated, and the

scale of diminishing merit, fairly adjusted. Each lady has the
hope of raising to the highest class. Good work is prized
above quick work, but it is generally proved that the best
hands are also the fastest. Of course, this scale is allowed to
be moveable, in individual cases, and will be modified by the
profits of the School.

A great opening for progress, has been inaugurated this
year, by the formation of a higher School of Art, within the
School. Mr. Leighton, R.A., Mr. Prinsep, and Mr. Bodley
have done us the great kindness to advise and criticize us.
Some of our best works have had their counsel and
approbation—of course they are not answerable for all we
do: we cannot afford to refuse any orders; but when these are
against our canons of taste, we try to modify and improve
what we cannot entirely approve.

The hours of work used to be eight. But the Council has
seen reason to reduce them to seven. We found that at Bruges
and Brussels, where men are employed, as well as women,
seven hours a day is the maximum. We have reason to believe
that we shall gain by the change, both as to the quality, and the
quantity we shall produce, as the continued strain of mind and
eye was too great on those who applied themselves—
diminishing their powers towards the evening, and even
impairing their energies the following morning. . . .

There is but little more to add to our year's report,
except to congratulate ourselves, on our Book-keeping
system, which promises well. Lady Charlotte Schreiber was
the active agent in organizing it. We have been so fortunate
as to secure a first-rate Lady Clerk, trained in a house of
business, to work it, the accounts being audited quarterly by
a regular accountant. . . .

## Susan N. Carter: An Art Pottery Studio in London (1879)

Women who studied ceramic decoration at England's School of
Design did not find it easy to obtain work in the potteries. Herbert
Minton, whose father had established Minton and Sons in 1796,
explained to a government Select Committee in 1849 that there

were fears that the "women would do the work which ought to belong to the men" (quoted Callen 1979, 52). Male employees of the potteries discouraged their daughters from studying at the local branches of the School of Design, which also introduced courses in porcelain decoration for women, and in Worcester and Staffordshire regulations were enacted that prohibited women from using the decorators' customary arm rest or from working with gilding. As late as 1872, the *Art Journal* reported that women were employed in a "subordinate" position: "Daughters assist fathers or wives husbands to fill in outlines or put in sprigs. . . . But the largest number of women are employed in the same kind of drudgery allotted to boys who, having less physical strength, are worth lower wages than men" ("Art Work for Women" 1872, 66).

English women found better opportunities in the art potteries established by Herbert Minton and Henry Doulton. Minton arranged to rent space in South Kensington, not far from the National Art Training School, as the School of Design was renamed in 1863, and in 1871 Minton's Art Pottery opened with studios, storerooms, two kilns, and William Stephen Coleman as Art Director. Coleman selected male and female students from the school to work in the pottery, where they executed designs by Coleman, Christopher Dresser, J. Moyr Smith and other leading designers. The opportunities that the pottery afforded women were welcomed by *The Queen*, *Victoria Magazine*, and the *Art Journal*, which noted that "twenty to twenty-five women of good social position [are] employed without loss of dignity and in an agreeable and profitable manner" (quoted Callen 1979, 56). Minton's effort was short-lived, however: Coleman, who proved a better designer than manager, left in 1873, and after a fire in 1875 the pottery was closed completely.

The Doulton Lambeth Art Pottery, established by Henry Doulton of Doulton Pottery and John Sparkes of the Lambeth School of Art in the years following the Paris international exposition of 1867, was longer lived. Most of the pottery's staff was drawn from the students at Lambeth, and many were women: in 1873 there were thirteen women employees, and by 1885, 250. After a trial month, students were hired as Junior Assistants to work as an Apprentice under the art director and a skilled artist. They could gradually move up to Senior Assistant and then Artist; seven years were considered necessary to complete their training. Among the women who worked at Doulton's were Hannah and Florence Barlow, Elizabeth Bankes, Elizabeth Simmance and Louisa Davis. Using a variety of techniques, including *sgraffito*,

*pâte sur pâte*, and glazes, they decorated the vessels that had been thrown by men.

The Doulton Lambeth Art Pottery became familiar to Americans at the 1876 Centennial Exposition in Philadelphia. Public attention focused on Sparkes and Doulton, but when Susan N. Carter, principal of New York's Cooper Union, visited the pottery in 1879, she found the women decorators hard at work, as she reported in the New York edition of the *Art Journal*.

**An interesting studio for the decoration** of china is in the great manufactory at Doultons, at Lambeth, which is so very convenient to the centres of London that it may be reached in a few minutes from the Parliament Houses by crossing Westminster Bridge.* But this studio is also very retired, and it is only a few pieces of the decoration done here that may be seen at the shops of Doultons' agents. The visitor to Doultons', after walking along the embankment on the south side of the Thames on his right hand, and the palace of the Archbishop of Canterbury on his left, finds himself at length in the midst of groups of buildings, old and new; some of them are tall and fine, and others nearly resembling sheds, they are so rough. Round tiles for draining purposes are stacked about in great pyramids among the buildings, and coarse pots and pans of every description appear. But now in the midst of these rough kinds of pottery, as well as the dismal old buildings of the Doulton manufactory, the eye is caught by the sight of two or three very fine and peculiar edifices, which tower high above their companions. Pointed windows, cased in grey, blue, and yellowish tiles, diversify in these buildings with buff, black, and red terra cotta, and the vision ranges over Elizabethan gables formed of many varieties of brick. These new edifices, for they have only recently been completed—contain the museums, the showrooms, and also the decorating studios for the famous Doulton pottery.

Going up several staircases to the two upper floors of

---

\*   Excerpted from Susan N. Carter, "Art Pottery Studios in London," *Art Journal* n.s. 5/New York edition (1879), 378-79.

one of Doultons' new buildings, we find ourselves first at the door of one and then another moderate-sized room. [The walls of] these various rooms are stained a pale greyish green, and their furniture is of the simplest description. Small wooden tables, with a little raised case containing shelves on one side of each of them, are occupied by ladies, who keep their various palettes of mixed colours on the shelves of the little cases on the tables, while before them, or in their hands, they hold a jar, a tile, or a plaque, whichever it may be that they are painting.

The Doultons are continually inventing new styles of ornamentation, and that now most in the hands of the decorators consists of colours so piled up and relieved above the surface of the jars or vases, that it resembles, when glazed and fired, nearly the rough surface of the French Haviland ware. One of the lady artists was dotting the intervals between the raised flower-patterns on her jar thickly with spots of heaped-up white paint, that would give, when baked, much the look of "jewelled" ware; while another of the painters in an underglaze studio—for the studios are divided according to the kind of decoration done in them—was copying a lovely landscape, with Watteau-like figures in it, upon a hollow plaque. There were no overglaze studios in the establishment of the Doultons, for the outlines of the overglaze painting remains so poor and hard after firing that they consider it in England scarcely worth the doing. In another studio, a number of ladies were at work upon dry but unbaked grey jars, pitchers, and plates, which had not been fired at all. These articles were scarcely harder than putty, and of much the same colour. Each artist—for many of these ladies have a very high reputation as artistic decorators—had her own patterns, consisting of original outlines of animals, plant-forms, and arabesques, made by herself, drawn either from nature or from her own invention. These designs she was inscribing with a sort of "stylus" or pen upon the unbaked pottery, digging farther into the clay to emphasize an eye, a raised paw, or the ear of a rabbit, a horse, or a cat, whichever it might be, of which her design was made. As each artistic decorator is allowed to make and carry out her own ideas, the manufacturer has the advantage

of possessing no two articles precisely similar, and any especial fancy or taste in the designer is able to create for its possessor a reputation of its own. . . .

## Candace Wheeler: The Development of Embroidery in America (1876-c. 1890)

The Royal School of Art Needlework sent two displays to the United States Centennial Exposition in Philadelphia in 1876. In the English section of the International Building, there were elaborate curtains designed by Walter Crane and samples worked by students; for the Women's Building Lady Marian Alford provided a selection of work "drawn in our own studio or especially for our use, by the ladies of our Staff—by her Royal Highness Princess Christian of Schleswig-Holstein, by the Princess Louise, Marchioness of Lorne, by the Hon. Percy Wyndham, and others" (Alford 1886, 3). American women were fascinated by "the Queen's needlework" and left the exhibition eager to try their own hands at art embroidery. Candace Thurber Wheeler (1827-1923) was impressed not only with the needlework, but also with the purposes of the Royal Society of Art Needlework.

Wheeler had grown up in central New York State. Her father was a Presbyterian deacon and abolitionist who allowed his dairy farm to be used as a stop on the Underground Railway. Because cotton was produced by the slave trade, her mother dressed the entire family in linen cloth she wove herself. In 1844 Candace Thurber married Thomas Wheeler, a bookkeeper and the brother-in-law of her family's pastor, and moved to the New York City area. T. B. Thorpe, who wrote on art for *Harper's Magazine*, had been Thomas Wheeler's college classmate, and he introduced the couple to artists working in New York. They visited the Tenth Street studios of the painters who would be later known as The Hudson River School, admired Rosa Bonheur's *Horse Fair* when it was exhibited at Williams Frame and Picture Shop on Broadway, and received what Candace Wheeler called "a constant education." Wheeler's interest in china painting was encouraged by family friends who included Frederic Edwin Church, Sanford Gifford, Albert Bierstadt, and Eastman Johnson.

After visiting the exhibition of the Royal School of Art Needlework at the Philadelphia Centennial Exposition, Wheeler founded the Society of Decorative Art of New York City in 1877. It

was modeled on the English example and included showrooms where women could sell their needlework and other decorative arts objects and classrooms where they could improve their skills. Wheeler was proud of the society's accomplishments, but she was also frustrated that its emphasis on art limited the kinds of work it would accept in the showroom. With Mrs. William Choate she founded The Women's Exchange, where "a woman of brains, industry and opportunity might make and sell whatever she could do best," from pies to paintings (Wheeler 1918, 227).

Wheeler had also exhibited her own needlework in the society's showrooms, and in 1879 Louis Comfort Tiffany, who had just turned his attention from painting to the decorative arts, offered her a position in his newly founded Associated Artists. As the partner in charge of textiles, Wheeler worked on the decoration of private and public buildings, from Mark Twain's home to the White House. Some of the textiles Wheeler designed herself; others, like the curtain for the Madison Square Theater in New York City, she executed after her partners' designs.

In 1883 the partnership was dissolved: Tiffany founded Louis Comfort Tiffany and Company, while Wheeler, working with her son and her daughter, continued to design textiles under the name Associated Artists. With Dora Wheeler, who had studied painting, she developed what she called "needle tapestries"—large and elaborate pictorial embroideries. For Cheney Brothers of Connecticut, she also created designs that could be printed on variety of fabrics, from silk to cotton, and sold at a variety of prices.

When she was asked how her husband felt about her work, Wheeler responded that "he says it keeps me busy and makes up to me for not voting," but she firmly believed that women's expanding educational and professional opportunities would profoundly affect the art of the future (Wheeler 1918, 147).

## American Tapestry*

While the success of this [New York] Society [of Decorative Art] was a source of great satisfaction to me, I had in my mind larger ambitions, which, by its very philanthropic purposes could not be satisfied, ambitions toward a truly great American effort in a lasting direction.

---

\* Excerpted from Candace Wheeler, *The Development of Embroidery in America*, New York: Harper and Bros., 1921, 121-26, 131-40, 142.

I therefore allied myself with [Associated Artists] a newly formed group of men, all well-known in their own lines of art, Louis Tiffany, famed for his Stained Glass, Mr. Coleman for color decoration and the use of textiles, and Mr. DeForest for carved and ornamental woodwork. My interests lay in the direction and execution of embroideries. I can speak authoritatively as to the effect upon it of the other arts, and I can hardly imagine better conditions for its development. The kindred arts of weaving and embroidery were carried on with those of stained glass, mural painting, illustration, and the other expressions of art peculiar to the different members. The association of different forms of art stimulated and developed and was the means of producing very important examples both in embroidery, needlewoven tapestries and loom weaving.

As I was the woman member of this association of artists, it treated with me to adapt the feminine art, which was a part of its activities, to the requirements of the association. This was no small task. It meant the fitting of any and every textile used in the furnishing of a house to its use and place, whether it might be curtains, portieres, or wall coverings. I drew designs which would give my draperies a framing which carried out the woodwork, and served as backgrounds for the desired wreaths and garlands of embroidered flowers. I learned many valuable lessons of adaptation for the beautiful embroideries we produced. The net holding roses was a triumph of picturesque stitchery, and most acceptable as placed in the house of the man whose fortunes depended upon fish, and many another of like character.

Then one day appeared Mrs. Langtry in her then radiance of beauty, insisting upon a conference with me upon the production of a set of bed-hangings which were intended for the astonishment of the London world and to overshadow all the modest and schooled productions of the Kensington, when she herself would be the proud exhibitor. She looked at all the beautiful things we had done and were doing, and admired and approved, but still she wanted "something different, something unusual." I suggested a canopy of our strong, gauze-like creamy silk bolting-cloth, the tissue used in flour mills for

sifting the superfine flour. I explained that the canopy could be crosses on the underside with loops of full-blown, sunset colored roses, and the hanging border heaped with them. That there might be a coverlet of bolting-cloth lined with the delicatest shade of rose-pink satin, sprinkled plentifully with rose petals fallen from the wreaths above. This idea satisfied the pretty lady, who seemed to find great pleasure in the range of our exhibits, our designs and our workrooms, and when her order was completed, she was triumphantly satisfied with its beauty and unusualness. The scattered petals were true portraits done from nature, and looked as though they could be shaken off any minute. . . .

When Mr. Tiffany came to me with an order for the drop-curtain of a theater, I did not trouble myself about a scheme for it, knowing that it had probably taken exact and interesting form in his own mind. It was a beautiful lesson to me, this largeness of purpose in needlework. The design for this curtain turned out to be a very realistic view of a vista in the woods, which gave opportunity for wonderful studies of color, from clear sun-lit foregrounds to tangles of misty green, melting into blue perspectives of distance. It was really a daring experiment in methods of appliqué, for no stitchery pure and simple was in place in the wide reaches of the picture. So we went on painting a woods interior in materials of all sorts, from tenuous crêpes to solid velvets and plushes. . . .

The variety of our work was a good influence for progress. We were constantly reaching out to fill the various demands, and, beyond them, to materialize our ideals. As far as art was concerned in our work, what we tried to do was not to repeat the triumphs of past needlework, but to see how far the best which had been done was applicable to the present.

If tapestries had been the highest mark of the past, to see whether and how their use could be fitted to the circumstances of today, and if we found a fit place for them in modern decoration, to see that their production took account of the methods and materials which belonged to present periods, and adapted the production to modern demands [*sic*].

We soon came to the ideal of tapestries which loomed above and beyond us and had been reached by every nation in turn which had applied art to textiles, but in all except the very early work the accomplishment had been ore of the loom than of hand work. My dream was of American Tapestries, made by embroidery alone, carrying personal thought into method. We decided that there was no reason for the limitation of the beautiful art of needlework to personal use, or even to its numerous domestic purposes. . . .

When we came to the decision to create tapestries, the actual substance of them, as well as the art was a thing to be considered. The wool fiber upon which they were usually based was a prey to many enemies. Dust may corrupt and moths utterly destroy fiber of wool, but dust does not accumulate on the threads of silk, neither are they quite acceptable to the appetite of moths. Therefore, we reasoned, if we did work which was worthy of comparative immortality, it must be done with comparatively imperishable material. Fiber of flax and silk shared this advantage, and the silk was tenacious of color, which was not the case with flax; therefore we chose silk and went bravely to our task of creating American tapestries. . . .

Being thus fully equipped for the production of real tapestries, well adapted to the processes of what I called "needle weaving," since the needle was really used as a shuttle to carry threads over and under the already fixed warp, the next decision rested upon the subject of this new application of the art and the knowledge we had gained by study and practice and love of textile art. With a courage which we now wonder at, we selected perhaps the most difficult, as it certainly is the most beautiful, of surviving tapestries, *The Miraculous Draught of Fishes*, the cartoon of which, designed by Raphael, is at present to be seen at the Kensington Museum in London. . . . I had two photographs, as large as possible, made from the cartoon, and one of them being very faintly printed, copied exactly in color; the other was ruled and cut into squares, and was again photographed and enlarged to a size which would bring them, when joined, to the same measurements as the original cartoon. These,

very carefully put together, made a working drawing for my tapestry copy, and the lighter photograph, which had been most carefully watercolored gave the color guide for the copy. . . .

Every inch of stitchery was carefully criticized and constantly compared to the colored copy, and at last it was a finished tapestry and was hung in a north light on one of the great spaces of the studio, where it was an object of expert examination and general admiration.

It is by far the most important work accomplished by needle weaving which has ever been made in America, and is as veritable a copy of the original as if it were painted with brush and pigment, instead of being woven with threads of silk. The low lights of the evening sky, the reflections of the boats, and the stooping figures of the fishermen, the perspective of the distant shore, and the wonderful grouping in the foreground, keep their charm in the tapestry as they do in the picture. . . .

After this achievement we naturally began to look for appropriate use for small tapestries, but here came our stumbling block. The breed of princes, who had been the former patrons of such works of art, were all asleep in their graves, and knew not America, or its ambitions, and our native breed was not an hereditary one, building galleries in palaces, and collecting there the largest of precious accomplishments in artistic skill in order to perpetuate their own memories, as well as to enrich their descendants. . . . I gladly record, however, that in these later days some of them have made the American world their heirs, and are building and enriching museums and colleges, making them palaces of growth and enlightenment, and so giving to the many what an older race of princes built and enriched and guarded for the few.

But in the meantime what were we to do about our tapestries? They were costly, very costly to produce, and although we took account of the delight of their creation and put it on the credit side of our books along with the fact that the weekly pay roll of the tapestry room went for the comfort and maintenance of the students whom we loved and

cherished, I soon realized the fact that a commercial firm could not be burdened with the fads of any one member. Before I had carried this conclusion to its logical end, we had opportunities for using our skill worthily in some of the new great houses of the time. When the Cornelius Vanderbilt house was erected on Fifth Avenue and Fifty-Seventh Street, we received an order for a set of tapestries for the drawing-room walls. These were executed from ideal subjects and of single figures. I remember the *Winged Moon* among them, which was an ideal figure of the new moon lying in a cradle of her own wings. This was but one of the set, one or two of which we afterward made in replica for an exhibit in London. There was no lack of subjects in our background of American history. The legends and beliefs of our North American Indians were full of them, and one of the first we selected was the lovely story of *Minnehaha, Laughing Water*, from Longfellow's *Hiawatha*. The sketch had been sent to us by Miss Dora Wheeler, as the prize competition of the Saturday Composition Class at Julian's Studio in Paris. . . .

When our embroideries and needlework had taken their place in this country, we were asked to make them part of an Exhibition of American Art in London. This we were very glad to do, for the artistic gratification of being able to measure what we were doing with the best art of the kind abroad. It was also pleasant to be considered worthy company with the best in our own land, to rub shoulders with our best painters, our great makers of stained glass, leaders who take genuine pleasure in ideal work. . . .

Embroidery has become a dependence and a business for thousands of women, and it is this which secures its permanence. We may trust skillful executants who live by its practice to keep ahead of the changing fancies of society and invent for it new wants and new fashions. And this, because their chance of living depends upon it, and it promises to be a permanent and growing art. It may, and will, undoubtedly, take on new directions, but it is no longer a lost art. On the contrary, it is one where practice has attained such perfection that it is fully equal to any new demands and quite competent to answer any of the higher calls of art.

# Mary Louise McLaughlin: My Own Story (1914)

In the 1870s, china painting became popular with English and American women. Overglaze decoration required a minimum of technical training and equipment: a Parisian chemist, Lacroix, had introduced prepared colors, and blank ceramic forms ready for decoration could be purchased from manufacturers. For many women, teaching china painting or selling their finished designs provided an acceptably ladylike livelihood. Amateurs and professionals exhibited their work at exhibitions sponsored by clubs and galleries, like London's Howell and James, and looked to magazines like *The China Decorator* or *Keramic Studio*, edited in Syracuse, New York, by Adelaide Alsop Robineau, for information on design and techniques.

One of the earliest and most important centers for china decoration in the United States was Cincinnati, Ohio. The women of the city had been committed to bringing art and culture to their community since the 1850s, when Sarah Worthington King Peter had organized the Ladies' Academy of Fine Art to purchase casts and copies of European masterpieces. In 1873 a Department of Practical Art was added to the University of Cincinnati's School of Design and a class in wood carving was introduced by Benn Pitman. Pitman, English born and deeply influenced by William Morris, believed that women had a special place in the decorative arts: "What the smile is to the human face . . . true decoration is to handicraft. To whom shall we turn for the adornment of our homes: To girls and women assuredly! Let men construct and women decorate" (quoted Macht 1976, 6). When his students expressed an interest in china painting, Pitman arranged for a teacher.

Among Pitman's students was Mary Louise McLaughlin (1847-1939), the daughter of a wealthy architect. McLaughlin's experience with overglaze decoration led to her first handbook, *China Painting: A Practical Manual for the Use of Amateurs in the Decoration of Hard Porcelain* (1877). Along with Pitman's class, she contributed work to the Women's Pavilion at the 1876 Centennial Exposition in Philadelphia. Visiting the fair, she was introduced to underglaze decoration in the works exhibited by Doulton's art pottery and Haviland faience from Limoges. Relying on Cincinnati's Coultry Pottery to fire her works, McLaughlin began experimenting with colored slips in an effort to duplicate the Haviland technique. By late 1877 she announced the development of what she called "Cincinnati Limoges."

In 1879 McLaughlin was named President of the newly created Cincinnati Pottery Club, whose members included Laura Fry, Laura Pitman, and Elizabeth Nourse. Not included, because she felt snubbed when her invitation was delivered late, was Maria Longworth Nichols. Nichols went on to found the Rookwood Pottery, which became one of the preeminent art potteries in the United States and, ironically, provided facilities for the Cincinnati Pottery Club until 1883. When Nichols asked the club to leave to make room for her successful commercial enterprise, McLaughlin returned to overglaze painting and decorative etching in metal, for which she received a prize at the Paris international exposition of 1889.

In 1898, however, McLaughlin returned to ceramics, turning her attention to porcelain. It was an ambitious undertaking: switching from china painting to porcelain was, as a colleague later said of Adelaide Alsop Robineau, who made a similar transition, "about as rational and as possible as a vocational change . . . from dentistry to cello playing" (quoted Weiss 1981, 107).

As McLaughlin recalled in 1914, when she read her autobiography at a meeting of the Cincinnati Porcelain League, her experiments also led her to mix her own clay. A division between the potters who made the clay and threw the forms and the artists who then decorated them was usual in nineteenth-century ceramics production, and most women—amateur or professional—stayed away from the aspects of ceramics considered too heavy or dirty. When McLaughlin—and Robineau—began to control the entire process of their ceramics production, they began to break down the stereotypes of what was appropriate for women.

**My earliest recollections are of drawing** and the desire to cover every available surface with my efforts.* In those days, however, the art was not considered a necessary part of the school curriculum, so it was not until after my school days were over that I sought instruction in drawing at a small private art academy on East Fourth Street, Cincinnati. This school was presided over by a lady whose artistic ideas and

---

*     Excerpted from Mary Louise McLaughlin, "Miss McLaughlin Tells Her Own Story," *Bulletin of the American Ceramic Society* 17 (May 1938), 217-222. Reprinted with permission of The American Ceramic Society, Inc. First read at the Porcelain League, Cincinnati, April 1914.

methods were decidedly early Victorian. After some time pleasantly but most unprofitably spent at this school, I went to the Art School then held in the College Building and graduated therefrom without honors, except the winning of one or two prizes, one for sculpture in 1876 and a prize for an original design. . . .

We were, in fact, at this time, upon the eve of a great awakening in matters artistic. Tidings of the veritable renaissance in England under the leadership of William Morris and his associates had reached this country. It was the beginning of the Arts and Crafts movement, and it was given to Cincinnati to take the first step in its organized development in America. Mr. Benn Pitman had entered the Art School as an instructor, giving his services free during the establishment of a department in wood carving.

Under his inspiring leadership, our efforts were soon to be drawn into unexpected channels. In the exhibition of the Art School in 1874, some pieces of china painting executed by one of the pupils at home were shown, and we expressed a desire to learn something of the mysteries of this art. Mr. Pitman undertook to procure the necessary information and, on his return from his vacation trip to New York in that year, he brought some mineral colors. He also unearthed an instructor in the person of a young German woman who had learned the art in Berlin. Mr. Pitman then invited a group of his scholars in the woodcarving class to meet at his office and be instructed in the art of painting on china. . . .

The Cincinnati Exhibit at the Centennial attracted much attention, as its features of wood carving and china painting were novel and in advance of the women's work shown by other cities. My own contribution to this exhibit was a carved cabinet done under the direction of Mr. Henry Fry and a number of pieces of china painting.

It was while visiting the Centennial that I saw the faience made by the Havilands at Limoges, then exhibited for the first time in this country. The new ware in its exquisite coloring and novel effects was a revelation to me, and I immediately began to wonder how it was done and if I could not do something of the kind. I learned something of hard-fire colors and sent to Paris to procure some, but it was

not until nearly a year had elapsed that my purpose was carried out. . . .

A visit to the pottery of Patrick Coultry in September, 1877, convinced me that my idea as to the method of the decoration used in the Haviland ware was correct, or rather that the process was slip painting and an evolution of that by which the common yellow or Rockingham ware was decorated with stripes of blue and white at this pottery. I carried home a vase in the raw clay upon which to experiment. It was a teapot turned upside down and minus the handle and the spout. This piece came from the kiln in October, 1877, and while it was somewhat defective from the slip painting having been applied too thinly and thus revealing the yellow ground color underneath it, it showed the feasibility of producing effects similar to the Haviland ware with the facilities at hand. . . .

On account of the origin of the style in Limoges, I had called my ware "Limoges Faience." Reporters, who could scarcely be expected to be entirely familiar with nice ceramic distinctions, confounded the name with that of the Limoges enamel, formerly made and now extremely valuable, and heralded the new ware as a rediscovery of a long-lost process. All this drew attention to it, and there were many who desired to practice the art of making it. These found instruction in a class which was formed at the Coultry Pottery in which were some young men who afterward composed the nucleus of the decorators of the Rookwood Pottery, which was founded in 1880. Aside from these art students, there were many others who took up the work of decorating pottery, persons gathered together without any regard to previous condition of knowledge of art or decoration. It may be imagined with what abandon the women of that time, whose efforts had been directed to the making of antimacassars or woolen afghans, threw themselves into the fascinating occupation of working in wet clay. The potters imparted to them various tricks of the trade and some fearful and wonderful things were produced. Not long ago, the proud possessor of some of these treasures showed me a pair of vases with characteristic decoration of the period. While still wet, they had been rolled or otherwise peppered with fragments of dry clay until their surfaces were



the texture of nutmeg graters, while over all had been hung realistically colored branches of fruit. For a time, it was a wild ceramic orgy during which much perfectly good clay was spoiled and numerous freaks created. . . .

In 1879, the Pottery Club was organized and, composed as it was of the best workers in the different branches of ceramic decoration, did much to uphold the standard of good workmanship during the sixteen successful years of its existence. In the first year after it was organized, the workroom of the club was in the Dallas Pottery on Hamilton Road, where in the spring of 1880 was held the unique reception which drew a large crowd of the representative people of the city into the labyrinthine passages of the dusty old pottery to view the results of the first year's work. Later, the club followed the manager of this pottery, Mr. Joseph Baily, to the Rookwood which had just been opened at what is now known as Rookwood Crossing on Eastern Avenue. As the pottery became established, there was less time and inclination to undertake outside work, and from force of circumstances we were obliged to abandon underglaze work and to return to the overglaze decoration which could be carried out without the resources of a pottery. Pieces of my work representing each year from 1878 to 1885 have been given to the Museum, including the large vase, thirty-eight inches high, to which was given the name "Ali Baba."

About 1885 I gave up my work in pottery and actually refrained from dabbling in wet clay for nearly ten years, and then returned to it only to try out a method of decoration with inlays of clay which I patented in 1895 and practiced for a short time. This work was carried on at the Brockmann Pottery, but again the disadvantage of not being able to control the entire process caused me to discontinue it . . . .

One who has experienced the fascination of working in wet clay is never safe from its lure, and after a while I was again dreaming of the possibility of carrying out another ceramic venture, this time of much larger scope. This was no less than the making of porcelain, an enterprise the difficulty of which I had as yet but a faint conception. Had I been able to form an idea of this difficulty, it is doubtful if the Losanti ware would ever have existed. . . .

Technical instruction also as to methods was not at that time available. Since then one or two expert ceramists have written detailed descriptions of processes which would have been invaluable to me if I could have availed myself of them. The only practical help I could find was the formula of the composition of the Sèvres paste, which gave the proportions of flint, feldspar, and kaolin used. The other compositions published in books at hand were chemical analyses which threw but little light upon the actual ingredients entering into the bodies and glazes. I thought that by giving a formula to a potter I could save myself the trouble of grinding and mixing the preparations, but the result proved that this was anything but a safe procedure.

As to the firing, after two abortive attempts in which I had invested in gas kilns, I found myself without the means of attaining the high temperature necessary for the firing of porcelain. At that time natural gas, which would have solved all my difficulties, had not been brought to the city. Finally I was advised to build a brick kiln, such as potters use, which could be fired with coal. . . .

The day the kiln was tried to see if it would "draw" the wind was, unfortunately, for the south and it not only drew, but also drew the attention of the neighbors to the smoke which, as I was presently informed, annoyed them. Thereafter, together with the other troubles which came thick and fast, I had also this to reckon with. I was placed in the unfortunate position of one who finds it difficult to go forward and impossible to retreat. . . .

A trying-out of the kiln with some ware that had been prepared took place, an occasion of such tribulation both before, during, and after the performance that it will always be remembered, now with amusement; but at the time amusement was not unmixed with apprehension. As it was thought that the heat required could not be attained under eighteen hours and it would therefore be necessary to run into the night during firing, it had been arranged to have a man who was a night fireman at the pottery take it on off nights. On this occasion, the head potter and the kiln builder sat up with the kiln although it had been started early in the day. . . . In the early morning, they stole away leaving a note

saying the kiln was "O.K." In order to test the firing capacity of the kiln, however, they had apparently forgotten the temperature at which a biscuit firing for porcelain should stop, and the result was that the pieces in this firing could never be glazed as they were too hard. . . .

That the body which the potter had prepared was too soft was apparent, and when he showed me the formula by which he had arrived at it, the faulty composition was evident even to my inexperience. Having received instructions to follow more closely the original formula given to him and to leave out any coloring matter, he prepared a new batch of clay which was used in a number of pieces afterward. There was a firing in which twenty seven pieces were broken or otherwise destroyed, and on another occasion several pieces were broken in setting the kiln, for previous to firing and even after the first firing porcelain clay is exceedingly fragile. These mishaps and the preparation for another firing brought us to the first of June when there was a biscuit firing, the first of which I have kept a record, and two days later, a glaze firing. Perhaps two firings in such close succession were too severe a tax upon my neighbors and, to add to the difficulty, the night of the last firing was close and murky with an atmosphere that caused the smoke to hang around like a pall. It was a critical time, for I knew that the contents of this kiln were practically to determine the question between success and failure, if only the firing could proceed without the intervention of the police. Fortunately this was the case and, although the fireman was threatened with arrest during the night, the firing proceeded to the end.

From this kiln came an interesting piece of glaze from the transmutation of copper which is now in the historical collection of the Pennsylvania Museum, two others I have in my possession, and one was purchased by Paul Jeanneney, the artist potter of Paris, who said he would have given any amount to possess it as he had nothing like it in his collection. Neither have I nor do I know by what means it was brought about. I became aware, moreover, that while certain results had been achieved, I never could be quite certain as to the means unless I made the compositions myself, while the potter would prefer to have me remain dependent upon him

for the mixing of the materials for which he was charging me a very high price. The whole situation called for a rearrangement and this, after some reflection, I entered upon.

In the first place a new fuel must be found in order to have peace, and I must also procure the raw materials and mix my own body and glaze for the ware. The question of fuel was finally settled by the choice of Connellsville coke, although I think this had never been used for such a purpose before. . . . Materials were also procured, and a series of trials of various mixtures for a porcelain body were begun during which nearly a hundred compositions of bodies and glazes were tried. It was not until late in the year of 1900 that the composition that had proved satisfactory had been settled upon and it was even later, about March 1901, that the best results were secured. During this period, it seemed as if every flaw that fire could produce upon pottery had shown itself in the ware that came from my kiln. Cracks, blisters, warping, it appeared that the whole category was lavished upon the unfortunate product. . . . Being of rather an optimistic temperament I declined to recognize defeat and continued until the processes were practically under control, although there is always in the ordeal of fire an element of the unexpected that only adds to the charm. . . .

The trials that have been recited are merely those which have always beset those who stray away from the beaten track in any field and are not to be mentioned beside those of many other potters. . . .

# VI.  WOMEN IN ART SCHOOLS

By the second half of the nineteenth century, the importance of improving women's education was evident to many in France, England, and the United States. As England's Schools' Enquiry Commission noted in 1868: "The appropriation of almost all the educational endowments of the country to the education of boys is felt by a large and increasing number of both men and women to be a cruel injustice" (quoted Strachey 1978, 140). Post-secondary schools for women were established: Vassar College, the first four-year women's college in the United States opened in 1861, and by 1871 Girton and Newnham Colleges had been created at England's Cambridge University. Women's secondary schooling also improved: in France state-sponsored *lycées* for women were introduced in the 1880s.

Art schools, many of which had first opened their doors to women before 1850, began after mid-century to accept female students in greater numbers and to offer them more rigorous instruction. Private institutions were the first to admit women; the academy schools in France and England—which were still considered the best fine art schools and which charged no tuition—responded only when women mounted well-organized campaigns. By the 1870s it was possible, for the first time, for women who were not the daughters of artists to acquire an adequate professional art education. In increasing numbers, women ventured to the urban centers—Paris, London, Philadelphia, and New York—where the best art schools were located.

Whereas the strong-minded artists of earlier generations had been anomalies, whose professional commitments contrasted and conflicted with the prevailing emphasis on feminine domesticity, the professionalism of the women artists who came of age in the 1870s and 1880s was characteristic of their generation. Middle-class daughters were now becoming nurses and teachers, typists and doctors, and the need to choose between marriage and career was no longer so acute. As Lydia Field Emmett, who taught with William Merritt Chase, put it: "Art and domesticity are apt to

interfere, though circumstances being propitious, they are not necessarily incompatible" ("What Field . . ." 1893, 126).

In the last quarter of the century, the number of women participating in exhibitions rose significantly. The percentage of women included in England's Royal Academy exhibitions almost doubled between 1870 and 1880: at the start of the decade they made up 7.6 percent of the participants, by the end they numbered slightly over 15 percent. In France during this same period, the proportion of women participating in the Salon climbed from around 12 percent in 1870—the first year after the more restrictive juries of the Second Empire—to almost 20 percent in 1880. By 1884, even John Ruskin was forced to admit to the female students at the Royal Academy that "while for more than five and twenty years of my life I would not believe that women could paint pictures . . . I was wrong in that established conviction of mine—women *can* paint" (Ruskin 1908, 34:641).

# Memorial to Members of the Royal Academy (1859)

At mid-century there were a number of schools in London that offered art classes for women. Drawing was an important part of the curriculum at two schools founded in the late 1840s to educate governesses—Queen's College for Women and Bedford College for Ladies. In addition to Henry Sass' School of Art in Bloomsbury, which admitted women in the 1830s, there was Dickinson's Academy, a private art school founded by dissidents from the School of Design and run by James Matthew Leigh. After 1852 the government-sponsored School of Design offered classes for women at its Central Training School of Art as well as at the Female School of Design, which had moved to Gower Street.

The Royal Academy Schools, however, offered the best education to aspiring artists, and they remained closed to women. Applicants submitted drawings to earn the rank of "Probationer," which entitled them to three months to complete a satisfactory series of specified drawings. Once accepted as students, they received free tuition for seven years as they progressed from the Antique School to the Living Model and the School of Painting.

The matter of women's admission to the schools was brought before the public in 1859, when English newspapers and the government began to examine the administration of the Royal Academy. Since the 1830s the Academy had been housed in the

National Gallery's building on Trafalgar Square, but now the museum needed space for its expanding collections. When some Members of Parliament suggested that the government should provide land in Piccadilly for a new Academy building, others objected that public monies should not support a society that, while it was sponsored by the crown, remained essentially private and unaccountable to the government.

In March, as the question of the academicians' "abuse" of their position began to draw attention, a letter published in the *Athenaeum* pointed out that women were among those excluded from the advantages of the Academy schools:

> Instead of enjoying the opportunity of working for years under the supervision of our most eminent masters, women are left to struggle unaided through the difficulties and discouragements, which only artists can fully appreciate. Unless women are supposed capable of attaining by their talents alone as much as men with talents and years of *instructed* study can accomplish, it is difficult to conceive on what principle all the advantages of a national institution such as the Academy should be given to one sex and denied to the other. ("Royal Academy" 1859, 1637:361)

One month later, a group of women signed the following letter that was directed to the academicians themselves. Most of the women who signed the memorial were artists and were known to the public as participants in London's annual exhibitions. Others were better known in other fields. Anna Jameson, Ellen Clayton, and S. Ellen Blackwell—a member of America's extraordinary Blackwell family—were writers. Barbara Leigh Smith had come to public attention as the author of a *Brief Summary in Plain Language of the Most Important Laws Concerning Women*, which sparked efforts to reform England's property laws. Louisa Gann had recently been appointed head of the Female School of Design.

**Sir:**\*

We appeal to you to use your influence, as an artist and a member of the Royal Academy, in favour of a proposal to open the Schools of that institution to women. We request your attentive consideration of the reasons which have

---

\*    Reprinted from "Royal Academy," *The Athenaeum*, no. 1644 (30 April 1859), 581.

originated this proposal. When the Academy was established in 1769, women artists were rare; no provision was therefore required for their Art-education. Since that time, however, the general advance of education and liberal opinions has produced a great change in this particular; no less than one hundred and twenty ladies have exhibited their works in the Royal Academy alone, during the past three years, and the profession must be considered as fairly open to women. It thus becomes of the greatest importance that they should have the best means of study placed within their reach; especially that they should be enabled to gain a thorough knowledge of *Drawing* in all its branches, for it is in this quality that their works are invariably found deficient. It is generally acknowledged that study from the Antique and from Nature, under qualified masters, forms the best education for the artist; this education is given in the Royal Academy to young men, and it is given gratuitously. The difficulty and expense of obtaining good instruction oblige many women artists to enter upon their profession without adequate preparatory study, and thus prevent their attaining the position for which their talents might qualify them. It is in order to remove this great disadvantage, that we ask the members of the Royal Academy to provide accommodation in their Schools for properly qualified Female Students, and we feel assured that the gentlemen composing that body will not grudge the expenditure required to afford to women artists the same opportunities as far as practicable by which they have themselves so greatly profited. We are, Sir, your obedient servants,

> J. K. Barclay, A. C. Bartholomew, S. Ellen Blackwell, Anna Blunden, B. L. S. Bodichon, Eliza F. Bredell (late Fox), Naomi Burrell, M. Burrowes, Florence Claxton, Ellen Clayton, Louisa Gann, Margaret Gillies, F. Greata, Charlotte Hardcastle, Laura Herford, Caroline Hullah, Elizabeth Hunter, Charlotte James, Anna Jameson, F. Jolly, R. Le Breton, R. Levison, Eliza Dundas Murray, M. D. Mutrie, A. F. Mutrie, Emma Novello, Emma S. Oliver, E. Osborn, Margaret Robinson, Emily Sarjent, Eliza Sharpe, Mary Anne Sharpe, Sophia Sinnett, Bella Leigh Smith, R. Solomon, M. Tekusch, Mary Thornycroft, Henrietta Ward.

April, 1859

The Royal Academy responded that admitting women would necessitate a separate life class, for which there was neither space nor money. But it did not ignore the issue of women's educational opportunities: it donated fifty pounds to a campaign to raise money for the Female School of Design. In 1860, at the suggestion of Charles Eastlake, president of the Academy, Laura Herford, who had studied at Leigh's school and signed the petition the year before, submitted to the Academy's schools a drawing signed only with her initials. As reported by the *Athenaeum*, "the excellence of the drawing the fair probationer sent in . . . was such that the [Academy's] Council were committed to its worthiness before they knew 'what they were about' " ("Fine Art Gossip" 1860, 330). The Council then discovered there were in fact no regulations prohibiting women from entering the schools. Several other women sent in applications, and the following year there were five women studying in the Antique Class.

Two years later the Royal Academy refused to accept any more women until a separate school could be built for them. Despite petitions from female students at the National Art Training School—as the School of Design had been renamed—and at the Female School of Design as well as from the women admitted to the Academy schools, no more women were admitted for the next five years, when the first group of students had progressed from Antique Class to the Living Draped Model. Until 1869, when the Royal Academy moved to its new quarters in Burlington House, the Council limited the number of female students to thirteen.

# Elizabeth Thompson Butler: An Autobiography (1866-1875)

Elizabeth Thompson Butler (1850?-1933) was born to an English family that easily accommodated her desire to become an artist. Her mother, Christina Thompson, was more interested in watercolors and the piano than in running a household. Her father, James Thompson, whose independent income allowed the family to live for extended periods in Italy, was neither practical nor ambitious, and turned his scholarly instincts to his daughters' education. When Charles Dickens, a family friend, came to visit, he found

James on the terrace giving lessons to "two little girls in an untidy state" with their hair cropped "in a manner never before seen" and decorated with bows (quoted Badeni 1981, 8).

Elizabeth Thompson's formal art education began in the lower classes at the National Art Training School in South Kensington, but when she grew impatient with a curriculum that emphasized design and repetition, her parents sent her to work with a Mr. Standish. She returned to the South Kensington schools in 1866, eager to succeed. Her family settled temporarily and reluctantly in England: "You know," she admonished her mother, "that if I am to study I must not run about hither and thither and take snatches of study instead of keeping on regularly" (quoted Badeni 1981, 31).

Women students at South Kensington were limited to working from the costumed model, but in 1866 that was all that was available to women art students in any of the English schools. Women in the Royal Academy schools would not work from the nude model until 1903. When the Slade School of Fine Art at University College London opened in 1871, female and male students worked together from the antique and costumed model; a separate class with a nude model for women was introduced in 1898.

Elizabeth Thompson enjoyed the life of an art student: "There cannot," she felt, "be a happier one for a boy or girl" (Butler 1923, 45). She joined the Sketching Club and attended classes with the draped model sponsored by the Society of Female Artists, exhibited at the Dudley Gallery and the Society of Female Artists, and was rejected from the Society of British Artists. In 1868 her parents became concerned about their younger daughter Alice's health, and the family returned to Italy. While Alice, who would become a poet, read Keats under an arbor, Elizabeth persuaded the peasants who worked the neighboring vineyards to sit for her. She studied with Giuseppe Bellucci and painted *The Magnificat*, for which her mother posed as the Virgin. The painting was included in the international exhibition sponsored by the Pope at the cloisters of S. Maria degli Angeli, but in 1871 it was rejected by the Royal Academy, which returned it to the artist with a hole in the canvas. She continued to send Italian genre scenes and religious and military subjects to the Dudley Gallery and Society of Female Artists exhibitions. Finally in 1873 her *Missing* was accepted at the Royal Academy—though it was "skyed," hung so near the ceiling it was difficult to see. She returned to London to complete *The Roll Call*, a work commissioned by Charles Galloway that met with overwhelming success at the Academy. In 1875 her *Quatre Bras* won over even John Ruskin, who called it "Amazon's work."

By the middle 1870s, Elizabeth Thompson was concentrating on military subjects. The parameters of this highly specialized sub-genre had been set by such French artists as Edouard Détaille and Horace Vernet. It required, as she recognized, a meticulous attention to the detail of military costume and custom, for veterans and patriots would tolerate no lapses. She concentrated on rank and file soldiers rather than officers and maintained that she never "painted for the glory of war, but to portray its pathos and heroism" (quoted Yeldham 1984, 1:327).

In 1877 Elizabeth Thompson married Major William Francis Butler, G.C.B. His military career took her, and later their six children, to the Middle East and South Africa and provided her with subjects for the paintings she regularly exhibited at the Royal Academy. In 1879 she was proposed for Associateship in the Royal Academy and lost by two votes. Elizabeth Thompson Butler's autobiography, published in 1923, drew freely on the journal she had kept during her early years.

## In the Art Schools*

*"January 1.* Enter, 1866, bearing for me happy promise for my future, for to-day I had the interview with Mr. Burchett, the Headmaster of the South Kensington School of Art, and everything proved satisfactory and sunny. First Papa and I trotted off to Mr. Burchett's office and saw him, a bearded, velvet-skull-capped and cold-searching-eyed man. After a little talk, we galloped off home, packed the drawings and the oil, then, Mama with us, we returned, and came into The Presence once more. The office being at the end of the passage of the male schools, I could see, and envy, the students going about. So the drawings were scrutinized by *that Eye*, and I must say I never expected things to go so well. . . . We were a long time talking, and he was very kind, and told me off to the Life School after preliminary work in the Antique. I join to-morrow. I now really feel as though fairly launched. Ah! they shall hear of me one day. But, believe me, my ambition is of the right sort.

---

* Excerpted from Elizabeth Thompson Butler, *An Autobiography,* London: Constable and Co., Ltd., 1923, 39-41, 43-44, 101-7, 110, 113, 120-24, 130-33, 135.

"*January 2.* A very pleasant day for me. At ten marched off, with board, paper, chalk, etc., to the schools, and signed my name and went through all the rest of the formalities, and was put to do a huge eye in chalk. I felt very raw indeed, never having drawn from a cast before. Everything was strange to me.

"*January 24.* I shall soon have done the big head and shall soon reach a full-length statue, and I shall go in for anatomy rather than give so much time to this shading which the students waste so much time over. I don't believe in carrying it so far. The little pale girl I like, on the completion of her gladiator, has been promoted to the life class. A girl made friends with me, a big grenadier of a girl, who says she wants to know 'all about the joints and muscles' and seems a 'thoroughgoer' like myself.

"*March 19.* Oh, joyous day! Oh, white! oh snowy Monday! or should I say *golden* Monday? I entered the Life this joyous morn, and, what's more, acquitted myself there not only to my satisfaction (for how could I be satisfied if the masters weren't?), but to Mr. Denby's and the oil master's *par excellence*, Mr. Collinson's. I own I was rather diffident, feeling such a greenhorn in that room, but I may joyfully say 'So far, so good,' and do my very best of bests, and I can't fail to progress. . . . Little 'Pale Face' took me in hand and got me a nice position quite near the sitter, as I am only to do his head. There was a good deal of struggling as the number of girls increased, and late comers tried amicably to badger me out of my good position. Three semi-circles surround the sitter and his platform. The inner and smaller circle is for us who do his head only, and is formed by desks and low chairs; the next is formed by small fixed easels, and the outer one by the loose easel brigade, so there are lots of us at work. At length the martyr issued from the curtained closet where Messrs. Burchett, Denby, and Collinson had been helping the unhappy victim to make a lobster of his upper half with heavy plates of armor. He became sadly modern below the waist, for his nether part was not wanted. . . . Mr. Denby was much pleased with my drawing in, and Mr. Collinson commended my carefulness. This pleases me more than

anything else, for I know that carefulness is the most essential quality in a student."

### The Roll Call

. . . After my not inconsiderable success with *Missing* at the Academy [of 1873], I became more and more convinced that a London studio *must* be my destiny for the coming winter. Of course, my father demurred. He couldn't bear to part with me. Still, it must be done, and to London I went, with his sad consent. I had long been turning *The Roll Call* in my mind. My father shook his head; the Crimea was "forgotten." My mother rather shivered at the idea of the snow. It was no use, they saw I was bent on that subject. My dear mother and our devoted family doctor in London (Dr. Pollard), who would do anything in his power to help me, between them got me the studio No. 76, Fulham Road, where I painted the picture which brought me such utterly unexpected celebrity.

Mr. Burchett, still headmaster at South Kensington, was delighted to see me with all the necessary facilities for carrying out my work, and he sent me the best models in London, nearly all ex-soldiers. One in particular, who had been in the Crimea, was invaluable. He stood for the sergeant who calls the roll. I engaged my models for five hours each day, but often asked them to give me an extra half-hour. Towards the end, as always happens, I had to put on pressure, and had them for six hours. . . .

I called Saturday, December 13th, 1873, a "red letter day," for I then began my picture at the London studio. Having made a little water colour sketch previously, very carefully, of every attitude of the figures, I had none of those alterations to make in the course of my work which waste so much time. Each figure was drawn in first without the great coat, my models posing in a tight "shell jacket," so as to get the figure well drawn first. How easily then could the thick, less shapely great coat be painted on the well-secured foundation. . . .

On March 29th and 30th, 1874, came my first "Studio Sunday" and Monday, and on the Tuesday the poor old *Roll*

*Call* was sent in. I watched the men take it down my narrow stairs and said "Au revoir," for I was disappointed with it, and apprehensive of its rejection and speedy return. So it always is with artists. We never feel we have fulfilled our hopes.

The two show days were very tiring. Somehow the studio, after church time on the Sunday, was crowded. Good Dr. Pollard hired a "Buttons" for me, to open the door, and busied himself with the people, and enjoyed it. So did I, though so tired. It was "the thing" in those days to make the round of the studios on the eve of "sending-in day." . . .

*"Saturday, April 11th.* A charming morning, for Dr. Pollard had a fine piece of news to tell me. First, Elmore, R.A., had burst out to him yesterday about my picture at the Academy, saying that all the academicians are in quite a commotion about it, and Elmore wants to make my acquaintance very much. He told Dr. P. I might get £500 for *The Roll Call!* I little expected to have such early and gratifying news of the picture which I sent in with such forebodings. . . .

*" 'Varnishing Day,' Tuesday, April 28th.* My real feelings as, laden like last year, with palette, brushes, and paint box, I ascended the great staircase, all alone, though meeting and being overtaken by hurrying men similarly equipped to myself, were not happy ones. Before reaching the top stairs, I sighed to myself, 'after all your working extra hours through the winter, what has it been for? That you may have a cause for mortification in having an unsatisfactory picture on the Academy walls for people to stare at.' I tried to feel indifferent, but had not to make the effort for long, for I soon espied my dark battalion in Room *II*, *on the line*, with a knot of artists before it. Then began my ovation (!)(which, meaning a second-class triumph, is *not* quite the word). I never expected anything so perfectly satisfactory and so like the realization of a castle in the air as the events of this day. It would be impossible to say all that was said to me by the swells. Millais, R.A., talked and talked, so did Calderon, R.A., and Val Prinsep, asking me questions as to where I had studied, and praising this figure and that. . . . I could hardly do the little helmet alterations necessary, so crowded was I

by congratulating and questioning artists and starers. I by no means disliked it all. . . . 'Only send as *good* a picture next year' was Millais' answer to my expressed hope that next year I should do better. This was after overhearing Mr. C. tell me I might be elected A.R.A. if I kept up to the mark next year. O'Neil, R.A., seemed rather to deprecate all the applause I had today and, shaking his head, warned me of the dangers of sudden popularity. I know all about *that*, I think. . . .

"*Monday, May 4th.* The opening day of the Royal Academy. A dense crowd before my grenadiers. I fear that fully half of the crowd have been sent there by the royal speeches on Sunday. I may say that I awoke this morning and found myself famous. Great fun at the Academy, where were some of my dear fellow students rejoicing in the fulfillment of their prophecies in the old days. Overwhelmed with congratulations on all sides; and as to the papers, it is impossible to copy their magnificent critiques, from *The Times* downwards.

"It is a curious condition of the mind between gratitude for the appreciation of one's work by those who know, and the uncomfortable sense of an exaggerated popularity with the crowd. The exaggeration is unavoidable, and, no doubt, passes, but the fact that counts is the power of touching the people's heart, an 'organ' which remains the same through all the changing fashions in art.'' . . .

### Quatre Bras

On July 4th Colonel Browne, C.B., R.E., who took the keenest interest in my *Quatre Bras*, and did all in his power to help me with the military part of it, had a day at Chatham for me. He, Mrs. B. and daughters called for me in the morning, and we set forth for Chatham, where some 300 men of the Royal Engineers were awaiting us on the "Lines." Colonel Browne had ordered them beforehand, and had them in full dress, with knapsacks, as I desired. . . .

They first formed the old-fashioned four-deep square for me, and not only that, but the beautiful parade dressing was broken and *accidenté* by my direction, so as to have a little more the appearance of the real thing. They fired in sections, too, as I wished, but, unfortunately, the wind was

so strong that the smoke was whisked away in a twinkling, and what I chiefly wished to study was unobtainable, i.e., masses of men seen through smoke. After they had fired away all their ammunition, the whole body of men were drawn up in a line, and, the rear rank having been distanced from the front rank, I, attended by Colonel Browne and a sergeant, walked down them both, slowly, picking out here and there a man I thought would do for a *Quatre Bras* model (beardless), and the sergeant took down the name of each man as I pointed him out very unobtrusively, Colonel Browne promising to have these men up at Brompton, quartered there for the time I wanted them. . . .

"*July 16th*. Mama and I went to Henley-on-Thames in search of a rye field for my *Quatre Bras*. Eagerly I looked at the harvest fields as we sped to our goal to see how advanced they were. We had a great difficulty in finding any rye at Henley, it having all been cut, except a little patch which we at length discovered by the direction of a farmer. I bought a piece of it, and then immediately trampled it down with the aid of a lot of children. Mama and I then went to work, but, oh! horror, my oil brushes were missing. I had left them in the chaise, which had returned to Henley. So Mama went frantically to work with two slimy water-color brushes to get down tints whilst I threw down forms in pencil. We laughed a good deal and worked on into the darkness, two regular 'Pre-Raphaelite Brethren,' to all appearances, bending over a patch of trampled rye." . . .

The next entries are connected with the *Quatre Bras* cartoon: "Dreadful misgivings about a vital point. I have made my front rank sitting on their heels in the kneeling position. Not so the drill book. After my model went, most luckily came Colonel Browne. Shakes his head at the attitudes. Will telegraph to Chatham about the heel and let me know in the morning.

"*July 23rd*. Colonel Browne came, and with him a smart sergeant-major, instructor of musketry. Alas! this man and telegram from Chatham dead against me. Sergeant says the men at Chatham must have been sitting on their heels to rest and steady themselves. He showed me the exact position when at the 'ready' to receive calvary. To my delight I may

have him tomorrow as a model, but it is no end of a bore, this wasted time.

"*July 24th.* . . . It is extraordinary what a well-studied position that kneeling to resist cavalry is. I dread to think what blunders I might have committed. No civilian would have detected them, but the military would have been down upon me. I feel, of course, rather fettered at having to observe rules so strict and imperative concerning the poses of my figures, which, I hope will have much action. I have to combine the drill book and the fierce fray! I told an artist the other day, very seriously, that I wished to show what an English square looks like viewed quite close at the end of two hours' action, when about to receive a last charge. A cool speech, seeing I have never seen the thing! And yet I seem to have seen it—the hot, blackened faces, the set teeth or gasping mouths, the bloodshot eyes and the mocking laughter, the stern cool, calculating look here and there; the unimpressionable, dogged stare! Oh! that I could put on canvas what I have in my mind!". . .

And so I worked steadily at the big picture, finding the red coats very trying. . . .

One day the Horse Guards, directed by their surgeon, had a magnificent black charger thrown down in the riding school at Knightsbridge (on deep sawdust) for me to see, and get hints from, for the fallen horse in my foreground. The riding master strapped up one of the furious animal's forelegs and then let him go. What a commotion before he fell! How he plunged and snorted in clouds of dust till the final plunge, when the riding master and a trooper threw themselves on him to keep him down while I made a frantic sketch. "What must it be," I ask, "when a horse is wounded in battle, if this painless proceeding can put him into such a state?"

The spring of 1875 was full of experiences for me. . . . "I was favoured with a charge, two troopers riding full tilt at me and pulling up at within two yards of where I stood, covering me with sawdust. I stood it bravely the second time, but the first I got out of the way. With *Quatre Bras* in my head, I tried to fancy myself one of my young fellows being charged, but I fear my expression was much too feminine and pacific.". . .

On "Studio Monday" the crowds came, so that I could do very little in the morning. The novelty which at first amused me, had worn off, and I was vexed that such numbers arrived. . . .

On Varnishing Day at the Academy I was evidently not enchanted with the position of my picture. "It is in what is called 'the Black Hole'—the only dark room, the light of which looks quite blue by contrast with the golden sun-glow in the others. However, the artists seemed to think it a most enviable position. The big picture is conspicuous, forming the centre of the line on that wall. One academician told me that on account of the rush there would be to see it they felt they must put it there. This 'Lecture Room' I don't think was originally meant for pictures and acts on the principle of a lobster pot. You may go round and round the galleries and never find your way into it! I had the gratification of being told by R.A. after R.A. that my picture was in some respects an advance on last year's, and I was much congratulated on having done what was generally believed more than doubt-ful—that is, sending an important picture this year with the load and responsibility of my 'almost overwhelming success,' as they called it, of last year on my mind. And that I should send such a difficult one, with so much more in it than the other, they all consider 'very plucky.'. . .

"*May 3rd.* To the Academy on this, the opening day. A dense, surging multitude before my picture. The whole place was crowded so that before *Quatre Bras* the jammed people numbered in dozens and the picture was most completely and satisfactorily rendered invisible. . . . I see I am in for minute and severe criticism in the papers, which actually give me their first notices of the R.A. The *Telegraph* gives me its entire article. The *Times* leads off with me because it says *Quatre Bras* will be the picture the public will want to hear about most. It seems to be discussed from every point of view in a way not usual with battle pieces. But that is as it should be, for I hope my military pictures will have moral and artistic qualities not generally thought necessary to military genre."

# Cecilia Beaux: Background with Figures (1872-1920)

When Adolph Beaux's wife died, he returned to his native France and left his two daughters—Cecilia (c. 1855-1942) and Ernesta— in Philadelphia to be raised by their maternal grandmother, two aunts, and an uncle. Although the family was not well off financially, the girls learned to value culture and respect discipline. Their Aunt Eliza, a spinster who was an amateur pianist and watercolorist, taught the girls French, history, sewing, and drawing, and took them to exhibitions. Cecilia Beaux spent two years at a girls' school and at sixteen was allowed to study art with a cousin, Catherine or "Kate" Drinker, who was the first female instructor at the Pennsylvania Academy of Fine Arts. She and her sister transformed their third-floor bedroom into a "studio" filled with plaster casts of "heathen gods and goddesses" (Bowen 1970, 161). Although Beaux's aunts thought she might become an illustrator or a copyist, she did not consider art as a career until she realized that if she did not marry she would need a means to support herself.

Women's opportunities to study in American art schools were improving. The Pennsylvania Academy of Fine Arts, which had regularly enrolled women in the mid 1840s, allowed them to attend anatomy lectures by 1860. Eight years later a nude model was introduced into the female life class, making the academy the first American school where women worked from the nude. Beaux later maintained that her uncle did not want her to attend art school, but her name appears on the Pennsylvania Academy of Fine Arts student rosters for 1877 and 1879. At the National Academy of Design, widely considered New York's most important art school, men and women were working together from the clothed model by 1878. Women also studied at New York's Cooper Union, which had incorporated the New York School of Design for Women, and the Art Students League, a cooperative venture founded in 1875 by disaffected students of the National Academy of Design, women on an equal basis from the start. American art schools were generally considered inferior to European, however, and in the last quarter of the century increasing numbers of young women ventured to Europe—and especially Paris—to study.

Beaux, who sent her first important painting, *Les Derniers Jours d'Enfance*, to the French Salon of 1887, left for Paris herself

the following year accompanied by a cousin. She worked at the Académie Julian under Tony Robert-Fleury, copied paintings by Velázquez and Rubens, and travelled throughout Europe and England—but disdained the bohemian inconveniences that other young women revelled in. After her return to the United States in 1890, Beaux initially lived and worked in Philadelphia as she developed a reputation as a fashionable portrait painter. In 1896 she was named the first full-time female instructor at the Pennsylvania Academy of Fine Arts, and by 1900 she established a second studio in New York City. Her friends were drawn from the social, literary and political elite of the period, and her sitters included Mrs. Theodore Roosevelt, Mrs. Andrew Carnegie, and Georges Clemenceau.

In later years, her nieces remembered "Aunt Beaux" as a formidable and elegant lady with an indomitable spirit, steel-blue eyes and beautifully made tweed suits with fur collars. She had "a glance that could cut" and extraordinary powers of observation: she could "sit in a Chestnut Street trolly car for three minutes and afterward describe the passengers so that you sat enthralled" (Bowen 1970, 102). When William Merritt Chase awarded her the Carnegie Institute's gold medal in 1897, he annoyed the artist by calling her "not only the greatest living woman painter, but the best that has ever lived."

"They don't," Cecilia Beaux observed, "write about *men* painters" (quoted Bowen 1970, 167).

**Class and Studio\***

At seventeen, life begins to open up very perceptibly. Horizons broaden, consciousness appears, and more of this than desired. Even without brusque changes of circumstance or important events, one might say that the day was altered.

One development was clearly marked. I began going to Art School. It was not one that became permanent in Philadelphia though it promised well and was the only one of its kind. A Dutch artist, Van der Whelen, being obliged, just as his career was opening, to give up painting on account of eye trouble that threatened blindness, had come to America

---

\*    Excerpted from Cecilia Beaux, *Background with Figures,* Boston and
      New York: Houghton Mifflin, 1930, 64-66, 69, 84-89, 193, 194, 202-4,
      235, 280, 281-84, 292, 294-97.

and, under responsible patronage, opened a school. My uncle decided, and with great generosity gave me, everything that related to my art education, one day escorted me thither. There were many steps to climb, but we, that is I (for my uncle had already investigated it) found two large rooms, flooded with light; freshly painted walls, many casts, easels, a blackboard, and a few pupils. . . .

Some of my fellow pupils were drawing from the casts; that is busts and fragments from the antique. These were not very well chosen, but I longed to undertake them, especially as this was my first view of student work of this kind, and I felt I might surpass it. But other *épreuves* were to be met first. On a shelf there were rows of geometrical forms, also in plaster, cubes, circular and pyramidal, blocks and a sphere. . . . A group of these was arranged for me on the table by the director. . . .

What criticism we had always took place in the morning. We might stay all night if we liked. Our director never appeared again, and my pleasant recollection of the school is that of quiet afternoons, when my special friend among the students and I sat together at the big, comfortable table, under the light, and drew from a set of models [a complete set of the bones of the skull] she provided. . . .

<div align="center">*      *      *</div>

But life now began to contain in itself much that was completely outside of "Art," though that word was not used currently in our house, and I rarely heard it, although it was, in music and matters of living, persistently pursued by the family. Some one told me that a row of brown books on the shelves were Ruskin's *Modern Painters*. These I read, and of course accepting all, was wafted to glorious heights by the style and enthusiasm of the author. But as far as consciously connecting this with my own life was concerned, I might as well have been busy with gardening or mending.

Although all sorts of intangibilities and uncertainties hovered about my existence, there was one rock-bottom reality. I must become independent. My grandmother's house was my home, and in it I was the youngest born, but I

wished to earn my living and to be perhaps a contributor to
the family expenses. To do this I stepped naturally into the
opportunities offered, of which, for better or worse, there
were many. I took a month's lessons in china painting from a
French expert, in the ignoble art of over-glaze painting. How
ignorant I was and how quickly mastered what could be got
from it! My instructor said nothing to me of the legitimate
field of this kind of work, and I at once began adapting it to
portraiture. A sad confession. The results were, alas, too
successful, and were much desired. For, somehow, after four
firings in a remote kiln, I managed to get upon a large china
plaque a nearly life-size head of a child (background always
different), full modelling, flesh color and all, that parents
nearly wept over. . . .

My reputation spread. Mothers in the Far West sent
with the photograph a bit of ribbon, the color of the boy's
eyes, as well as a lock of hair. In such cases, of course, I never
saw the child.

Without knowing why, I am glad to say that I greatly
despised these productions, and would have been glad to
hear that, though they would never "wash off," some of
them had worn out their suspending wires and been dashed
to pieces.

This was the lowest depth I ever reached in commercial
art, and, although it was a period when youth and romance
were in their first attendance on me, I remember it with
gloom and record it with shame. . . .

The time came when the next allowed opening was
ready for me, and I for it.

Long before this, I would have turned toward the
classrooms of the P[ennsylvania] A[cademy of] F[ine] A[rts],
but my uncle, to whom I owed everything that my
grandmother had not done for me, was steadfastly opposed
to this. There was no reason to suppose that my trend was to
be serious or lasting. I was a seemly girl and would probably
marry. Why should I be thrown into a rabble of untidy and
indiscriminate art students and no one knew what influence?
So reasoned his chivalrous and also Quaker soul, which
revolted against the life-class and everything pertaining to it.
He put a strong and quiet arm between me and what he

judged to be the more than doubtful adventure, and before long an opportunity came of which he entirely approved.

I had one acquaintance—a schoolmate, indeed, at Miss Lyman's—who, after a year or two of social gaiety as a debutante, began seriously to turn toward painting. She organized a class and took a studio. She had none of my limitations in the way of "ways and means." She asked me to join the class. We were to work from a model three mornings in the week, and Mr. Sartain had consented to come over from New York once every fortnight to criticize us. My uncle entered at once into this arrangement, and with his usual generosity paid my share in the cost.

Across all the intervening years it now seems that the record of this adventure, for so it now appears to me, should be written with a pen of fire. Time and experience have given it a poignancy, a significance, only dimly felt at the moment.

There were a few, only in the class, all young, but all respectful toward what we were undertaking. It was my first conscious contact with the high and ancient demands of Art. No kind of Art, music or other, had ever been shown to me as a toy or plaything to be taken up, trifled with and perhaps abandoned. I already possessed the materials for oil painting, and had used them quite a little, but without advice.

But the unbroken morning hours, the companionship, and, of course above all, the model, static, silent, separated, so that the lighting and values could be seen and compared in their beautiful sequence and order, all this was the farther side of the very sharp corner I had turned, into a new world which was to be continuously mine.

When William Sartain appeared in the class as our teacher and critic, he was undoubtedly the first artist most of us had ever seen—and how far he was from the type generally described by story-writers! . . . What I most remember was the revelation his vision gave me of the model. What he saw was there, but I had not observed it. His voice warmed with the perception of tones of color in the modelling of cheek and jaw in the subject, and he always insisted upon the proportions of the head, in view of its power content, the summing up, of the measure of the individual. . . .

**Return from Paris**

After a separation [from my family] of nearly nineteen months, the great emotion and happiness of return [in 1890] was in finding them all there. The little ones were larger, and—this was best of all—the older unaltered to my perception. My uncle helped me to find a studio, and very soon I was undertaking new projects in painting, the next five years being very busy ones. . . .

It is needless to say that the environment of an artist, especially during the first years of struggle—for struggle is always present in one form or another—has an immense influence upon his productivity and expansion. Many a youthful proclivity, perhaps power, has gone under before family or other prejudice, or careless interruption, or a lack of belief or understanding of the "case." Equally pernicious is the overestimate of the beginner's promise; the parents bringing forward and exploiting their child's "talent," encouraging him to flutter from one art school or atelier to another. The world is full of the result of this method, which is a condition which has developed from the period when the young person, who at least felt himself possessed of a vocation, had to run away from home and suffer privation to pursue it. I am not sure that hardness is not better than cotton wool. It was my great good fortune not to experience either of these conditions. I sometimes think that one who is destined to be a pursuer of plastic art, in any form, cannot have a better fate than to be brought up in a family of musicians, and one that is not crowded by what George Herbert calls "the bane of bliss and source of woe." Of Art, such a group is always "aware," though they may have experience only in their own. They know what its pursuit means, and what it exacts. They do not apply other standards to other arts. My family never flattered me, to myself or others; neither did they pretend to understand an art they had not applied themselves to. They understood perfectly the spirit and the necessities of an artist's life. I never accomplished more than was expected of me. Any sign in me of an overestimate of myself or my doings would have been though humorous, perhaps distressing.

The aunt with the sleek head, with her curving smile,

used to quote a notice that had appeared in a penny newspaper: "The Item does not hesitate to declare that Miss Cecilia Beaux is the best Female Portrait Painter in Philadelphia." No wonder that I advanced with a thoroughly made-up mind on the subject of Sex in art. But this aunt was the very one, who, in order that I might start fresh for my day's work, made my bed and "did" my room, leaving the breakfast table—for I had to start early—to follow me to the front door, with my basket, containing a bottle of milk, and a large buttered roll that she had prepared. It was quite a long walk from our house in West Philadelphia to the trolley which bore me to town in about forty minutes. This was easy enough in the morning, and I generally reached my studio about nine. An hour was none too much for clearing the decks for action, preparing my palette, considering the canvas in progress, and my intentions concerning it, so that at ten I was no more than ready for the subject who was expected to be prompt also, and who finding me always waiting, easily got into the habit.

I soon found that the intensive work, for me, could not be carried over into the afternoon. Fortunately, I was aware when the moment came when there was nothing more, of the best, to give. But the later hours, though recognized not to be worthy of high pressure, could contain those operations and accumulations that characterized any studio, and upon which the golden hours should not be wasted. At this time also, I was liable to the agreeable interruptions of friends, from some of whom I received fresh and stimulating influence.

After a struggle in the short winter days, with the weather, crowds, and the long waits at street-corners at the rush hour (I rarely had a seat in the car), the walk home, on feet that had stood nearly all day, and with nerves that had spent all they had, what a refuge was mine! I need not speak to any one; I could go to my room until dinner time, and after it I frequently spent the whole evening on the parlor sofa, completely relaxed, and often asleep, or just conscious of my comfort, sometimes of my uncle's voice, reading, of quiet laughter, talk, and some challenge. Nothing was required of me. Although the life at home was or would have been monotonous, except for the mental quality of those who

formed it, I was never expected to bring in life and entertainment to revive a dull evening; still less to do any of those small services that would naturally have been the part of the young, active member of the family. In all the years that followed my return from abroad, to the, alas, final breaking-up of our family circle, I was never once asked to do an errand in town, some bit of shopping, or a call, that would have put the slightest pressure on me. So well did they understand. . . .

## War Portraits

In the spring of 1919, a committee was formed of men and women, prominent in our social and financial world, for the purpose of getting together a series of portraits of the outstanding figures of the War; these portraits to be presented finally, to the United States Government. . . .

The secretary of the committee called on me, and asked me to undertake to go abroad and execute three of these portraits. I accepted with a full sense of the significance and interest of the commission. I was told that the three to be entrusted to me were Cardinal Mercier, Clemenceau, and Admiral Lord Beatty. . . .

Arriving in Paris in the spring of 1919, the artist upon whom had been placed the responsibility of producing an interpretation of this personality [Clemenceau], in a painted portrait, had long to wait.

The Président du Conseil, it seemed, had had (outside of our boys and their officers) *plein le dos* of Americans. He was in no mood to resign himself to any polite suggestions from us. Moreover, anyone could see that there was no time. The preparation of the Treaty [of Versailles] was going on. The great event of the Signing was near. The elections were imminent. The gracious member of the Council who had charge of our rather inopportune affair decided that it would be useless to approach our victim at such a time. . . .

For many years everybody has been familiar with the physiognomy of Georges Clemenceau. There is a sprinkling everywhere of gossip about his vehemence, his duels, and his success in making enemies. Many were the newspaper prints of his bold, ironic head as he sat at the council table with

Wilson and Lloyd George. In many of these there was not even a thin veil over the exposure of his boredom. With the exception of the representative of Great Britain, how slow they were, the Council, how little *documented*! But one could not be too widely informed about even the merely superficial aspect of the man, and all that pursuit could furnish in print, in photograph, bust, and painting all that ages and in all surroundings, I made my own.

But while I was quietly, as one might say, nibbling at the great subject, there came at last one of those swift openings into the next "Square" so enjoyed by Alice. The shining spear flashed overhead, as when Pallas Athene used to swoop down for the deliverance of her adherents.

I had a message from Mr. White [the United States Ambassador to France] that there would be a seat for me in the "Loge Diplomatique" at the Chamber on the Monday after the Signing [of the Treaty of Versailles], when Clemenceau was to present the "Peace" to the Senate.

With only the power and protection of my ticket, which was irrefutable, I went alone to the remote Temple I had so often passed on foot and bus, at only a few yards' distance. Crowds and confusion hung about the outskirts, and there were many narrow, grudging defiles to pass, where uniforms were on guard. When the last suspicious functionary showed me up the last dark stair and shoved open a door, I entered the Historic Theatre. There were other occupants of the Loge, which faced the Tribune, and all were grudging but one who made a place for me in the front row of seats. . . .

But suddenly on the left of the Tribune, the crowd gave way and there entered a small old man in a dark grey suit. A great shout went up, and turned into a continuous roar, but the small man with the great head seemed not to know it was for him, and moved unsmiling among his friends to one of the front rows of benches, on the Left, of course, and took his seat, resting his grey gloved hands on his stick.

I hardly know what happened next. I supposed the proceedings began. The elegant Duchenel, in faultless *redingote*, used the hammer incessantly. French Deputies are not always either polite or patient. . . .

But my *lorgnon* was not bent upon the Treaty, nor what

it might contain. When the Président du Conseil began to read, which he seemed to do without much consultation with the sheets before him, but with no sign of extemporaneous speech, I saw that the old man was young. He had had no dealings with age, an enemy who would have to wait.

The top-light brought out only the large masses, the superb construction of his head and his rich healthy color. How thankful I was for the simple lighting, and even for the distance!—and I learned that the great should always be seen first, if possible, *from a distance*, and without contradictory detail, by those who wished to study them. In this way the big forms and gestures become and remain predominant. . . .

I did not see Clemenceau again until the following spring. . . .

Opportunely enough, Mr. Gilder's daughter Rosamond accompanied me to the appointment [with Clemenceau], and we went right gaily, savoring mutually, after all, the adventure.

Number 8 rue Franklin is not very welcoming in appearance. . . .

Not an ancient servitor, but a good-looking young valet, answered our ring, and looked a little incredulous when I asked for M. Clemenceau; but I told him that I had an appointment with M. Clemenceau and was a little *avant l'heure*. Taking my card, he immediately returned smiling and said that Monsieur le Président du Conseil was engaged but would see me *dans un moment*. He showed us into the room with the yellow curtains, large, high-studded, and rather dark, in spite of its high windows. . . .

I had almost forgotten what we had come for when the door opened behind me and a great head wearing a black silk skull cap literally popped in. I believe I made some sort of noise—Rosamond said, I whooped—and in another moment I was crossing the hall with him to his study.

*Sans façon*, certainly. Why send for me when it was easier to stop for me, after seeing the other man out, and this small incident showed me how little waste there had been in the giant's life.

When the door of the study was closed behind us, the

little old man—for he seemed this now—turned on me and shouted, almost savagely, "Vous parlez Français?"

"Oui, Monsieur," I said; "but you know English so well that, if you please, we will speak English."

"Very well," he said, rather gently, and then, turning on me again, "Well, to begin with, we hate each other."

"No, Monsieur," I said, "that's only half true."

Whereupon he threw up his hands and laughed aloud, and I felt that the assault was over and the breach opened. . . .

Strangely enough, I have no recollection of this part of our interview. I suppose because all but my automatic facilities were engaged in *seeing*. The eyes of my *vis-á-vis* took my whole attention. The big modelling of the head had been conspicuous from a distance, at the Chamber, but the eyes there were only caverns. Now I got their full dynamic power, though the general form of the head, seen so near, became somewhat diminished. In a moment practical matters served up.

"What do you want from me?" he said.

I replied with the usual formula, "As much as I can have."

He said: "I have just come back from Egypt. I have had pneumonia. My doctors prescribe a few days inaction. I will give you a half hour tomorrow, and the same on the following two days."

"That would be no use to me," I said, desperately clinging to the exact truth; and then went on to explain, he listening with a sort of curiously amused interest.

"I have seen you in the Chamber, Monsieur," I said. "I watched you for two hours through a glass when you read the Treaty last September. I decided on the composition then, and have not changed my mind. I have spent much time in examining every bust and photograph of you to be found. I do not count on regular sittings from you which you would not have time for.

"It would do me no good to come to-morrow, as I must work to-morrow on what I have seen today. I am not going to make a *Monsieur dans un fauteuil*."

Clemenceau seemed to approve entirely of this method, not offering any objection to it, and another appointment was made. . . .

## Marie Bashkirtseff: Journal (1877-1880)

Marie Bashkirtseff (1858-1884), whose Russian parents separated in her youth, grew up as a wealthy and privileged member of the émigré community of Nice and Paris. She wore elegant dresses to balls and the opera, studied voice and drawing with private instructors, and dreamed of marrying a duke and performing on the stage. The onset of tuberculosis forced Bashkirtseff to give up singing; in 1877 she entered the Académie Julian to study art.

The Académie Julian had been founded in 1868 by Rudolphe Julian, a former art student and prize fighter. The program was based on the French *atelier* method: the nude model posed in three sessions a day and instructors visited several times a week to criticize the students' efforts. The visiting artists had all achieved official success; Tony Robert-Fleury was the instructor during Bashkirtseff's tenure. Students regularly participated in *concours*, the traditional competitions designed to hone students' skills. But—unlike the Ecole des Beaux-Arts—there were no entrance requirements: the Académie Julian was open to anyone, male or female, French or foreign, who could pay the fees. And it prospered. Initially men and women met together in a former dance studio in the Passage des Panoramas. By the time Marie Bashkirtseff entered, however, Julian had opened a second class: men met in the lower rooms, while women met up on the floor above and paid slightly higher fees. Students who were male and French often went on to the Ecole des Beaux-Arts and the Prix de Rome competition; the others went directly to professional careers.

Bashkirtseff first appeared in the stuffy, grimy studio at the Passage des Panoramas dressed "in pure white from head to foot, as if she were a lily of the field," and accompanied by two tall ladies in black, her mother and aunt (Blind 1892, 156). Initially the other students—and Julian himself—thought her "a spoiled child." Bashkirtseff continued to enjoy balls and the opera, but she also worked hard and many of her fellow students eventually recognized her as studious and serious. She exhibited at the Salon for the first time in 1880, sending a study of her cousin Dina reading *The Question of Divorce*.

As her commitment to painting grew, Bashkirtseff found

herself frustrated by the conventions that restricted the lives of well-bred young ladies. Late in 1880, wearing a disguise and using the pseudonym Pauline Orell, she joined the militant suffrage group, Le Droit des Femmes, and began contributing reviews and articles to their journal *La citoyenne*.

By 1882 Bashkirtseff's health was beginning to fail. She became close friends with Jules Bastien-Lepage, whose naturalistic peasant subjects she admired and who was also very ill. At the Salon of 1884 Bashkirtseff's *The Meeting* brought her public praise, but not the award she coveted; the painting was similar in style to Bastien-Lepage's work, and she was suspected of having received assistance. Shortly thereafter, she was dead.

In 1873 Bashkirtseff had started a journal in which she described her studies, friendships, rivalries, and flirtations. She made no attempt to censor herself or to conform to contemporary ideas of feminine propriety. At her death, she had filled eighty-four volumes that she directed her mother to publish in full. Mme. Bashkirtseff recopied the manuscript, subtracted two years from her daughter's age, deleted some passages—notably those which Bashkirtseff spoke frankly of her sexuality or an interest in feminism—and turned the journal over to André Theuriet to edit.

The two volumes of excerpts published in 1887 were a sensation and were quickly translated into English. Some readers saw in Bashkirtseff a romantic heroine—wealthy, beautiful, headstrong, and tragic; others were offended by her ambition and lack of modesty. Elizabeth Rigby, Lady Eastlake, called her "a vain, frivolous, forward young lady" and pronounced the book "the most detestable and unhealthy rubbish I have ever read" (Rigby 1895, 1:300). For William Stead, the editor of *The Review of Reviews*, Bashkirtseff was "artist, musician, wit, philosopher, student, anything you like but a natural woman with a heart to love, and a soul to find its supreme satisfaction in sacrifice for lover or child" (quoted Bell and Offen 1983, 2:41).

*2 October 1877.** Today we move to 71, avenue des Champs-Elysées. In spite of all the bustle, I have found time

---

* Excerpted from Marie Bashkirtseff, *The Journal of Marie Bashkirtseff,* translated by Mathilde Blind, introduction. by Rozsika Parker and Griselda Pollock, London: Virago Press, 1985; 274-78, 282-85, 289-92, 303, 306, 335, 337, 340-41, 347-48, 359, 390-92, 394-97, 399-401; reprinted from London: Cassell and Co., Ltd., 1890.

to go to Julian's studio—the only good one for women. They work there every day from eight till twelve, and from one till five. A man was posing nude when M. Julian took me into the studio.

*3 October.* I sketched a three-quarter view of a head in charcoal at Julian's in ten minutes, and he told me that he had not expected anything so good from a beginner. I left early, as I only wanted to make a start today. We went to the Bois; I gathered five oak-leaves and went to Doucet, who made me a delicious little blue chaplet in half an hour. But what do I really want? . . . To be a millionaire? To recover my voice? To get the Prix de Rome under a man's name? To marry Napoleon IV? To get into the best society?
   *I want my voice to come back at once.*

*4 October.* The day passes quickly when you are drawing from eight till twelve, and from one till five. Going backwards and forwards takes up nearly an hour and a half, and then I was a little late, so that I had only six hours work. . . .
   At last I am working with artists, real artists, who have exhibited at the Salon, and who sell their pictures and portraits—who even give lessons.
   Julian is pleased with the way I have begun. "By the end of the winter you will be able to paint some very good portraits," he said to me.
   He says that sometimes his female students are as clever as the young men. I should have worked with the latter, but they smoke—and, besides, there is no advantage. There was when the women had only the draped model; but since they make studies from the nude, it is just the same.

*6 October.* Every time Julian corrects my drawing he asks me with distrust if I did it alone.
   I should think so indeed. I have never asked for advice of any of the pupils, except how to commence the study of the nude.
   I am getting rather used to their ways—their artistic ways.
   In the studio all distinctions disappear; you have neither

name nor family; you are no longer the daughter of your mother; you are yourself; you are an individual with art before you—art and nothing else. One feels so happy, so free, so proud!

*10 October.* Don't suppose I am doing wonders because M. Julian is surprised. He is surprised because he expected to find the whims of a rich young girl and a beginner. I need experience, but my work is correct and like the model. As for the execution, it is just what may be expected after a week's work.

All my fellow-students draw better than I do, but none of them can get it as like and true in proportion. What makes me think I shall do better than they, is that, although I see their merit, I should never be content to draw no better than they, whereas generally the beginners are continually saying, "Oh! If only I could draw as well as such or such a one!"

*20 October.* [Louise] Breslau has received many compliments from Robert-Fleury; I did not. The nude was pretty good, but the head was not. I think with terror of the time it will take me to learn to draw really well. . . .

How well that Breslau does draw!

*22 October.* The model was ugly, and everyone in the studio refused to draw him. I proposed to go and see the Prix de Rome, which were being exhibited at the Beaux-Arts. Half of them walked, and Breslau, Mme. Simonides, Zilhardt, and I drove there.

The exhibition closed yesterday. We walked about on the quays, looked at the old books and engravings, and talked art. Then in a open *fiacre* we went to the Bois. Can't you see me doing it? I would not say anything, it would have spoilt their pleasure. They were so charming, so well-behaved, and we were just beginning to be at ease with one another.

Indeed, all would have gone well enough if we had not met the landau with all my family, which took to following us.

I made a sign to the coachman not to pass in front of us; they saw me, and I knew it, but did not care to speak to them before my artist friends. I had my cap on my head and I

looked untidy and uncomfortable. Naturally, my people were furious, and, more than that, hurt with me.

I was dreadfully annoyed—in short, it was a tiresome thing to happen.

*14 November.* I have been to the neighborhood of the Ecole de Médecine, to get various books and plaster casts. I went to Vasser's. You know Vasser, who sells all kinds of anatomical models, skeletons, etc. Well, I have some influence there through friends, and they spoke of me to M. Mathias Duval, who is professor of anatomy at the Beaux-Arts, and to other people, and some one is to come and give me lessons.

I am enchanted: the streets were full of students coming out from the schools. These narrow streets! these musical instrument makers, and all that kind of thing! Ah, heavens! how well I understood the magic, if I may call it so, of the Quartier Latin!

I have nothing of the woman about me but the envelope, and that envelope is deucedly feminine. As for the rest, that's quite another affair. It is not I who say this, since it seems to me that all women are like myself. . . .

The people in society, otherwise known as *bourgeois*, will never understand me. Indeed, it is not to them that I address myself, but to those of our own set.

Unhappy girls, listen!

For instance, my mother is horrified at seeing me in a shop·where one sees such things. Oh such things! "Naked peasants!" Philistine! When I have painted a beautiful picture, they will see only the poetry, the flower, the fruit. They never think of the dunghill.

I see only the end, the goal. And I march straight on towards this goal.

I love to go to the booksellers and the other people, who, thanks to my unassuming dress, take me for a Breslau or someone of that class; they look at you in a certain kindly encouraging way, which is quite different from what I am accustomed to. . . .

*16 November.* I can't forgive myself for not knowing as much as Breslau. . . . The fact is . . . I have never gone deeply into

anything in life, though I know a little of everything; and I am afraid it will be the same in this; and yet, no; from the way I am working, it must turn out well. It does not follow because you have never done a thing that you will never be able to do it. At each beginning I doubt afresh.

*23 November.* That creature Breslau has done a composition—*Monday Morning, or the Choice of a Model.* The whole studio is there, and Julian is next to me and Amelia, etc., etc. It is done correctly, the perspective good, the likenesses, everything is there. When you are capable of doing a thing like that, you are certain to become a great artist.

You can guess, can't you? I am jealous. That is a good thing, because it is an incentive.

*28 January 1878.* The competition is to be decided tomorrow. I am so afraid of getting a bad place! . . .

*29 January.* I was so mortally afraid of the examination that poor Rosalie had to make superhuman efforts to induce me to get up.

I expected either to obtain the medal, or else to be placed only among the very last.

Neither one thing nor the other. I remained in the same place I had two months ago; consequently it was a failure.

I went to see Breslau, who is still ill.

*12 February.* This evening at the Italian Opera, they played *La Traviata.* Albani, Capoul, and Pandolfini, are great artists, but it gave me no pleasure; yet in the last act I had not exactly the wish to die, but the idea that I should suffer and die just at the moment when all was about to end happily.

It is a presentiment I have. I was dressed *en bébé*—a very graceful costume when one is slight and of good figure. The white bows on the shoulders, the bare neck and arms, made me look like an Infanta of Velázquez. . . .

*16 March.* Robert-Fleury said to me this morning: "For some time there has been a certain point beyond which you cannot go; that is bad. With the gifts you possess, you ought not to

be stopped by easy things; the less so, that you can conquer what is most difficult."

Yes, I know it, *pardieu*. A portrait to do at home, and then the domestic worries. But that shall trouble me no longer; I will not let it. . . .

*23 March.* I promised you to get beyond the point of which Robert-Fleury spoke.

I kept my word. They were extremely pleased with me. They told me again that it was worth while working with such genuine abilities, that I had made astonishing progress, and that in a month or two. . .

"You will be among the best of the students," added Robert-Fleury. . . .

*30 September.* I have done my first regular painting. I was to do still-life studies, so I painted a blue vase and two oranges, and afterwards a man's foot, and that is all.

I dispensed with drawing from the antique; I shall perhaps be able to do without the work from still-life.

I have written to Colignon that I should like to be a man. I know that I could be somebody, but with petticoats what do you expect one to do? Marriage is the only career for women; men have thirty-six chances, women only one, as with the bank of the gaming table, but nevertheless, the bank is always sure to win; they say it is the same with women, but it is not so, for there is winning and winning. But how can one ever be too particular in the choice of a husband? I have never before felt so indignant at the present condition of women. I am not mad enough to claim that stupid equality which is an utopian idea—besides it is bad form—for there can be no equality between two creatures so different as man and woman. I do not demand anything, for woman already possesses all that she ought to have, but I grumble at being a woman because there is nothing of the woman about me but the envelope.

*9 October.* The successes obtained at the competition of the Ecole des Beaux-Arts by Julian's pupils have given his studio a good standing.

There are more students than enough. Each one imagines he will get a Prix de Rome, or at least compete at the Ecole.

The ladies' studio shares in this distinction, and Robert-Fleury views with Lefebvre and Boulanger. To everything, Julian says, "What would they say of it downstairs?" or else "I should like to show that to the gentlemen below."

I long indeed for the honour of having a drawing of mine shown downstairs. You know they only send down the drawings to show off what we can do, or to make them furious, because they say that women are of no account. For some considerable time I have been thinking of the honour of having my work sent down.

Well! Today Julian entered the room, and after looking at my study from the nude, he *spoke thus*:

"Finish that well, and I will take it *downstairs*."

*20 October.* I ordered the carriage for nine o'clock and, accompanied by my maid of honour, Mlle. Elsnitz, I went to see Saint-Philippe, Saint-Thomas d'Aquin, and Notre-Dame. I ascended to the top, and I went to see the bells, just like an English girl. . . .

We saw the Ecole des Beaux-Arts. It is enough to make one cry.

Why cannot I go and study there? Where can any one get such thorough teaching as there? I went to see the Exhibition of the Prix de Rome. The second prize was won by one of Julian's pupils. Julian is much pleased. If ever I am rich I will found a School of Art for women.

*26 October.* My painting is much better, and my study from the nude very good. M. T—— was the examiner for the competition. Breslau was first, I second.

In short I ought to be satisfied.

*3 November.* Mamma, Dina, Mme. X——, and I drove out together. They want to get me married, but in order that they should not make me the means of enriching some good gentleman, I declared plainly that I was perfectly willing to marry, but only on condition that the man was rich, in a good

position, and handsome, or else some clever and distin-
guished man. As for his temper, were he the devil himself
that is my look-out.

Madame G—— spoke so profanely of the arts that I shall
have to go out of the room if she speaks of them again before
me. She quotes the example of ladies who paint at home and
have masters, and she says that I shall be able to do the same
when I am married. In the tone of indifference of the woman
of the world, of the *bourgeoise*, there is something horribly
revolting, which shocks all the nobler artistic feelings.

You understand, I reason things out for myself sensibly
and logically.

I shall try first to compass the marriage of my dreams. If
I am not successful in that I shall marry, as every one else
does, by the help of my fortune. And so I am quite easy in my
mind about it.

*5 November.* One thing there is which I think truly beautiful,
and worthy of the heroic age: that self-annihilation of a
woman before the superiority of the man she loves must be
the most exquisite gratification of her self-esteem that can be
felt by a woman of a noble mind.

*2 January 1879.* What I long for is the freedom of going about
alone, of coming and going, of sitting on the seats in the
Tuileries, and especially in the Luxembourg, of stopping and
looking at the artistic shops, of entering the churches and
museums, of walking about the old streets at night; that's
what I long for; and that's the freedom without which one
can't become a real artist. Do you imagine I can get much
good from what I see, chaperoned as I am, and when, in
order to go to the Louvre, I must wait for my carriage, my
lady companion, or my family?

Curse it all, it is this that makes me gnash my teeth to
think I am a woman! I'll get myself a *bourgeoise* dress and a
wig, and make myself so ugly that I shall be as free as a man.
It is this sort of liberty that I need, and without it I can never
hope to do anything of note.

The mind is cramped by these stupid and depressing
obstacles; even if I succeeded in making myself ugly by means

of some disguise I should still be only half free, for a woman
who rambles about alone commits an imprudence. . . .

This is one of the principle reasons why there are no
female artists. O profound ignorance! O cruel routine! But
what is the use of talking?

Even if we talked most reasonably we should be subject
to the old, well-worn scoffs with which the apostles of women
are overwhelmed. After all, there may be some cause for
laughter. Women will always remain women! But still . . .
supposing they were brought up in the way men are trained,
the inequality which I regret would disappear, and there
would remain only that which is inherent in nature itself. Ah,
well no matter what I may say, we shall have to go on
shrieking and making ourselves ridiculous (I will leave that to
others) in order to gain this equality a hundred years hence.
As for myself, I will try to set an example by showing Society
a woman who shall have made her mark, in spite of all the
disadvantages with which it hampered her.

*12 March.* I do not get on with my painting. It is true,
however, that since I commenced painting I have worked
anyhow, and with many interruptions; but that has nothing to
do with the matter. I who had dreamed of being rich, happy,
a leader of fashion, an attraction . . . to lead, or I should say,
to drag out such a life!

Mlle. Elsnitz is my companion as usual, but the poor
thing is so dull. Picture to yourself a tiny body, with a large
head and blue eyes. . . . She often comes into the room and
stands in the middle of the floor as if rooted to the spot, and
looking as though she did not know where she was. Perhaps
her most irritating trick is her way of opening the doors; this
operation lasts so long that every time I hear her I feel
inclined to rush to her assistance. I know that she is
young—only nineteen. I know too that she has always been
unfortunate, that she is in a strange house where she has not
found a friend, not a soul with whom to exchange an idea.
. . . It often grieves me to see her, and her gentle, passive
expression touches me; and then I make up my mind to chat
with her, to . . . But it is no good; I find her quite as repulsive
as I did the Pole and B——.

*5 January 1880.* Well, I am going on badly. I begin work again, but as I have not had a complete change I feel a profound languor and discouragement. And the time for the Salon is approaching! I go to talk it all over with the great Julian, and we are of opinion, especially he, that I am not prepared for it. . . .

Oh, for myself, I should not care—I could wait. I have courage, and if I am told to wait a year I reply with sincerity, "Very well." But my friends—but my family—they will no longer believe in me! I might exhibit, but what Julian wanted was that I should paint such a portrait as would cause a sensation, and I shall succeed but indifferently. That's what it is to ride a high horse.

*10 February.* I have had a long interview with father Julian about my picture for the Salon. I have submitted to him two proposals, which he approves. I will draw them both, that will take three days, and then we will choose. I am not advanced enough to succeed brilliantly with the portrait of a man—an unsatisfactory subject; but I can paint a figure (life size of course) and the nude, which, as Julian says, attracts me as it does all those who have a consciousness of power. . . .

For this year, I, the "inventor," have thought of this: a woman at a table, her chin resting on her hand, and her elbow on the table, reading a book; a bright light falling on her beautiful fair hair. Title: "La Question du Divorce," by Dumas. This book has just appeared and the question excites everybody.

The other subject is simply Dina in a skirt of white crêpe de chine, sitting in a large antique chair, with listless arms and fingers interlaced. A very simple attitude, but so graceful that I hastened to sketch her one evening when she was sitting thus quite by chance, and I was wanting to get her into position.

*3 March.* Now I must go out no more at night so that I may be able to get up feeling refreshed and work from eight o'clock. I have only sixteen days left.

*12 March.* Julian came to see my picture; he thinks the plush table, the book and the flowers are very good. The rest will come; the whole thing, he says, is spirited, has go about it, and is bold, almost brutal; I who was weeping this morning, came home at six o'clock consoled and confident. . . .

*19 March.* At a quarter to twelve, Tony! "Why did I not begin earlier? It is very beautiful, charming, but what a pity," etc., etc. In short, he reassures me, but we must ask for a delay. . . .

Then he pulls up his sleeves, takes the palette, and touches the picture a little everywhere to make me understand that it lacks light. But I will work at it again . . . if I can get the delay.

He stayed more than two hours. He is a charming fellow; I am much entertained, and feel in such good spirits that I don't care much what may happen to the picture. In a word, his few touches are an excellent lesson.

At two o'clock I go in one direction and mamma in another to see what can be done. I take Dina with me, and we go to the Chamber of Deputies. I ask for M. Andrieux. . . . I have to wait an hour in vain. We go to the police office but he is not there. . . .

When I get home I learn that the Prefect of Police has been to see us, to place himself at our service, and that Julian is at No. 37 with mamma. Julian is delighted with the picture. . . .

I am quite elated and joyous even before I hear the result of mamma's proceedings with Gavini, who has written to Turquet [the Under-Secretary of the Beaux-Arts]. In fact, I have been allowed the delay—a delay of six days. I do not exactly know whom to thank, but tonight I go to the opera with the Gavinis. I thank father Gavini, as I think it is to him that I owe it. I feel radiant, triumphant, and happy. . . .

*22 March.* Tony is astonished that I have been able to do what I have done in so short a time. . . .

He takes off his coat, seizes a palette and paints a hand for me, the lower one, in that whitish shade that is peculiar to

him. He touched up the hair, which I entirely repainted, as
well as the hand. So he works at the hand, and I am amused,
and we talk.

All the same, excepting the background, the hair, and
the plushes, it is dirty colour. It's all muddled. I can do
better. This is Tony's opinion, but for all that he is pleased,
and says that if there were any possibility of my picture being
refused at the Salon he would be the first to tell me not to
send it. He says he is astonished to see what I have done; it is
well conceived, well arranged, well worked out, it is
harmonious, elegant and graceful.

Oh yes, yes! But I am dissatisfied with the flesh! And to
think that it will be said that it is my style! . . .

*25 March.* I am giving the finishing touches to my picture, but
I cannot work any more for there is nothing more to be done,
or else all is to be done over again. It is finished as an
ill-arranged thing. . . .

It is my first appearance—an independent act in public.
One feels alone on an eminence surrounded by water. . . .
But it is done; my number is 9,091. "Mademoiselle
Marie-Constantine Russ."

I hope it will be well received. I send the number to
Tony.

*7 April.* We must not forget to say that Julian has informed
me that my picture has been received; and curiously enough,
I feel no joy about it. Mamma's delight bores me. This
success is not worthy of me.

# Virginie Elodie Demont-Breton: Houses I Have Known (c. 1865 and 1890)

Virginie Elodie Demont-Breton (1859-1935), an only child, grew up
surrounded by artists. Her father, Jules Breton, was a well-known
realist painter of peasant life. Her maternal grandfather, Félix de
Vigne, was an artist of considerable reputation. Her uncles—both
maternal and paternal—and her cousins were all artists. And her

father's friends were artists, whose studios she visited when the family went to Paris to review the Salon. Nevertheless, as she later recounted in her autobiography, she did not at first believe her father when he told her she too could become an artist.

**Memories of My Parents' House\***
One day I had just finished a small drawing highlighted with watercolor that, to my mind, represented my friend Baptiste Frisé working in the garden with a large rake in his hand. It showed the garden and the green lawn and butterflies in the sky that were at least half the size of Baptiste. I was five years old. The work must have showed great progress over my previous efforts, because my father was enchanted. I still remember the moment, his pleasure and all that followed it, because it was the memorable moment of first success. It was in our dining room; my father was leaning back against the window overlooking the garden and he made a strong silhouette against the white ground of the embroidered muslin curtains, and he said, "You will be a painter."

Laughing, I answered, "But no, I won't be a painter, because I will be a woman!"

"That does not matter. You will be a painter all the same."

"Will I have the right?"

"Certainly! And you won't be the first to have the right: you know well that there are Rosa Bonheur and others."

I had heard Rosa Bonheur's name as often as I had heard those of Baudry, Corot, Daubigny and Cabanel, but since no one added "Madame" or "Mademoiselle," I assumed it was a man's name like all the others. I was very astonished and vaguely happy as I cried, "Ah! Rosa Bonheur is a woman!"

This idea upset all the firm convictions I had acquired up to then regarding men's unquestioning superiority to women in all respects—in strength, independence, and power. In

---

\*   Translated from Virginie Elodie Demont-Breton, *Les maisons que j'ai connues, vol. 1: notre pays natal,* Paris: Librairie Plon, 1926, 47-51.

fact, all the small boys with whom I played (even Louis, who had such a natural feeling for justice and impartiality) took themselves for personages of much greater importance than we girls. They said, with the slightly disdainful ease so natural to those who feel themselves masters, "Those are girls' games; that work is for girls."

Even grown-ups used conventional expressions like "crying like a woman" or "to be as soft as a girl," and when speaking of a weak and cowardly young man, they called him "a little woman." This was confirmed by the grammar book by Lhomond that my mother began to use at this time when she taught me to read; it carried on the first page a rule I learned by heart: Masculine gender is more noble than feminine gender.

Therefore, I had accepted this degree of inferiority as given and did not even question it. Thus, the idea that a woman, like a man, had a right to a palette, models, a serious studio, to paint and exhibit her work beside that of men, to sign her paintings with her name and put them in handsome gold frames, opened a joyful, new horizon on the future and what it might hold for me.

However, it should not be thought that a preoccupation with ambition developed suddenly in me. From that moment, it was a much simpler feeling, a kind of peaceful dream that when grown I would be permitted to express the ideas that came to me in the way that pleased me and that this would be considered natural and legitimate and that I would not have to be sorry I hadn't been born a boy. I well knew then that what I did would no longer be treated like a game, that people would look at my work seriously, and in my own eyes this perspective raised the naive efforts I had made up to then, because I felt dimly and almost without reasoning yet, that in them the seed of something more complete could already be found, like the green grains in the stamen of a flower after it blooms. I noticed that when my father looked at my small sketches, he no longer said only "I can see that this is a man, a woman, a bird, a dog"; he added, "This is a subject you can turn into a painting later."

To dream of the fruit when the first flower has barely bloomed, to see the forest when looking at the frail seedlings

is one of the greatest charms and special characteristics of paternal love. In this it differs from maternal love, which is less ambitious but quicker to take full pleasure in joys received. . . .

Thus, after the morning when I drew Baptiste leaning on his rake, there was a new element in my father's tender affection for me. I was no longer just his little girl: I was his future pupil. From then on, he studied all my inclinations; he rejoiced in my progress and worried when I did not succeed; he worried that intellectual work might damage my health, and said to me now and then, "Play—don't draw any more, you will tire yourself out!" Or in many other ways, he would encourage me to work, since he feared that the gifts he thought he saw in me were only a childish fantasy and would pass away without producing significant results. He was careful not to say something that would influence my way of seeing, so that my originality of invention and conception would remain whole, and thus he would create a thousand happy or sad day dreams for himself.

"What a painting that would make," he repeated, and he would smile and be abstracted after he said this, as if he already foresaw the hoped for blossoming of all those childish works.

Until Virginie Breton was thirteen or fourteen, her father allowed her to work informally, but then he set her to serious studies. When she was nineteen and ready to prepare for her Salon debut, she and her mother took a studio in Paris that would allow her to work independently of her father and would give her easier access to children who were used to posing nude. She won an honorable mention in 1880 and thereafter she exhibited regularly with the Société des Artistes Français, which was given control of the Salon in 1881.

In 1880 she also married Adrien Demont, a painter and a student of her uncle. The couple had three daughters; one became an artist. They shared a studio at their summer home on the Normandy coast, but divided it with a curtain so that they would not influence each other. Virginie Demont-Breton, who shared her father's interest in peasant life, often turned to the wives and children of Norman fishing families for her subjects.

In the early 1880s, Demont-Breton also began exhibiting with the Union des Femmes Peintres et Sculpteurs and joined the organization's campaign to open the Ecole des Beaux-Arts to women students. At a conference at the Paris international exposition of 1889 Mme. Léon Bertaux, first president of the union, officially proposed that women be admitted to the Ecole des Beaux-Arts (see pages 247–50). In response, the Conseil Supérieur des Beaux-Arts appointed a commission to study the question. Bertaux and Demont-Breton, who had been elected vice president of the Union des Femmes Peintres et Sculpteurs, met with the committee to explain their point of view. The members' reactions, as Demont-Breton recounted in her memoirs, were not encouraging.

## Women's Admission to the Ecole des Beaux-Arts*

The two sexes, made to be united in love for physical creation, should also understand each other in art and science for spiritual production, and it is fair to give them the same means for intellectual development. To this purpose, in 1884, since the previous year I had been named *hors-concours* at the Salon, I discussed with Jules Ferry a project that would overturn perennially accepted prejudices: the admission of women to the Ecole des Beaux-Arts and the competition for the Prix de Rome.

Jules Ferry, a liberal soul who was much in favor of this idea, responded, "One day it will happen, because justice is always served sooner or later."

He formally promised me his support when the opportunity came.

Therefore on May 10, 1890, the sculptor Mme. Léon Bertaux and I obtained a meeting with a committee from the Ecole des Beaux-Arts that included, Paul Dubois, director, and Charles Garnier, [Jules Pierre] Cavalier, [Antoine] Bailly, [Léon] Gérôme, and [Jean Baptiste] Guillaume.

At the meeting the six members of this imposing committee were seated around a table covered with a green cloth. Each had in front of him a large sheet of blank paper and pencils. This is what I saw first when we were introduced

---

*   Translated from Virginie Elodie Demont-Breton, *Les maisons que j'ai connues, vol. 2: nos amies artistes*, Paris, Librairie Plon, 1927, 196-200

by the usher. The solemnity of the setting impressed me and added to my worry about fulfilling as well as possible the mission imposed upon us.

Mme. Léon Bertaux represented the women sculptors and I the women painters. As president of the Union des Femmes Peintres et Sculpteurs and the elder, Mme. Bertaux spoke first.

Paul Dubois, who was presiding, listened to her solemnly. His colleagues smiled kindly; Guillaume even supported her warmly. Encouraged by their sympathetic faces, when my turn came, I energetically enlarged on what I considered a simple matter of justice.

As I spoke, I watched the muscles contract in the bony, interesting, wild, and expressive head of Charles Garnier, the architect of the Opera, and wondered whether the contractions were hostile or approving. Bailly, the great, loveable, elderly octogenarian, approved with a nod of his beautiful head framed with white hair. Gérôme twisted his military mustache.

Paul Dubois, still impassive, was playing with his pencil.

All of a sudden Charles Garnier cried vehemently that it was impossible, that to put young men and women under the same roof was to mix powder and flint and would produce an explosion in which art would be entirely dashed to pieces!

Guillaume, usually so composed, warmed up in turn and cried, "What are you—a street kid? You don't know what you are saying. When an artist works, does he dream of anything except the study which excites and worries him? In such a school, where legitimate progress is made, there would no longer be men and women, only artists animated by pure and noble ambition!"

"Listen to me, wise man," Garnier replied. "Maybe you, the great sculptor, are made of marble or wood like your work, but as for me, if at twenty I had seen a sweet young face next to my easel, my drawing would have gone to the devil. Oh, Guillaume, you are not a man!"

And Guillaume answered, "Oh, Garnier, you are not an artist!"

Which was the worse insult? No one will ever know, but the contrast between Garnier's comic expression and the

serious and indignant face of Guillaume, that most official of sculptors, produced a general burst of laughter.

Only Paul Dubois, although he could put so much life into his magnificent works, remained quiet and mute; undoubtedly he was trying to preserve his presidential impartiality.

He contented himself with ringing his bell and giving the floor to Cavalier, a small distinguished man with a calm shrewdness who, to conciliate the group, suggested the establishment of a special building for young women.

Gérôme, who had only laughed up to this point, objected that from every point of view the expense would be double; this threw a chill—the chill that accompanies all budget questions—over the proceedings, and everyone agreed to put serious consideration of the question off until later. A stenographer brought forward the paper on which, hidden in a dark corner, he had recorded the debate.

Paul Dubois, standing erect and correct, assured us that the matter we presented would be put on file.

It was all we could hope for. It was the first step towards our goal.

# French Artists on the Question of Admitting Women to the Ecole des Beaux-Arts (1893)

In March 1891 the Conseil Supérieur des Beaux-Arts approved the report issued by the commission it had appointed to examine women's admission to the Ecole des Beaux-Arts. In principle the report favored permitting women the same education and the same facilities as men, but it also stated that "it is absolutely impossible to give this instruction to women within the Ecole des Beaux-Arts" ("Causerie: Les femmes" 1896). As an alternative, it recommended·the creation of a separate school for women, which it estimated would cost 7,500 francs to furnish and an additional 134,000 francs annually in salaries and expenses to run. For the next five years a budget allotment for women's artistic education was regularly proposed to the French Parlement—and just as regularly voted down.

The issue, however, provoked a lively debate. In February 1893, Firmen Javel, the editor of L'art français, a weekly magazine

founded in 1887, asked leading French artists for their opinions on the matter. Javel supported women's admission to the Ecole des Beaux-Arts, but the responses he received show that among French artists opinion remained sharply divided.

**I am very much at a loss to respond** in a satisfactory manner to your question, which seems to me too complex to be dealt with without a thorough examination.* Will you please, therefore, permit me to abstain.
—[Pierre Cécile] Puvis de Chavannes

. . . Certainly woman has the right to learn, to educate herself, to paint, and even if worse comes to worst, to sculpt. But does she have the necessary physical strength? Does she have the essential intellectual power? Can you imagine Michelangelo, Titian, Rubens, Rembrandt, Ribera as women? No, it is impossible, she was not created and put into the world for that. She has better things to do. Her role is far more noble and elevated. She has no reason to envy us.
—Léon Bonnat

. . . I think that women should have the right to study in the same manner as men, not in the same classroom, but in special studios.
—[Charles Auguste Emile] Carolus-Duran

. . . No—one hundred times no—women should not and cannot be admitted to the program at the Ecole des Beaux-Arts and even less to the studios. It is absolutely impossible in my opinion.
—Théobald Chartran

I do not believe that either men or women should be admitted to the Ecole des Beaux-Arts, which I consider an utterly useless, if not dangerous, institution. If the inter-

---

* Translated from "Les femmes artistes et l'Ecole des Beaux-Arts," *L'Art Français* 6, no. 304 (18 Feb. 1893) and no. 305 (25 Feb. 1893), n.p.

vention of the State is intolerable in one case, then certainly it is in all artistic matters. Art can only develop through the independence of both students and teachers, and this official factory of artists, which in fact is a fairly recent innovation, has only served to fill the exhibitions with boring works.

—Jean Beraud

Women artists are free; they should take advantage of this! Why do they want to become students at the Ecole?

—Auguste Rodin

I see no reason why women shouldn't be admitted to the Ecole des Beaux-Arts, since there is an Ecole des Beaux-Arts; but I do not believe, for reasons of simple decency, that women can work in the same studios as the men. . . .

—Rosa Bonheur

Painting is not an exclusively masculine art and I do not see why women, who are admitted to medical schools, should be excluded from the Ecole des Beaux-Arts. Their innate charm and grace, sustained by serious work, would certainly produce excellent results—while I do not believe that charm and grace are necessary for medical studies. . . .

—Louise Abbema

The teaching of art by master painters is absurd: one can only teach what one practices—and when one is practicing one is no longer creating.

The artist of our period should spend his life seeking the artistic formula that best defines his thought. Once he has found that formula, it is useless—to himself or to others. . . .

In art, the only thing one knows is what one has learned himself. After that, all that remains is to guard against knowing what one knows too well. . . .

—[Jean-François] Raffaeli

Yes! Yes! women should be admitted to the Ecole des Beaux-Arts—on condition that the men leave!

—Bartholomé

By January 1895 idea of separate studios for women was abandoned as too expensive, and the government began to reestimate the costs of admitting women to the existing school. Paul Dubois, director of the Ecole des Beaux-Arts requested an additional 26,300 francs, but feared that even with additional funding substantial problems would remain:

> The number of places is already inadequate for male students and will become even more so when it will be necessary to arbitrate between men and women at the same time. . . . From the point of view of interior order, I would respectfully suggest an increase in the number of guardians in the school. It will become extremely difficult to watch over the students, and I am sure that contact between male and female students within the school will lead to difficulties which today I cannot anticipate. ("Causerie: Les femmes" 1896)

The Ministry of Fine Arts, however, estimated the costs at about 13,500 francs, and at the request of Deputy Senator Maurice Faure the Parlement added this to the budget. In 1897 ten women were admitted to the Ecole des Beaux-Arts.

Virginie Demont-Breton, who had been elected president of the Union des Femmes Peintres et Sculpteurs in 1895, celebrated the event in a speech at the organization's general meeting:

> From now on women will be able to study at the Ecole des Beaux-Arts in equality with men: they will follow *the same course*, work with *the same professors*, take *the same exams*, and have access to *the same advantages and awards*. Henceforth, perfect equality between the two sexes will exist. . . . Now it is up to women to demonstrate their capabilities and to justify the reasons for the claims which have become law. ("Causerie: Voici le remarquable" 1896)

Demont-Breton's celebration proved somewhat premature: the number of women admitted to the Ecole dropped in the following years, and complaints that the instruction given to women was not equal grew. Not until 1903 were women admitted to studios with nude models and to the competition for the Prix de Rome.

# VII. WOMEN ARTISTS ORGANIZE

The beginning of the organized women's movement dates from 1848. In the opening weeks of the revolution that swept Louis Philippe from the throne of France, women—many of whom had been associated with Fourierist or Saint-Simonian groups—organized workshops, newspapers and political clubs and presented the provisional government with a call for female suffrage. Their initiatives were cut short when the new government restricted women's right to publish newspapers or assemble for political reasons, but the effort continued in the United States and Britain. American women had learned the power of organization and the techniques of public speaking while working for the abolition of slavery. Those who met in Seneca Falls, New York, on July 19, 1848 to hear the "Declaration of Sentiment" drawn up by Elizabeth Cady Stanton and Lucretia Mott were prepared to act on their resolution that "all men and women are created equal" (quoted Bell and Offen 1983, 1:252). In the following decades, American and English women organized to address the specific legal, economic, political, and educational issues that affected them.

Women artists, whose participation in academies and artists' societies was still severely limited, established their own organizations to provide women with support and encouragement. By the 1850s they were organizing in England, where there was a long tradition of independent artists' societies; American women artists followed in the 1860s. In France they waited until after the establishment of the Third Republic, which encouraged the decentralization of France's art exhibitions and guaranteed the freedom of assembly. By the end of the century, groups of women artists not only sponsored exhibitions but also offered classes, published journals, and provided a forum from which they vigorously campaigned for women's inclusion in existing institutions.

The international expositions that were organized at irregular intervals throughout the latter half of the century provided women's groups with a unique opportunity to make their work known and

their voices heard. At the American expositions of 1876 and 1893, women sponsored pavilions in which, because the expositions were encyclopedic, they brought together women's accomplishments in many areas. Ignoring traditional distinctions between the fine and the decorative arts and amateur and professional, they assembled exhibitions that included art pottery and painting, embroidery and sculpture. Although women's buildings were not a part of the major international expositions in France and England, women artists did participate in the conferences planned to coincide with the expositions. Such gatherings enabled women from different countries to exchange information about their activities and to present and discuss proposals to improve their situation.

Most women artists considered women's exhibitions and conferences primarily an opportunity to "practice" as they developed the skills that would enable them to compete with men for public attention. Indeed, many well-established women artists did not participate in women's exhibitions, preferring to see their work hung alongside that of their male colleagues. Art critics regularly complained that the standards of women's exhibitions were too low, but feminist journalists tended to argue, like the anonymous artist who wrote for the *Journal des femmes*, that "until the day when women are treated as men's equals, women's organizations are essential" ("Salons" 1893, n.p.). Certainly women's exhibitions demonstrated to the public and critics that the numbers of women artists were increasing and their skills improving; they not only bolstered demands that women should be admitted to art schools and academies, but also focused attention on the criteria by which women's work was evaluated.

## The Society of Female Artists

On June 1, 1857 the Society of Female Artists opened an exhibition of 358 works by 159 artists in a gallery on London's Oxford Street. It was the first exhibition in England, France, or the United States organized by women and devoted exclusively to painting and sculpture by women artists. English artists and connoisseurs were accustomed to establishing new societies whenever existing institutions didn't meet their needs, but even so the *Art Journal*'s critic considered a woman's exhibition a "bold experiment" ("Society of Female Artists" 1857a, 215). The

*Athenaeum* hoped that it was not the result of "those ridiculous, wrong-headed pretensions which have led in America to almost a war of sexes as in the old Amazonian wars that the Greek artists loved to record" ("Society of Female Artists" 1857b, 825). But both journals agreed that women artists had not been treated unfairly at the established exhibitions.

Indeed, a healthy proportion of the participants in the exhibition—including Henrietta Ward, Fanny Mclan, Mary Anne Heaphy Musgrave, Anne Charlotte Bartholomew, Mary Rossiter Harrison, Mary Frances Thornycroft, and Elizabeth Heaphy Murray—exhibited regularly at the Royal Academy, the Society of British Artists, or the watercolor societies. Other participants, who did not exhibit elsewhere or who participated anonymously, were very likely amateurs.

By its second year, when the exhibition moved to the Egyptian Hall on Piccadilly, it attracted 582 participants and a higher proportion of women well known in the art world. For the *Athenaeum*'s anonymous critic it was opportunity to summarize the character of "female art":

> We find it tender and refined, but essentially unimaginative, restricted, patient, dealing chiefly with Blenheim spaniels, castles of Chillon, roses, first-borns, Zillahs, camellias, ball-dresses, copies and miniatures. In transcript painting as to truth detail, patience and love, it is capable of every triumph, but it can never reach the robust or the exalted. We may have a female Fra Angelico, but never a female Buonarroti. ("Society of Female Artists" 1858, 439)

A very different view of the society and its exhibition was taken by the critic in *The English Woman's Journal*, newly founded by Barbara Leigh Smith and Bessie Rayner Parkes. In March 1858, Smith and Parkes had rallied the committee that, a few years earlier, had gathered support for reforms in the Married Women's Property Act. They established a bimonthly journal devoted to "the present industrial employments of women, both manual and intellectual, the best mode of judiciously extending the sphere of such employments, and the laws affecting the property and condition of the sex" ([Prospectus] 1858, 2). Smith provided the vision and funds and Parkes contributed the day-to-day editorial guidance for the "Ladies of Langham Place," as they came to be known. The review of the second exhibition of the Society of Female Artists published in the May 1858 issue of the journal reflects the editors' confidence that by organizing, women would be able to help themselves.

# Anonymous, *The English Woman's Journal:*
# The Second Exhibition of the Society of Female Artists (1858)*

The annual exhibition of this society is now opened for the second time, and presents a marked improvement upon that of last year. It may be considered as the first real test of its claims to public interest, since we have been given to understand that few of the pictures exhibited in 1857 were painted for the express purpose of appearing under the auspices of the new institution. The committee did not organize their plans until the winter of 1856-57, and could only avail themselves of such works as happened to be in the studios.

Here, therefore, we have now the result of the first year's work of the female artists as connected with this society, and it is very satisfactory to any one who feels more interest in watching the development of female talent as applied to artistic study, than in weighing the exact relation such talent bears to the perfected powers of academicians and associates of the other sex. Indeed, we feel some regret at the tone of comparison adopted by some contemporaries; a comparison which the Society does not invite, and which is so wholly irrelevant so long as the domestic and academical facilities afforded to the female student are so very far below those of a male student.

Two hundred lady artists compared *en masse* with an equal number of gentlemen, following the same profession, will inevitably show a deficiency in those qualities of accurate work which the most ungifted boy is forced to acquire; and none but a working woman herself can estimate the thousand hindrances placed in her path by domestic life as at present constituted, and by the customs of society as at present imposed. For instance, how many of the painters who compose the Society of Female Artists would dare to imitate

---

* Excerpted from "The Second Exhibition of the Society of Female Artists," *English Woman's Journal* 1 (May 1858), 205-9.

Rosa Bonheur in her convenient, we had almost said her *inevitable*, blouse?

We prefer, therefore, to take this exhibition on its own grounds and to examine its double object, that of opening a new field for the emulation of the female student, and also a wider channel of industrial occupation, thereby relieving part of the strain now bearing heavily on the few other profitable avocations open to educated women.

We shall have little difficulty in showing that it accomplishes both these ends. Firstly, it has opened a new field where one was wanted. The Royal Academy is wholly under the control of its own members, among whom no woman has been entered since Angelica Kauffmann; the walls are naturally hung with a large proportion of their pictures, and when these are duly accommodated, a crowd of young male students aspire to the next best places, many of whom have been well trained in the elements of art in the classes of the Royal Academy itself, and who therefore are sure to possess just those titles to admission, in the average excellences of their work, which women can with difficulty obtain. It is true that many pictures by female artists are admitted, but they are in general small and delicate, ill fitted to sustain their own amidst a host of highly colored pictures; add *en attendant* that the women win their way into the better places of these shining walls, there is surely no harm and great good in their setting up a quieter exhibition of their own, where the same technical qualities are not as yet strictly demanded, and where patient study, and fidelity to the highest aims of art, may enable them one day to compete with the best painters, without any reference to sex.

The Old and the New Society of Water Colours are both closed to general exhibitors, none but elected members can hang their pictures there; each contains a few lady associates but they are allowed no share in the management of the society. We should be very glad to see a larger proportion of female names in the Catalogue, but are very far from wishing to render the admission a less exclusive test of executive perfection. In the mean time, it is not unnatural that the female artists should like a little space in which to expand.

Secondly, the Society affords a new industrial opening

to women. It brings a class together, gives them *esprit de corps*, and forcibly draws the attention of the public to the number of those who follow art as a profession, and will stimulate many a young painter who would have despaired of the Royal Academy.

Everything which, in the present needs of society at large, helps to rouse the energy, concentrate the ambition, and support the social relations and professional status of working women, is a great step in advance; let them not be deterred by the accusation of setting up a rivalry, or by the ridicule of a comparison which is under their present opportunities, wholly beside the mark. This society may be a noble means of *self-help*, and we feel sure that the Royal Academicians themselves will be the first to give encouragement and assistance.

We are therefore, exceedingly rejoiced to see that many of the best female artists, who had conquered a place in the Royal Academy, have this year sent in some works to the younger sister of all the exhibitions. Miss Susan Durant, the sculptor, has a statue in marble of Robin Hood (which stands in the nave of the Art Exhibition at Manchester), also a bust in plaster of little Toussain Pasha, and a noble model for *Warwick, the Kingmaker* offering a crown with dignified nonchalance. Miss [Anna Mary] Howitt has a sunset landscape; we wish that one of her delicately-wrought figure-pieces had been here also, to bear witness to the thoughtful poetry of the pupil of Kaulbach. Mrs. [Barbara Leigh Smith] Bodichon has several elaborate Algerian landscapes, in watercolour. Divers critics have observed that these are very cold in colour, for what they sapiently call a "warm climate"; any artist will tell them that a dazzling and nearly vertical sunlight makes the landscape itself seem cold, any traveller in North Africa will tell them that the prevailing colour of the luxuriant vegetation is a very blue green. . . .

But among the new accessions we do not see the names of either of the Misses [Annie and Martha] Mutrie; a blank much to be regretted. Will not these admirable artists send in next year a few floral groups, whose native home might be searched for, not in a conservatory, but under the wild

hedgerow? The Society should be gallantly supported by those very painters in whose behalf it was *not* instituted, and who might gracefully quit "the line" in Trafalgar Square, to adorn these walls. There is a triple virtue in:

A long pull, and a strong pull, and a pull altogether.

In looking round the large room at the Egyptian Hall, which Lord Ward has this year kindly ceded to the Society, we perceive no want of inspiration. The *Athenaeum* says that we must not look for a Michael Angelo among the ladies; but we cannot say that we discern much trace of a Michael Angelesque genius in the English school at large just now! Perhaps the most noticeable thing about the intentions of these pictures is the way in which they reflect, not so much the ideas of any number of male painters, but the general aspect of English art at the present time. If the execution of the majority were better it would be impossible to tell that we were not standing in some supplementary room of the Royal Academy. There are the same portraits, landscapes, scenes from Shakespeare, old houses, animals and fruit. The ideas which appear to govern the ladies in the selection of their subjects are not one whit wiser or weaker than those which guide the gentlemen: only in historical scenes we discern a deficiency, probably from the difficulty of grouping a number of figures consistently with severe anatomical requirements.

Of anything approaching the subtle delicacy of a Fra Angelico we find not a trace, none of the female artists have lent their brushes to subjects of spiritual refinement. Perhaps the most purely feminine picture in the room is a small and exceedingly lovely one entitled *The Wife* by Miss M[argaret] Tekusch; in which a dainty young matron, habited in the costume of the last century, sits copying law papers for her husband, while with the left hand she amuses her baby in the cradle. A singular sweetness and humor presided over the conception; yet there are many French male artists who paint with equal delicacy just such *scènes de la vie privée*, while Rosa Bonheur chooses bulls and horses. . . .

To any one who can appreciate fun we recommend the little *Scenes from the Life of a Female Artist* by Miss F. A.

Caxton. They are a fit commentary on the whole exhibition; there is the "ladies class," the studio, the woodland wide-awake, all the aspirations, difficulties, disappointments, which lead in time to successes. The little dog barks with all the hidden meaning of a dog in a fairy tale, the plaster head on the shelf winks with a certain dry amusement at its mistress, who is represented as painting a picture of the ascent to the Temple of Fame; the picture is rejected and the disconsolate young painter is seen sitting in comical despair, gazing at an enormous "R" chalked at the back. Do not grieve too much, O rejected artist! The great Etty himself tried for nine years before he gained entrance to Somerset House. Remember the magnificent words of a Trans-Atlantic Poet:

> Endurance is the crowning quality,
> And patience all the passion of great hearts.

Over the next few years the Society of Female Artists expanded its activities. It established a school where women could work from the live clothed model. Its exhibitions included works by French as well as English artists, and in 1862 it leased space on Pall Mall. Because the new space was smaller, the exhibitions of necessity became more selective: in 1863 over 200 pictures submitted for exhibition were returned to their authors for lack of room. But the critics' early enthusiasm for the exhibitions was waning: they complained there were too many copies and not enough works by the best-known artists.

As early as 1859, the critic for *The English Woman's Journal* suggested that "unless some severer test of exclusion is applied to the works of art submitted to the hanging committee, it can hardly become the foster-mother of a noble school; and is only too likely to make women believe they paint like artists, when they only paint like amateurs" ("Third Annual Exhibition" 1859, 53). The *Art Journal*'s critic politely but condescendingly reminded the women in 1863 that they were competing against a high standard, as public expectations had been "pampered to an exquisite epicurism in 'Art' " by existing exhibitions ("Society of Female Artists" 1863, 95). Other critics, like William Michael Rossetti, whose articles appeared anonymously in the *Fine Arts Quarterly*, questioned the society's very purpose.

## Anonymous [William Michael Rossetti], *Fine Arts Quarterly:* The Seventh Exhibition of the Society of Female Artists (1863)*

To call this or others of the Ladies' Exhibitions satisfactory to the artistic or critical sense would be neither true nor really complimentary to the ladies themselves, who may at any rate be credited with sufficient appreciation of art to know what a "success" is, and consequently what is not a success. The policy of distinct female exhibitions might probably with little hesitation be pronounced altogether erroneous; were it not for the one practical consideration that, if the ladies did not exhibit by themselves, they would too likely be crowded out of other exhibitions, or so inconspicuously placed that the important fact of the effort which a certain number of women are making to establish a standing in art would sink out of public observation. Considering this, we are inclined to think that the ladies have a fair show of reason for starting and maintaining an exhibition of their own. On any other ground, we should decidedly deem it a mistake; and especially on the ground that art is a matter of capacity and attainment, not of sex; that such few women as have attained ought to come forward among their peers, who are artists of the male sex; and that the large number who have not attained are scarcely, in a female exhibition, supplied with the great incentive of emulation. They can paint very indifferently indeed, and yet keep head above water according to the level of the separate Female Exhibition; and this is no shame for the present to the ladies, but a necessity of their case.

Despite the critics' reservations, women continued to turn to the Society of Female Artists. Many of England's women artists participated in its exhibitions for a few years at some point in their careers, but few remained committed to the society, and the size of the organization and the quality of its exhibitions tended to rise and fall. It was reorganized several times: in 1865 eighteen titled

---

*      "Art Exhibitions in London," *Fine Arts Quarterly,* 1 (October 1863), 340-41.

ladies agreed to sponsor the society, and in 1872 it was renamed the Society of Lady Artists and membership was limited to professionals. In 1899 it became the Society of Women Artists, as it continues to be known today.

# Eleanor E. Greatorex: Among the Oils at the Women's Pavilion at the Centennial Exposition, Philadelphia, 1876

In 1873 the Board of Finance for the Centennial Exposition that would be held in 1876 in Philadelphia appointed a Women's Centennial Executive Committee with Elizabeth Duane Gillespie as president. The committee organized women from Maine to California: for two years they sponsored fund-raising events, lobbied Congress, collected signatures—and planned an exhibition that would focus attention on women's contributions to modern society. When Mrs. Gillespie was told in June 1875 that there was not enough room in the main building for the women's exhibit, her committee quickly raised another $30,000 and asked H. J. Schwarzmann, the architect of the fair's Memorial Hall, to design a separate women's building. Critics asked why—since women had not exhibited separately at the previous international expositions in London and Paris—there was a need for such a building; Mrs. Gillespie explained that it was "because custom, society, and the laws of corporations present each so many obstacles in the way of self-supporting women, that this womens' department pledges itself wholly to their interests" ("How It Came About" 1876, 4).

The Women's Centennial Executive Committee filled the 26,368 square feet of exhibition space in the Women's Pavilion with "nearly everything of woman's work or invention that could be collected" (McCabe 1876, 591). There were machines that women had patented, including washing machines, self-fitting pattern systems, and other devices to make household labor more efficient and economical. Photographs documented the institutions founded or run by women: homes for orphans, the elderly, and destitute women; hospitals; and schools, from kindergartens to the Women's Art School at Cooper Union. There were paintings, sculpture and handwork from Europe, Egypt, and Japan, and— perhaps the most popular display—hangings and embroideries sent from London by the Royal School of Art Needlework. In a small printing office near the building's center, female compositors

set type for *The New Century for Women*, a weekly journal that for
the duration of the fair reported on "all means for advancing the
prosperity and extending the opportunities of women workers"
(Women's Executive Committee 1876, 4).

"E. E. G."—Eleanor Elizabeth Greatorex (1854-1897)—
contributed reports on women's painting and sculpture at the
centennial. She was the daughter of painter Eliza Pratt Greatorex,
had studied with her mother and in Munich, Paris, and New York,
and was active as a painter and illustrator. Greatorex found the
work of women artists in two locations: at the main art exhibition in
Memorial Hall and at the Women's Pavilion. At Memorial Hall,
works by well-known women, including Anna Lea Merritt, Eliza-
beth Gardner Bouguereau, Ellen Day Hale, Emily Sartain, Lilly
Martin Spencer, Emily Mary Osborn, Henrietta Ward, and Louise
Jopling, hung among the works of their male colleagues.
Greatorex was disappointed that many of these women had not
also contributed to the Women's Pavilion:

> When it was decided by the Women's Committee to afford the
> long-desired opportunity of testing her industry and skill by other
> gauges than the needle and the frying pan, was it not for the few who
> had conquered a position side by side with men, to turn back in
> generous sisterhood, and range themselves with the beginners?
> . . . No one knows better than successful women how hard the
> struggle, how grateful the word of encouragement early in the race.
> (E. E. G. 1876, 1)

When Greatorex turned to the work in the Women's Pavilion,
she felt compelled to defend what some observers called a less
distinguished group of artists. In the words of one observer, "The
collection falls short of illustrating the highest triumphs achieved by
the sex in these departments of art" (McCabe 1876, 591).
Nevertheless, Greatorex continued to adhere to the critical
standards and vocabulary that had become customary in judging
international expositions: rather than trying to identify the qualities
that characterized the artists' sex, she considered their work as
representative of national schools.

**He who leaves the exhibition of oil paintings** in the
Woman's Department with a sneer and a smile, is as lazy as he
is unjust.*

---

\* Excerpted from E. E. G., "Among the Oils," *New Century for Women*
no. 12 (29 July 1876), 91, 94.

A critic must, in honor bound be cognizant of good and bad, before he passes judgement. In Memorial Hall women are strongly represented, but the strength is spent. For the most part, they are too weak, too new in art to cope with men, to whom the advantages of study and of start in the race are multiplied a hundred fold, while a woman must learn, as best she can, and work with tied hands.

"The Art Gallery in the Woman's Pavilion?" said a visitor the other day, "there is no such thing! There are alcoves to hang pictures in, but you do not call those murderous cross lights, a gallery, in any sense. Take the Leightons and Boughtons from Memorial Hall and hang them here, and see how they would be slaughtered! Then judge of the test to which you put those Innocents, who come willingly to the sacrifice."

The spirit which has induced so many women to send their pictures to these "alcoves" as an exhibit of the progress reached thus far, is deserving of high praise; and in looking upon the "oils," so severely tested here, one must remember the disadvantages of light and position, in praising the good ones and passing by the bad; of these the number is not few, but they must all have the benefit of the doubtful light, that would, as has been shortly put, slaughter even a Boughton.

The Art Gallery in the Woman's Building was an after thought, and as such, though an ingenious architect might have done better with it, must be accepted. We are glad that it was not planned by a woman, we should all have laughed at the "inefficient she."

First among the good pictures that defy even the cross lights, is a charming picture by the Italian artist Leopoldina Borrino; a church interior, wherein a group of women and children are at prayers or vespers. . . . The technique of the picture is good, and with the exception of a slight exaggeration of color is harmonious and effective. . . . The picture reminds one of Schubert's exquisite *Ave Maria*, and when turning away from it the last notes linger softly quieting the hot pulses of a July day.

*An Interior* hangs in the neighboring alcove, quietly inobtrusive beside its companion, *The Charity Scholar*, by Cornelia W. Conant, who sends the picture from her

Dusseldorf studio. It represents a dear old lady in a white cap, sitting with folded hands before the table on which rests a cup of tea and her bible. Her face is in shadow, as she listens to the charity scholar, who is undergoing the painful process of spelling and dividing syllables. . . . The work is of the Dusseldorf School, which gives solidity without much transparency, a more realistic style than the floating atmospheric effects of the old Dutch school. The subject, however, bears this, as the imagination is not appealed to over-much, and the drowsiness of it is pleasant enough to be a refuge from the exciting allegorical attempts so generously distributed here, illustrating nothing stronger than that "fools rush in where angels fear to tread." Jeanne Rongier has a pasty effect of eastern color. She represents French art, not badly either, for, though the style is poor, she has some life and spirit, which would render the painting ornamental, could it be transposed to anything as solid and thick as itself. The tone is white, with gay reds, blues, and yellows, the primary colors, rollicking untrammeled by any demi-tones, produce what Hudson Holly terms a swimming sensation. A mulatto, in pink tunic, holds aloft a parrot, while on its cage, draped with a Turkey rug, a monkey delightedly teases a handsome dog, another sits in an arched green latticed window, below which a dog quietly sleeps. . . .

A correspondent of the *Evening Post* informs us, in a letter from Rome, that Madame Elisabeth Jerichau[-Baumann] has sent eight pictures to the Philadelphia Exposition, and at the same time gives a glowing description of her work. . . . We should be unwilling to judge so renowned a woman by the work of her brush in the Pavilion, and it cannot be else than a sore disappointment to the expectant visitors to stand before her pictures. Her Sahara is illy framed, being as mussy as her subject, an Egyptian mother, clad in deep blue draperies with her baby supported eastern fashion on her shoulders. The woman is large and ugly, and the baby looks as if the crocodiles had been trying to swallow him and had left him slightly mutilated and squeezed. . . .

Miss Emily Sartain's work shows a study of a superior order and has a certain refined finish which satisfies, but

lacks fire; a kind of perfection which has no wickedness to back it up. She has an exquisite eye for form and color, but in the two pictures here there is a pretty monotony, she catches moments which have no continuation, her models come and sit to her she does not go to them, and catch them in the act of looking or doing something picturesque. It is she who makes up the picturesque and puts them into it so gracefully, that you can forget for a moment that it is but a well dressed fancy picture. The young girl sewing, is lovely, the colors warm and good, and the effect perfect, did not the background throw into exaggerated relief the girl and her draperies, giving it too great a sharpness. Philadelphia owns two women artists who deserve the name, and she must needs be proud of Miss [Anna] Lea [Merritt], whose pictures in the Memorial Hall have no need of mention here, though her work would have done honor to her sister artists, who have, unlike her, studied in the home school against some weary odds. The American school is unworthy of the name, but even now the woman who is inspired to begin at the grammar of painting, and instead of daubing unmeaning, imbecile pictures, submits what talent she has to an education, even with the limited opportunities afforded here, may show honest work. . . .

I have not spoken of the redeeming points to be found in some of the poorer pictures, as we do not wish to excuse but to criticize. Trusting the visitor will have the wisdom to turn to the many pleasant pictures so unfortunately hung among the many daubs, against which no protest can be too strong, as they but kill the better and deserving works of art.

# Hélène Bertaux: Report on the Union des Femmes Peintres et Sculpteurs to the Congrès International des Oeuvres et Institutions Féminines, Paris, 1889

In 1878 Jean Alesson, editor of the *Gazette des femmes*, counted 762 women artists participating in the French Salon and

universal exposition. Although his figures showed that their numbers had more than doubled in five years, he added that the encouragement women artists received was "so rare and so weak" that he considered it a duty to extend to them a helping hand (Alesson 1878, 1).

But few others, it seemed, shared Alesson's feelings. When Hélène Hébert Bertaux (1825-1909) asked the director of the Ecole des Beaux-Arts to establish a separate studio for women students, she was told it was too expensive. Frustrated, she suggested that women organize to help themselves, and the Union des Femmes Peintres et Sculpteurs was founded in 1881 with Bertaux as its first president. Bertaux was a sculptor who had studied with her father, Pierre Hébert, and with J. E. Dumont, and had made her debut at the Salon of 1849, using the pseudonym "Allelit." By the 1880s she was winning religious and public commissions as well as gold medals and had married Léon Bertaux—who became her student.

The first annual exhibition of the Union des Femmes Peintres et Sculpteurs opened in January 1882 with 94 works by 38 artists and was well received. The *Chronique des beaux-arts* called it a distinguished group and suggested that with the addition of a few names—notably the three women Impressionists: Berthe Morisot, Mary Cassatt, and Eva Gonzalès—"it would be possible to organize very interesting exhibitions, since certain qualities of execution and sentiment link all women and justify bringing their works together" ("Union des Femmes" 1882, 27). In following years, the quality of the exhibitions improved and the number of participants grew—though the Impressionists did not join the group. In 1885 the Union sponsored a retrospective of the works of Marie Bashkirtseff with a catalogue in which extracts of her diary were published for the first time. Gaston de Raimes reported in *L'artiste* that the opening of their eighth exhibition was "an event that attracted the elegant, the famous, the intellectual, and the worldly of Paris society" (Raimes 1889, 195). By 1890 the organization included about 500 members who contributed over 750 works to the exhibition.

In 1888 Bertaux was named to the government committee planning the Congrès International des Oeuvres et Institutions Féminines that would coincide with the international exposition of 1889. Since women were not represented on the committees that organized the exposition, the women who organized the congress—which would bring together women active in philanthropy, teaching, the arts and letters, sciences, and law—considered their

role an "act of justice and amends." But the tone was set by the president of the congress, Jules Simon, a senator, a member of the Académie Française and secretary of the Académie des Sciences, who explained that the conference would not address "sect and dogma, militant politics and class struggle"—or the issue of woman's suffrage (quoted Bidelman 1982, 175).

When Hélène Bertaux addressed the assembled participants on the purposes and history of the Union des Femmes Peintres et Sculpteurs, she adopted a conciliatory tone, but she concluded with a resolution that was implicitly critical of government policy and that made it clear that the group was interested in more than organizing exhibitions for its members.

**At first glance it is not clear** what a society of painters and sculptors is doing here, among so many works characterized by philanthropic intentions; I see that we do share something, for I believe our institution is the sister of your organizations since it, like them, is the daughter of progress and fraternity.* . . .

The desire to contribute to women's progress in the arts was the mother idea of our society, which I represent here: the Union des Femmes Peintres et Sculpteurs.

It is an international society and includes a great number of foreigners among its members; its aims are to mount an annual exhibition of the most remarkable works of its members, to defend their interests, to contribute to raising artistic standards and to giving every possible advantage to accomplished and budding talents.

Our conscientious founders might have wondered somewhat anxiously whether we would be diminished or elevated by these arrangements, these special exhibitions of women's work; yet without hesitation those rich and poor in talent and those rich and poor in money have set to work, and each contributed her stone the building, that is to say the exhibition.

---

*   Translated from Mme. Léon Bertaux, "Rapport sur l'Union des Femmes Peintres et Sculpteurs," *Actes du Congrès International des Oeuvres et Institutions Féminines,* Paris: Bibliothèque des Annales Economiques, 1890, 387-89.

Although the first exhibition in 1882 was very summary, it was adequate to give a sense of the advantages to be gained from the idea. The second year, I obtained permission to use rooms in the Palais des Champs-Elysées from the Minister of Fine Arts. There we have exhibited ever since, and the exhibition has grown larger each year under the surprised and astonished eye of the general public, which despite the rigors of winter [when the exhibition takes place] always crowds the gallery.

It is fair to recognize the critics, who from the start, no doubt sensing the praiseworthy intentions of our group of sincere workers, saw fit to moderate their usual banter and replace it with useful advice, thus making our progress faster and more certain.

Ever since, the good and honest press, sharing our efforts each year, has spoken of us in terms marked by esteem and admiration. Thanks to their prudent and valuable accompaniment, we have taken a prominent place among the numerous groups that exhibit in Paris each year.

It is precise and appropriate here to recall that our last exhibition, which opened in February to all the official recognition one could wish, was a veritable triumph. But more than this success, which inspires confidence in the future of our organization and demonstrates its high purpose, is the approval of the masters of art, the great professors. Among these we count the respected chief of the Etudes, M. Guillaume, at the Institute, who publicly stated at an assembly that not only had our exhibitions contributed to great progress amongst its members, but in addition by stimulating the rivalry which always produces progress, they serve a useful purpose among women who study art in the schools, academies, and every sort of course.

Considering the large number of women who will henceforth seek a livelihood as professional painters or sculptors, we must anticipate that women will occupy a more and more important place in industrial and decorative arts: here above all our organization must exercise its beneficial influence to maintain standards in an art which is unquestionably one of our national glories. . . .

Until now a plan to bring together peacefully a large

number of women—and women artists especially—was thought impossible to realize and was considered simply a dream. In our eight years of existence we have corrected this mistake; today we have over 350 women who share the expenses in order to improve the progress of talent, and who govern themselves in perfect accord and solidarity . . . .

We may thus well believe that a new era is opening for beginning artists—that henceforth women will no longer meet systematic obstacles, that the tutelary protection of the state will no longer be denied them, and that the day has arrived when women's participation in all the competitions which have been open only to men of equal talent will be facilitated. We may believe finally that the Ecole des Beaux-Arts will open to them and that in a separate class women painters and sculptors will be able to follow the same program as the men, and that they will be able to compete for the Prix de Rome. . . .

Following a custom that was no doubt worthy at its origin, woman has found herself at a disadvantage in these incomparable means of study, and even if heaven endowed her the greatest genius, she was not allowed to take part honorably in fine art competitions. But, since today barriers of ignorance and prejudice are falling to the approach of a better educated woman, I bring the following proposition which I submit to the vote of this congress in the name of the Union des Femmes Peintres et Sculpteurs:

> That there be created at the Ecole des Beaux-Arts a special class separate from that of the men in which women will be able, without the customary restrictions, to receive the same instruction as men and that according to the conditions which regulate the school they be admitted to all the competitions which determine the winner of the Prix de Rome.

The congress supported Bertaux's proposal, which in the 1890s became a central focus of the union's efforts to see women artists represented in the official institutions of French art. In addition to the Ecole des Beaux-Arts, they campaigned for women's presence on the Salon jury, which since 1881 had been controlled by the Société des Artistes Français: Virginie Demont-Breton and

Elodie la Vilette were proposed as candidates in 1890 and Virginie Demont-Breton and Rosa Bonheur the following year. In 1891 and 1892 Bertaux applied for membership in the Académie des Beaux-Arts; she was not accepted, but she was told that her application was acceptable in principle.

Gradually their efforts began to see results. In 1893 Louise Breslau was named to the jury of the Salon du Champ de Mars, organized by the Société Nationale des Beaux-Arts. The following year, Demont-Breton, who had replaced Bertaux at the head of the union, became the second woman artist to be named to the Légion d'Honneur. By 1897 the government found the funds that made it possible to admit ten women to the Ecole des Beaux-Arts (see pages 226–31), and the following year Bertaux became the first woman elected to the Salon jury.

# The Woman's Building at the Columbian Exposition, Chicago, 1893

Even before a city had been selected as the site of the Columbian Exposition, American women's organizations—including a group led by suffragist Susan B. Anthony—lobbied the United States Congress to insure that women would be well represented in the celebration of the 400th anniversary of Columbus' discovery of the New World. The Board of Lady Managers was appointed, and Bertha Honoré Palmer was elected its president. A wealthy and well-connected society belle, Palmer had been active in the Chicago Women's Club, which supported reform work in the city. She maintained a careful distance between her board and the leaders of the suffrage movement because she did not want political controversies to overshadow the celebration of women's progress. She proved a splendid administrator, however, able to organize an exhibition that was a monument to feminine achievement.

Although the Women's Pavilion at Centennial Exposition had not been designed by a woman, Bertha Palmer insisted that the Lady Managers would "not have a man called in until the woman architects have tried and failed to produce a suitable plan" (quoted Weimann 1981, 144). Thirteen women entered a competition for the building's design: Sophia Hayden, who had studied at the Massachusetts Institute of Technology, won the competition and the $1,000 honorarium. For the exterior Enid Yandell, a sculptor from Kentucky, provided a line of caryatids, and Alice Rideout depicted "woman's work in the various walks of life" on the

pediment. The building's interior decoration was supervised by Candace Wheeler, who planned a gold and white background for the exhibits. Murals by Lydia Field Emmett, Rosina Emmett Sherwood, Amanda Brewster Sewell and Lucia Fairchild Fuller decorated the second floor of the Main Gallery.

The most important murals on the interior, however, were the two paintings high on the end walls of the Main Gallery. For these Bertha Palmer wanted images of "woman in her primitive condition as a bearer of burdens and doing drudgery . . . and as a contrast woman in the position she occupies today" (quoted Weimann 1981, 191). Sara Hallowell, the secretary to the Exposition's director of fine arts, was in Paris arranging for a loan exhibition of paintings, and she assisted Mrs. Palmer in locating two American women working in France: Mary Fairchild MacMonnies and Mary Cassatt.

Mary Fairchild MacMonnies was given the subject of "Primitive Woman." As a student at the Saint Louis School of Fine Arts, she had organized a petition campaign that enabled women students—who had been limited to working from "a plate of apples"—to work from the nude model. In 1885 she was awarded a scholarship that took her to Paris, where she studied at the Académie Julian and with Charles Auguste Emile Carolus-Duran. In France she had met and married the American sculptor Frederick MacMonnies. In 1892, Frederick MacMonnies had been asked to design a fountain for the Columbian Exposition; when Mary Fairchild MacMonnies was given the commission for the mural he made room in the studio for her oversized work. Eleanor E. Greatorex, who was living in Paris, visited Mary MacMonnies and reported on the artist's progress for *Godey's Ladies Magazine*, one of the most popular of American women's magazines. Greatorex was pleased to be able to report that the mural had met with approval from France's most distinguished artists.

## Eleanor E. Greatorex: Mary Fairchild MacMonnies*

"As for composition, it needs nothing added, nothing taken away."

"Not a line to change."

"Very charming!"

---

\* Excerpted from Eleanor E. Greatorex, "Mary Fairchild MacMonnies," *Godey's Ladies Magazine* 126 (1893), 624-32.

"The scheme of color is perfectly harmonious; the subject seen with an agreeable sympathy and the border very successful."

These are Cazin's words as he stands before Mrs. MacMonnies' completed fresco in the glass roofed yard or studio where her husband Mr. MacMonnies, had modeled his fountain for the World's Fair on which, at this moment of writing, workmen are still noisily engaged on colossal fragments about to be shipped to Chicago.

One of these fragments is a sea horse, shrouded in linen wrappings, but lending an air of triumph and benediction as it rears almost above Mrs. MacMonnies' head, where she stands in turn listening to the unqualified approval of such men as Cazin, Puvis de Chavannes, Raffaeli, Boldini, and other so-called *arrivés*, denoting the artist who has "got there," I suppose. . . .

It is with some pride that I preface my sketch of Mrs. MacMonnies with such positive praise of her work, which hitherto has no precedent, I believe—or more correctly, that no woman has till now ever decorated a public building. . . .

Last May, Mrs. MacMonnies received from Mrs. Potter Palmer, president of the board of lady managers of the Chicago Exposition, the commission to decorate one of the large tympans in the rotunda of the Woman's Building, the subject being "The Primitive Woman."

Mrs. MacMonnies' own words in answer to my question of how she solved the mystery of such a subject to begin with, will be more to the point than my own surmises—and at the same time outline the history of her work.

"I began immediately to study the composition, rejecting in turn the idea of the savage, the pre-historic, the slave, the oriental woman, or any that would require precision as to detail of costume, race or environment as being unfit to express an abstract and universal idea.

"I finally settled on the simplest draped figures of women, without special type or costume, in a landscape background that might be of any time or country, and is certainly not un-American. These women indicate with the completest possible simplicity the bearers of burdens, the

tillers of the earth, the servants of man, and more than this, being without ambition, contented with her lot."

This coincides with the generally accepted idea of primitive women, judging from a recent charming *causerie* on the subject by Charles Dudley Warner, who says "woman at that time thought man not good for much except to bring in game, go on thieving expeditions, and fight other tribes."

This lamentable mistake of hers began the evolution of man's present so-called "supremacy," though it is still generally admitted that she "manages a picnic better, much better, than can a man!" After Mrs. MacMonnies had solved her first important problem satisfactorily, she considered the real difficulties of the work were practically over. She then began her studies in detail. Each figure had to be carefully studied separately from the nude model, each bit of drapery drawn and painted. She went to the forest of Fontainebleau for the studies of her landscape, and also made numbers of studies for the foreground, such as weeds, grasses, etc.

These preparatory sketches altogether occupied about three months. After this the "Working Model," one-third the size of the completed decoration (whose dimensions, by the way, measure 66 feet long and 15 feet high) was to be done with the greatest care from the first design and the numerous studies. This absorbed about two and a half or three months time but once accomplished, Mrs. Mac-Monnies had thorough possession of her subject, and the large final work was done in about the same time.

The canvas was divided into three sections, and stretched in the glass covered yard or sculptor's studio, where a forge in one corner and two stoves at red heat made work possible during the severe cold of this winter. The artist on her high ladder with a wing-like palette, almost half her own size, on her thumb, her lithe young figure outlined against the expanse of white canvas on which she is brushing in, with the verve of a strong arm, primeval women nine feet high, is a charming symbol of the "Coming Woman." . . .

Bertha Palmer asked Mary Stevenson Cassatt (1844-1926) to depict "Modern Woman." Cassatt had studied at the Pennsylvania

Academy of Fine Arts and in the late 1860s left the United States
for Europe, where she concentrated on copying old masters in
Italian, Spanish, and Dutch galleries. After she settled in Paris,
where she was joined by her parents, she exhibited at the Salon
until 1879, when she had joined the Impressionists. In response to
a request from Palmer, Cassatt sent the following description of
her mural.

## Mary Cassatt: Letter to Bertha Palmer*

> Bachivillers
> Par Chaumont-En-Vexin
> [11 October 1892]

My Dear Mrs. Palmer,

Your letter of September 27th only arrived this morn-
ing, so unfortunately this will not reach you by the 18th as
you desired. Notwithstanding that my letter will be too late
for the ladies of the committee, I should like very much to
give you some account of the manner [in which] I have tried
to carry out my idea of the decoration.

Mr. Avery sent me an article from one of the New York
papers this summer in which the writer, referring to the order
given to me, said my subject was to be "The Modern Woman
as glorified by Worth!" That would hardly describe my idea
of course. I have tried to express the modern woman in the
fashions of our day and have tried to represent those fashions
as accurately and as much in detail as possible. I took for the
subject of the center and largest composition Young Women
plucking the fruits of Knowledge and Science. That enabled
me to place my figures out of doors and allowed of brilliancy
of color. I have tried to make the general effect as bright, as
gay, as amusing as possible. The occasion is one of rejoicing,
a great national *fête*. I reserved all the seriousness for the
execution, for the drawing and painting. My ideal would

---

*  Reprinted courtesy of The Art Institute of Chicago Libraries.

have been one of those admirable old tapestries brilliant yet soft. My figures are rather under life size although they seem as large as life. I could not manage women in modern dress eight or nine feet high. An American friend asked me in a rather huffy tone the other day, "Then this is woman apart from her relations to man?" I told him it was. Men I have no doubt are painted in all their vigor on the walls of the other buildings; to us the sweetness of childhood, the charm of womanhood, if I have not conveyed some sense of that charm, in one word if I have not been absolutely feminine, then I have failed. My central canvas I hope to finish in a few days. I shall have some photographs taken and sent to you. I will still have place on the side panels for two compositions, one which I shall begin immediately is Young Girls Pursuing Fame. This seems to me very modern and besides will give me an opportunity for some figures in clinging draperies. The other panel will represent the Arts, Music (nothing of St. Cecilia), Dancing and all treated in the most modern way. The whole is surrounded by a border, wide below, narrow above, bands of color, the lower cut with circles containing naked babies tossing fruit, etc. I think, my dear Mrs. Palmer, that if you were here and I could take you out to my studio and show you what I have done that you would be pleased. Indeed without too much vanity, I may say I am almost sure you would.

When the work reaches Chicago, when it is dragged up 48 feet and you will have to stretch your neck to get sight of it at all, whether you will like it then, is another question. Hillman in a recent article declares his belief that in the evolution of the race painting is no longer needed, the architects evidently are of that opinion. Painting was never intended to be put out of sight. This idea however has not troubled me much, for I have passed a most enjoyable summer of hard work. If painting is no longer needed, it seems a pity that some of us are born into the world with such a passion for line and color. Better painters than I am have been put out of sight. Baudry spent years on his decorations. The only time we saw them was when they were exhibited in the Beaux-Arts, then they were buried in the ceiling of the

Grand Opera. After this grumbling I must get back to my work knowing that the sooner we get to Chicago the better. You will be pleased, believe me, my dear Mrs. Palmer.

Most sincerely yours,
Mary Cassatt

Cassatt and MacMonnies took very different approaches to their commissions, and when the fair opened, critics generally agreed that "Primitive Woman" was to be preferred to "Modern Woman." Writing for the *Chicago Tribune* Henry Fuller noted that "Mrs. MacMonnies' tone is light and silvery, while the impudent greens and brutal blues of Miss Cassatt seem to indicate an aggressive personality with which compromise and cooperation would be impossible" (quoted Weimann 1981, 316).

# Emily Sartain: Report on Women's Contribution to the Arts for the World's Congress of Representative Women at the Columbian Exposition, Chicago, 1893

When the Board of Lady Managers began to plan exhibits and activities for the Woman's Building at the Columbian Exposition, some questioned whether women's work should be displayed separately from men's. As Bertha Palmer later explained:

> Those who favored a separate exhibit building believed that the extent and variety of the valuable work by women would not be appreciated or comprehended unless shown in a building separate from the work of men. On the other hand, the most advanced and radical thinkers felt that the exhibit should not be one of the *sex*, but of *merit*, and that women had reached the point where they could afford to compete side by side with men, with a fair chance of success, and that they would not *value* prizes given upon the sentimental basis of sex. (Elliott 1893, 11)

As a compromise, the Lady Managers decided to make their exhibitions "honorary": the displays in the Woman's Building would celebrate women's achievements and "bring together such evidences of [woman's] skill in the various industries, arts and

professions as may convince the world that ability is not a matter of sex" (Truman 1893, 180).

As Bertha Palmer assembled an art exhibition for the "Court of Honor" in the Woman's Building, she had to use all her powers of persuasion to convince some artists to participate. Anne Whitney, for example, didn't want her sculpture exhibited with "bed quilts, needlework and other rubbish" (quoted Weimann 1981, 285). Palmer put together an exhibition that included works by Elizabeth Thompson Butler, Cecilia Beaux, Marie Bashkirtseff, Rosa Bonheur, and Angelica Kauffmann, and eventually persuaded Whitney to contribute not only a fountain that stood in the center of the building but also busts of Lucy Stone and Harriet Beecher Stowe that were displayed along with portraits of suffragists Susan B. Anthony, Lucy Mott, and Elizabeth Cady Stanton.

Women who wanted to compete for awards submitted their work to the juries that selected the exhibitions for other buildings. When displays began to arrive, however, the juries found that they could not accommodate many of the works which women submitted, and the Woman's Building made room for the overflow. Although this distorted the Lady Managers' original plans, it gave substance to their arguments that women should be included in the jury. For the first time at an international exposition, women were named to the awards juries and contributed to determining the standards by which all exhibitions were valued.

To examine the "revolution wrought in recent years on the world's conception of women's natural capabilities" and to commemorate "the struggle through which some women (aided by some men) have won for all women the place conceded them in modern life," the Lady Managers convened a World's Congress of Representative Women *(World's Congress* 1894, 2). It was organized in cooperation with the National Council of Women, which had been founded in 1888 to bring together women's organizations throughout the country, and it followed the precedents set by the congresses at the Paris expositions of 1878 and 1889. For the week from May 15 through 21, 330 delegates from all over the world met in Chicago's new "Art Palace," which at the close of the fair would become the home of the Chicago Art Institute. Delegates examined women's progress in education, literature and dramatic art, science and religion, moral and social reform, civil law and government, and industries and occupations.

Emily Sartain (1841-1927) was one of several women to address women's progress in the fine and applied arts. At fifty-two,

Sartain had experienced the transformation in women artists' opportunities. The daughter of engraver John Sartain, she, like women of earlier generations, had first studied with her father. Between 1864 and 1870 she attended the Pennsylvania Academy of Fine Arts, where she was among the first women students to have access to the nude model. After several years travelling in Europe and studying in Paris studios, she worked as an engraver and exhibited her paintings in the Paris Salon and in American exhibitions. By the last quarter of the century she was among the women who were moving into official, public positions. In 1886 she had been named director of the Philadelphia School of Design for Women, where she initiated curriculum reforms—including the introduction of the first life class. In 1893 Sartain was asked to play several important roles at the Columbian Exposition: she was chairman of the Women's Art Committee for Pennsylvania, decorator of the Ladies Room at the Pennsylvania State Building, and a member of the jury for the fair's art department. Her address to the women's congress reflected not only the breadth of her personal experience, but also the new confidence that many women felt as they surveyed the exhibitions in the Woman's Building.

**In the Woman's Building,** in the women's rooms of the Illinois and Pennsylvania State buildings, you will see stained-glass windows employing the latest resources of the art on its practical side to heighten the effect of color and the tonal qualities;* mural decorations shining the impulse of the most recent movement in art through which started with the story of Ste. Geneviève on the walls of the Pantheon, embroidered portieres which are full-chorded symphonies of color the complementary and contrasting tones of warm and cool hues giving the base and treble clef in the shortened scale of white and black. In engraving, both on wood and steel, in etching, in book illustration, many women are now doing work of· the highest class; and at least one woman architect, Minerva Parker Nichols, is changing the aspect of

---

*    Excerpted from Emily Sartain, "The Contribution of Women to the
     Arts," in *The World's Congress of Representative Women,* edited by
     May Wright Sewall, Chicago and New York: Rand McNally and Co.,
     1894, 567-71.

her city's streets with her many creations in brick and stone, while Miss Hayden's beautiful building before our eyes here speaks for itself.

So many women have so long been doing first-class work in the applied arts that I think a young woman who is thoroughly equipped finds little discrimination against her sex; in fact, she perhaps obtains readier acceptance than her brother. For myself, I may say that during many years of a successful business career as an engraver, my capability being once proven, my womanhood has been in nowise a disability among businessmen; chivalry even taking the form of prompt payment. . . .

But many of the pioneers among our professional women were less fortunate, and carried graven on their faces the lines of nerve-tire and harassment, revolt against the trammels of destiny, and protest against the derision and skepticism of environing conservatism. The skepticism was sometimes justified by a want of thoroughness; the fault not of the woman, but the racial fault of this new nation whose tense nervous organization responds readily in the all-accomplishing "spurt," and often fails to appreciate the dogged, steady, persistent pull upon the collar possible only to the certitude and mastery of thorough training. But now that the solid phalanx of competent professional wage-earners has closed in about these leaders, who are no longer exceptional women to be stared at, their countenances are relaxed, the trade-mark of aggressiveness is gone, and the "becoming" is studied, the evidence of the photographic pass to the exposition to the contrary notwithstanding. We have now in hand today's most powerful business lever, coopera-tion, and with our joint-stock companies of women building women's club-houses and temples, we have our firms of associated artists ready to cooperate with our architects in making the house beautiful.

It is one of the elements of the progress of the last seventeen years that women do now join together and are gaining an *esprit de corps*. In the Woman's Building of the Centennial, the names of the finest women artists were conspicuous by their absence; but those same women have contributed their best toward the Woman's Building of

today's Exposition. I speak with knowledge, for I have hard service in the art collection of the Centennial.

The most important art lesson of the Centennial, and of the exquisitely beautiful buildings in which this Columbian Exposition is housed is addressed not so much to the artist and the art student as it is to the public. It is you, the great public, who need instruction in art, that you may know what is really fine. Our women decorators and designers, sculptors and architects are ready to do good work for you. As you ask for more harmonious coloring in your homes, purer styles, appropriate construction in building and ornament, you will appreciate understandingly how much they have accomplished and stimulate them to still higher attainment. Have faith in them, not the credulity which prostrates itself before false gods, but a discerning faith, and as you ask, so shall you receive.

## Giles Edgerton [Mary Fanton Roberts]: The Quality of Woman's Art Achievement (1908)

"Where are the great women artists?" English and American critics, journalists, and artists began to ask as women's participation in exhibitions and institutions increased. Candace Wheeler predicted that as soon as art became "a natural language to both sexes, instead of one, it is certain to show the wider range of feeling and tendency comprised in the race as a whole, rather than as a part," but she was forced to admit that her contemporaries had done little to justify her expectations (Wheeler 1897, 87). Elizabeth Robins Pennell, who for almost three decades reported on French and English exhibitions for *The Nation*, was even harsher in her assessment of women artists: "In the past hardly any women adopted art as a profession. During the last fifty years or so, they have rushed into art in crowds. And art is as unchanged by their rush as it was by their indifference" (Pennell 1918, 663).

For some observers, the failure of women artists to affect the art of their time suggested that feminine creativity was fundamentally different from masculine creativity. George Moore argued in "Sex in Art" that while women lacked originality, they had extraordinary powers of assimilation and had done their best work "when confined to the arrangements of themes invented by men"

(Moore [1910], 226). C. J. Holmes, in an article entitled "Women as Painters" written for *The Dome*, agreed: "The true genius of the [female] sex is observant, tasteful, and teachable, but not creative" (Holmes 1899, 6). Arthur Edwin Bye believed that the greatest artists were characterized by "pure masculinity, oftentimes of a superhuman order" and wondered whether women had "the force, the strength, the powers of concentration, the prophetic insight" that greatness demanded. It seemed to him unlikely:

> To create a child is the greatest aspiration of [a woman's] life, and when she can do that she rightly cares for nothing else. . . . The lives of great men painters show us they devoted themselves so exclusively to their art that they often neglected all other interests, families included. This would be a sacrifice for a woman, tragic for the race. (Bye 1910, 88)

For other—particularly female—observers, the question remained more problematic: they were only too aware of the social restrictions that women artists continued to experience. In "A Letter to Artists" written for *Lippincott's Magazine*, Anna Lea Merritt, herself a painter, pointed to "untoward domestic incidents" as a particular obstacle for women:

> Some near relative may be ill, and a woman will give her care and thought where a man would not dream of so doing, where no one would expect it from him. . . . The chief obstacle to a woman's success is that she can never have a wife. (Merritt 1900, 467)

Mary Fanton Roberts (1871-1956) addressed the question for *The Craftsman*, the magazine introduced by Gustav Stickley in 1901. Roberts, whose regular contributions to *The Craftsman* appeared under the pseudonym Giles Edgerton until 1910, first wrote about the work of women artists in the June 1908 issue, when she reviewed an exhibition of women's work organized by the Knoedler Galleries in New York City. As a friend of Robert Henri, Roberts supported the independent exhibitions organized by Henri and the Eight, but she strongly opposed separate women's exhibitions, which she considered "something out of the past." She did believe there was "a compulsory sex difference in art," but her attempts to arrive at a standard for judging men's and women's work were confused and contradictory: though she argued that men's and women's differing expressions were "of equal interest," she went on to suggest that women rarely obtained the "universal" quality which characterized the work of the greatest male artists (Edgerton 1908, 240-41). She herself must

have felt dissatisfied with her arguments, for she returned to the question in the following article published in *The Craftsman* six months later.

**In spite of the valiant championship of woman** at the beginning of this new century, there seems still lurking suspicion in the mind of that unidentified assemblage known as the intelligent public that, judged impartially, woman's work in the great fields of art, in sculpture, in music, is on the average distinctly inferior to man's, and that in the remote realm known as the land of genius she seldom walks abroad unaided.* Just here the champions of woman seem to spring up all about me and I hear the drawing of swords—which end in stub pens—and the flowing of ink in defense of the place and success of modern woman in art. Yet, this very agitation of chivalry—does it not spring from a sense of the need of defense? The sword has ever been drawn for the weaker amongst us and the pen has in no small measure imitated this o'er valiant attitude toward womankind.

I do not mean that the modern woman herself seeks the devotion of the knights of the blue pencil and red ink. *Justice* is what she claims in art matters. But when in reply to her prayer for justice she receives flattery, who is to point out so fine a distinction? Surely not the knight of the literary arena, or the lover or the friend. And thus it has become somewhat an established precedent that a woman's mediocre effort should be praised as "good work," "fine," "a great success," and her better work pointed out as "wonderful," "the best ever," or if the critic forgets himself, "Why, by Jove, you know you'd almost think it was a man's work!" And so we have unconsciously established separate standards of excellence for men and women in art, as we have in athletics, and when we say a woman is an excellent painter, we usually only

---

*    Excerpted from Giles Edgerton [Mary Fanton Roberts], "The Quality of Woman's Art Achievement," *The Craftsman* 15 (Dec. 1908), 292-98.

mean that her work is about as good as the merely average
man artist could do.

Of course, the sincere, conscientious, successful workers
among women, those inspired with the genuine gift,
recognize this state of affairs and deplore it; the women on
the other hand who do not achieve refuse to credit it and
insist that woman's work averages as high as man's, but that
galleries and hanging committees are prejudiced against
women. As a matter of fact, hanging committees except in a
very small way, have nothing whatever to do with it. Of
course, one hanging committee may blunder all the time and
all committees may occasionally shut their eyes to merit; but
mostly these committees of men, or men and women, are
earnestly seeking the best art, from their own cultivated
standard, that they can secure to put in their galleries, and
although they sometimes do evidence surprise when a
particularly brilliant canvas carries a woman's signature,
nevertheless, a fair criticism of this maligned body seems to
be that they do not disparage really good work even if signed
Jane or Mary instead of John or James. And for the matter of
that, John and James have themselves been heard to lift up
their manly notes against hanging committees.

The question is indeed not one of sex discrimination, but
of fundamental sex variation in expression, which may only
be changed by what some call progress, and some call
devastation, in our social system, but scarcely affected by the
triumph of the suffragette, or by any greater tribute to the
modern woman's brain or beauty. For, far back of all this sex
variation in expression lies the great fact that true art must
forever reflect existing conditions of life; in other words, that
painting must be saturated with the outlook of the painter,
and his outlook in turn must be great or small as the life he
lives affords him freedom. The monk and the non-conformist
alike are bound back from productive art by the limitations
of renunciation; the scientist by the limitations of mathemat-
ics, the royal man by the limitations of formalities. And so,
great art does not flourish in the monastery, in the laboratory
or in the palace. For it has always demanded freedom, the
liberty to think straight and see clear, a perfect freedom of
observation and experience. It is this freedom rendered

widely divergent in expression by the varying temperament, that produced valuable permanent art which becomes a part of a nation's growth. And woman, the world over, in all civilized and in most primitive lands, has not this freedom. In the East, zenanas; in the West, social usage—render woman more or less ineffectual in relation to art.

Not inevitably so, of course; there are a few women who are great as men are great; in music, painting, sculpture; and in literature, which is a more subjective art, the number is ever on the increase. But up on high Olympus, where according to tradition, genius congregates, the seats reserved for women are pretty generally empty. In the past fifty years I doubt if a dozen women have been admitted, and these representing all the arts; not because women have not been developing a steadily increasing interest in all higher expressions of life, but rather because they have not had combined the great gift itself and the capacity or courage for absolute freedom of soul and mind. And for the woman who has not this courage and yet possesses somewhat of the illuminating vision, there is but one road to great achievement, and that is self-immolation, to become wholly a vehicle for the expression, to forget utterly her birthright as a mother and a sweetheart. Such sacrifices are not demanded of men, you say, and this is true, because men have the freedom of the world afforded them, and a man can at one and the same time become a great artist and a good parent. But what of the mother of children, the tender, devoted, adoring mother who also has the great gift? There is much that a woman can do which is beautiful and essential and a definite part of the world's development in art conditions with her studio next to the nursery; nevertheless, these women do not eventually find seats on Olympus. And the fact of the justice or injustice of it is not what we are considering, but merely the actuality of the condition.

If this seems unjust or exaggerated, recall for a moment the women who count as a definite asset in the compiling of the genius of the world. Study their lives—it will not take long—and see how inevitably they are checked off into one or the other of these classifications. There is the woman who

achieves because she arrogates to herself all the privileges of existence and the woman who achieves at the sacrifice of her identity. Also there is the woman who does her lovely portion of the work of life, making her art subjective, and subjected as well to her greater duties; and as art matters stand today in relation to modern social conditions, the very subjective nature of the work which this greater class is contributing has a value and a charm which otherwise our art history might lose wholly. And we do not find that charm by balancing woman's work *against* man's work and urging an imitation of his methods, but by coupling woman's work *with* man's work and so getting the completest variation in the expression of the life we are now living.

## Teodor de Wyzewa: Forgotten Women (1903)

Critics who looked to women's exhibitions for a "feminine art" were, like G. Darenty who reviewed the second exhibition of the Union des Femmes Peintres et Sculpteurs for *Courrier de l'art*, disappointed:

> I would have hoped on entering the hall of the Palais de l'Industrie to have felt a special impression, a slight shock, something finally which corresponds to Don Juan's *l'odor di femina*. I had allowed myself to expect that the bosom of this exclusive exhibition would have exhaled an artistic scent *sui generis*, a particular demonstration deriving neither from knowledge nor genius, but of that complex entitity, so subtle, so astute, so fugitive, so interesting: feminine emotion. Bitter disillusionment. There was nothing like this. All these works, quite mediocre for the most part, smell of the masculine force to which the brains of their authors have been subjected. (quoted Garb 1989a, 47)

But if women artists were seen to be too dependent on male colleagues and their work was considered too derivative of masculine work, this only confirmed what many considered the essential characteristic of female genius. Sociologist Charles Turgeon, whose *Le féminisme français* was published in 1901 and who considered the Union des Femmes Peintres et Sculpteurs to be symptomatic of a new feminine aggressiveness in the arts, was one of many who believed that women had a "remarkable talent for

assimilation, adaptation, and interpretation" that differed funda-
mentally from the male power of "synthesis, discovery and
invention" (Turgeon 1907, 144).

Bertaux and Demont-Breton, as they called on French
institutions to admit women, called on women artists to create
work that would express their feminine identity and reconcile their
artistic and domestic roles. In 1891, at the celebration of the tenth
anniversary of the founding of the Union des Femmes Peintres et
Sculpteurs, Hélène Bertaux asked the union's members to invent
a feminine art:

> Woman's art will appear very personal: it will be the natural corollary
> of masculine art. . . . Let us remain women. . . . Let us demonstrate
> that one can be an artist and even a great artist without breaking with
> the sum of duties that is our glory and our honor. Let us remain
> women from the artistic point of view as well: Let us not trace our
> masters' work, but create according to our own feeling; Let us give
> birth to an art which will be marked with the genius of our sex.
> (quoted Yeldham 1984, 1:102)

Three years later, at a dinner held to celebrate her election to the
Légion d'Honneur, Demont-Breton reiterated the call:

> Art reflects intelligence, and we will find our most original and
> personal inspiration in our instinctive feelings. . . . Let us try never to
> fight our natural tendencies: what things we can express, having felt
> them so strongly! . . . But let us never scorn the many small works
> which occupy the fingers and restore the spirit; why should the brush
> or the pen be at war with the needle or the crochet hook? Why should
> art conflict with the many small cares which make up the happiness
> and well-being of husband and family? Let the art that fills our lives
> surround our children's cradles with poetry; . . . let us remain women:
> the love of art and the love of the home must go forward together.
> ("Femme Artiste" 1894, [1])

In 1903—the first year women were permitted to compete for
the Prix de Rome—Teodor de Wyzewa (1862-1917) took up the
subject of women artists in a volume of his collected essays,
*Peintres de jadis et d'aujourd'hui*. De Wyzewa's family had come
to France from Poland when he was a child. In the small
community where they settled, the young boy felt very much a
foreigner, and as soon as his education was complete he escaped
to Paris and the Latin quarter. He was determined to make his
living as a writer. In 1885 he and Edouard Dujardin founded the
*Revue Wagnerienne*, which helped to define the doctrines of the
Symbolist movement. Breaking with the Symbolists in 1893, de

Wyzewa became editor of foreign literature for the respected *Revue des deux mondes*. He held this influential position for twenty-four years, but also reviewed events in music, art, literature, and politics for many publications.

De Wyzewa had earlier published essays on Rosalba Carriera and Berthe Morisot—whom he considered the only modern woman who brought something "truly feminine" to art—but "Forgotten Women" had not appeared previously. In it, he attempted to bring together his thoughts on the history of women artists and to suggest a direction for contemporary women artists.

**In the history of art,** three women have won immortal fame: Rosalba, Mme. Vigée-Lebrun and Angelica Kauffmann.* The trace of their passage is slight, like the light prints of small feminine feet; but it remains today very distinct and clear, while so many other traces that seemed much deeper, have been erased. And, what's more, none of these pleasant artists ever aspired to the higher glory of genius. None was ambitious to take her art down new paths or to fabricate an entirely new ideal. On the contrary, they were perfectly happy to be able to run freely down the paths that they found already open. To adapt their feeling of beauty to the taste of their period, to translate their personal vision into the common language—that is how they always modestly employed themselves.

Their originality, nevertheless, stood out only more strongly. Free of any concern for innovation, they easily mastered a craft in which they accepted the existing traditions. After that they had only to be natural and frank for their souls to be revealed completely and to embellish and give a particular charm to the style that they appropriated.

At least this was the case with two of these artists: Rosalba Carriera and Mme. [Vigée-]Lebrun. And perhaps the perpetual attraction of their painting comes precisely from the fact that they did not cease being women in order to become artists. Both preferred grace to novelty and left the arduous task of creation to stronger arms. In fact, they

---

\* Translated from Teodor de Wyzewa, "Les oubliées," *Peintres de jadis et d'aujourd'hui,* Paris: Perrin et Cie., 1903, 177-84.

created neither a genre or a manner, and in what they say we can see who taught them to say it. But they say it so well, with a gentle smile that is so tender and so mischievous, that we do not tire of listening to them. Thus Mme. [Vigée-]Lebrun's portraits at the Louvre sing their little song sweetly without fearing the dangerous proximity of David's more vivid portraits. And how many times, upon entering another room in the museum in search of the pastels of La Tour and Chardin, have we not been attracted, held, and detained by Rosalba's pale images! The great masters had more genius, a stronger touch, and more daring ideas, but a gentle perfume, a delicate feminine fragrance wafts from the work of these two women and slowly, irresistibly insinuates itself into us. And so what does it matter to us if the color is banal or the drawing a little weak and sometimes imprecise! Beneath the color and the drawing—or rather beneath the exterior forms—two charming souls are opened to us with an artless and modest intimacy.

They are two souls all the more charming because they are never preoccupied with being so; because Rosalba and Mme. [Vigée-]Lebrun were capital women, the simplest in the world, who dreamed only of living in peace and working at their best. Both were beautiful, however, as portraits of them show, and they prove that a woman need not be ugly to have talent, nor need she scorn the customary duties and pleasures of her sex. Mme. [Vigée-]Lebrun took the same care when she taught her daughter and when she painted her portrait; Rosalba's contemporaries could not praise highly enough the harmonious dignity of her life. Nothing ever stopped them from being always witty, gay, and even elegant, from following new fashions untainted by false shame—they were the enemies of every affectation, but especially the affectation of severity.

On the other hand, there is many an affectation in the character and the work of their famous rival, Angelica Kauffmann. She brought the highest ambitions to her work. The unfortunate effect of the lessons she received was to push her to consider painting a sacred calling for which she was invested with a supernatural mission. Instead of painting herself in her everyday clothes, as did Rosalba and Mme.

[Vigée-]Lebrun, she painted herself as a Vestal Virgin—and at first I found it very difficult to forgive this. But finally I noted that her Roman costume could not hide a face that was not in the least Roman, but the beautiful and good face of a German with large surprised eyes and a pair of pink cheeks shining with health. By the same token, it seemed to me that, beneath the solemn veil which she believed she had to drape over her work, Angelica Kauffmann's art was a very feminine art, the reflection of a small and light and timid soul. . . .

Thus today the works and lives of these three artists still supply us with instructive examples and useful advice, and they should be studied from this point of view especially. I want to learn from them by what means and under what conditions a woman can hope to succeed in the arts, what she may dare to do and what she should guard against, what is within her reach and what is above or below it . . . .

I should add, moreover, that despite the admiration that their contemporaries lavished on them, Angelica Kauffmann, Mme. [Vigée-]Lebrun and Rosalba have not been treated in our time with the attention that is their due. Their names are familiar and their works continue to attract us, but it is in some ways in spite of the critics. Critics openly affect not to take them seriously. The historians of painting hardly mention them. Museum curators relegate them to the attics. And I do not think that any one has written a study on them for fifty years. There has not even been a woman to take pity on these charming ladies, to condescend to see in their paintings the perfect expression of some of the most noble characteristics of the feminine soul.

What an unfortunate injustice, which comes from an even more unfortunate prejudice! We are only too willing indeed to imagine that woman is not capable of real artistic originality. Despite all our theories of emancipation and equality, we are in fact more scornful of her than anyone before us has ever been. And perhaps it is the fault of our theories. In our desire to open to woman all the fields which man has previously reserved for himself, we have forgotten that there are other areas that, for centuries, were appropriately hers alone and which admirably accommodated her

tastes and powers. We no longer consider the possibility of a feminine art, which as such has not only particular limits, but also a particular beauty. Yet such an art is not impossible. There are sad souls who have argued that since women do not have their own manner of thinking or feeling, literary or musical composition is not in their line; but no one can deny that they see the exterior world in their own particular way. The skill which they put into their movements, into their dress, into the decoration of everything which surrounds them—is that not adequate proof of the instinctive genius of vision which every woman received at birth? And why, seeing things as they know to see them, should they be condemned to represent them otherwise?

It is we and our current ideas that have condemned them to do so. As far back in history as we care to go, we meet women who became famous for producing beautiful works of art. But the majority restricted themselves to the genres which suit them—miniatures, pastels, painting of birds or flowers—and all of them, in every genre, have had a distinct manner, a manner that was truly feminine, that was more familiar and more tender, more modest than that of other artists, and that did not attempt to do any more than to caress the eyes, to please, to be feminine in feminine tasks. Their contemporaries did not ask more of them than that: it would not have occurred to them to apply to these delicate flowers the same critical rules that they applied to the work of men, to reproach Rosalba for the faults in her drawing or to be surprised that Mme. [Vigée-]Lebrun had neither the strength nor brilliance of David.

Alas! How far removed we are from these civilities. We intend that from now on woman will compete with man, that she will pursue the same means to the same ends, and it has not occurred to us that this useless competition will mean that little by little she will lose everything—her precious qualities of grace, elegance and distinction. How many genres which for centuries were hers alone have already disappeared? And among the many women painters whose works fill our exhibitions, is there one who offers us an art which is the least bit feminine? Many, in truth, have assimilated our habits very happily: they draw and paint

better than women painters of the past ever did; and it would be tempting to consider them real artists, if there were not a certain sense of artificiality and dissimulation that one always feels in their paintings. Whatever they do, something is false. We feel that it is not natural for them to see the world as they are painting it and that their hands, however skillfully, are serving someone else's eyes and ideas. There is not even a mediocre rival for Rosalba or Mme. [Vigée-]Lebrun to translate something different from our vision, something with a little more lightness, fickleness and sweetness, something that exists in a woman's eyes.

Yes, it is a common characteristic of all the women painters of earlier times that their paintings retain the precious qualities of a feminine soul. . . .

# VIII. WOMEN AND THE AVANT-GARDE

That a woman should hold a show of pictures in Bond Street
is not usual, nor, perhaps, altogether to be commended. For
it implies, I fancy, some study of the nude and while for many
ages it has been admitted that women are naked and bring
nakedness to birth, it was held, until sixty years ago that for a
woman to look upon nakedness with the eye of an artist, and
not simply the eye of mother, wife or mistress, was corruptive
of her innocency and destructive of her domesticity. Hence
the extreme activity of women in philanthropy, society,
religion and all pursuits requiring clothing.

Virginia Woolf, 1930

Over the course of half a century, the women's movement had
focused public attention on patriarchal structures that relegated
women to the private sphere; by the beginning of the twentieth
century the "new woman" seemed to be shutting the door on
domesticity. George Bernard Shaw predicted that "unless Woman
repudiates her womanliness, her duty to her husband, to her
children, to society, to the law and to everyone but herself, she
cannot emancipate herself," and census figures in Europe and the
United States showed an increase in the number of women in the
paid labor force and a decline in the birthrate (quoted Bell and
Offen 1983, 2:45). These statistics alarmed political and religious
leaders, and proponents of women's rights, wary of antagonizing
the public, responded that allowing women to vote would enhance
rather than jeopardize traditional family structures. By the end of
World War I, women had won civic equality in Britain and the
United States, but in the decades that followed governments
encouraged working women to give up their jobs to veterans and
to return to the house.

At the close of the nineteenth century, a generation of women
artists had been educated in the same schools as men and had
established their right to participate in the institutions that shaped
the public practice of art. But by the beginning of the twentieth

century artists were abandoning the academy for the avant-garde: the rigidly structured, hierarchical institutions that had prevailed through the nineteenth century and consistently excluded women were giving way to informally organized groups of independent artists. Modernist artists identified the academy with the bourgeoisie and with reverence for the past, and they defied traditional middle-class values with an oppositional conception of progress that came to dominate the twentieth-century definition of art.

Avant-garde groups varied considerably in their attitudes towards women and femininity. In questioning tradition, some artists—like the Impressionists—reappraised genres or media that had been considered "feminine." Others—like the Surrealists—incorporated into their theories an idealization of "woman" that was as narrow and restrictive as the Victorian ideal of femininity. Some theorists and critics who welcomed women artists' new presence turned to contemporary psychological theory to articulate their sense of masculine and feminine difference, but most relied on ideas inherited from the past, which contributed little to the inquiry into the character of women's art. For those women artists who came to be associated with the avant-garde through their marriage to another artist, their relationship with modernism was personal as well as aesthetic, and their artistic identities and their feminine roles intertwined. Thus the lives and work of the women artists associated with modernism had much in common with the experiences of women artists of earlier generations.

# Berthe Morisot: Correspondence (1869-1870)

Berthe Morisot (1841-1895) is remembered as a member of the avant-garde Impressionists, but she never abandoned the traditional feminine roles acceptable within her upper-middle-class family. Initially, she was educated by a governess; later she spent several years at an exclusive girls school. According to her brother, Berthe and her two sisters—Yves and Edma—were given drawing lessons because their mother wanted them to be able to make gifts for their father. Classes in cross-hatching bored Yves, but Berthe and Edma persevered. Their next instructor, Joseph-Benoît Guichard, who in 1868 would found a municipal course in drawing and painting for women at Lyons, soon warned their parents that they might become professional artists. Their parents were not alarmed: Mme. Morisot continued to chaperone Berthe and Edma when their studies took them to the Louvre to copy or to

the countryside in search of landscapes, and M. Morisot built them a studio in the garden.

Berthe and Edma first registered as copyists at the Louvre in 1858. Working in front of paintings by Paolo Veronese and Peter Paul Rubens, they were introduced to an artistic circle that included Félix Bracquemond—who had also studied with Guichard—Henri Fantin-Latour and, eventually, Alfred Stevens and Edouard Manet. Berthe and Edma could not visit the Café Guerbois, where Manet, Fantin-Latour, Degas, and other male artists met. But many of these artists shared the Morisot family's genteel background, and Berthe and Edma saw them regularly at the salons that were a part of the social life of their milieu. For most young women such weekly gatherings were an opportunity to meet eligible suitors; for the Morisot daughters they probably also served as an opportunity to discuss aesthetic theory. Berthe could also discuss technique when she sat for Stevens and Manet, who included her in *The Balcony*, which he exhibited in 1869. Although Morisot never actually studied with Manet, she asked him for advice on finishing a painting she was preparing for exhibition—with the unfortunate results that she recounted in a letter to her sister.

In 1869 Edma married Adolphe Pontillon; the sisters' correspondence over the next few years documents Berthe's continuing commitment to and Edma's gradual withdrawal from painting. After her marriage in 1874 to Edouard Manet's brother, Eugène Manet, Berthe Morisot maintained her close connections with the artists who were becoming known as the Impressionists. In 1873—despite the disapproval of Manet, Fantin-Latour, and Guichard—Morisot, who had participated in the Salon for almost a decade, contributed to the group's inaugural exhibition. She sent work to every subsequent Impressionist exhibition except that of 1879—the year after her only daughter was born.

Most of Morisot's models were women and children from her circle of family and friends, and most of her works depicted the routines of middle-class domesticity. She did not work from the nude until the 1880s—well after women students were working in life classes at the Académie Julian and other schools. Rarely, in fact, did Morisot stray beyond the subjects that Marie-Elisabeth Cavé and others of an earlier generation had deemed appropriate for women.

Morisot's—and Mary Cassatt's—place within the Impressionist circle was secured by their interest in technical innovations and their contemporaries' changing attitudes towards subject matter.

Critic Teodor de Wyzewa considered the Impressionists' vision particularly adapted to women artists: "It is appropriate for a woman not to be concerned with the intimate relations between things, but to perceive the universe like a gracious and mobile, infinitely nuanced surface" (Wyzewa 1903, 216). The Impressionists, in turning away from the historical and heroic subjects of the academic tradition, concentrated on "modern life." While Manet and Degas ventured out to paint the demi-monde of the music halls and the boulevards, Morisot and Cassatt depicted the apartments and gardens of the *haute bourgeoise*. Unlike Rosa Bonheur, whose portrayals of animals had taken her to the slaughterhouses of Paris, Berthe Morisot and Mary Cassatt could join the avant-garde without leaving the domestic circle.

### Edma to Berthe, 1869*

I have never once in my life written to you, my dear Berthe. It is therefore not too surprising that I was very sad when we separated for the first time. I am beginning to recover a little, and I hope that my husband is not aware of the void that I feel without you. He is very sweet, full of attentions and solicitude for me, something which I neglected to tell you yesterday. On learning that I had not mentioned him, he cried out, "But they will think I am making you very unhappy!"

### Edma to Berthe, 15 March 1869

I thought I should have a letter from you today, my dear Berthe, but the postman brought me only a *billet-doux* from Robert. The snow came down in big flakes all morning. The mountains have disappeared in the mist, and we remain by the fire. . . . Would you believe that I have been to see the exhibition of the *Société des Amis des Arts*, and that the sight

---

* Excerpted from Berthe Morisot, *The Correspondence of Berthe Morisot with Her Family and Friends,* edited by Denis Rouart, translated by Betty W. Hubbard, London: Percy Lund, Humphries and Co., Ltd., 1959, 27, 28, 30-33, 38-44. Copyright © 1957 by Percy Lund, Humphries and Co., Ltd., and reprinted by permission of Lund Humphries Publishers, Ltd., Park House, 1 Russell Gardens, London NW11 9NN.

of certain pictures gave me pleasure as though I hadn't seen any painting for a long time?

I am often with you, my dear Berthe. In my thoughts I follow you about in your studio, and wish that I could escape, were it only for a quarter of an hour, to breathe that air in which we lived for many long years.

### Berthe to Edma, 19 March 1869

If we go on this way, my dear Edma, we shall no longer be good for anything. You cry on receiving my letters, and I did just the same thing this morning. Your letters so affectionate, but so melancholy, and your husband's kind words made me burst into tears. But, I repeat, this sort of thing is unhealthy. It is making us lose whatever remains of our youth and beauty. For me this is of no importance, but for you it is different.

Yes, I find you are childish: this painting, this work that you mourn for, is the cause of many griefs and troubles. You know it as well as I do, and yet, child that you are, you are already lamenting that which was depressing you only a little while ago.

Come, now, the lot you have chosen is not the worst one. You have a serious attachment, and a man's heart utterly devoted to you. Do not revile your fate. Remember that it is sad to be alone; despite anything that may be said or done, a woman has an immense need of affection. For her to withdraw into herself is to attempt the impossible.

Oh, now I am lecturing you! I don't mean to. I am simply saying what I think, what seems to be true.

### Berthe to Edma, 2 May 1869

The first thing we behold as we went up the big staircase [to the Salon] was Puvis' painting. It looked well. . . . I don't have to tell you that one of the first things I did was to go to Room M. There I found Manet, with his hat on in bright sunlight, looking dazed. He begged me to go and see his painting [*The Balcony*] as he did not dare move a step.

I have never seen such an expressive face as his; he was laughing, then had a worried look, assuring everybody that his picture was very bad, and adding in the same breath that

it would be a great success. I think he has a decidedly charming temperament, I like it very much.

His paintings, as they always do, produce the impression of a wild or even a somewhat unripe fruit. I do not in the least dislike them, but I prefer his portrait of [Emile] Zola.

I am more strange than ugly [in *The Balcony*]. It seems that the epithet of *femme fatale* has been circulating among the curious, but I realize that if I tell you about everything at once, the people and the paintings, I will use up all my writing paper, and so I think I had better tell you another time about my impressions of the paintings, all the more so because I could scarcely see them. However, I did look for our friend Fantin. His insignificant little sketch was hung incredibly high, and looked extremely forlorn. I finally found him, but he disappeared before I could say a word about his exhibit. I do not know whether he was avoiding me, or whether he was conscious of the worthlessness of his work.

I certainly think that his excessive visits to the Louvre and to Mademoiselle Dubourg bring him no luck. Monsieur Degas seemed happy, but guess for whom he forsook me—for Mademoiselle Lille and Madame Loubens. I must admit that I was a little annoyed when a man whom I consider to be very intelligent deserted me to pay compliments to two silly women.

I was beginning to find all this rather dull. For about an hour Manet, in high spirits, was leading his wife, his mother, and me all over the place, when I bumped headlong into Puvis de Chavannes. He seemed delighted to see me, told me that he had come largely on my account as he was beginning to lose hope of seeing me again at the Stevenses, and he asked if he might accompany me for a few minutes. I wanted to see the pictures, but he implored me so eagerly; "I beg of you, let us just talk. We have plenty of time for looking at pictures." Such conversation might have appealed to me had I not found myself confronted at every step by familiar faces. What is more, I had completely lost sight of Manet and his wife, which further increased my embarrassment. I did not think it proper to walk around all alone. When I finally found Manet again, I reproached him for his behaviour; he answered that I could count on all his devotion, but

nevertheless he would never risk playing the part of a child's nurse.

You will ask what has become of my mother during all this time. She was afraid of getting a headache, and sat on a sofa, where I would join her from time to time.

### Berthe to Edma, 11 May 1869

I have missed my chance, dear Edma, and you may congratulate me on having got rid so quickly of all my agitations. I think that I should have fallen ill, if at that moment I had to decide in favour [of marrying] Monsieur D——. Fortunately, this gentleman turned out to be completely ludicrous. I had not expected this, and was quite surprised, but by no means disappointed! Now that I am free of all anxiety, and am taking up again my plans for travel, which in truth I had never given up, I am counting definitely on my stay [with you] in Lorient to do something worthwhile. I have done absolutely nothing since you left, and this is beginning to distress me. My painting never seemed to me as bad as it has in recent days. I sit on my sofa, and the sight of all these daubs nauseates me. I am going to do my mother and Yves in the garden; you see I am reduced to doing the same things over and over again. Yesterday I arranged a bouquet of poppies and snowballs, and could not find the courage to begin it . . . .

### Berthe to Edma, 13 August 1869

Manet lectures me, and holds up that eternal Mademoiselle [Eva] Gonzalès as an example; she has poise, perseverance, she is able to carry an undertaking to a successful issue, whereas I am not capable of anything. In the meantime he has begun her portrait over again for the twenty-fifth time. She poses every day, and every night the head is washed out with soft soap. This will scarcely encourage anyone to pose for him!

### Edma to Berthe, August 1869

I made an attempt to work during the day, and I completely ruined a still life on a white canvas, and this tired me so that after dinner I lay down on my couch and almost fell asleep. Following your advice, on Saturday I went to the

boat, just to get the view. There was a mist in the air, and the scene was pretty. Since then the weather has not been propitious, and all the charm of this place is in the effect. If your landscape does not look good at home, I am even less inclined to try. What is the good of tiring yourself over something that satisfies you so little?

## Berthe to Edma, September 1869

During the day, I received a visit from Puvis de Chavannes. He saw what I had done at Lorient and seemed to find it not too bad. Tell Adolphe that when we examined the pier he complimented me on my knowledge of perspective, and that naturally I gave full credit where it was due. . . .

The Manets came to see us Tuesday evening, and we all went into the studio. To my great surprise and satisfaction, I received the highest praise; it seems that what I do is decidedly better than Eva Gonzalès. . . . Since I have been told that without knowing it I produced masterpieces at Lorient, I have stood gaping before them, and I feel myself no longer capable of anything. . . .

Manet exhorted me so strongly to do a little retouching on my painting of you, that when you come here I shall ask you to let me draw the head again and add some touches at the bottom of the dress, and that is all. He says that the success of my exhibition is assured and that I do not need to worry; the next instant he adds that I shall be rejected. I wish I were not concerned with all this.

## Berthe to Edma, March 1870

I shall at once tell you about my misfortunes, and then we shall speak of them no more.

Mother wrote to you at the time Puvis told me that the head [in my painting of you and mother] was not done and could not be done; whereupon great emotion; I took it out, I did it over again. Friday night I wrote him a note asking him to come to see me; he answered immediately that this was impossible for him and complimented me a great deal on all the rest of the picture, advising me only to put some accents on mother's head. So far no great misfortune. Tired, unnerved, I went to Manet's studio on Saturday. He asked

me how I was getting on, and seeing that I felt dubious, he said to me enthusiastically: "Tomorrow, after I have sent off my pictures, I shall come to see yours and you may put yourself in my hands. I shall tell you what needs to be done."

The next day, which was yesterday, he came at about one o'clock; he found it very good, except for the lower part of the dress. He took the brushes and put in a few accents that looked very well; mother was in ecstasies. That is where my misfortunes began. Once started, nothing could stop him; from the skirt he went to the bust, from the bust to the head, from the head to the background. He cracked a thousand jokes, laughed like a madman, handed me the palette, took it back; finally by five o'clock in the afternoon we had made the prettiest caricature that was ever seen. The carter was waiting to take it away; he made me put it on the hand-cart, willy-nilly. And now I am left confounded. My only hope is that I shall be rejected. My mother thinks this episode funny, but I find it agonizing.

I put in with it the painting I did of you at Lorient. I hope they take only that.

### Berthe to Edma, May 1870

Your friend Fantin is having a real success; the portrait of the two Dubourg sisters is a real gem. I met him Saturday morning, and he was very friendly to me; because he had criticized me, I accepted his praise as genuine and it has given me a little courage again. All in all, since I am talking about myself, I do not make as absurd an impression as I feared; the little portrait of you I did at Lorient is hung so high that it is impossible to judge it.

Manet is in despair about where he is placed. However, his two paintings look well; as usual, they attract much attention. Monsieur Degas has sent a very pretty painting, but his masterpiece is the portrait of Yves in pastel. I am sorry that you did not see it during your stay here.

Mademoiselle Gonzalès is passable but nothing more.

### Edma to Berthe, 8 May 1870

There is nothing that could surprise me less than to learn that Fantin has produced a masterpiece; he is at his best in

studies from nature and in the *genre intime*; I am sure that I should prefer this picture to the one I know. Your enthusiasm for Manet does not seem to be at the same pitch, and this makes me think that he has spoiled *Mademoiselle Gonzalès* and *Leçon de guitare*.

Do you know that I am not yet clear as to whether you did exhibit your picture or not? You write that you "do not make as absurd an impression as you feared." This sentence obviously cannot refer to the study you did of me at Lorient. I am sure that you receive compliments, and refrain from mentioning them.

**Berthe to Edma, May 1870**

The garden has become pretty again; the chestnut trees are in flower, and for the first time this year we are enjoying spring; the pleasure is somewhat diminished by the thought that we shall soon be deprived of it. Do you know that I am very sorry that I did not go to Cherbourg? First because of you two (I should say three), and then because I might have done something there. I am still engrossed in this wretched painting. I certainly did show my two pictures; it is my principle never to try to rectify a blunder, and that is the main reason why I did not profit from my mother's intervention. Now I am thankful: having got over my first emotion, I find that one always derives benefit from exhibiting one's work, however mediocre it may be. On the other hand I am not receiving a great many compliments, as you think, but everyone is sufficiently kind enough not to make me feel any regrets, except of course Degas, who has a supreme contempt for anything I do. . . .

# Paula Modersohn-Becker: Letters and Journal (1901-1906)

Paula Modersohn-Becker (1876-1907) grew up in Bremen in a close-knit middle-class family. Her mother encouraged her to study drawing; her father, a civil engineer, wanted her to be able to support herself and insisted that she complete a teacher's training program in Bremen. In the winters of 1897 and 1898, she studied

at the Zeichen und Malschule des Vereins der Künstlerinnen, a school sponsored by the Berlin society of women artists, and in the summer of 1897 she worked at Worpswede, an artists' colony in the moors near the Hamme River.

In 1898, when she had received her certificate and her father urged her to find a job, an unexpected inheritance from an aunt and uncle enabled Paula Becker to continue working for three more years. In September 1898, she returned to Worpswede to stay for the following two winters. She studied with painter Fritz Mackensen (even though she grew impatient with his emphasis on a naturalist realism), hired models from the local poorhouse to work on her own, and made friends with several other women who were working in the area, including Clara Westhoff.

On the eve of the new century, with the last of her uncle's stipend, Paula Becker left Worpswede to spend several months in Paris. She enrolled in the Académie Cola Rossi, an independent studio similar to the Académie Julian, where she worked in a class with men and women for the first time, and studied anatomy at the Ecole des Beaux-Arts. She visited the museums and galleries, discovered the work of Cézanne, and admired the International Exposition.

Returning to Worpswede in the summer of 1900, she rented a studio in the home of Hermann Brünjes. Her father worried about her finances and warned her that she could only return to Paris if she could earn or borrow the money to finance the trip. By September she was engaged to painter Otto Modersohn, a recent widower with a small child. Her parents now worried about her housekeeping skills—the family joke was that she could only cook pancakes—and sent her to cooking school in Berlin.

Paula Becker and Otto Modersohn married May of 1901. After their marriage, Modersohn-Becker spent mornings and afternoons in her studio. When they had been married a little over a year, Modersohn wrote in his journal that he thought Modersohn-Becker "a highly gifted woman, the most gifted one here, and rare anywhere" (Modersohn-Becker 1983, 283). But he noted that her family never asked about her work and that the other artists of Worpswede did not take her seriously.

Perhaps that is why, early in 1903, he consented when she returned to Paris while he remained in the country. In her journal and her letters to her husband and family, Modersohn-Becker recorded her exhilarated impressions of Paris. But when she returned to Worpswede, she found herself increasingly impatient

with her husband's painting and the conventional life of their quiet rural community. Otto, for his part, found her changed:

> Paula has more intellectual interests and a more spirited mind than anyone else. . . . It is only her feeling for family and her relationship to the house that are too meager. . . . Paula hates to be conventional and is now falling prey to the error of preferring to make everything angular, ugly, bizarre, wooden. Her colors are wonderful—but the form? The expression! Hands like spoons, noses like cobs, mouths like wounds, faces like cretins. (Modersohn-Becker 1983, 324)

Modersohn-Becker made another trip to Paris early in 1905. When she again returned to Worpswede she celebrated her thirtieth birthday—which according to her sister was "her deadline for her painting" (Modersohn-Becker 1983, 384). Despite financial difficulties, her family's reservations, and her husband's pleas for her return, she moved in February 1906 to establish herself permanently and independently in Paris. Otto joined her for the winter of 1906-1907; they reconciled, made plans for a new life together, and in March 1907, with Paula pregnant, returned to Worpswede. On November 7, 1907 their daughter was born; thirteen days later Modersohn-Becker died of an embolism.

Throughout her life, Modersohn-Becker had kept a journal and had corresponded with her family. Her letters and journals were edited for publication by the journalist Sophie Dorothea Gallwitz and appeared in book form in 1920.

## To Otto Modersohn, Berlin, 15 January 1901*

I was in the museum today and heard cherubs singing in heaven. It was so beautiful that I have to tell you about it. Art is the most beautiful thing in the world. Here in Berlin, with all the feathered hats and the terribly noisy tramcars, art is a sweet loving mother to me, a shelter from this torment. I sit very quietly amidst all the noise and curl up into myself. Inwardly I smile and my soul is in the Elysian Fields.

---

* Reprinted by permission from *The Letters and Journals of Paula Modersohn-Becker*, translated and annotated by J. Diane Radycki (Metuchen, NJ, and London: Scarecrow Press, Inc.) Copyright © 1980 by J. Diane Radycki.

Your Rembrandt is a great and mighty person, a king. But I can't always accept him. He's very far from me, beyond me in many of his works, as in *The Consolation of the Widow*. He has a colorfulness to which I was not sympathetic at first glance. But you're right, there's a vibrating in him. The small sketch of the angel in the stable with Joseph and Mary in Bethlehem is wonderful: the light on the wings and parts of the arms of the angel; the angel's hands; Mary in a blue shawl with a striking red; and the cow's head. Everything's so movingly human and so deeply, deeply felt.

Oh, the depth in our hearts! For a long time mine was covered with mists. I knew and sensed little of it. Now it's as if each of my inner experiences lifts these veils so I may glance into this sweet trembling darkness, the darkness that conceals all that makes life worth living.

I feel strongly that everything I previously dreamed of for my own art was not nearly experienced enough inwardly. It must go through the whole person, through every fiber of one's being. . . .

And cooking! . . . So far I've just been looking at kitchens. I haven't made my final decision yet. There's a drawback to every one of them. But I'll get around to it.

And now I kiss you on your red beard very affectionately, very like a bride, my King.

### Journal, Easter Monday, 31 March 1902

.It's my experience that marriage doesn't make one happier. It takes away the illusion that previously sustained one's whole reality, that there is a companion for one's soul.

One feels doubly misunderstood in marriage, since beforehand one's whole life was directed at finding a companion who was understanding. Perhaps it is better to be without this illusion, eye to eye with the great lonely truth?

I write this in my house book, sitting in my kitchen, cooking a roast veal, Easter Monday, 1902.

### Journal, 29 May 1902

I stood in the grass in my bare feet while my husband painted me. First, I wore my wedding dress and then a rose,

a blue, and finally a white satin dress trimmed in gold. The rose dress was open at the back and sleeveless. I was standing in the sun, and whenever a hint of wind swept over my bare neck, I would smile a little and my eyes which were closed in the bright sunlight, would open for a moment. . . . The grass around me was sown with white starwort, I picked a handful and looked at them against the bright sky and at the play of their shadow on my arm. I was in a dream though awake, and I looked on my life as though from another life.

## To her mother, 6 July 1902

It's Sunday morning and I've escaped to my dear atelier. I'm sitting all alone in my dear Brünjes' house. The entire household seems to have gone to church. I had to force every one of the rickety windows in order to let myself in.

My mother, there's a good reason why this is not my punctual Sunday letter—namely, work. Work, in which at present I am involved heart and soul. There are times when this feeling of devotion and dependence lies dormant. Times when I read a lot, joke around, or just exist. Then all at once this feeling awakens and surges and roars, as if the container would nearly burst. There's no room for anything else.

My Mother. Dawn is within me and I feel the approaching day. I am becoming something. If only I could have shown our Father that my life is not just an aimless shot in the dark. If only I could have accounted to him for the part of himself he planted in me! I feel the time is soon approaching when I won't need to be silent and ashamed, rather I will feel with pride that I am a painter.

I have made a study of Elsbeth. She's standing in Brünjes' orchard with a couple of chickens running around, and next to her stands a bib, blossoming foxglove. Of course it's not earth-shaking, but in this work my creative power has grown, my expressive power. I know that many other good works will come after this one. I wasn't sure during the winter. This feeling and knowledge is blessed. My dear Otto stood by, shaking his head, and said I was one devil of a girl. We love each other heartily and talk about each other's art and about our own. Oh, when I'm finally something, it'll take

a weight off my heart. Then I'll be able to look Uncle A. bravely in the eye and I won't have to put him off with all kinds of promises. He'll have the satisfaction of knowing that his kind subsidy was a good investment. And I'll be able to face all the other people who treated my being a painter sympathetically and sensitively, like a funny little obstinate spleen that one has to put up with. You think I'm getting cocky.

**To Otto Modersohn, Paris, 10 February 1903**
I'm sitting in the little Grand Hôtel de la Haute Loire where I stayed three years ago in the same tiny Room 53. Only now in number 54 I hear two strange German painters—back then Clara Westhoff occupied that red-canopied bed. I'm beginning to enjoy Paris, although I'm still very shy and a little scared of the people. When I went to the *crémerie* for supper, one of the well-known Spanish rascals came right up to me. And as I stepped inside two Frenchmen passed me and said, "Aha, aha, elle est retournée." But in my fur jacket I didn't feel at ease among this colorful tribe.

Good night, my King Red Beard. In a couple of weeks I feel I may be writing you to come, because there's champagne in the air here, quite aside from the art everywhere you look. . . .

**Journal, 25 February 1903**
. . . A great simplicity of form is something marvelous. I've always striven to bestow the simplicity of nature on the heads I painted or drew. Now I deeply feel I can learn from antique heads. How greatly and simply they are conceived! Brow, eyes, mouth, nose, cheeks, chin—that's all. It sounds so simple and yet it's so very, very much. How simple in its planes is an antique mouth realized. I feel I must look for all the remarkable shapes and overlapping planes when drawing nature. I have a feeling for how things slide into and over each other. I must carefully develop and refine this feeling. I want to draw much more in Worpswede. I want to arrange in groups the poorhouse children or the A or N families. I'm really looking forward to working. I feel my stay here is doing me a lot of good. . . .

**To Otto Modersohn, 2 March 1903**

You must come. There are many reasons why, but I'll name only one, the great, the greatest: Rodin.

You must experience this man and his whole life's work, which he has gathered around himself in casts. His great art unfolds in full bloom, with its incredible force of will, in complete privacy and secrecy.

I can say little about the work in particular because it should be seen very often and in very different moods in order to absorb it fully.

It's marvelous, the way he works in spite of whether the world approves of his ways or not. It's his unshakable confidence that he's bringing the world beauty. . . .

The remarkable dreamlike figures that he hurls onto the paper are the most singular expression of his art. He uses the most minimum of means, he draws with pencil and then shades in with extraordinary, passionate watercolors. The passion of genius reigns over those pages, disregarding convention. They remind me of the old Japanese things I saw, perhaps of antique frescoes too, or the figures on antique vases.

You have to see them! For a painter their colorfulness is very stimulating. . . .

**Journal, Worpswede, April 1903**

After my trip to Paris. Home in Worpswede.

I'm becoming close to our people here again and feeling their great biblical simplicity. Yesterday I spent an hour with old Frau Schmidt on Hürdenberg. That sensual insight with which she told me about the death of her five children and three winter hogs. She showed me a big cherry tree planted by her daughter, who died at the age of eight. "Well, well, like the proverb says, 'When the tree is tall, the planter's dead.' " . . .

**To her mother, 2 November 1903**

I'm so close to you and still not with you! I don't know how to steal myself out of my little house without sadly deserting its three other occupants. Otto needs to see my face several times a day. Elsbeth makes too much of a racket for him, so he's not feeling very sympathetic to her. I have to be the oil that calms the waves. "Last not least" is our new

strange house guest [the new maid], whom I don't have the heart to let sail the ocean of our little house alone. . . .

## To Otto Modersohn, 15 April 1904

Dear, when I said *adieu* to you I had almost the same feeling Elsbeth has when she happily puts us in the coach and sees us off to Bremen. She thinks about having a whole day or two to herself with no one forbidding her anything. I feel so divinely free! As I walked over the hill, listening to the larks, I wore a quiet smile within me. The feeling I often had as a girl came over me, "Oh yes, I'll buy this world." It's having you in the background that makes my freedom so beautiful. If I were free and didn't have you, my freedom would be worth nothing to me.

I'm thinking about how I'll spend these next few days at my disposal. To begin with, I ordered something very tempting to eat: cold sweet rice with cold apple slices and raisins.

And it's not raining and our wash is fluttering merrily in the wind.

I went out and dug up some anemones and planted them in our little forest. They should be blooming when you return.

I've also been in your atelier. I said to myself very proudly and softly: "This is the atelier of my husband." The new picture has to be even better. It's a little uncertain in mood. I want to say that, instead of being great, it seems bombastic to me. I'd like to talk to you about it again. The idea pleases me very much though, and you've brought out the head of the old woman splendidly. It makes me think of the old "Empress" on Klinkerberg. Were you thinking of her too?

Dear, do you know where I slept last night? At Brünjes'. It was so delightful. I cooked my eggs on my little oil stove as in the old days. I sat up until ten with my two windows wide open. First a blackbird sang, then a robin, and then they were silent. Throughout the night there were soft sounds, the voice of awakening nature, and every now and then the distant bark of a dog.

I'm as attached to this little room as you are to your bachelor den at Grimm's. Sleeping, waking, the jangling of cows' chains during the night, the cries of the cock and hens in the morning—I enjoy it all. . . .

## To Otto Modersohn, Paris, 19 February 1905

I'm writing you my birthday letter and am with you in all my wishes for art and life and life and art. I'm sending you a couple of droll Daumiers and a little Japanese sketchbook. I'd prefer sending you greater and more beautiful things, but I'll have to wait a couple of years before I can do that, until you or I or both of us have amassed the necessary coins. . . .

I've registered at the Académie Julian for a month to paint the nude from eight to eleven. The museums don't open until ten, so my morning hours won't be wasted and it certainly can't hurt me. . . .

## To Otto Modersohn, 23 February 1905

. . . It's very funny in the atelier, genuine Frenchwomen are very amusing. Only I'm still afraid of them because they laugh so easily. They paint as artists did a hundred years ago, as if they hadn't seen painting since Courbet. The only exhibitions they attend are those for the Prix de Rome, probably the same trash but of somewhat better quality.

I've found a canvas here that I feel is my canvas. The others regard my paintings very suspiciously. When I leave my easel at recess, they stand six deep in front of my work and debate it.

A Russian asked me if I really see things the way I paint them and who taught me.

I lied and said proudly, "Mon mari."

Whereupon a light dawned and she said, enlightened, "Oh, you paint the way your husband paints."

That you paint the way you see things yourself, that they would never assume. . . .

## To her mother, Worpswede, 26 November 1905

The few hours of daylight that still shine are now over. I sent away my little nude model and lit my lamp with the intention and resolve to overcome my writing "allergy." . . .

Mornings I'm painting Clara [Westhoff-]Rilke in a white dress, her head and part of her hand and a red rose. She looks very beautiful and I hope I can capture something of her. Her little girl Ruth plays next to us, a small chubby human being. I'm happy to be seeing Clara Rilke frequently like this. In

spite of everything I still like her the best. She lived quite
close to Rodin for three or four weeks and is still very much
under the influence of his personality and his simple great
maxims. Rilke, as Rodin's secretary, is little by little getting
to see the intelligentsia of Europe.

Otto is painting, painting, painting. And we've earned
enough so that perhaps after Christmas we can visit you after
a small detour to Schreiberhau. That would be very nice. On
the whole I've begun this hibernation with all these feelings
of longing—perhaps why I dislike writing. I'm secretly
planning a little trip to Paris again, for which I've already
saved fifty marks. Otto, on the other hand, feels utterly
comfortable. He needs activity only as a rest from his art, and
he's always satisfied. I get the strong desire from time to time
to experience something else. That one is so terribly stuck
when one is married, is rather hard. . . .

### Journal, Paris, 24 February 1906

I have left Otto Modersohn and I am standing between
my old and my new life. What will it be like? And what will
I be like in my new life? . . .

### To Otto Modersohn, 9 April 1906

I've just read your letter. It moved me deeply. I was also
moved by the words from my own letter that you quoted.
How I loved you. Dear Red, if you can, hold your hands over
me a while longer without condemning me. I can't come to
you now, I can't. And I don't want to meet you in any other
place either.

So many things about you lived in my heart, but then
disappeared. I have to wait to see if they'll return or if
something else will appear instead. Over and over I ponder
what the best thing is to do. I feel insecure myself about
having forsaken everything that was certain in and around
me. I must stay in the world for a while now, to be tested and
to be able to test myself. Will you give me 120 marks a month
for the time being? So I can live?

I'll stay in Paris as long as I can stand it. At the moment
I don't want to work independently, but in school. I've
rented my atelier at Brünjes' to Fraulein W. from May 1st

on. I wrote her only that I wouldn't be in Worpswede for the summer. . . .

### To her sister, May 1906

I am going to become something—I am living the most intensely happy period of my life. Pray for me. Send me sixty francs for models' fees. Thanks. Never lose faith in me.

### To her mother, 8 May 1906

You're not angry with me! I was so afraid you'd be angry. It would have made me sad and hard. And now you are so good to me. Yes, Mother, I couldn't stand it any longer, and I'll probably never be able to stand it again either. It was all too confining for me and not what—and always less of what—I needed.

Now I am beginning a new life. Don't interfere, just let me be. It's so very beautiful. This last week I've been living as if in ecstasy. I feel I've accomplished something good.

Don't be sad about me. If my life should not bring me back to Worpswede, still the eight years I spent there were very beautiful. . . .

### To Otto Modersohn, 15 May 1906

I haven't written you for a terribly long time because, as it happens, I've been so hard at work. These last two weeks have gone very well for me. Night and day I've been intensely thinking about my painting, and I've been fairly satisfied with everything I've done. I'm flagging somewhat now, not working as much, and no longer as satisfied. But on the whole, I still have a deeper and happier attitude toward my art than I did in Worpswede. Only it demands great, great exertion.

Sleeping amongst my paintings is delightful. My atelier is very bright in the moonlight. When I wake during the night I jump out of bed and look at my work. And in the morning it's the first thing I see. . . .

### To her sister, 18 November 1906

. . . The review [of my work at the Bremen Kunsthalle] gave me more satisfaction than pleasure. The joy—the overpoweringly beautiful hours—takes place in art without

others noticing. The same is true of the sorrow. That's why one most lives alone in art. But the review will be good for my show in Bremen and may place a different light on my leaving Worpswede.

Otto and I will move back home in the spring. The man is so touching in his love. We want to try to buy Brünjeshof in order to make our life together more free and open, with all kinds of animals around us. I look at it this way: if the good Lord allows me to create something beautiful once more, I'll be happy and content as long as I have a place where I can work in peace. And I'll be grateful for whatever part of love has come my way. . . .

# Sonia Delaunay-Terk: We Will Go As Far As the Sun (1905-1929)

Sonia Delaunay-Terk (1885-1979) was the daughter of a Ukrainian factory worker, but at five she was adopted by her uncle, Henri Terk, a wealthy Jewish lawyer in St. Petersburg. She grew up in a fashionable, cultured, and rigidly proper milieu. In later years she remembered that when she was bored with the adults' conversation she was allowed to look through albums with reproductions of paintings: "They were the basis of my painting school. And there I saw a certain woman painter whom I envied—what was her name? There are portraits of her with her daughter" (Delaunay and Delaunay 1978, 223). A teacher persuaded Sonia Terk's family to send her to art school and she spent two winters studying drawing and anatomy in Karlsruhe and in 1905 left for Paris.

Terk had been familiar with the work of the Impressionists through publications, but in France she was introduced to the paintings of the Fauves, which made the Impressionists seem "old fashioned and descriptive." She began to experiment with color. In 1908, when her family asked her return to St. Petersburg, she turned to the German gallery owner, William Uhde; their marriage of convenience allowed her to remain in France. Two years later she and Uhde were divorced and she married painter Robert Delaunay, whom she had first met in 1907.

In the early years of their marriage, Robert Delaunay concentrated on painting and developing his theories of the simultaneous contrast of colors while Sonia Delaunay-Terk

painted and experimented with textiles. As early as the summer of 1909, Sonia Delaunay-Terk embroidered a leaf pattern in an attempt to emulate the work of Henri Rousseau, and textiles would remain important to the artist throughout her career. Needlework was not only a part of her Russian heritage, but allowed her to experiment with colors in ways that paint and canvas did not. Robert Delaunay later recalled that her explorations with fabric led to a new awareness of color:

> Delaunay-Terk made some satin-stitch wall hangings which, by means of their expressiveness were to bring into view the prospect of liberation. About 1912, we helped inaugurate the birth of color, completely freed from its links with the past and expressed in book bindings of modern poets, in lampshades of regulated colors. With these experiments she first set out toward a form of art as yet unknown. (Delaunay and Delaunay 1978, 134)

Delaunay-Terk "collaged" fabrics into a quilt for her infant son, book covers, cushion covers, and "simultaneous clothing" that she and Delaunay wore to the Bal Bullier, where artists gathered to dance the tango. Guillaume Apollinaire "reviewed" one of her dresses for the *Mercure de France*:

> Purple dress, wide purple-and-green belt, and under the jacket a corsage divided into brightly colored zones, delicate or faded, where the following colors are mixed: antique rose, yellow-orange, Nattier blue, scarlet, etc. appearing on different materials so that woolen cloth, taffeta, tulle, flannelette, watered silk and peau de soie are juxtaposed. (Delaunay and Delaunay 1978, 179)

At the start of World War I, the Delaunays left France for Spain and Portugal, where they remained until 1921. Initially Delaunay-Terk devoted most of her time to painting, but with the loss of her income following the Russian Revolution, she returned to design. A commission from a Lyons silk manufacturer in 1922 allowed her to establish her business; by 1925 her designs won a gold medal at the Exposition Internationale des Arts Décoratifs et Industriels Modernes in Paris. Guillermo de Torre described the effect of her designs:

> New art has descended to the streets. . . . Color is not trapped anymore between the four edges of a painting. It has come to earth, entered our sentimental pockets, clings to our clothes, dances on the walls, giggles under screens and peers down at us from the ceiling. The color is free and its prisoner, traditional decorative art, despairs and fades away. (quoted Albright-Knox Art Gallery 1980, 53)

Although Sonia Delaunay-Terk returned to painting in the early thirties, she never abandoned the decorative arts completely. When she was awarded the Légion d'Honneur in 1975, it was for a career that included textiles, prints, posters, mosaics, theatrical sets, and decorations as well as painting. Her autobiography, published in 1978, included extracts from the journal she kept from 1902-1906 and 1933-1970 and selections from her conversations with Jacques Damase.

### Five Young Russian Women in Paris*

I come to Paris in 1905. Barely twenty years old. I settle in the Latin quarter. I live in a pension with four other young Russian girls, and every evening twenty of us get together. Like a good girl, I enroll at Académie de La Palette. Five masters, as neo-classic as they were "established," teach there, Cottet, Aman Jean, Desvallieres, Simon and Jacques-Emile Blanche. They take turns correcting our efforts, which truly confuses the students. From that moment, I work alone. . . .

Gauguin's work is exhibited at rue Laffitte; everyone is talking about him. Next to La Madeleine, on what is today the place du Madelios, I admire Bonnard and Vuillard in the windows of the Berheim gallery. Our group of young Russians is critical of Matisse. Except for his great still lifes, I find his vision too bourgeois. He is not avant garde enough for us; we want to go farther. . . .

### Robert, Of the Birds and the Plants

When I met Robert [Delaunay], he was doing many studies of plants. He was in love with flowers. He cultivated them in his small studio in the quai aux Oiseaux. . . .

I admired the way that he conveyed the colors of what surrounded him. He did not paint a bouquet of flowers, but a mass of pink, of amaranth red. Begonias were some of his

---

\* Translated from Sonia Delaunay-Terk with Jacques Damase and Patrick Raynaud, *Nous irons jusqu'au Soleil,* Paris: Editions Robert Laffont, 1978, 19, 23, 31-35, 45-46, 53-54, 67, 71, 73, 76-79, 83, 95-96, 102, by permission of Editions Robert Laffont.

favorite flowers because of the color they brought into his
studio. . . .

## Shall We Play at Life?

In Delaunay I had met a poet. A poet who wrote not
with words, but with colors. We lived like children. We still
had a private income, and we played at life like others played
with dolls. . . .

The early years of our marriage, we lived in a style very
much beyond our means. We spent double our income. The
situation was complicated. I was assured a fixed sum each
month from my aunt, and Robert's mother, with a similar
enthusiasm, promised to pay him the same thing. Finally, she
never gave us a cent, and she concealed from us that she did
not have any more money. She had to sell her emeralds,
which were magnificent, and even her furniture. Because we
could not guess from her appearance, we had counted on her
help in setting up housekeeping, this made my life very
difficult from the start. . . . But that did not stop us from
entertaining in our studio on the rue des Grands-Augustins.
On Sundays we had open house. People came from all over,
French and foreign, many Russians, the painters and poets of
the Russian avant-garde. . . .

Little by little, I changed the decoration in our apartment
at 3 rue des Grands-Augustins, next door to Lapérouse. Here
and there I ferreted out beautiful Empire furniture. The house
lent itself to this. On the walls I found layers of old paper
twenty centimeters thick. I replaced it with a white muslin and
I set out my first simultaneous lamp shades.

When Charles was born in January 1911, he had an
Empire bed. I tucked him in with a quilt made from
fragments of cloth. Russian peasants made quilts like that.
Looking at the arrangement of the fragments of fabric, our
friends exclaimed: "But that is Cubist!" This fabric mosaic
was simply spontaneous. I continued to use this construction
method for other objects. Art critics have seen a "geomet-
rized" form and singing colors in these works which
predicted my later work.

The baby's presence did not prevent us from working
freely. He did not annoy Delaunay; he never cried. There

was never a quieter baby. And also the studio was some
distance from the cradle. We opened up a wall to put a
bathroom between the kitchen and the studio, and that made
a sound barrier. While I worked, a young girl watched
Charles. Almost every day, I took him for a walk in the
Luxembourg garden. . . .

"As soon as they wake up, the Delaunays talk painting,"
said Apollinaire. He did not exaggerate, and he could have
added that we breathed and lived painting, and might even
have said that we painted on our bed sheets. It was true. We
were in love in art as other couples are united in faith, in crime,
in alcohol, in politics. Our passion for painting linked us
together. It was mingled with a love of life. . . .

Tireless, hell-bent, Robert proceeded by leaps, huge
bounds that projected him into the future. With his still lifes,
his landscapes of Pont-Avon, and his first self-portraits, he
quickly passed by Neo-Impressionism. Like a meteor, he
traversed Cubism. He went beyond Cubism and made it a
satellite of the Eiffel Tower, the steel muse of a new world
that he observed, gazed at and adored from every angle with
prismatic visionary glasses.

The tower was not an isolated beacon, he would say with
enthusiasm. "A new inspiration is stirring in the tower, in
bridges, houses, man, woman, toys, eyes, books, New York,
Berlin, Moscow."

In the studio at Grands-Augustins, he was already
dreaming of other things. The *Cities* and the *Towers* marked
his destructive period. He wanted to construct. Beside him,
I saw the prismatic and circular forms of his new efforts surge
forth. His painting separated itself from concern for repre-
sentation. He turned toward another law which I gradually
recognized as an eternal truth: the simultaneous contrast of
colors. Four years before we met he had discovered this law
in Chevreul's book of 1839. He dreamed of applying
Chevreul's theory to painting. As for me, I did not discuss the
theory—I was content to see the contrast of colors every-
where, in everyday things. I made my first collages, book
bindings of applied paper and fabric for the books I
cherished; I painted the small chests; I made pillows, vests,
lamp shades. These simultaneous objects astonished our

Sunday guests. All this I did for my own amusement. I began a series of pastels taking off from electoral posters. Color excited me; I was not aware of what I was doing. These are the things which come from one's guts. It would be the same all my life. Let us call it instinct. Robert said, "Sonia has an atavistic sense of color."

Freedom drew us together when we talked painting. Each of us could say without question, "I am my own disciple."

## City Lights

1912, 13, 14—what intense, explosive years for Robert and myself! Delaunay prophesied without stopping. Before the war broke out, Robert was shooting off rockets everywhere, while I, back on the ground, caught the sparks that fell from his fireworks. I was lighting the more intimate, transient fires of daily life, while quietly continuing the important work. Already, Robert was dreaming of spatial collaborations between architects and painters; he was rising towards the monumental, and I followed him, loving the scale of it. In the sky we had rediscovered the emotional principle of every work of art: the light, the movement of color. When they disregarded it, the Cubists—and the Surrealists later—dried everything out, disembodied and congealed it. This "unreasoning, senseless, and lyric" element so necessary to human creation—which Cendrars described so eloquently—is the sensual song of color. We celebrated it on the roofs and the walls of the city. I wanted to see it everywhere, not to leave it behind in the studio. Everywhere, in every circumstance of life, it has a place. It makes houses habitable and bodies alive, mysterious or truly nude. It can be a book jacket or the surface of an object; it is the harlequin that chases away the ugliness, the sadness and the sclerosis of all the academies and schools, of the barracks and prisons in the world where poetry is locked up.

The poets who were part of our circle—Apollinaire and Cendrars especially—understood what I wanted to do. I didn't want to reduce abstract art to an intellectual prejudice, to a geometry of simple calculations; I didn't want to let it become impoverished; I wanted to return to primitive

sources, to bring together order and lyricism. For me the abstract and the sensual had to be joined. To break with the descriptive line did not mean to sterilize. I willingly accept recognition as a predecessor of abstract art—as has been said only lately. But I would add that the "abstract" artists did not follow me; they broke with life and its natural rhythms. They have forgotten that abstraction is not so grand a thing if it is only a manner, a simplistic reaction; it is important as long as it is a complete art, a complex art. Cendrars was the first and the only one to understand that abstract art is only important if it is the endless rhythm in which the ancient past and the distant future are joined. . . .

[I met Cendrars at Apollinaire's.] At one of his Wednesday evenings, I saw a small young man, frail and blond, seated on a large sofa. Blaise Cendrars. He had just written *Les paques à New York*. He lived three or four doors away from us. "Come see us at the studio." The next day, he brought us a small pamphlet. *Les paques.*

I read it first. Thrilled by the freshness of his ideas, I gave it to Delaunay and rushed to my supplier on the rue Dauphine to get the materials to make the cover and binding that I imagined for this poem. I applied a paper collage to a suede cover. On the inside, I did the same, with great squares of colored paper. It was a tangible response to the beauty of the poem. . . .

A little later, Cendrars brought me *La prose du transsibérien et de la petite Jehanne de France*, and moved by the beauty of the text, I suggested creating a folding book that would be two meters long when unfolded. The text inspired a harmony of colors unwinding parallel to the poem. We selected type in varied faces and sizes, which was revolutionary at this time. The ground of the text was colored to harmonize with the illustration. I composed a bulletin, executed also in pochoir, in which the ground and letters harmonized in simultaneous contrasts. . . .

**Monsieur "Coup de Poing"**

[Robert] talked to clarify his thoughts. Ideas came to him when he spoke, as eating produces an appetite. Sometimes I would reproach him for talking with fools. "I

am talking to myself," he would say. In fact, he wanted to broadcast to the entire world, not just a single person. Most often, I was the one who best understood what he was saying. I understood, but I never followed it to the letter.

My life was more physical. He would think a lot; as for me, I was always painting. In many ways we were similar, but there was a fundamental difference. Because he sought to justify his work in theory, his attitude towards painting was more scientific than mine. From the moment we started living together, I played second fiddle, and I didn't put myself forward until the 1950s. Robert was the brilliant one with the genius to sense which way the wind was blowing. For myself, I lived in greater depth. . . .

**Our Vacation**

[The period from 1914 to 1920 when we were in voluntary exile in Spain and Portugal was] the most beautiful period of my life, a great holiday because I could work in the best conditions a painter could dream of: fiery light of these countries, the lively bustle of the streets, which reminded me of the Russia of my childhood, the feasts, the open air markets, the songs, the popular dances. Life was not expensive; we were free of every care, helped by native women who were marvelously devoted and gentle. . . .

With Sam Halpert, an American whom Robert met in England and Edouardo Vianna, a Portuguese, we moved into a villa in northern Portugal at Villa do Conde. It was a dream life. We could work quietly morning to night. The villa was perched on the dunes, facing the sea, with a garden of cacti and flowers. I thought we were living in a fairy tale. I loved the village from the very moment we arrived. . . .

In Portugal, more than elsewhere, we began naturally to move away from realism and toward abstraction, towards the essential elements, circular forms in which there were no lines to break the rhythms of the colors. It was a watermelon seller sitting in the market at Minho, a pumpkin structure, a good bull's head with long horns, a toy seen in a store window, a Gypsy woman accompanied by an Andalusian guitar who did not stop turning. While Robert saw his youthful taste for still life blossom—this was the period of his

water bearers and Portuguese still lifes—I studied dance movements. In *Le Grand Flamenco*, only the singer's face is still expressionist . . . but in the rest I sought the music's endless rhythm. At this period Robert was more of a realist than I. I worked a long time on *Le Grand Flamenco* because I wanted to bring off a painting as beautiful as a Veronese. It was not easy. . . .

The Revolution of October, the death of the czar, and the end of our income.

On the Ramblas of Barcelona, we learn of the Bolshevik victory. We are completely ruined, but even before we react to the repercussions that the ruin of the Terk family will have on our artistic independence, hope for the Russian people makes us cry with joy.

The great Russian-Portuguese holiday is over.

It is necessary to return to society and to seek to apply our discoveries to the decorative arts. We shall return to Madrid.

Diaghilev is on our route. Every night in Madrid we gather to hear and see the best Flamenco artists. The dances affected me more than Robert. Nijinsky was with us. He was very seductive. He was carried away by our work and he wanted to do a ballet with us. "It will be a *ménage à trois*," he said with an amorous fire which pleased me. What spectacle should we plan with the creator of the Ballets Russes?

—"What about Cleopatra?" asked Diaghilev. He asked me to do the costumes and Robert to do the sets. . . .

For the sets, Robert made a model of "A view over the Nile." As for me, I envisioned Cleopatra as a mummy who would be revealed as she was unwrapped. The wrappings would be scarves, each different. I thought of the sarcophagus which haunted my trips to the Louvre with Delaunay. And had I not gone to a costume ball when I was sixteen in St. Petersburg as an Egyptian Princess? When the mummy was completely unwrapped, projectors illuminated the queen in her solar costume: on her breasts she wore discs of armor, concentric circles in every color and crimps of pearls formed sumptuous rays around her navel. These were the discs that appeared on a sarcophagus at the Louvre.

Diaghilev showed us a telegram from London. The

production was well received. Cries of "Ahh" greeted Cleopatra's simultaneous robe and joyous discs replaced the sad and congealed cubes that crowded Parisian salons. . . .

To amuse myself, I also agree to dress the aristocracy. A tunic, a rafia hat, an umbrella, each four times—and the four daughters of the Marquis d'Urquijo are dressed in this style.

Gaby, a madrilenian star, asks me to redecorate the interiors of the old Bonavente theater which was to be rechristened "Petit Casino" and where revue performances were to be introduced. I arrange a contrast: the entrance is all in black, the room is red, white and yellow.

I open "Casa Sonia" for interior decoration. . . .

Tristan Tzara's voice made us homesick for Paris. I was the first to read about what was happening in France. His prophetic manifesto reaches us in Madrid and connects with our ideas. We are no longer crying alone in the desert. Paris is beginning to stir again. Reading the Dada manifesto, we know that the hour of our repatriation is rapidly approaching. . . .

## La Maison Delaunay

The crazy years—I prefer to call them the poetic years, were also the lean years. There was not enough money to maintain two studios—Robert had kept his on the rue Grands-Augustins—to be open handed with hospitality, to raise a child. Shortly after our return, we had to part with [Henri Rousseau's] *La Charmeuse de Serpents*. We sold it to a collector, Jacques Doucet, with the condition that when he died the work would go to the Louvre. That was not enough to keep the pot boiling. But I did not balk at work. But for whom? For what clientele?

Memories of Spain encouraged me to step forth. The four young daughters of the marquis whom I had dressed—I had done that for my own amusement, like an older sister preparing costumes for a ball. I had planned their toilettes as an amateur. But in Paris, I was asked to do theatrical costumes. Why not dress society women?

I had tried to do new things with upholstery fabric, but always for friends, for our group. Why not create overcoats using the same technique? And here was another opportunity.

A silk manufacturer in Lyons gave me the first order for

simultaneous fabrics. For financial reasons, I wanted to print them myself. There I was thrown into the production process.

When I opened a boutique, a *couture* studio, a fabric house, I did not anticipate that the venture would do too well. To grow into a business. I was capable of being the boss, but I had other goals in life. Business always inspired me with horror and disgust. I had a registered office, letterhead, publicity folders, advertising showcases. I shipped truckloads of printed fabric to the United States.

My success became particularly enormous after the International Expositions des Arts-Déco, for which I decorated a simultaneous boutique with the cooperation of Jacques Heim. Our stall was on the Pont Alexandre III. Mannequins modeled my works. Heim put in my hands the design of fur coats. Fabric manufacturers began to bite and to sell only geometric patterns. My friend, Jacques Damase . . . has understood perfectly that there was no break between my painting and the work which is called "decorative" and that the "minor genres" have never been a frustration for me. Instead they have been an opportunity to expand, to conquer new spaces, to apply the same research. The conception excited me. The multiplication of the orders, the worldly comedy, the business problems—in the end I employed thirty workers—ate me up. I led three lives at once; it was a crazy pace, and towards the 1930s I suffered not because of what I was doing, but because I could not attack on more fronts at once. . . .

The great Depression of 1929 rescued me from business. Orders stopped. America was withdrawing into its economic wreckage. I worried about what work I could give to my employees, how I was going to pay my bills when there was hardly any work. The answer came like a lightning bolt out of the blue. We were seated, Robert and I, at a cafe across from the Dome. I noticed, on the other side of the boulevard, a quiet old gentleman smoking his pipe in the sun. This serene philosopher—it was the painter Vantongerloo—suggested the course I should take.

"We are foolish to try to keep our business going at any cost. Let's do as Vantongerloo does, dreaming in the sun. Let us drop it all and return to pure painting." . . .

# Marie Laurencin: Masculine Genius Intimidates Me (1942)

At her death, Marie Laurencin (1885-1956) was remembered as "the belle of the Cubists" ("Belle of the Cubists" 1956, 12). Born in Paris, she was illegitimate and never knew her father, who left her to be brought up by her Creole mother. At the Lycée Lamartine she received the carefully circumscribed education accorded to young girls. Later, despite her mother's reluctance, Laurencin studied painting at the Académie Humbert and china painting at the Ecole de Sèvres. At the Académie Humbert she met Georges Braque, who was a fellow student, and by 1907, the year Laurencin made her debut at the Salon des Indépendants, she was a regular visitor to the *bateau-lavoir* in Montmartre where Braque, Pablo Picasso, Juan Gris, and Max Jacob had their studios. According to an apocryphal story, Picasso introduced Laurencin to the poet and art critic Guillaume Apollinaire with the words "I have a fiancée for you."

Apollinaire called her "bright, witty, kind-hearted, and very talented . . . a feminine version of myself. She is a true Parisian with all the adorable little ways of a Parisian child" (quoted Steegmuller 1963, 158). Though Laurencin and Apollinaire did not marry, their liaison lasted six years. For Apollinaire the poet, Laurencin was muse; Henri Rousseau painted them in this guise in 1909 and she inspired such poems as *Vitam Impendere Amore*. For Apollinaire the art critic, Laurencin represented the feminine painter.

Echoing ideas that were widespread before the turn of the century, Apollinaire suggested that women would contribute to art "not technical innovations, but rather taste, intuition, and something like a new and joyous vision of the universe" (Apollinaire 1972, 227). Reviewing Laurencin's work at the 1908 Salon des Indépendants, Apollinaire noted:

> Though she has masculine defects, she has every conceivable feminine quality. The greatest error of most women artists is that they try to surpass men, losing their taste and charm in the process. Mlle. Laurencin is very different. She is aware of the deep differences—essential, ideal differences—that separate men from women. (quoted Steegmuller 1963, 162)

In his *Méditations aesthétiques: Les peintres cubistes* of 1913, he suggested that feminine aesthetics—"which, up to the present, have appeared almost exclusively in the applied arts, such as lacework and embroidery"—were embodied in Laurencin's paint-

ing. Yet he also suggested that Laurencin's "feminine aesthetic" derived from Pablo Picasso and Henri Matisse and placed the serpentine lines that fragmented forms in her paintings and the stylized faces of her figures, "between Picasso and Rousseau" (Apollinaire 1944, 25).

By 1913 Apollinaire and Laurencin had separated, though he would continue to praise her work until his death in 1918. In June 1914 Laurencin married a German aristocrat and painter, Otto von Waëtjen, and at the start of World War I, the couple left Paris for Barcelona. In Spain, Laurencin joined a circle of exiles that included Francis Picabia and Albert Gleizes, and she co-edited the Dada review *391*. Divorced from her husband, Laurencin returned to Paris in 1920 to resume her painting career and to begin experiments in other media. She was a very successful portrait painter; she designed fabrics and wallpapers for André Groult, provided costumes for Serge Diaghilev's production of Francis Poulenc's ballet *Les biches*, and illustrated numerous books.

By the twenties, however, Laurencin had developed a style that would remain virtually unchanged throughout her career and owed little to Cubism. Painter Augustus John, writing in 1928, voiced typical reservations about her work:

> Her delicate fantasies of young girls, with their witty and rather perverse charm and their diaphanous color are apt to become monotonous. They are like a tune that is delightful when first heard, but tiresome when repeated too frequently. But their nervous grace has a piquancy that prevents them from being sentimental, and their originality is undeniable. (John 1928, 116)

Marie Laurencin's own assessment of her talents, which appeared in the jottings of poetry and biographical notes published as *Le carnet des nuits*, was equally modest.

**It seems to me that painting is not a duty** because I love it.* When I was very young, I realized that when I wanted to

---

* Translated from Marie Laurencin, *Le carnet des nuits,* Geneva: Pierre Cailler, 1956, 15-22. First published Brussels: Editions de la Nouvelle revue belgique, 1942. This selection was also published as "Le génie de l'homme m'intimide," *Arts* (Paris), no. 369 (24 July 1952), 1, 10.

do something—learn my lessons, draw, sew—if I simply spoke of it beforehand it would never be carried out.

So ever since I began painting I have always been careful, out of a sort of superstition, never to talk about it. Even my paintings disturbed me—if they remained in my studio. I do not like to run across them; those which I have kept I kept because of their frames.

If I feel myself so different from painters, it is because they are men—and because men seem to me difficult problems to resolve. Their discussions, their inquiries, their genius have always amazed me.

When a poet writes, he says so well what I would like to say that, calmed, I fall quiet.

As for painting, it is exactly the same, and in any case the great painters who are my contemporaries painted in my place.

But if masculine genius intimidates me, I feel perfectly at ease with everything feminine: when I was small, I loved silk thread, and I stole pearls and spools of colored thread which I thought I hid carefully and I would look at when I was alone. I would have liked to have had many children to comb their hair and dress it with ribbons. I loved to hear mothers sing. The most beautiful days were those when I was taken to a small community of nuns: the sisters would take me in their arms, show me picture books, and let me play the harmonium.

Most of all I loved to look at faces, to seek out the sweetness of a smile or a voice. I surely was the laziest little girl in the world. . . .

And suddenly, we were fifteen years old—in other words we began to look at ourselves.

Ghirlandaijo and Botticelli were our favorite painters.

With their adolescent grace, some of my friends' faces were like models for the Italian school. Their narrow jaws, their long hair and their eyes with their natural brows made one forget that their clothes were not beautiful. . . .

Youth, how one loves and admires it in others! But for most of us it was a gloomy period: we never ran. Only a few played tennis or knew how to swim. We were taken for walks on the Champs-Elysées on Sundays and in museums on

Thursdays. On feast days, our holidays, we became so plain that we spent our evenings crying.

Hungry for freshness, on the next day we would ask each other about our pleasant day off. We felt surrounded by secrets—Alfred de Musset, courtesans. . . . We did not go out alone. . . .

Kept apart from life, we passionately sought it in painting and poetry.

In order to learn to paint, one must use colors. To fling oneself in the water and swim always seemed to me very pleasant because water is a clean element; but colors terrified me. They became dirty so quickly. Red was my enemy.

I have never been able to use vermilion. And until now I have never felt any desire to do so. I used madder lake instead. . . .

We continued to see in our friends the ephemeral likeness of Jean Goujon's and even Leonardo da Vinci's angels, but since we were always watched by our parents, we continually used crayon or charcoal to copy the portrait of Mme. Vigée-Lebrun and her daughter. Lace collars, *fichus*, all that sentimental baggage: the glove maker, the milliner.

Men are not crazy about Mme. Vigée-Lebrun; they accept her in a museum. Perhaps it is because as a painter she is a little cold, if one compares her with Goya, who carries one into a lively world of ruses and lies, of dancing in the street and grace. The way he painted stylish marionettes of steel, one knows he was not fooled by them. He painted them an eye for an eye and a tooth for a tooth, the haughty and cold look of the Duchess of Alba, the ugliness of Queen Maria Louisa. They did not lose an inch of their very straight waists, and they set their ravishing feet not like goddesses, but like Eves, sure of themselves and dominant. . . .

Often, I am politely asked, either to please me or out of curiosity, how I began to paint, despite such sorry beginnings and my struggles with color.

For a time I attended an academy. The professors who gave their names to the school would come for a half-hour each week, made a little speech, and leave. They ignored us.

But there were female students, and for us—young Parisian *bourgeoises*—it was very exciting to be surrounded

by foreigners. Every country was represented there, and it seemed that Paris was the only, the unique, the central, the ideal city for artists. Meeting foreigners, I realized that I had been lucky in one real sense—I had been born in Paris, and I was very proud of it. . . .

The little that I have learned was taught to me because Matisse, Derain, Braque, and Picasso, whom I considered great painters, were my contemporaries. They will be unhappy that I have named them; they are like that. It's like the song from *Carmen*, "If you do not like me, I like you. . . ."

If I have not become a Cubist painter, it is because I cannot. I did not have the ability, but I was passionate about their inquiries.

## Georgia O'Keeffe: About Myself (1939)

Georgia O'Keeffe (1887-1986) was born in the rural American Midwest, but in 1902 her family left Sun Prairie, Wisconsin, for Williamsburg, Virginia. Elizabeth May Willis, who taught art at the girls' boarding school O'Keeffe attended, encouraged her to go on to art school: she studied at the Art Institute of Chicago, moved to the Art Students League in New York, and finally ended up in New York at Columbia Teachers College. In the intermittent periods O'Keeffe spent in New York between 1912 and 1916, she was not only influenced by the theories of Arthur Wesley Dow, but became familiar with work of American and European avant-garde artists through visits to 291, the gallery established by Alfred Stieglitz. When O'Keeffe left New York to teach—first in Virginia and later in South Carolina and Texas—friends sent her copies of Stieglitz's magazine *Camera Work* and letters describing New York events.

In 1915, while in South Carolina, O'Keeffe destroyed all her earlier work and began painting complete abstractions. As she later explained:

> I found myself saying to myself—I can't live where I want to—I can't go where I want to go—I can't do what I want to do—I can't even say what I want to. . . . I decided I was a very stupid fool not to at least paint as I wanted to and say what I wanted to when I painted as that seemed to be the only thing I could do that didn't concern anybody but myself, that was nobody's business but my own. (quoted Norman 1973, 136)

She must have had some doubts, however: when she sent several of her charcoal drawings to Anita Pollitzer in New York she wondered if she were not "crazy." Pollitzer in turn showed the drawings to Stieglitz. Years later, Stieglitz described his reaction when he opened the package and looked at the first drawing: "I realized I had never seen anything like it before. All my tiredness vanished. I studied the second and the third, exclaiming, 'Finally a woman on paper. A woman gives herself. The miracle has happened' " (quoted Norman 1973, 129).

Stieglitz exhibited the drawings at 291 in 1917 and began a correspondence with the artist. At his urging, O'Keeffe returned to New York the following year; they were married in 1924. O'Keeffe did not have another solo exhibition until 1923, but she was soon well known in New York's critical and artistic circles: her paintings were regularly included in group exhibitions and in 1921 Stieglitz exhibited his extensive and often intimate series of photographs of her.

For many in the 1920s O'Keeffe's works embodied a feminine sensibility. Stieglitz, in response to a question from Stanton MacDonald Wright, called the "Advent of Woman in the Field of Art" a new factor:

> Woman *feels* the World *differently* than Man feels it. And one of the chief generating forces crystallizing into art is undoubtedly elemental feeling—Woman's and Man's are differentiated through the difference in their sex make-up. They are *One* together—potentially *One* always. The Woman receives the World through her Womb. That is the seat of her deepest feeling. Mind comes second. (quoted Norman 1973, 137)

Only in the twentieth century—and particularly with the work of O'Keeffe—had feminine "elemental force and vision" become "overpowering enough to throw off the Male Shackles" and express "*her* vision of the world."

For the New York avant-garde of the twenties, femininity was defined not by the Victorian ideal of domesticity but by Freudian sexuality. Paul Rosenfeld, writing for *The Dial* in 1921, called O'Keeffe's work "gloriously female":

> Her great painful and ecstatic climaxes make us at last to know something the man has always wanted to know. For here in this painting, there is registered the manner of perception anchored in the constitution of the woman. The organs that differentiate the sex speak. Woman, one would judge, always feel, when they feel strongly, through the womb. (Rosenfeld 1921, 666)

Louis Kalonyme, writing in *Creative Art* in 1928, noted that "in opening flowers and opened seashells, in twisting branches and thrusting seawaves, she has revealed the world as a woman functions in it" (Kalonyme 1928, xxxvii).

Whatever she thought of Stieglitz's theories, O'Keeffe found herself "embarrassed" and angered by the critics' analyses of her work. Her own statements about her work never emphasized the Freudian, and she complained that "the things they write sound so strange and far removed from what I feel of myself" (quoted Cowart, Hamilton, and Greenough 1987, 137).

In the summer of 1929 O'Keeffe visited New Mexico; for the next two decades she spent summers in the southwest and winters in New York. The landscape paintings she completed in the summers were a reassertion of her personal vision, and in a preface to the catalogue of her 1939 exhibition at Stieglitz's An American Place, she explained her point of view.

**A flower is relatively small.**\* Everyone has many associations with a flower—the idea of flowers. You put out your hand to touch a flower—lean forward to smell it—maybe touch it with your lips almost without thinking—or give it to someone to please them. Still—in a way—nobody sees a flower—really—it is so small—we haven't time—and to see takes time like to have a friend takes time. If I could paint the flower exactly as I see it no one would see what I see because I would paint it small like the flower is small.

So I said to myself—I'll paint what I see—what the flower is to me but I'll paint it big and they will be surprised into taking time to look at it—I will make even busy New Yorkers take time to see what I see of flowers.

Well—I made you take time to look at what I saw and when you took time to really notice my flower you hung all your own associations with flowers on my flower and you write about my flower as if I think and see what you think and see of the flower—and I don't.

---

\* Excerpted from Georgia O'Keeffe, "About Myself," in *Georgia O'Keeffe: Exhibition of Oils and Pastels* (exhibition catalogue), New York: An American Place, 1939, n.p.

Then when I paint a red hill, because a red hill has no particular association for you like the flower has, you say it is too bad that I don't always paint flowers. A flower touches almost everyone's heart. A red hill doesn't touch everyone's heart as it touches mine and I suppose there is no reason why it should. The red hill is a piece of the bad lands where even the grass is gone. Bad lands roll away outside my door—hill after hill—red hills of apparently the same sort of earth that you mix with oil to make paint. All the earth colors of the painter's palette are out there in the many miles of bad lands. The light naples yellow through the ochres—orange and red and purple earth—even the soft earth greens. You have no associations with those hills—our waste land—I think our most beautiful country—You may have not seen it, so you want me always to paint flowers.

I fancy all this hasn't much to do with painting.

I have wanted to paint the desert and I haven't known how. I always think that I can not stay with it long enough. So I brought home the bleached bones as my symbols of the desert. To me they are as beautiful as anything I know. To me they are strangely more living than the animals walking around—hair, eyes and all with their tails switching. The bones seem to cut sharply to the center of something that is keenly alive on the desert even tho' it is vast and empty and untouchable—and knows no kindness with all its beauty.

## Marsden Hartley: Some Women Artists in Modern Painting: Delaunay, Laurencin, O'Keeffe (1921)

As a poet and an art critic, painter Marsden Hartley (1877-1943) was largely self-educated. He explained to Alfred Stieglitz, "I have not esthetics as a background—I have only life as background" (Hartley 1972, 27). His life, however, brought him into avant-garde circles in New York and Paris and familiarized him with the work of women artists active in these circles.

Hartley was born in Lewiston, Maine. After leaving school at fifteen, he worked as a clerk in a shoe factory and in his free time wandered the countryside and read Thoreau. He first studied art in

Cleveland, where his family had relocated: after several years of private classes while he continued to work, Hartley spent a year at the Cleveland Art Institute. The gift of a stipend allowed him to study in New York. He remained there after the money ran out, painting, reading, and writing poetry, but received little recognition until in 1909 he was introduced to Alfred Stieglitz.

Stieglitz exhibited Hartley's paintings immediately—if somewhat reluctantly—at 291, and the painter became the photographer's faithful protégé. Hartley learned from the exhibitions of European modernists that Stieglitz mounted at 291, and Stieglitz found the financial assistance that enabled Hartley to visit Europe. Arriving in Paris in April 1912, Hartley joined those who gathered at the studio of Robert Delaunay and Sonia Delaunay-Terk and at the home of Gertrude Stein and discovered that "poetry is one piece with life, not the result of stuffy studios and excessively ornate library corners" (Hartley 1972, 29).

From Paris and later from Munich and Berlin, Hartley wrote Stieglitz long letters describing his experiences. The photographer encouraged him to undertake more formal essays, which were published as catalogues to exhibitions at 291 and reprinted in *Camera Work*. Hartley, who returned to the United States to stay in 1916, was soon a well-published essayist and poet: his work appeared in "little magazines" like *Seven Arts* and *Contact* and in well-established, widely read weeklies like *The Dial* and the *New Republic*. His first collection of essays, *Adventures in the Arts*, was published in 1921 with Stieglitz's assistance.

Included in the volume was a previously unpublished essay "Some Women Artists in Modern Painting," which singled out the work of three women: Sonia Delaunay-Terk, Marie Laurencin, and Georgia O'Keeffe. Hartley's approach to the question of femininity in art was contradictory: while he argued that "art is neither male nor female," he readily praised the "feminine" qualities in the work of the three women. The only other woman on whom he lavished attention in this volume was Jennie Vanvleet Cowdery, who was the subject of "The Virtues of Amateur Painting." Mrs.Cowdery, whom Hartley described as a "southern lady," painted "quaint and convincingly original pictures" that recalled the work of Victorian lady amateurs (Hartley 1972, 134).

Hartley explained in a preface to the volume that he considered his essays "entertaining conversations" rather than "professional treatises"—reactions through "direct impulse" and not essays by means of "stiffened analysis" (Hartley 1972, n.p.). He was well aware, however, of the debates within avant-garde

circles of Europe and the United States, and the portions of his essay that dealt with O'Keeffe and Laurencin were later republished as catalogue essays for exhibitions at Stieglitz's gallery.

**It is for the purpose of specialization** that the term woman is herewith applied to the idea of art in painting.* Art is for anyone naturally who can show degree of mastery of it. There have been a great many women poets and musicians as well as actors, though singularly enough the woman painters of history have been few, and for that matter in question of proportion remain so. Whatever the wish may be in point of dismissing the idea of sex in painting, there has so often been felt among many women engaging to express themselves in it, the need to shake off marked signs of masculinity, and even brutishness in attack, as denoting, and it must be said here, a factitious notion of power. Power in painting does not come from muscularity of art; it comes naturally from the intellect. There are a great many male painters showing too many signs of femininity in their appreciation and conception of art in painting. Art is neither male nor female. Nevertheless, it is pleasing to find women artists such as I wish to take up here, keeping to the charm of their own feminine perceptions and feminine powers of expression. It is their very femininity which makes them distinctive in these instances. This does not imply a lady-like approach or womanly attitude of moral. It merely means that their quality is a feminine quality.

In the work of Madame Delaunay-Terk, who is the wife of Delaunay, the French Orphiste, which I have not seen since the war came on, one can say that she was then running her husband a very close second for distinction in painting and intelligence of expression. When two people work so closely in harmony with each other, it is and will always

* Excerpted from Marsden Hartley, "Some Women Artists in Modern Painting" in *Adventures in the Arts,* New York: Hacker, 1972, 112-19, by permission of Hacker Art Books, Inc. Reprint of New York: Boni and Liveright, 1921.

remain a matter of difficulty in knowing just who is the real expressor of an idea. Whatever there is of originality in the idea of Orphisme shall be credited to Delaunay as the inventor, but whether his own examples are more replete than those of Madame Delaunay-Terk is not easy of statement. There was at that time a marked increase of virility in production over those of Delaunay himself, but these are matters of private personal attack. Her Russian temper was probably responsible for this, at least no doubt, assisted considerably. There was nevertheless at that time marked evidence that she was in mastery of the idea of Orphisme both as to conception and execution. She showed greater signs of virility in her approach than did Delaunay himself. . . .

With Marie Laurencin there was a greater sense of personal and individual creation. One can never quite think of anyone in connection with her pictures other than the happy reminiscence of Watteau. With her works comes charm in the highest, finest sense; there is nothing trivial about her pictures, yet they abound in all the graces of the 18th century. Her drawings and paintings with spread fans and now and then a greyhound or a gazelle opposed against them in design, hold grace and elegance of feeling that Watteau would certainly have sanctioned. She brings up the same sense of exquisite gesture and simplicity of movement with a feeling for the romantic aspect of virginal life which exists nowhere else in modern painting. She eliminates all severities of intellect, and super-imposes wistful charm of idea upon a pattern of the most delicate beauty. She is essentially an original which means that she invents her own experience in art.

Marie Laurencin concerns herself chiefly with the idea of girlish youth, young girls gazing toward each other with fans spread or folded and fine braids of hair tied gently with pale cerise or pale blue ribbon, and a pearl-like hush of quietude hovers over them. She arrests the attention by her fine reticence and holds one's interest by the veracity of esthetic experience she evinces in her least or greatest painting or drawing. She paints with miniature sensibility and

knows best of all what to leave out. She is eminently devoid of expressiveness either in pose or treatment, with the result that your eye is refreshingly cooled with the delicate process.

With Georgia O'Keeffe one takes a far jump into volcanic crateral ethers, and sees the world of a woman turned inside out and gaping with deep open eyes and fixed mouth at the rather trivial world of living people. "I wish people were all trees and I think I could enjoy them then," says Georgia O'Keeffe. Georgia O'Keeffe has had her feet scorched on the laval effusiveness of terrible experience; she has walked on fire and listened to the hissing of vapors around her person. The pictures of O'Keeffe, the name by which she is mostly known, are probably as living and as shameless private documents as exist, in painting certainly, and probably in any other art. By shamelessness I mean unqualified nakedness of statement. Her pictures are essential abstractions as all her sensations have been tempered to abstraction by the too vicarious experience with actual life. She has seen hell, one might say, and is the Sphynxian sniffer at the value of a secret. She looks as if she had ridden the millions of miles of her every known imaginary horizon and has left all her horses lying dead in their tracks. All in quest of greater knowledge and the greater sense of truth. What these quests for truth are worth no one can precisely say, but the tendency would be to say at least by one who has gone far to find them out that they are not worthy of the earth or sky they are written on. Truth has soiled many an avenue, it has left many a drawing room window open. It has left the confession box filled with bones. However, Georgia O'Keeffe's pictures are essays in experience that neither Rops nor Moreau nor Baudelaire could have smiled away.

She is far nearer to St. Theresa's vision of life as experience than she could ever be to that of Catherine the Great or Lucrezia Borgia. Georgia O'Keeffe wears no poisoned emeralds. She wears too much white; she is impaled with a white consciousness. It is not without significance that she wishes to paint red in white and still have it look like red. She thinks it can be done and yet there is more red in her pictures than any other color at present; though they do, it must be said, run to rose from ashy white

with oppositions of blue to keep them companionable and calm. The work of Georgia O'Keeffe startles by its actual experience of life. This does not imply street life or sky life or drawing room life, but life in all its huge abstraction of pain and misery and its huge propensity for silencing the spirit of adventure. These pictures might also be called expositions of psychism in color and movement. . . .

If there are other significant women in modern art I am not as yet familiarized with them. These foregoing women take their place definitely as artists within the circle of women painters like Le Brun, Mary Cassatt, Berthe Morisot, and are in advance of them by being closer to the true appreciation of esthetics in inventing for themselves.

## Marguerite Thompson Zorach: A Painter Turns Craftsman (1945)

As a child in Fresno, California, Marguerite Thompson Zorach (1887-1968) drew and painted at an early age. Her serious studies began in 1908, however, when she was invited to join her Aunt Harriet Adelaide Harris in Paris. "Aunt Addie," who had taught school for twenty-five years before retiring to Paris in 1900, was familiar with recent artistic developments. On the day Marguerite Thompson arrived in Paris, she was guided to the Salon d'Automne, where the Fauves were exhibiting for the first time. Gertrude Stein had been a childhood friend of Marguerite's aunt, and the art student visited the Stein home at 27 rue de Fleurus, where she met Pablo Picasso and Ossip Zadkine.

Although Marguerite failed the exam for the Ecole des Beaux-Arts—she had never drawn from the nude—she enrolled at the Ecole de la Grande Chaumière and the Académie de La Palette. At La Palette she worked under John Duncan Fergusson, a Scot who considered himself a "Post-Impressionist" and worked in a Fauvist style. Her friends included Jessie Dismorr, with whom she shared a studio, and William Zorach, who had come to Paris from Cleveland, Ohio. Zorach, born in Lithuania, had worked as a lithographer to earn the money that permitted him to spend a year studying in Paris.

Concerned about her niece's growing attachment to Zorach, in October 1911 Harris returned Marguerite to her parents in

California, travelling by way of Egypt, Palestine, India, Burma, Malaysia, and China. Marguerite remained six months in California: her family wanted her to join Fresno society, but she made plans to join Zorach in New York. Marguerite Thompson and William Zorach were married on Christmas Eve, 1912 and settled into a "Post-Impressionist studio" in Greenwich Village. Because Marguerite refused to allow William to return to lithography, they were poor. She made most of their wardrobe—except for their shoes and her husband's suits—and they decorated their studio with scavenged furniture and yards of muslin that she transformed into a wall hanging with stylized birds and trees.

In the early years of their marriage, the Zorachs' paintings developed along similar lines and they often exhibited together. Both participated in the Armory Show of 1913, and at William's insistence, Marguerite was the only woman included in the 1916 Forum Exhibition of Modern American Painters. After their children were born, however, Marguerite found it difficult to paint, as William later recalled:

> Marguerite was frustrated at not having any uninterrupted time for painting. . . . To be distracted or torn away at a crucial moment was very destructive to her. There was no uninterrupted time with caring for two small children, cooking, and running a house; and running a house came hard for her. I helped, but it didn't come easy to me either. (Zorach, W. 1967, 56)

Marguerite had first turned to embroidery when she was dissatisfied with the colors in a picture she painted in India, as she explained in 1945 in the following article for *Crafts Horizons*. She grew to appreciate the flexibility it allowed her:

> Needlework can be picked up and put down because the creative image and pattern exists in the artist's brain and must be built up little by little, in actual work. It is not dependent upon consecutive time which is always more of a problem for women than for men. It is something to be dreamed over at night and during the mechanical work of the day and is ready and waiting to find its form and color when the moments of leisure can be wrested from the busy day. (Zorach, M. 1956, 50)

William was fascinated as well, and they collaborated on several embroideries. When Marguerite taught a needlework class at the Modern Art School, the embroideries were described as "a remarkable new departure, a modern expression of that something which went into the old samplers," and those exhibited in

1916 at the Daniel Gallery were an immediate critical and financial success (quoted Tarbell 1980, 20). One critic noted that "people who view with some alarm the simplifications and distortions of modern painting feel no disquietude at all in contemplating the same thing in the realm of textile design" (Slusser 1923, 30). William later recounted:

> For many years they were really our main source of income and brought us unexpected security and gave us money to carry on our painting and sculpture. The work she did because she loved it. She ignored the time element, and when someone bought something it just meant that we had money to live on and time to devote to our work. (Zorach, W. 1967, 58)

By 1956, Marguerite Thompson Zorach wrote that she had completed seventeen tapestries and four bedspreads. She never, however, gave up painting, and in her later years she alternated painting with appliquéd textile designs and hooked rugs.

**I never learned to do embroidery** or even to sew properly.* I hadn't the slightest interest in this handicraft. But when I became a painter, in the days when painters were revelling in pure color, I was fascinated by the brilliancy of color in wools and the extraordinary variety and life of these colors.

I had been in India and I was trying to put on canvas the brightness and richness of color in an Indian wedding procession. I was so exasperated with the limitations of paint, that I bought some wool yarn and started to paint my picture with a needle on a piece of linen. My husband became so fascinated that he too got a needle and we both stitched, hardly stopping to eat. It was exciting. We didn't know anything about stitches. We had the linen on a canvas stretcher and poked the needles in and out as the sailors used to do when they embroidered at sea.

All my first tapestries were a repainting in wool of the

---

\*   Reprinted from "A Painter Turns Craftsman" by Marguerite Zorach, *Craft Horizons* (now *American Craft*) 4, no. 8 (February 1945), 2-3, by permission of *American Craft*.

pictures I was dissatisfied with in paint. But it was not long before the tapestries began to have a life of their own. I began to develop the possibilities of the medium, to use different stitches to express different textures, to find a way of making a stitch express the form. People are in awe of stitches; yet they are really so simple and so few. A person with a needle could sit down and in an hour arrive at all the stitches that have ever been used by needleworkers. It is only what you do with them that counts.

I do not believe in teaching or in learning from others how to do things. The things which we all do best (as artists) are the things we develop through doing and an inner drive. This leaves our development free to take its own forms and directions. Because I was going into the unknown I had to find my own ways and means of doing things. Because I was a painter I brought the knowledge and perception of a painter to this craft.

As in my paintings, I find the subjects for my tapestries in my life and in the life that touches me; seen through the imagination, selecting and combining the things that interest me most. Out of this material I create patterns and build relationships. These things take a very long time to do. I don't mind how many days or months or years an idea grows in my brain or on my linen. I have all the time in the world.

When I know what I want to do, I work out a sketch on paper. When I feel right about it, I trace the general design on the linen. This I have to do because I no longer use a frame of any kind, but hold the linen in my hand and sew a little here and a little there. I have done this work so much that I never destroy the tension; the finished work never buckles or pulls, but lies flat.

I never plan the color. That develops with the working. It is a delightful process—every bit is an adventure. I constantly move about. I only do what I feel is right. When there is a question or a problem I just drop that spot and go elsewhere. I never have to make any decisions—I just avoid them—and a few days later when I look at the difficult spot, it isn't there. The problem has vanished, and I find that I know just what to do. The actual work is so slow one's mind

has infinite time to play with and solve problems. Hence, there are no mistakes or changes; just a free growing.

People say, "What patience!" I have no patience. I don't need any. I am not filling dull spaces with work. I am filling them with all sorts of interesting things and relating a complicated and involved whole. The more complicated the embroidery, the more fascinating the problems. It is no more difficult to spend three years on a single tapestry than to spend three years on a dozen paintings.

I always use the same materials—wool on handwoven linen, simply because I like these things. I do not dye my own wools, the world is full of beautiful wools. I don't use knitting yarns, only tapestry and crewel and odd wools I pick up. Once, many years ago, I went out and bought $250 worth of wools. These just filled a small suitcase and, while most of the original wool is gone now, my stock remains about the same—a suitcase-ful.

I am always pursuing some beloved color through the pile and being a perfectionist, I spend endless time looking for just the right color, finally taking a substitute which does just as well. I do all the work myself. No one could possibly help me. It is a constant creation in which the imagination has endless time to develop themes and solve problems.

To me, my paintings have the same qualities on a simpler and larger scale that are in my tapestries. But people will never agree with me. They are fascinated by a craftsmanship they can see, and whose accomplishment is obvious. I'm always a bit indignant, but I do realize these works are rare and unusual as well as beautiful, and if I were the general public I would feel the same way.

Of late years I have done a number of large tapestries on order—quite remarkable orders and the only kind I can manage undertaking. People have said to me, "Make me an embroidered tapestry." We have discussed the subject, and sometimes the price. Sometimes not. No one has ever said, "Do this" or "Don't do that." No one has ever asked to see the design or look at the work in progress. I have made these tapestries as I would have made them for myself and if those who ordered them had said, "We don't like them," I would

have been happy to keep them. But so far no one has let me keep one.

## Florine Stettheimer: Crystal Flowers (1949)

Born into a wealthy German-Jewish banking family, Florine Stettheimer (1871-1944) lived with her mother, Rosetta, and her two sisters, Ettie and Carrie. They were educated, cultured, genteel, upperclass—and bohemian. Florine attended the Art Students League from 1892 to 1895, and Ettie studied philosophy at Columbia University. In 1906 the Stettheimers left for Europe, where their income would go further. They settled for extended periods in Germany so that Ettie could finish her dissertation for the University of Freiburg and Florine could continue her art studies. In German galleries Florine became familiar with the work of Symbolist artists like Klimt and Hodler; in Paris she visited exhibitions of the work of Cézanne, Rodin, Morisot, and Renoir.

With the outbreak of World War I, the Stettheimers returned to New York, where they were soon introduced to exiled European and American avant-garde artists. They became close friends with Carl Van Vechten, whose interests included music, dance, theater, and popular culture, as well as art. He introduced them in 1916 to Marcel Duchamp, whose *Nude Descending a Staircase* had been a *succès de scandale* at the Armory Show a few years earlier. Before long the guests invited to tea and dinner at the Stettheimers' New York apartment included Gaston Lachaise, Elie Nadelman, William and Marguerite Zorach, Edward Steichen, and Albert Gleizes, in addition to Van Vechten and Duchamp.

In 1916 Florine Stettheimer exhibited flower paintings, still lifes and family portraits at Knoedler Galleries. In agreeing to the exhibition, she stipulated that she would arrange the installation; using muslin and gold fringe, she transformed the gallery into a white baldachino that resembled her bedroom and recreated the environment in which her paintings had been completed. The exhibition was not a success. The anonymous critic for the *New York Times* called her paintings "very modern as to color, not without weakness in construction and design, and filled with a pleasant sense of humor and fantasy" ("Clever Paintings" 1916, 18). Stettheimer noted in her journal that "only one person asked to see the price list" (quoted Tyler 1963, 29).

From 1917 to 1926 Stettheimer regularly sent paintings to the annual exhibitions of the Society of Independent Artists, but she

turned away offers for solo exhibitions from Alfred Stieglitz and others and unveiled her paintings at private gatherings in her studio in the Beaux-Arts Building on Bryant Park. It was said that when buyers approached her, she set fantastically high prices to discourage them.

Stettheimer's mature paintings included individual portraits of family and friends and what Duchamp called "group" paintings: depictions of the private parties and public events where the Stettheimers and their friends gathered. She blended close observation and very personal fantasy. If her work reflects her awareness of Dada, the Surrealists and folk art, it also revives the pictorial traditions of the nineteenth-century lady amateurs whose works recorded their families' histories. Unlike the lady amateurs of the previous century, however, Stettheimer infused her work with a pointed irony. In her late *Cathedral Series*—four paintings summarizing the contemporary worlds of fashion, finance, art, and theater—she became, in the words of Van Vechten, "both the historian and the critic of her period" (quoted Institute of Contemporary Art 1980, n.p.).

After Florine Stettheimer's death in 1944, Ettie Stettheimer collected fragments of her sister's poetry and edited them with Van Vechten's help. The poems that were published as *Crystal Flowers* in 1949 were never, as Ettie pointed out, intended for publication; in that sense, as in their tone and subjects, they are similar to Florine's paintings.

### As Tho From a Diary*

A pink candy heart
In a fluted tin
A spun glass rainbow
A toy peacock
That spread its tail
A first beau's picture
With glossy curls
Were early cherished treasures.

---

\* Excerpted from Florine Stettheimer, *Crystal Flowers*, New York: privately published 1949.

My ring fell from the nursery window
into a flower bed below
A fairy hopped out of a waterlily
in a Christmas Pantomime Show.
Maggie carried me into a circus
to give the little rider a kiss
In our oleandered yard on a stage
I sang "Little Maggie May" with bliss.
I dressed up in paper muslin
With gold fringes and gold stars
In that golden era when to
adventure there were no bars. . . .

Schooldays in a pretty town
Where lived a King and Queen
And Papageno and Oberon
Goetz and Lohengrin
There was a military band
To which we 'Little Ones' Paraded
With Maggie every day at noon
And a cakestore which we raided
Every day at four
And life was full of parties
In woods where wildflowers grew
In parks where Greek gods postured
In our parlour of tufted Nattier blue.

### First Plastic Art: Herr Gott

Sh-sh-shushed Maggie
Sprinkling holy water in my face
On entering the little chapel
From the sunny village street

In the light of the tall window
An enormous statue stood
A man in a purple gown
With a high golden crown.

He had very pink cheeks
And a long white beard
And his hand was raised in blessing.

Maggie knelt and pulled me down.
Crossing herself as she loudly whispered
"That is the Lord God
With the Golden Crown."

In Berlin
I went to school
I painted
I skated
I adored gay uniforms
I thought they contained superforms
Though they did not quite conform
To my beauty norm
The Belvedere Apollo

Art student days in New York
Streets of stoop-houses all alike
People dressed sedately
Bright colors considered loud
Jewels shoddy
I affected Empire gowns
Had an afternoon at home
Attended balls and parties
At Sherrys and Delmonicos
Sat through operas and the Philharmonic
I had a friend who looked Byronic
With whom I discussed books
Emerson and Ruskin
Mills and Henry James
When we felt mild.
When we felt ironic
It was Whistler and Wilde.

Must one have models
must one have models forever

Nude ones
draped ones
costumed ones
The Blue Hat
The Yellow Shawl
The patent leather slippers
Possibly men painters really
need them—they created them.

Munich with its Carnival
Rosenkavalier Parzival
Kunstler Feste Bals Paris
Satisfying my costume craze—
The gay youths had chic ways
And fortunately fantastic arrays
And I tried many a new painting medium
Which prevented any tedium

Casein was once milk,
And then it was cheese
And now it is pictures
   How wonderful
At noon came my 'Meister'
In white tie and tails
To look at my work
   How wonderful
Casein looks like fresco
And Herr Apotheker F said
"red vill last foreffer"
   How vonterfool
I shall paint the walls
for tout New York
On my return
   Most wonderful

Then back to New York
And skytowers had begun to grow
And front stoop houses started to go
And life became quite different

And it was as though someone
  had planted seeds
And people sprouted like common weeds
And seemed unaware of accepted things
And did all sorts of unheard of things
And out of it grew an amusing thing
Which I think is America having its fling
And what I should like is to paint this thing.

Young artist rat
In a garret sat
Caught in a trap
"I'm a modern chap
For the funnel
I look for a tunnel
And the dead fish
I thought smelt delish
I shall paint it in cubes
And call it Prudes
And add a rotten banana
In my very best manner."

### The Unloved Painting

I was pure white
You made a painted show-thing of me
You called me the real thing
Your creation
No setting was too good for me
Silver—even gold
I needed gorgeous surroundings
You then sold me to another man.

Art is spelled with a capital A
And capital also backs it
Ignorance also makes it sway
The chief thing is to make it pay
In a quite dizzy way
Hurrah—Hurrah

# Vally Wieselthier: Studying Art in Vienna (1936)

As a student of Michael Powolny at Vienna's Kunstgewerbeschule or school of applied arts, ceramist Valerie Wieselthier (1895-1945)—known as Vally—came to the attention of Josef Hoffmann, who regularly encouraged outstanding students to join the Wiener Werkstätte, the cooperative design workshops that he founded in 1903 with Koloman Moser. At Hoffmann's invitation, Wieselthier joined in 1919.

World War I brought changes to the Wiener Werkstätte and to the elegant and austere style that had characterized its earlier years. As young Austrian men joined the army, women came to predominate at the workshop: by 1920 there were nineteen women among the twenty-three designers. When the luxury materials characteristic of the Werkstätte's early production became scarce during the war years, the designers turned to cheaper materials that they treated in a witty, lighthearted manner. Dagobert Peche's curvilinear animals covered textiles and metalwork. Wieselthier, Susi Singer, and the other ceramists developed a style of sculptural and functional ware that relied on a spontaneous, expressionist handling of clay and bright glazes.

Werkstätte design dominated the 1920 Kuntshau, the second arts and crafts exhibition since the war, but in the straitened economy of postwar Austria critical reactions to the new work were mixed. Some found the expressionist ceramics exciting; others were disturbed by what Hans Tietz described as "rare, orchid-like shapes, overbred, devoid of purpose, . . . the typical products of unhealthy circumstances in an unhealthy hothouse environment" (quoted Schweiger 1984, 110).

Certainly the experimentation that Hoffmann encouraged proved expensive, and he moved to reorganize the workshops. A commercial approach, in which design for production took precedence over unique works, was introduced and Wieselthier, unhappy with the changes, left in 1922 to establish an independent workshop. By 1925 her work won silver and gold medals at the 1925 Exposition Internationale des Arts Décoratifs et Industriels Modernes in Paris—success that she believed was due to the integration of art and craft that characterized her working method.

The Austrian pavilion at the exhibition, designed by Hoffmann

and filled with Wiener Werkstätte designs, had been much less successful. Increasingly critics like Adolf Loos and Armand Weiser attributed the Werkstätte's failings to the predominance of female designers. Weiser complained:

> What we miss more than ever is simple, clear, and strong virility, purposefully aware of its aim and of its inner conviction. Away with the pampered feminine touch, and with superfluous trifling amid depraved daydreams! (quoted Schweiger 1984, 117)

As the economic situation in Austria worsened, the demand for luxury crafts was increasingly strained. In 1927 Wieselthier sold her business to the Wiener Werkstätte and returned to the workshop as head of ceramics, but she remained only briefly. The reception to the Wiener Werkstätte's contribution to the American Federation of Arts' International Exhibition of Ceramic Art in 1928 convinced Wieselthier that she would find better opportunities in the United States. Although Helen Appleton Read, echoing the ideas of Austrian critics, decried the Werkstätte ceramists' "careless technique and frivolity," others were delighted with their freedom and experimentation and singled out Wieselthier for praise (quoted Clark and Hughto 1979, 82). Wieselthier—whose Jewish background made it more and more difficult for her to remain in Austria—emigrated to the United States for good in 1932.

In the years before her death in 1945, Wieselthier established a new and successful American career. She joined with a group of American and European artists to form The Contempora Group, a cooperative gallery in New York where she exhibited life-size ceramic figures. When the gallery closed in the early years of the Depression, she went on to work for Sebring Pottery in Ohio. Wieselthier considered ceramics a gay and joyous art:

> There are arts which have no deep message to give the world save that of their own beauty and the artist's joy in making, intimate arts that make life gayer, and yet have all the seriousness of a thing that is felt intensely and worked out with the utmost care. (quoted Anscombe 1984, 108)

Her attitude and the ceramic sculptures she exhibited throughout the United States would have an impact on younger American ceramists.

**A lady in Jonestown, New York,** once wanted to read my hands.* She said, after looking at them, that she wanted to sleep it over and tell me in the morning. After a while she said, "Two things I can tell you right away. You are generous and hypersensitive." Maybe she was right.

The first accounts for my constant struggle with material things (like petit cash, etc.). The second accounts—maybe—for my artistic qualities. These I began to display in very early life. As soon as I could hold a pencil, I scribbled everywhere, and my dream was always to design beautiful ladies and clothes. (I do not know whether that is the reason for my love of art and love of luxuries.) I remember having a little slanting school-desk, and my pleasure was to draw "well dressed ladies," cut them out of paper, and do parties and fancy dress balls with them. My inspiration was the "Wiener Mode," which my mother received every month, and which was then a fashionable magazine.

I began to "fight" with my mother very early, about clothes. As I remember, we used to have a dressmaker coming to our house, and my mother always wanted me to wear the same clothes, only in my size, that my one and one-half year old sister wore. I always had different ideas about it that caused many a tear in my young eyes. I became worse! . . .

In school we had a very nice old man for an art teacher, and he persuaded me to come every morning at eight o'clock (instead of nine), and to have an extra drawing lesson beside the usual ones. I always had the worst grade in behavior, but good ones otherwise—although I never studied and always passed my examinations with funny tricks. The last big examination I had did not do at all, because of hatred for my only woman teacher, in German style and literature.

Now I had·but one wish—to go to an art school. I had satisfied up to now my ambitions in sports. I was a swimming and diving champion at twelve and thirteen years, a tennis and ski and hockey champion at fourteen or fifteen. The next thing was to become an Artist.

---

*    Excerpted from Vally Wieselthier, "Studying Art in Vienna: A Brief Autobiography," *Arts and Decoration* 44 (Feb. 1936), 28-46.

My family was bourgeois and old-fashioned, and would not allow me to learn a profession. A girl has to get married, and that's all there is to it. After two years of arguing, my father gave me the promise never to force me to get married, and my mother decided to let me join a fashionable art school, because she felt that, after all, it was "quite smart."

After two seasons' work, I realised that all the girls were just "smart," but not working at all, and I decided, with a girl-friend of mine, secretly to try and make the much-talked-of and feared examination for the Kunstgewerbeschule. This examination took two whole days—from eight o'clock in the morning until six-thirty at night, and was said to be very difficult. Out of 140 pupils, not more than forty were admitted. With beating hearts we tried, and to be sure, we both passed. After this, our parents simply could not forbid us to go on. Besides, there was the war in Austria, and that seemed to have made even the most conservative parents "milder."

I was at school every day during the War from eight to six-thirty; and on Saturdays and Sundays from seven in the morning to ten at night at the hospital as a war nurse. It seems as though this was a lot of work, but I weighed about one hundred and forty pounds then and was in good condition physically.

Drawing and sketching were my joys from my very earliest youth. I must say I was never so very enthusiastic about drawing from life. Painting I liked better. And my work has always been more or less inspired by phantasy and not reality.

I think the first expression of my artistic impulse came when I was quite young and first "discovered" wool. From then on I knitted and crocheted odd and fantastic wool flowers on everything I could lay my hands on. I made many dresses—marvellous dresses—trimmed with this gay woolen embroidery in a thousand and one colors.

Under Professor Josef Hoffmann at the Wiener Werkstätte, I won several competitions organized by manufacturers. I made fashion drawings for a little magazine that we printed ourselves in school. I made designs for wallpaper, furniture, interiors, glass, porcelain—and every other decorative thing you can think of.

I remember one day, a girl-friend of mine brought a lump of clay to the studio. I bargained with her right away to let me have half of it. She consented, and I modelled a figure in one afternoon. When Professor Hoffmann saw it, he said: "Now at last I know that Vally is a sculptor"—! So, from then on, I became a sculptor. I kept on modelling, and went back to school to learn how to work the wheel. Because it happened that brightly glazed figural sculpture was little known at that time—my porcelains finished in many colors made an immediate hit.

I kept this up for three years until Professor Hoffmann said: "I have talked to the director, asking him to give you your degree. You can't learn anything more here. And besides, I should like you to work for the Wiener Werkstätte. You will see me there every day anyway." So I did, and the first three years there were the happiest of my life.

My friend and I had a huge studio at the Wiener Werkstätte, and each of us had a latchkey. We had free run of the workshops, also the best trained foremen and workers all the time and all the material we desired. I think the erection of this Kunstler Werkstätte was one of the genial ideas of Professor Hoffmann. We just created what pleased us, and when the Wiener Werkstätte would sell one of our products, there was always a big party given by the happy winner.

We made really beautiful things, in no way restricted either by monetary considerations or by a grouchy manufacturer. We also gave the most wonderful parties, turning the whole place into all sorts of Fairylands, and inventing novel costumes. . . .

In 1922, there came a new director to the Wiener Werkstätte. He tried to engage us on a fixed salary, and our paradise was lost. Within twenty-four hours, I decided to leave the school, and took away with me 140 pieces of my pottery, including two or three pieces of sculpture, made at a friend's house, and went with them to the newly opened Haus Werkbund Fair at Frankfurt-am-Main. My success seemed a dream. It was the first time for me that I had been away from Vienna, on business and out in the world. I arrived in Frankfurt at five o'clock on a Saturday, looked

around, and bought a lot of white wallpaper. I hung this on the wall, and working until six in the morning, made a painting for a background for my exhibits. At ten o'clock on the morning of my arrival, I had already an offer and an order from the greatest wallpaper concern in Berlin.

At eleven o'clock, when all the ministers came to open the fair, everyone congratulated me and I had many invitations. I had gone to Frankfurt with a few cents in my pocket. I had not to pay for my exhibition space. I got everything, including a fur coat, in exchange for some pot or vase or the like. It was an old-fashioned exchange trade market. Everyone photographed me and my work. Museums bought my porcelains, and I had order books filled.

I returned to Vienna. Now the trouble began. I had books full of orders, I seemingly had a business, but all my business was for my two hands. No workshops, no wheels, no kiln. I ran from Pontius to Pilate. The city of Vienna offered me a hospital barracks. It was so huge that the money for coal to heat it would have eaten up all my profits, and the shipping was difficult. The Chamber of Commerce offered me a beautiful Baroque Pavilion in the Prater. It was forty-five feet high, and you had to walk twenty minutes from the last trolley car station. Again it was impossible to heat it (you had to fight for coal at that time in Vienna), and too far from communication. At last I hired a dark cellar in an old pottery shop, and the owner allowed me to fire in his kiln, charging me twice the cost of everything and not opening the kiln without my paying in advance.

Later the Socialist Government helped me to open a still better workshop, which I called Keramische Werkstätte Vally Wieselthier. The city also gave me orders to be executed for the various buildings being erected at that time in Vienna, and paid their bills promptly.

Now the big American trade began, and I shipped cases every week to the U.S.A. Nevertheless, I suffered such losses in Germany, on account of the inflation, that I decided in 1927 to sell my workshop to the Wiener Werkstätte. I profited by this, and was made the head of both ceramic workshops.

In 1928 suddenly one night at dinner the president of the

Wiener Werkstätte told me he was going to make an exhibit
in New York City the 12th of October. I said, "I am going
too." He said that it would be too expensive, and the Wiener
Werkstätte could not pay the money at that time. I said that
I would pay it myself. The next morning, I went to the Red
Star Line and secured my ticket. I wrote a letter to Professor
Richards, at that time he was at the Rockefeller Foundation.

My intention was to stay in New York six weeks and go
home to Vienna. This plan did not go through. After this
exhibition, I was invited to exhibit in Detroit, in Pittsburgh,
etc. I made an elevator door for the Squibb Building. I made
a thousand and one things. I could not get away from the
United States.

After eighteen months, I was called back to Vienna.
After three months at home, I returned here, and stayed to
work in the pottery in Columbus, in Ohio State University,
for an Ohio pottery firm, making exhibits all over the
country.

I could tell you something about my great success in
Paris in 1925. I was invited to the Salon des Tuileries, and the
Salon des Indépendants. I exhibited at the Salon in the
Grand Palais, and received silver and golden medals. I guess
the 1200 words are long come and passed, so I must stop.

# Helene Nonné-Schmidt: Woman's Place at the Bauhaus (1926)

The Bauhaus—Das Staatliche Bauhaus Weimar—was estab-
lished in 1919 to replace the Weimar Kunstgewerbeschule
organized by Henry van de Velde in 1907. Van de Velde had been
inspired by the philosophy of the English Arts and Crafts
movement; Walter Gropius, the architect appointed to lead the
new school, envisioned an institution that would train artists to
collaborate with each other and with industry to create "the new
building of the future, which will combine everything—sculpture,
and architecture and painting—in a single form" (quoted Naylor
1985, 54).

Beginning students at the Bauhaus enrolled in a probationary
"Basic Course" intended to free them from academic conventions

and introduce them to the principles of design. Having completed this six-month-long course, they selected the workshop in which they were to become apprentices. Gropius' program called for six workshops—printing/bookbinding, sculpture, painting, metal-work, cabinet-making, and weaving—each to be headed by a Formmeister or "Master of Form" and a Lehrmeister or "Craft and Technical Master."

In the school's early years following World War I, supplies and equipment were scarce, and students were forced to experiment with materials and ideas. Female students formed a "women's class" to make fantastic toys from fabric, beads, and other scavenged materials that were sold at the Weimar Christmas market to raise money. The weaving workshop, which incorporated looms and dye shop from the Kunstgewerbeschule, was initially run by Helene Börner, who had taught at the earlier school. Börner was an embroiderer, however, so students like Gunta Stölzl experimented with weaving techniques until 1921, when they learned the rudiments of loom work at a course in Krefeld.

Male and female students worked together in the introductory course, but almost all the women students went on to the weaving studio. Although the painter and architect Georg Muche was named Formmeister of the weaving studio, he considered weaving "primarily a woman's field of work" and did not play an active role in the workshop (quoted Wingler 1969, 116). Helene Nonné-Schmidt, whose 1926 article on woman's place at the Bauhaus follows, explained the association between women and textiles in psychological and social terms. Anni Albers, who entered the weaving shop reluctantly because there was no place in the glass shop, intially considered weaving a "sissy" discipline, but stayed to become one of the many distinguished fiber artists trained at the Bauhaus.

In the early years, the weaving shop produced "pictures in wool"—wall hangings and tapestries made on hand looms. After the school moved to Dessau in 1926 and Muche left the Bauhaus, Stölzl was asked to lead the weaving workshop. Working on hand looms, students experimented with innovative materials from cellophane to paper and turned their attention to developing prototypes for fabrics that could be mass produced. A close connection was established between the Bauhaus weaving studio and German manufacturers.

According to Stölzl, it was "the heavy planes, hard metals and the physical strain of mural painting" that inhibited women's contributions in other areas (quoted Naylor 1985, 109). But if

women's work in other workshops was limited, it was no less distinguished. Alma Buscher, who worked in the carpentry shop, developed innovative toys and children's furniture based on her research into their play habits. Marianne Brandt joined the metal shop in 1924 despite resistance—"There was no place for a woman in the metal shop"—and became head of the shop when Laszlo Moholy-Nagy resigned in 1928 (quoted Neumann 1970, 98).

. . . **The artistically active woman** applies herself most often and most successfully to work in a two-dimensional plane.* This observation can be explained by her lack of the spatial imagination characteristic of men. Of course there are individual differences of degree here, just as the nature of the sex is seldom either purely masculine or feminine. In addition, the way the woman sees is, so to speak, childlike, because like a child she sees the details instead of the overall picture. The woman's way of seeing things is not to be taken as a deficiency; rather it is simply the way she is constituted, and it enables her to pick up the richness of nuances which are lost to the more comprehensive view. But let us not deceive ourselves into thinking that this aspect of her nature will change, despite all the accomplishments of the Women's Movement and despite all the investigations and experiments. There are even indications that woman is counting on her limitations, considering them a great advantage.

Within the Bauhaus and its workshops the woman is primarily interested in the work of the weaving workshop and there finds the widest range of opportunities. Weaving represents the fusion of an infinite multiplicity to unity, the interlocking of many threads to make up a fabric. It is quite evident to what extent this field of work is appropriate to a woman and her talents. . . .

The tasks of the weaving workship (which is said to be a

---

\* Excerpted from Helene Nonné-Schmidt, "Woman's Place at the Bauhaus," *Vivos Voco* (Leipzig) 5 (August/September 1926), as translated in Hans M. Wingler, *The Bauhaus,* Cambridge: M.I.T. Press, 1969, 116-17. Copyright © 1969 by the M.I.T. Press and reprinted by permission of the M.I.T. Press.

laboratory) lie within the area of interior decoration. These tasks are quite varied, even when they are dictated by functional requirements, except in the case of tapestries. A tapestry or petit point has a place in the modern, ornament-free room, because, as an object freed from the necessity of serving practical ends, it offers itself as a purely visual experience. And man's desire for that will never diminish. The advantage of woven pictures over framed pictures is that they can be easily removed and folded into a very small space. Their special distinction, as against painting, is the wealth of possibilities they offer for varying surface effects by using different materials, such as wool, cotton, linen, silk, rayon, metal, and glass, to obtain smooth, rough, glossy, matt, flat, coarse, fine, soft, hard, thick, and thin effects. There are also rich opportunities for varying the textural structure.

These same characteristics can also be considered for other woven fabrics but are subordinated to the requirements of their use. With respect to such fabrics it is our special task to satisfy practical and aesthetic needs at the same time.

The ability of woman to become absorbed in detail and her interest in experimental "play" with surfaces suit her for this work. In addition, her feeling for colors finds free reign for expression in the multitude of possible nuances.

The fact that in the weaving workshop we are developing *standard types* for certain purposes, with regard to material, texture, and color, by no means represents a lack of imagination. Rather, it is the result of the work which the Bauhaus as a whole attempts to accomplish. For to exercise voluntary restraint in using the means of expression requires discipline.

# Leonora Carrington: Jezzamathatics or Introduction to the Wonderful Process of Painting (1974)

Leonora Carrington (b. 1917) grew up in Lancashire, England, the daughter of a wealthy and eccentric textile manufacturer and an

Irish mother who told her Celtic legends and Biblical stories. In her teens Carrington rebelled against the strict mores of her Catholic upbringing and a series of governesses and private schools. She had learned to paint at a Florentine school and—though her parents wanted her to make her debut in London society—she persuaded them to allow her to attend Amadée Ozenfant's London academy. In 1937 Carrington's mother gave her a copy of Herbert Read's *Surrealism*.

The Surrealist painters and poets considered "woman" an important key to creativity: she was idealized as the opposite of the male principle, the *femme-enfant* whose youth and gender brought her close to the powers of the unconscious and could unloose male creativity from the trammels of convention. Initially, however, there were no women in the group that gathered around André Breton, and there were no women participants in the first exhibition of Surrealist painting in 1924.

Women entered the Surrealist circle as muses—the wives or lovers of artists, admired for their beauty, youth, and uninhibited behavior. But many of them were also artists. Lee Miller was a former art student and sometime fashion model when she came to Paris from New York with an introduction to Man Ray; from 1929 to 1932 they collaborated in photographic experiments. Kay Sage was a wealthy American who had left her Italian husband to establish herself as a painter in Paris when she was "discovered" by the Surrealists and married Yves Tanguy. Meret Oppenheim, whose uninhibited behavior and inventive grace made her the perfect Surrealist woman, was a young Swiss art student. The Surrealists' disdain for home and hearth offered a number of these women an alternative to traditional middle-class feminine roles— but the Surrealist vision of woman as muse offered little to their artistic identity and development, and few identified completely with Surrealist theory.

Shortly after Carrington read Herbert Read's book, she met Max Ernst at the opening of an exhibition at London's Mayer Gallery. Carrington returned to France with Ernst, and the couple settled in the countryside near Lyons. Ernst called her his "Bride of the Wind," describing her as an elemental natural force, untouched by intellectual culture: "She is warmed by her intense life, by her mystery, by her poetry. She has read nothing, but she has drunk everything. She does not know how to read" (quoted Chadwick 1986, 38). While living with Ernst, Carrington wrote her first short stories, which were published in 1938 with illustrations by Ernst.

Their liaison ended as World War II began: because of his German origins, Ernst was interned, and Carrington, frightened as troops began to occupy the village where they had settled, fled to Spain. Her subsequent mental collapse and institutionalization were harrowingly described in *Down Below*, published in 1944. From Spain, Carrington went to New York, where she was reunited with the exiled Surrealists and contributed stories to the Surrealist magazine *View*.

By 1942 Carrington joined other exiled Europeans—including painter Remedios Varo, whom she had first met in France—in Mexico. Carrington's studio was described by collector Edward James in 1944:

> Small in the extreme, it was an ill-furnished and not very well lighted room. It had nothing to endow it with the title of studio at all, save a few almost worn-out paint brushes and a number of gesso panels, set on a dog and cat populated floor, leaning face-averted against a white-washed and peeling wall. The place was a combined kitchen, nursery, bedroom, kennel and junk store. The disorder was apocalyptic; the appurtenances of the poorest. My hopes and expectations began to swell. (quoted Chadwick 1986, 41)

Many of Carrington's early paintings and drawings had an autobiographical basis, and in early stories like *The House of Fear*, written with Ernst in 1927, she appeared in the guise of a white horse—the counterpart to Ernst's animal persona, the Bird Superior Loplop. In later years Carrington, working in close contact with Remedios Varo, developed an imagery based on alchemical symbolism and the occult. Her "autobiography"—Jezzamathatics—is a wry commentary on the conventions of artistic identity.

**In the early part of the latter nineties** I was born under curious circumstances, in an Eneahexagram, Mathematically.*

The only person present at my birth was our dear and faithful old fox-terrier, Boozy, and an x-ray apparatus for

* Reprinted from Leonora Carrington, "Jezzamathatics or Introduction to the Wonderful Process of Painting," in Juan Garcia Ponce and Leonora Carrington, *Leonora Carrington,* Mexico City: Ediciones Era, S.A., 1974, 33-37, by permission of the publisher. Copyright © 1974 by Ediciones Era, S.A.

sterilising cows. My mother was away at the time snaring crayfish which then plagued the upper Andes and wrought misery and devastation among the natives.

My father, a practising golf-professional, invented the famous perforated bunker which swallowed Lord Baden Powell's initiates locked in closed combat in the Netherlands.

My early childhood was spent in exhaustive studies of geological conditions of sub-maritimous playgrounds for displaced persons. This, of course, took me far abroad from my native land yet widened and stretched my field of consciousness to such a degree that I had to resort to a jibaro head shrinker to undergo normal mentation in the metropoli of the world. Undaunted by the wonderful flexibility of the cranial reflex, I was able to make a donation of accurate calculi to Lord Mayor of Chorley who went down to posterity riding the first mechanical Yoghurt eater.

Irrevelant though it may appear I must add that the invention of the painting machine which later became the father mother of modern aesthetics and the great mobile stability for future artistic endeavour was flashed (comet-wise) out of the delicate sensibility of the first computer to be donated to the Bolton cricket team in order to *Score* where scoring was an obsolete art. The fact that the apparatus became fertile enough to give birth to the painting machine can only emphasize the wonderful nature of Mechanical Chance. Again, if the Centre forward gave it a banana instead of the formula for averages from one to five runs per season perhaps the Computer activity would have been otherwise. These savage Miscalculations gave forth the glorious future of Art, culture and new and better railwayline girders all over the world. Due to this Fortuitous Accident, the Painting Machine, new Mediums blossomed like fruitful barnacles on the gnarled bottom of human invention.

'Ergot en. ex humidus in creatum unt.'

The Fungi which belowered the glorious profusion of Late Socromorphic Reason addled necrocritically like a Chinese egg. Quote: "We are, therefore we are not what we might have been if we were otherwise than that which we would have been if we were." (Professor A. J. Ayer has abundantly demonstrated the empirical logic of this austere argument.)

Therefore because of the marvellous capacity of the Painting that I entered the Mysteries of Creative Art when, in fact, I was a born Jezzamathician.

Ergot.

I was decubing the root of a Hyperbollick Symposium in order to calculate the outer Denominator of a fig tree into equal Xextopodic chloriomorfacious sections when the latent metamorphosis blurted the great unexpected shriek into something between a squeak and a smile. It gave, so to speak, in order to return.

Magnificat.

It painted. It painted organic Subterreanean Entities, it painted Chthonic faunae in jubilant contrast to the class calculus in exhaustive despeculation on the so-called reductive recapitulation of summarized sentential reason. This miracle was sufficient, of course, to launch a new era in Neo-proletariat politics based on the ever inflating ethics of anarcho-organised government, a system of circular dissentation to promote the growth of rice mutations within the arctic circle. A question of well planned drainage from Gleneagles golf course to south Chile only to enter the hole of the poles with Stratoproads from recent outerspatial artifacts.

We feel confident that the general public are now adequately informed on the simple but arduous projection of the Artist from the humid warmth of genealogical gestation to the dizzy freezing point of oil paint on canvas in well established Morphology going from one vicissitude to numberless combinations of zoological colour gnodes to ambivalent orchestration of strangely timed psychlograms deftly intershot with sparrowhawks pressed into tablets of concentrated malice only to explode here and there with the soundless perversity of zero sirns in an incalculable gesture of suspended astonishment.

# Barbara Hepworth: Carvings and Drawings (1952)

Barbara Hepworth (1903-75) was the eldest of four children—three girls and one boy—whose parents believed, as she later

remembered, that sons and daughters "should have equal opportunities" (Hepworth 1970, 7). They planned for Hepworth to go to university, but at the age of sixteen she knew that she wanted to be an artist. Miss McCroben, the sympathetic headmistress of her high school, arranged for her to take the examination and apply for the scholarship that enabled her to enter Leeds School of Art in 1919. After a year at Leeds, Hepworth went on to London's Royal College of Art—as the National Art Training School had been renamed; from London Hepworth went to Italy, when the Yorkshire County Council awarded her a travelling scholarship. While in Italy Hepworth married sculptor John Skeaping. For two years they remained in Rome, where they learned to carve marble, which was not part of the standard English art school curriculum. Returning to England, they took a studio, organized a private exhibition, and in 1929 had a child, but the marriage was soon deteriorating.

In 1930 Hepworth met painter Ben Nicholson, who would become her second husband in 1938 and who shared her growing interest in abstraction. Their studios in The Mall Studios in Hampstead brought them into a circle that included Henry Moore, John Stephenson, and the writer and philosopher Herbert Read. They became a part of Unit One, a group of eleven painters, sculptors, and architects with a common interest in design as a "structural pursuit" and "imagination apart from literature and metaphysics." In the early thirties they visited France and joined the Parisian group Abstraction-Creation, and by the late thirties, their neighbors were artists escaping from Europe.

For Herbert Read and Paul Nash, who wrote about Hepworth's work during the thirties, and for the critics who wrote about her work in later years, the artist's sex was not an issue. One of the few critics to speak of feminine aspects in Hepworth's art was Adrian Stokes, who in reviewing Hepworth's exhibition of 1933 noted a concentration on the motif of mother and child:

> Nothing, it would appear should be attempted for a time on the mountain and mother-and-child themes in view of what Miss Hepworth has here accomplished. . . . This is the child which the mother owns with all her weight, a child that is of the block yet separate, beyond her womb yet of her being. So poignant are these shapes of stone that in spite of the degree in which a more representational aim and treatment have been avoided, no one could mistake the underlying subject of the group. . . . Miss Hepworth's stone is a mother, her huge pebble its child. A man would have made the group more pointed: no man could have

treated this composition with such a pure complacence. The idea itself is a spectacular one, but it gains from Miss Hepworth's hands a surer poignancy. (Stokes 1978, 310)

In 1934 Nicholson and Hepworth had triplets. Hepworth later recalled that friends and relations warned her that marriage and a career as an artist were an impossible combination. She, however, found that "a woman artist is not deprived by cooking and having children, nor by nursing children with measles (even in triplicate)— one is in fact nourished by this rich life, provided one always does some work each day; even a single half hour, so the images grow in one's mind" (Hepworth 1970, 20).

At the start of World War II, with the advice and assistance of Stokes and his wife, Hepworth, Nicholson, the triplets and Hepworth's eldest son left London for St. Ives on the Cornish coast. The small community soon became a refuge for other artists as well, including Naum and Miriam Gabo and Bernard Leach, and Hepworth maintained a studio there for the rest of her life, even after she separated from Nicholson in 1951. In the years following the war, Hepworth won international acclaim: she had retrospective exhibitions at the Venice Bienale in 1950, in England in 1954, 1962, and 1968, and in Sao Paolo, Brazil, in 1959. At her death in 1975 in a studio fire, the Manchester *Guardian* considered her probably the most significant women artist in the history of art.

## 1903-1930*

During the first years of my life I do not think I ever saw real country or landscape. Whether with my parents in Wakefield or with relatives in Dewsbury the whole scene appeared to me as a curiously rhythmic patterning of cobbled streets, stunted and most ungracious houses dominated by the structure of mills, works' yards, mines, slag heaps, warehouses, noise, dirt and smell—the whole disorderly pattern of an industrial area.

My first few journeys by tram or train revealed stunted

---

* Excerpted from Barbara Hepworth, *Carvings and Drawings,* London: Lund Humphries and Co., Ltd., 1952, no pagination. Copyright © 1952 by Percy Lund, Humphries and Co., Ltd., and reprinted by permission of Lund Humphries Publishers, Ltd., Park House, 1 Russell Gardens, London NW11 9NN.

grass, collieries, more slag heaps, pit ponies, foundries by the railway lines, distant hills wreathed with indigo smoke which the very earth seemed to be exhaling. This was my visual background. It was pierced, in my earliest memory, by the incredible magic of a musical box owned by the people next door; later, by astonishment when I first went to school and saw on every classroom wall reproductions of the work of old masters, and by a lecture which I attended at the age of seven given by the headmistress on Egyptian sculpture. I remember sitting quite rigid—it was the first time I had seen a lantern slide and both sculpture and architecture seem to exert some special kind of compulsion when thrown up on the screen—they have a very different quality from painting, because space and volume are enormously tangible and enveloping in a spot of brilliance in surrounding darkness.

Soon after this I sensed the geography of the West Riding. My father in the course of his work motored all over the country and when not at school I was allowed to go with him. He was a wonderful companion on these journeys as he spoke little. Perched up on front of one of the early types of car I followed the contours of the superb Yorkshire dales. Here was deep true landscape—the true source of man's energy. Every hill and valley became a sculpture in my eyes, and each landscape was intrinsic in the astonishing "architecture" of the industrial Pennines which spread west, north, and south of us. . . .

I went to Leeds School of Art when I was approaching seventeen on a Junior County Art Scholarship. I was determined to be a sculptor, and I was fortunate enough to win a major art scholarship and enter the School of Sculpture at the Royal College of Art within a year. Henry Moore, whom I had met at Leeds School of Art, went to the Royal College at the same time, and three years later we were each granted a West Riding Scholarship for one year's travel abroad and I chose to go to Italy. . . .

The travelling scholarship provided my most formative year by far. There had been something lacking in my childhood in Yorkshire, and that was *light*. In my early experiences the sun never shone enough, the atmosphere rarely cleared, shadows were never sharp, surfaces never

brilliant. Italy opened for me the wonderful realm of light—light which transforms and reveals, which intensifies the subtleties of form and contours and colour, and in which darkness—the darkness of window, door, or arch—is set as an altogether new and tangible object. To my northern conception it added a knowledge of the grace of the Mediterranean approach which imparts a richness and gaiety into the "living" material of marble and stone.

During this year I did no sculpture. I made my headquarters in Florence. I explored the whole of Tuscany; Romanesque architecture in landscape and sunlight; Masaccio; Michelangelo; Cimabue; Giotto; Assisi; Siena, and Perugia. I looked over and over again—relating all I saw to the events in Yorkshire in earlier years. And when this scholarship year was over I remained in Italy for a further eighteen months, working in Rome.

A chance remark by Ardini, an Italian master carver whom I met there, that "marble changes colour under different people's hands" made me decide immediately that it was not dominance which one had to attain over material, but an understanding, almost a kind of persuasion, and above all greater co-ordination between head and hand. . . .

**1931-1934**

In trying to find a new way of composing form other than by the accepted order of human anatomy or by my own experience of the special forms induced by carving direct into the material, and feeling in harmony with the properties of wood or stone, I discovered a new approach which would allow me to build my own sculptural anatomy dictated only by my poetic demands from the material.

In 1930 I saw the paintings of Ben Nicholson (whom I later married) and Frances Hodgkins for the first time. To find an equivalent movement in painting to the one of which I was a part in sculpture was very exciting, and the impact of Ben Nicholson's work had a deep effect on me, opening up a new and imaginative approach to the object in landscape, or group in space, and a free conception of colour and form. It often happens that one can obtain special revelations

through a similar idea in a different medium. The first exhibition which I saw of his work revealed a freedom of approach to colour and perspective which was new to me. The experience helped to release all my energies for an exploration of free sculptural form, rather than being expended, as they had been until then, in breaking with an accepted order of teaching and tradition.

In 1932 Ben Nicholson and I visited the Rumanian sculptor Constantin Brancusi in his Paris studio. I took with me to show to Brancusi (and Arp and Picasso the next day) photographs of my sculptures including ones of the *Pierced Form* in alabaster 1931, and *Profile*, 1932. In both these carvings I had been seeking a free assembly of certain formal elements including space and calligraphy as well as weight and texture, and in the *Pierced Form* I had felt the most intense pleasure in piercing the stone in order to make an abstract form and space; quite a different sensation from that of doing it for the purpose of realism. I was, therefore, looking for some sort of ratification of an idea which had germinated during the last two years and which has been the basis of my work ever since.

In Brancusi's studio I encountered the miraculous feeling of eternity mixed with beloved stone and stone dust. It is not easy to describe a vivid experience of this order in a few words—the simplicity and dignity of the artist; the inspiration of the dedicated workshop with great millstones used as bases for classical forms; inches of accumulated dust and chips on the floor; the whole great studio filled with soaring forms and still, quiet forms, all in a state of perfection in purpose and loving execution, whether they were in marble, brass, or wood—all this filled me with a sense of humility hitherto unknown to me. . . .

The following day a visit to Meudon to see Jean Arp in his studio presented an experience of quite another kind. We were disappointed to find that Arp was not there, but his wife Sophie Tauber-Arp showed us his studio. It was very quiet in the room so that one was aware of the movement in the forms. All the sculptures appeared to be in plaster, dead white, except for some early reliefs in wood painted white with sharp accents of black. Plaster is a material which I have

always particularly disliked because of the absence of tactile pleasure and light-carrying particles—a dead material excluding all the magical and sensuous qualities of the sculptural idea. Therefore, my delight in the poetic idea in Arp's sculptures, although they lacked these special qualities of material which I cannot do without in my work, came as a surprise to me, and the next day, as we travelled on the train to Avignon, I considered the question. I had never had any first-hand knowledge of the Dadaist movement, so seeing Jean Arp's work for the first time freed me of many inhibitions and this helped me to see the figure in landscape with new eyes. I stood in the corridor almost all the way looking out on the superb Rhone Valley and thinking of the way Arp had fused landscape with the human form in so extraordinary a manner. Perhaps in freeing himself from material demands his idea transcended all possible limitations. I began to imagine the earth rising and becoming human. I speculated as to how I was to find my own identification, as a human being and a sculptor, with the landscape around me. . . .

## 1934-1939

On October 3rd, 1934, our triplets were born, Simon, Rachel, and Sarah, in a small basement flat very near our studios. It was a tremendously exciting event. We were only prepared for one child and the arrival of three babies by six o'clock in the morning meant considerable improvisation for the first few days. One of the things I remember best of that time was the profoundly moving quality of the affection that we felt for the three children who appeared so similar, and yet, from the earliest moment, showed such marked differences of personality.

It seemed as though it might be impossible to provide for such a family by the sale of abstract paintings and white reliefs, which Ben Nicholson was then doing, and by my sculptures; but the experience of the children seemed to intensify our sense of direction and purpose, and gave us both an even greater unity of idea and aim. Our influence on each other remained free and stimulating and is shown, I

think, at its best in the coloured reliefs of Ben Nicholson's and in my sculptures with colour that were to come later. . . .

When I started carving again in November 1934, my work seemed to have changed direction although the only fresh influence had been the arrival of the children. The work was more formal and all traces of naturalism had disappeared, and for some years I was absorbed in the relationships in space, in size and texture and weight, as well as in the tensions between the forms. This formality initiated the exploration with which I have been preoccupied continuously since then, and in which I hope to discover some absolute essence in sculptural terms giving the quality of human relationships. . . .

By 1935 the artists who had formed *Unit One* the year before had, quite naturally it seemed, split and joined the two new groups—Constructive on the one hand, and Surrealist on the other. For the next four years these expanding groups presented the main streams of activity in the visual and literary arts. The period during which Ben Nicholson had acted as a liaison with Paris had now ended and a new phase began. As a consequence of his friendships in Paris, Naum Gabo came over and decided to remain in England. Later Piet Mondrian came over and we found him a studio opposite our own.

Gropius, Moholy-Nagy, Breuer, Mendelssohn, had all come to live in London and suddenly England seemed alive and rich—the centre of an international movement in architecture and art. We all seemed to be carried on the crest of this robust and inspiring wave of imaginative and creative energy. We were not at that time prepared to admit that it was a movement in flight. But because of the danger of totalitarianism and impending war, all of us worked the harder to lay strong foundations for the future through an understanding of the true relationship between architecture, painting, and sculpture.

Early in 1935 the idea of publishing a book on Constructive Art was born during an evening's conversation in our studio between J. L. Martin, Ben Nicholson, Naum Gabo, Sadie Speaight (Martin's wife), and myself. Work

began on it almost at once. The three men became co-editors, and the two wives became responsible for production and layout. The work involved in its preparation seemed prodigious coming on top of our ordinary day's work; but the co-operation between the five of us was most exciting. At the end of the year the book was published by Faber under the title *"Circle", an International Survey of Constructive Art.* . . .

My own work went well. Carving became increasingly rhythmical and I was aware of the special pleasure which sculptors can have through carving, that of a complete unity of physical and mental rhythm. It seemed to be the most natural occupation in the world. It is perhaps strange that I should have become particularly aware of this at the moment when the forms themselves had become the absolute reverse of all that was arbitrary—when there had developed a deliberate conception of form and relationship. . . .

## 1939-1946

When war was declared in September 1939 I was in Cornwall where good friends had offered hospitality to the children. Early in 1940 we managed to find a small house and for the next three years I ran a small nursery school. I was not able to carve at all; the only sculptures I carried out were some small plaster maquettes for the second "sculpture with colour", and it was not until 1943, when we moved to another house, that I was able to carve this idea, and also the first idea for sculpture with colour of 1938, both in a larger and slightly different form in wood.

In the late evenings and during the night I did innumerable drawings in gouache and pencil—all of them abstract, and all of them my own way of exploring the particular tensions and relationships of form and colour which were to occupy me in sculpture during the later years of the war. . . .

In St. Ives I was fortunate enough to have constant contact with artists and writers and craftsmen who lived there. Ben Nicholson my husband, Naum Gabo, Bernard Leach, Adrian Stokes, and there was a steady stream of

visitors from London who came for a few days' rest, and who contributed in a great measure to the important exchange of ideas and stimulus to creative activity. . . .

A new era seemed to begin for me when we moved into a larger house high on the cliff overlooking the grand sweep of the whole of St. Ives Bay from the Island to Godrevy lighthouse. There was a sudden release from what had seemed to be an almost unbearable diminution of space and now I had a studio workroom looking straight towards the horizon of the sea and enfolded (but with always the escape for the eye straight out to the Atlantic) by the arms of land to the left and right of me. I have used this idea in *Pelagos* 1946. . . .

From the sculptor's point of view one can either be the spectator of the object or the object itself. For a few years I became the object. I was the figure in the landscape and every sculpture contained to a greater or lesser degree the ever changing forms and contours embodying my own response to a given position in that landscape. What a different shape and "being" one becomes lying on the sand with the sea almost above from when standing against the wind on a high sheer cliff with seabirds circling patterns below one; and again what a contrast between the form one feels within oneself sheltering near some great rocks or reclining in the sun on the grass-covered rocky shapes which make the double spiral of Pendour or Zennor Cove; this transmutation of essential unity with land and seascape, which derives from all the sensibilities, was for me a voyage of exploration. There is no landscape without the human figure: it is impossible for me to contemplate pre-history in the abstract. Without the relationship of man and his land, the mental image becomes a nightmare. A sculpture might, and sculptures do, reside in emptiness; but nothing happens until the living human encounters the image. Then the magic occurs—the magic of scale and weight, form and texture, colour and movement, the encircling interplay and dance occurs between the object and the human sensibilities. . . .

**1949-1952**

. . . In making my roots in a small seaboard town I have felt compelled to meet the all-round problem of living in a comprehensible community, because I think that the discipline of my sculpture demands this sort of integration. The years I spent preoccupied with the landscape image in sculpture now form the apprenticeship to my present concern with an image in sculpture of the community as a unit in landscape. The two things which interest me most are the significance of human action, gesture, and movement, in the particular circumstance of our contemporary life, and the relation of these human actions to forms which are eternal in their significance.

In opposition to "social realism" I believe that meanings in sculpture emerge more powerfully when they are carried through sculpture's own silent language; and that if the sculptor himself can find *personal* integration with his surroundings and his community his work will stand a greater chance of developing the poetry which is his free and affirmative contribution to society. I believe also very strongly that if the artist and his community are free in this way, the purpose and evocation of meaning in his work will be far more easily and clearly understandable in the long run.

In these very brief notes I seem to have omitted everything that goes to make up my usual working day. These things are immensely important to me; perhaps more important than the things about which I have written. My home and my children; listening to music, and thinking about its relation to the life of forms; the need for dancing as a recreation, and where dancing links with the actual physical rhythm of carving; the intense pleasure derived from tools and craftsmanship—all these things are daily expressions of the whole.

I have never understood why the word feminine is considered to be a compliment to one's sex if one is a woman, but has a derogatory meaning when applied to anything else. The feminine point of view is a complementary one to the masculine. Perhaps in the visual arts many women have been

intimidated by the false idea of competing with the masculine. There is no question of competition. The woman's approach presents a different emphasis.

I think that women will contribute a great deal to this understanding through the visual arts, and perhaps especially in sculpture, for there is a whole range of formal perception belonging to feminine experience. So many ideas spring from an inside response to form; for example, if I see a woman carrying a child in her arms it is not so much what I see that affects me, but what I feel within my own body. There is an immediate transference of sensation, a response within to the rhythm of weight, balance and tension of the large and small form making an interior organic whole. The transmutation of experience is, therefore, organically controlled and contains new emphasis of forms. It may be that the *sensation* of being a woman presents yet another facet of the sculptural idea. In some respects it is a form of "being" rather than observing, which in sculpture should provide its own emotional and logical development of form.

# SUGGESTED FURTHER READINGS

## I.  Women and the Academies

**Diderot:** Bachmann and Piland 1978; Conisbee 1981; Crow, T. E. 1985; Hôtel de la Monnaie 1984; Tapazio 1963.
**Kauffmann:** Bachmann and Piland 1978; Chadwick 1990; Fine 1978; Gerard 1893; Harris and Nochlin 1976; Manners and Williamson 1924; Mayer 1972; Petersen and Wilson 1976; Roworth 1984.
**Vigée-Lebrun:** Bachmann and Piland 1978; Baillio 1981, 1982; Chadwick 1990; Fine 1978; Harris and Nochlin 1976; Helm 1915; Nolhac 1912; Petersen and Wilson 1976; Vigée-Lebrun 1869, 1879, 1903, [1927].
**Bachaumont:** Tate 1968.
**d'Angiviller/David:** Aulanier 1950; David 1880; Delécluze 1855.
**Société Populaire et Républicaine des Arts:** Applewhite, Johnson, and Levy 1979; Benoit 1897; Harris and Nochlin 1976.

## II.  Wives and Artists

**Sharples:** Clark 1919; Hufton 1975; Knox 1930; Neff 1966; Pointon 1984; Roland-Michel 1980.
**Linwood:** Altick 1978; Ingram 1917; Parker 1984.
**Landon:** Holt 1979.
**Benoist:** Ballot 1914; Harris and Nochlin 1976; Petersen and Wilson 1976.
**Aragon:** Abensour 1913; Adler 1979.
**L'artiste:** Damiron 1954; Jaunez 1834a, 1834b; Mirbel 1829
**Jameson:** Erskine 1915; Macpherson 1878; Sherman with Holcomb 1981; Thomas 1976.

# III.  Lady Amateurs

**Ellis:** Crow 1971; Dewhurst, MacDowell, and MacDowell 1979;
Ellis 1873; Gorham 1972; Oakley 1974.
**Stone:** Morris 1961, 1963; Parker 1984.
**Scheffer:** Grote 1860.
**Cavé:** Bachmann and Piland 1978; Trapp 1967.
**Arnold's:** Higgonet 1987; Wood 1913.

# IV.  Strong-minded Artists

**Bonheur:** Ashton and Hare 1981; Bachmann and Piland 1978;
Boime 1981; Chadwick 1990; Fine 1978; Harris and Nochlin 1976;
Petersen and Wilson 1976; Stanton 1910; Yeldham 1984.
**Howitt:** Burton 1949; Herstein 1985; Howitt, A. M., 1855, 1856;
Howitt, M., 1889; Lee 1955; Marsh and Nunn 1989; Woodring
1952.
**Hosmer:** Bachmann and Piland 1978; Carr 1912; Chadwick 1990;
Fine 1978; Gerdts 1972; Leach 1976; Petersen and Wilson 1976;
Rensselaer 1963; Rubenstein 1982; Tufts 1987; Waller 1983.
**Ward:** Nunn 1978, 1987; Yeldham 1984.
**Cobbe:** Boime 1981; Strachey 1978.

# V.  Women and the Decorative Arts

**Cole:** Bell 1963; Brown 1912; Callen 1979; Cole 1884; Dalziel
1901; M. S. R. 1858, 1859.
**McIan:** Bell 1963; Brown 1912; Callen 1979; MacDonald 1970.
**Lagrange:** Boxer 1982; Guilbert 1966; Henriet 1868; MacMillan
1981.
**Alford:** Alford 1886; Callen 1979; Chadwick 1990; Morris 1963,
1964; Parker 1984.
**Carter:** Archer 1874; Callen 1979; Eyles 1975; "Improvements"
1872; "Pottery and Art" 1871-72.
**Wheeler:** Callen 1979; Metropolitan 1987; Rubenstein 1982;
Wheeler 1897, 1918.
**McLaughlin:** Callen 1979; Chadwick 1990; Clark and Hughto
1979; Macht 1976; Metropolitan 1987; Perry 1881.

# VI. Women in Art Schools

**Royal Academy:** Chadwick 1990; "Female Art Students" 1864; Hutchison 1968; "Royal Academy" 1859; Sandby 1862; Yeldham 1984.

**Butler:** Bachmann and Piland 1978; Bademi 1981; Butler 1923; Chadwick 1990; Harris and Nochlin 1976; Lalumia 1983; Oldcastle 1879; Taylor 1986; Usherwood 1988.

**Beaux:** Bachmann and Piland 1978; Bowen 1970; Fine 1978; Goodyear and Bailey 1974-75; Harris and Nochlin 1976; Pepper 1893; Rubenstein 1982; Tufts 1987; Walton 1897; Wein 1981.

**Bashkirtseff:** Bachmann and Piland 1978; Bashkirtseff 1919, 1985; Bell and Offen 1983, vol. 2; Blind 1892; Breakell 1907; Dixon 1890; Feherer 1984; Holland 1904; Yeldham 1984.

**Demont-Breton:** Bacon 1896; "Causerie: Mme. Demont-Breton" 1895; Yeldham 1984.

**Ecole des Beaux-Arts:** Radycki 1982; Yeldham 1984.

# VII. Women Artists Organize

**Society of Female Artists:** Kendall 1981; Nunn 1987; Yeldham 1984.

**Centennial Exposition:** Maass 1973; McCabe 1876; Paine 1975-76; Weimann 1981.

**Bertaux:** Alesson 1878; Garb 1989a, 1989b; Raimes 1889; Yeldham 1984.

**Columbian Exposition:** Chadwick 1990; Elliott 1893; Hale 1975; Henrotin 1893; Kysela 1966; Mathews 1984; Miller 1893; Rubenstein 1982; Smart 1984; Sweet 1966.

**Sartain:** Eagle 1894; Goodman 1987; Rubenstein 1982; Sewall 1894; Weimann 1981.

**Edgerton [Roberts]:** Bye 1910; Holmes 1899; Merritt 1900; Moore 1910; Tufts 1987.

**Wyzewa:** Duval 1960, 1961; Garb 1989a.

# VIII. Women and the Avant-Garde

**Morisot:** Adler and Garb 1987; Bachmann and Piland 1978; Chadwick 1990; Fine 1978; Harris and Nochlin 1976; Higgonet

1990; Petersen and Wilson 1976; Rouart 1950, 1957, 1987; Stuckey and Scott 1988; Yeldham 1984.

**Modersohn-Becker:** Albright-Knox 1980; Bachmann and Piland 1978; Chadwick 1990; Comini 1980; Fine 1978; Harris and Nochlin 1976; Modersohn-Becker 1980, 1983; Petersen and Wilson 1976; Radycki 1982.

**Delaunay-Terk:** Anscombe 1984; Bachmann and Piland 1978; Chadwick 1990; Damase 1972; Delaunay and Delaunay 1978; Fine 1978; Harris and Nochlin 1976; Marter 1979; Nemser 1975; Petersen and Wilson 1976.

**Laurencin:** Bachmann and Piland 1978; Chadwick 1990; Fine 1978; Gere 1977; Harris and Nochlin 1976; Howe 1950; McPherson and Hyland, 1990; Petersen and Wilson 1976.

**O'Keeffe:** Bachmann and Piland 1978; Chadwick 1990; Cowart, Hamilton, and Greenough 1987; Fine 1978; Goodrich and Bry 1970; Harris and Nochlin 1976; Kalonyme 1928; Lisle 1980; Mitchell 1978; Norman 1973; Petersen and Wilson 1976; Rubenstein 1982; Tufts 1987.

**Hartley:** Hartley 1931, 1972, 1982; Haskell 1980; Homer 1977.

**Zorach:** Currier Gallery 1987; Fine 1978; Mannes 1930; Marter 1979; National Collection of Fine Arts 1973; Rubenstein 1982; Slusser 1923; Tarbell 1980; Tufts 1987; Zorach, M., 1944, 1956; Zorach, W., 1967.

**Stettheimer:** Bachmann and Piland 1978; Chadwick 1990; Harris and Nochlin 1976; Hartley 1931; McBride 1946; Nochlin 1980; Petersen and Wilson 1976; Rosenfeld 1932; Rubenstein 1982; Tufts 1987; Tyler 1963.

**Wieselthier:** Anscombe 1984; Everson 1983; Levin 1986-87; Schweiger 1984.

**Bauhaus:** Anscombe 1984; Keller 1978; Naylor 1985; Neumann 1970; Wingler 1969.

**Carrington:** Bachmann and Piland 1978; Carrington 1972; Chadwick 1985, 1986, 1990.

**Hepworth:** Bachmann and Piland 1978; Hammacher 1968; Petersen and Wilson 1976; Roditi 1961; Stokes 1978.

# REFERENCES

Abensour, Leon. 1913. *Le féminisme sous le règne de Louis-Philippe en 1848*. Paris: Librairie Plon.

———. 1923. *La femme et le féminisme avant la Révolution*. Paris: Ernest Leroux.

Adler, Kathleen, and Tamar Garb. 1987. *Berthe Morisot*. Ithaca, NY: Cornell University Press.

Adler, Laure. 1979. *L'aube du féminisme: Les premières journalistes, 1830-1850*. Paris: Peyot.

Albright-Knox Art Gallery, Buffalo, NY. 1980. *Sonia Delaunay: A Retrospective* (exhibition catalogue). Essays by Sherry Buckberrough. Buffalo: Albright-Knox Art Gallery.

Alesson, Jean. 1878. *Les femmes artistes au salon de 1878 et l'exposition universelle*. Paris: Bureau de la Gazette des Femmes.

Alford, Marian. 1886. *Needlework as Art*. London: Sampson Low, Marston.

"Alfred Gatley." 1863. *Art Journal* (Sep), 181.

Altick, Richard D. 1978. *The Shows of London*. Cambridge, MA: Belknap/Harvard.

"Amateur Exhibition." 1851. *Art Journal* (June), 199-200.

Anscombe, Isabelle. 1984. *A Woman's Touch: Women in Design from 1860 to the Present Day*. London: Virago.

Apollinaire, Guillaume. 1944. *The Cubist Painters: Aesthetic Meditations*. Translated by Lionel Abel. New York: Wittenborn.

———. 1972. *Apollinaire on Art: Essays and Reviews 1902-1918*. Edited by Leroy C. Breunig; translated by Susan Suleiman. New York: Viking Press.

Applewhite, Harriet Branson, Mary Durham Johnson, and Darline Gay Levy, editors. 1979. *Women in Revolutionary Paris, 1789-95*. Urbana, IL: University of Illinois Press.

Archer. 1874. "The Lambeth Potteries." *Art Journal*, n.s., v. 13, 66-67.

"Art Work for Women [3 parts]." 1872. *Art Journal* (Mar) 65-66, (Apr) 102-103, (May) 129-131.

Ashton, Dore, and Denise Brown Hare. 1981. *Rosa Bonheur: A Life and a Legend*. New York: Viking.

Atkinson, J. Beavington. 1862. "Modern Sculpture of All Nations in the International Exhibition of 1862" in *Art Journal Illustrated Catalogue of the International Exhibition of 1862*. New York and London: J. S. Virtue 1862.

Aulanier, Christiane. 1947-71. *Histoire du Palais et du Musée du Louvre*, 10 Vols. Paris: Editions Musées Nationaux.

Bachaumont, Louis Petit de. 1785. *Mémoires secrets pour servir à l'histoire de la République des lettres en France, depuis MDCCLXII jusqu' à nos jours*, Vol. 24. London: John Adamson.

Bachmann, Donna G., and Sherry Piland, eds. 1978. *Women Artists: An Historical, Contemporary and Feminist Bibliography*. Metuchen, NJ, and London: Scarecrow Press.

Bacon, Lee. 1896. "A Painter of Motherhood: Virginie Demont-Breton." *Century Magazine* 103 (Dec), 210-215.

Badeni, June. 1981. *The Slender Tree: A Life of Alice Meynell*. Padstow, Eng.: Tabb House.

Baillio, Joseph. 1981. "Marie Antoinette et ses enfants par Mme. Vigée-Lebrun." *L'oeil*, no. 308 (March): 34-41; no. 310 (May): 52-60, 90-91.

———. 1982. *Elisabeth Louise Vigée Le Brun 1755-1842* (exhibition catalogue). Fort Worth, TX: Kimball Art Museum.

Ballot, Marie-Juliette. 1914. *Une élève de David: La Comtesse Benoist, l'Emilie de Demoustier 1768-1826*. Paris: E. Plon-Nourrit.

Bashkirtseff, Marie. 1919. *Marie Bashkirtseff: The Journal of a Young Artist 1860-1884*. Translated by Mary J. Serrano. New York: E. P. Dutton.

———. 1985. *The Journal of Marie Bashkirtseff*. Translated by Mathilde Blind, introduction by Roszika Parker and Griselda Pollock. London: Virago. Reprinted from London: Cassell and Co., 1890.

"Beatrice Cenci." 1857. *Art Journal* (April), 124.

Bell, Quentin. 1963. *The Schools of Design*. London: Routledge and Kegan Paul.

Bell, Susan Groag, and Karen M. Offen, eds. 1983. *Women, the Family, and Freedom: The Debate in Documents*, 2 vols. Stanford, CA: Stanford University Press.

"Belle of the Cubists." 1956. *Art News* 55 (Sep), 12.

Benoit, François. 1897. *L'art français sous la Révolution et l'Empire*. Paris: L. H. May.

Bidelman, Patrick Kay. 1982. *Pariahs Stand Up! The Founding of the Liberal Feminist Movement in France, 1858-1889*. Westport, CT: Greenwood.

Blind, Mathilde. 1892. "A Study of Marie Bashkirtseff" in André Theuriet, *Jules Bastien-LePage and His Art: A Memoir*. London: T. Fisher Unwin.

Boime, Albert. 1971. *The Academy and French Painting in the Nineteenth Century*. London: Phaidon.

———. 1981. "The Case of Rosa Bonheur: Why Should a Woman Want to Be More Like a Man?" *Art History* 4 (Dec), 384-439.

Bowen, Catherine Drinker. 1970. *Family Portrait*. Boston: Little, Brown.

Boxer, Marilyn J. 1982. "Women in Industrial Homework: The Flowermakers of Paris in the Belle Epoque." *French Historical Studies* 12 (Spring), 401-23.

Bradley, John William. 1887-89. *A Dictionary of Miniaturists, Illuminators, Calligraphers and Copyists*, 3 vols. London: Bouaritch.

Breakell, Mary L. 1907. "Marie Bashkirtseff: The Reminiscence of a Fellow Student." *The Nineteenth Century and After* 62 (July), 110-25.

Brown, Frank P. 1912. *South Kensington and Its Art Training*. London and New York: Longmans, Green.

Burton, Hester. 1949. *Barbara Bodichon 1827-1891*. London: John Murray.

Butler, Elizabeth Thompson. 1923. *An Autobiography*. London: Constable and Co.

Bye, Arthur Edwin. 1910. "Women and the World of Art." *Arts and Decoration* 10 (Dec), 86-89.

Callen, Anthea. 1979. *Women Artists of the Arts and Crafts Movement 1870-1914*. New York: Pantheon.

Carr, Cornelia Crow. 1912. *Harriet Hosmer: Letters and Memories*. New York: Moffat Yard.

Carrington, Leonora. 1972. *Down Below*. Chicago: Black Swan.

Casteras, Susan P. 1982. *The Substance or the Shadow: Images of Victorian Womanhood* (exhibition catalogue). New Haven, CT: Yale Center for British Art.

"Causerie: A l'heure. . . ." 1896. *L'art français* 10, no. 501 (28 Nov).

"Causerie: Les femmes l'Ecole des Beaux-Arts." 1896. *L'art français* 10, no. 498 (7 Nov).

"Causerie: Mme. Demont-Breton et les femmes artistes." 1895. *L'art français* 8, no. 410 (2 Mar).

"Causerie: Voici le remarquable. . . ." 1896. *L'art français* 10, no. 504 (19 Dec).

Chadwick, Whitney. 1985. *Women Artists and the Surrealist Movement*. Boston: Little, Brown.

———. 1986. "Leonora Carrington: Evolution of a Feminist Consciousness." *Woman's Art Journal* 7 (Spring/Summer), 37-43.

———. 1990. *Women, Art, and Society*. New York: Thames and Hudson.

Child, Lydia Maria. 1858. "Miss Harriet Hosmer." *Littel's Living Age* 56 (13 Mar), 697-98.

Clark, Alice. 1919. *Working Life of Women in the Seventeenth Century*. London: George Routledge.

Clark, Garth, and Margie Hughto. 1979. *A Century of Ceramics in the United States 1878-1978*. New York: E. P. Dutton.

Clayton, Ellen Creathorne. 1876. *English Female Artists*, 2 vols. London: Tinsley Bros.

"Clever Paintings." 1916. *New York Times*, Sun., 22 Oct., 18.

Cole, Sir Henry. 1884. *Fifty Years of Public Work of Sir Henry Cole*, 2 vols. London: G. Bell and Sons.

Comini, Alessandra. 1980. "The State of the Field 1980: The Woman Artists of German Expressionism." *Arts Magazine* 55 (Nov), 147-53.

Conisbee, Philip. 1981. *Painting in Eighteenth Century France*. Ithaca, NY: Cornell University Press.

Cowart, Jack, Juan Hamilton, and Sarah Greenough. 1987. *Georgia O'Keeffe: Art and Letters*. Washington and Boston: National Gallery of Art and New York Graphic Society Books, Little, Brown.

Crow, Duncan. 1971. *The Victorian Woman*. New York: Stein and Day.

Crow, Thomas E. 1985. *Painters and Public Life in Eighteenth Century Paris*. New Haven, CT: Yale University Press.

Currier Gallery of Art, Manchester, NH. 1987. *Marguerite and William Zorach: The Cubist Years 1915-18* (exhibition catalogue). Essay by Marilan Friedman Hofman. Hanover, NH: University Press of New England.

D. [Vizetelly, James D.] 1842. "Article X: Woodengraving Among Female Artists," *Westminster Review* 38 (July), 215 -16.

Dalziel, George. 1901. *The Brothers Dalziel 1840-90*. London: Methuen.

Damase, Jacques. 1972. *Sonia Delaunay: Rhythms and Colors.* Greenwich, CT: New York Graphic Society.

Damiron, Suzanne. 1954. "La revue *L'artiste*, sa fondation, son époque, ses amateurs." *Gazette des beaux-arts* 6e ser., 44 (Oct), 191-202, 223-25.

David, Jules Louis. 1880. *Le peintre Louis David 1748-1825. Souvenirs et documents inédits.* Paris: Victor Havard.

Delaunay, Robert, and Sonia Delaunay. 1978. *The New Art of Color: The Writings of Robert and Sonia Delaunay.* Edited by Arthur A. Cohen; translated by Arthur A. Cohen and David Shapiro. New York: Viking Penguin.

Delécluze, Etienne J. 1855. *Louis David: Son école et son temps.* Paris: Didier.

Denvir, Bernard. 1983. *The Eighteenth Century: Art, Design and Society, 1689-1789.* London: Longman.

———. 1984. *The Early Nineteenth Century: Art, Design and Society, 1789-1852.* London: Longman.

Dewhurst, C. Kurt, Betty MacDowell, and Marsha MacDowell. 1979. *Artists in Aprons: Folk Art by American Women.* New York: E. P. Dutton and Museum of American Folk Art.

Diderot, Denis. 1957-67. *Diderot Salons*, 4 vols. Edited by Jean Seznec and Jean Adhemar. Oxford: Clarendon Press.

Dixon, Marie Hepworth. 1890. "Marie Bashkirtseff: A Personal Reminiscence." *Fortnightly Review*, n.s. 53 (1 February), 276.

Duncan, Carol. 1973. "Happy Mothers and Other New Ideas in French Art." *Art Bulletin* 55 (Dec): 571-83.

Duval, Elga Liverman. 1960. "Teodor de Wyzewa: Critic Without a Country." *The Polish Review* 5 (Fall), 45-63.

———. 1961. *Teodor de Wyzewa: Critic Without a Country.* Geneva: Librairie Droz.

E. E. G. [Eleanor Elizabeth Greatorex]. 1876. "Memorial Hall: Pictures by American Women." *The New Century for Women* no. 3 (27 May), 1.

Eagle, Mary Kavanaugh Oldham, ed. 1895. *The Congress of Women Held in the Woman's Building, World's Columbian Exposition, Chicago.* Chicago: International Publishing Co.

Edgerton, Giles [Mary Fanton Roberts]. 1908. "Is There a Sex Distinction in Art?" *The Craftsman* 14 (June), 238-251.

Ellet, Elizabeth Fries Lummis. 1859. *Women Artists in All Ages and Countries.* New York: Harper.

Elliott, Maude Howe, ed. 1893. *Art and Handicraft in the Woman's Building of the World's Columbian Exposition, Chicago, 1893.* Paris and New York: Boussod Valadon.

Ellis, John Eimeo. 1873. *Life of William Ellis, Missionary in the South Seas and Madagascar.* London: J. Murray.

Erskine, Beatrice C. (Mrs. Steuart Erskine), editor. 1915. *Anna Jameson: Letters and Friendships 1812-60.* London: T. Fisher Unwin.

Everson Museum of Art, Syracuse, New York. 1983. *The Diversions of Keramos: American Clay Sculpture 1925-50,* (exhibition catalogue). Essays by Ross Anderson and Barbara Perry. Syracuse, NY: Everson Museum of Art.

Eyles, Desmond. 1975. *The Doulton Lambeth Wares.* London: Hutchinson.

Fawcett, Trevor, and Clive Phillpot. 1976. *The Art Press: Two Centuries of Art Magazines.* London: The Art Book Company.

Feherer, Catherine. 1984. "New Light on the Académie Julian and Its Founder." *Gazette des beaux-arts* ser. 6, 106 (Jun), 207-215.

"Female Art Students and the Royal Academy." 1864. *Art Journal* (May), 154.

"Female Students at the Royal Academy." 1863. *Art Journal* (Sep), 191.

"Femme Artiste." 1894. *L'art français* 8, no. 398 (8 Dec).

"Femmes Artistes." 1893. *L'art français* 7, no. 316 (13 May).

Fidière, Octave. 1885. *Les femmes artistes l'Académie Royale de Peinture et de Sculpture.* Paris: Charavey Frères.

Fine, Elsa Honig. 1978. *Women and Art.* Montclair, NJ: Allanheld and Schram.

"Fine Art Gossip." 1860. *Athenaeum* no. 1715 (8 Sep), 330.

Flexner, Eleanor. 1980. *Century of Struggle: The Woman's Rights Movement in the United States.* Reprint of 1975 revised edition. Cambridge, MA: Belknap.

Garb, Tamar. 1989a. "'L'Art Féminin': The Formation of a Critical Category in Late Nineteenth Century France." *Art History* 12 (Mar), 39-65.

———. 1989b. "Revising the Revisionists: The Formation of the Union des Femmes Peintres et Sculpteurs." *College Art Journal* 48 (Spring), 63-70.

Gerard, Frances A. 1893. *Angelica Kauffmann.* New York: Macmillan.

Gerdts, William. 1972. *The White Marmorean Flock: Nineteenth Century American Women Neoclassical Sculptors* (exhibition catalogue). Poughkeepsie, NY: Vassar College Art Gallery.

Gere, Charlotte. 1977. *Marie Laurencin.* New York: Rizzoli.

Goodman, Helen. 1987. "Emily Sartain: Her Career." *Arts Magazine* 61 (May), 61-65.

Goodrich, Lloyd, and Doris Bry. 1970. *Georgia O'Keeffe* (exhibition catalogue). New York: Praeger and Whitney Museum of American Art.

Goodyear, Frank, and Elizabeth Bailey. 1974-75. *Cecilia Beaux: Portrait of an Artist* (exhibition catalogue). Philadelphia: Pennsylvania Academy of Fine Arts.

Gorham, Deborah. 1982. *The Victorian Girl and the Feminine Ideal*. Bloomington, IN: Indiana University Press.

Gouma-Peterson, Thalia, and Patricia Mathews. 1987. "The Feminist Critique of Art History." *The Art Bulletin* 69 (Sep), 326-57.

Graham, Julie. 1980. "American Women Artists' Groups, 1867-1930." *Woman's Art Journal* 1 (Spring/Summer), 7-12.

Grand Palais, Paris; Detroit Institute of Arts; and Metropolitan Museum of Art, New York. 1974. *French Painting 1774-1830: The Age of Revolution* (exhibition catalogue). Detroit: Wayne State University Press.

Graves, Algernon. 1969. *The Society of Artists in Great Britain, 1760-1791, and The Free Society of Artists, 1761-1783*. Reprint of London: G. Bell and Sons, 1907. Bath, Eng.: Kingsmead Reprints.

———. 1970. *Dictionary of Artists Who Have Exhibited Works in the Principal London Exhibitions from 1760 to 1893*. Reprint of London: H. Graves and Co., 1901. New York: B. Franklin.

Greer, Germaine. 1979. *The Obstacle Race*. New York: Farrar, Straus and Giroux.

Grote, Harriet Lewis. 1860. *Memoir of the Life of Ary Scheffer*. London: John Murray.

Guiffrey, Jules Marie Joseph, ed. 1872. *Livrets des Expositions de l'Académie de Saint-Luc Paris, 1751, 1752, 1753, 1756, 1762, 1764, 1774*. Paris: J. Bauer.

———. 1875. *Livret de l'Exposition du Colisée, 1776*. Paris: J. Bauer.

Guilbert, Madelaine. 1966. *La fonction des femmes dans l'industrie*. Paris: Moulton and Co.

Hale, Nancy. 1975. *Mary Cassatt: A Biography of the Great American Painter*. New York: Doubleday.

Hale, Sarah Josepha. 1870. *Woman's Record or Sketches of All Distinguished Women from the Creation to AD 1868*. 3rd revised edition. New York: Harper and Row.

Hammacher, Abraham Marie. 1968. *Barbara Hepworth*. London: Thames and Hudson.

"Harriet Hosmer: Personal Sketch." 1858. *New York Times*, Wed., Feb. 3., 2.

Harris, Ann Sutherland, and Linda Nochlin. 1976. *Women Artists: 1550-1950* (exhibition catalogue). New York: Alfred Knopf.

Hartley, Marsden. 1931. "The Paintings of Florine Stettheimer." *Creative Art* 9 (Jul), 19-23.

———. 1972. *Adventures in the Arts: Informal Chapters on Painters, Vaudeville and Poets*. Reprint of New York: Boni and Liveright, 1921. New York: Hacker Art Books.

———. 1982. *On Art*. Edited by Gail R. Scott. New York: Horizon.

Haskell, Barbara. 1980. *Marsden Hartley* (exhibition catalogue). New York: Whitney Museum of American Art and New York University.

Helm, William Henry. 1915. *Vigée-Lebrun: Her Life, Works and Friendships*. Boston: Small, Maynard.

Henriet, Charles d'. 1868. "L'enseignement populaire des arts du dessin en Angleterre et en France [2 parts]." *Revue des deux mondes* 2 per., 77, (1 Sep) 193-212 and (15 Oct) 981-1010.

Henrotin, Ellen M. 1893. "An Outsider's View of the Women's Exhibit." *The Cosmopolitan* 15 (Sep), 560-66.

Hepworth, Barbara. 1970. *A Pictorial Autobiography*. New York: Praeger.

Herstein, Sheila R. 1985. *A Mid-Victorian Feminist: Barbara Leigh Smith Bodichon*. New Haven, CT: Yale University Press.

Hess, Thomas B., and Elizabeth C. Baker, eds. 1973. *Art and Sexual Politics*. New York: Art News and Collier.

Higgonet, Anne. 1987. "Secluded Visions: Images of Feminine Experience in Nineteenth Century Europe." *Radical History Review* no. 38, 16-36.

———. 1990. *Berthe Morisot*. New York: Harper and Row.

Holland, Clive. 1904. "Lady Art Students' Life in Paris." *International Studio* 21 (Jan), 225-233.

Holme, Charles, ed. 1905. *The 'Old' Watercolour Society*. London and New York: Offices of The Studio.

Holmes, C. J. 1899. "Women as Painters." *The Dome*, new series 3 (Apr), 2-9.

Holt, Elizabeth Gilmore, ed. 1979. *The Triumph of Art for the Public*. New York: Doubleday.

———, ed. 1981. *The Art of All Nations: 1850-73*. New York: Doubleday.

Homer, William Innes. 1977. *Alfred Stieglitz and the American Avant-Garde*. Boston: New York Graphic Society.

Hôtel de la Monnaie, Paris. 1984. *Diderot et l'art de Boucher à David* (exhibition catalogue). Paris: Ministère de la Culture, Editions de la Réunion des Musées Nationaux.

"How It Came About." 1876. *New Century for Women* no. 1 (13 May), 4.

Howe, Russell Warren. 1950. "The Painted Poem: Marie Laurencin." *Apollo* 51 (Jan), 7, 13.

Howitt [Watts], Anna Mary. 1855. *School of Life*. Boston: Ticknor and Fields.

———. 1856. "Unpainted Pictures: A Descendant of the Vikings and Sojourn in the Farm-House by the Sea." *The Crayon* 3 (Jan), 4-5 and (Feb), 68-70.

Howitt, Mary. 1889. *Mary Howitt: An Autobiography*, 2 vols. Edited by Margaret Howitt. London: Wm. Isbister.

Hufton, Olwen. 1975. "Women and the Family Economy in 18th Century France." *French Historical Studies* 9 (Spring): 1 -17.

Hutchison, Sidney C. 1968. *The History of the Royal Academy, 1768-1968*. New York: Taplinger.

"Improvements in Minor British Industries: Minton's Art Pottery Studio, South Kensington." 1872. *Art Journal* (April), 100-102.

Ingram, Caroline P. 1917. "Miss Mary Linwood." *The Connoisseur* 67 (July): 145-48.

Institute of Contemporary Art, Boston, MA. 1980. *Florine Stettheimer: Still Lifes, Portraits and Pageants, 1910 to 1941* (exhibition catalogue). Essay by Elisabeth Sussman. Boston: Institute of Contemporary Art.

Jameson, Anna. 1846. *Memoirs and Essays Illustrative of Art, Literature and Social Mores*. New York: Wiley and Putnam.

———. 1888. *Works*, 10 vols. Boston and New York: Houghton Mifflin.

Jaunez, Linna. 1834a. "Salon de 1834." *Journal des femmes* 8: 115-17, 185-87.

———. 1834b. "Un moyen pour dessiner d'après nature." *Journal des femmes* 9: 168-69.

John, Augustus. 1928. "Art: The Woman Artist." *Vogue* 72 (27 Oct), 76-77, 112, 116.

Kalonyme, Louis. 1928. "Georgia O'Keeffe: A Woman in Painting." *Creative Art* 2 (Jan), xxxv-xl.

Kamm, Josephine. 1966. *Rapiers and Battleaxes: The Women's Movement and Its Aftermath*. London: Allen and Unwin.

Keller, Martha. 1978. "Women of the Bauhaus." *Heresies* 4 (Winter), 54-56.

Kendall, Alice R. 1981. "The Society of Women Artists." *Artist* 96 (May), 16-20.

Knox, Katharine McCook. 1930. *The Sharples: Their Portraits of George Washington and His Contemporaries.* New Haven, CT: Yale University Press.

Kysela, John D. 1966. "Mary Cassatt's Mystery Mural and the World's Fair of 1893." *Art Quarterly* 29, no. 2, 129-144

Lalumia, Matthew. 1983. "Lady Elizabeth Thompson Butler in the 1870s." *Woman's Art Journal* 4, (Spring/Summer), 9-14.

Landon, Charles Paul. 1801-35. *Annales du Musée et de l'Ecole Moderne des Beaux-Arts et Salons.* 35 vols. Paris: C. P. Landon, Imprimerie des Annales du Musee.

Lapauze, Henry, ed. 1903. *Procès-verbaux de la Commune Générale des Arts et de la Société Populaire et Républicaine des Arts.* Paris: J.-E. Bulloz.

Leach, Joseph. 1976. "Harriet Hosmer: Feminist in Bronze and Marble." *Feminist Art Journal* 5 (Summer): 9-13.

Lee, Amice Macdonald. 1955. *Laurels and Rosemary: The Life of William and Mary Howitt.* London and New York: Oxford University Press.

[Leeds, W. H.] 1830. "Strictures on Art and Exhibitions." *Fraser's Magazine* 2 (August), 93-110.

Levin, Elaine. 1986-87. "Vally Wieselthier/Susi Singer." *American Craft* 46 (Dec/Jan), 46-51.

Lisle, Laurie. 1980. *Portrait of an Artist: A Biography of Georgia O'Keeffe.* New York: Seaview Books.

[Lister, T. H.] 1834. "Article III: Lives of the Most Eminent British Painters, Sculptors and Architects." *Edinburgh Review* 59 (April), 48-73.

M. S. R. [Maria Susan Rye?] 1858. "The History of Wood-Engraving." *English Woman's Journal* 1 (May), 165-77.

———. 1859. "Female Engravers from the 16th to the 19th Century." *English Woman's Journal* 3 (June), 259-70.

Maass, John. 1973. *The Glorious Enterprise.* New York: American Life Foundation.

McBride, Henry. 1946. *Florine Stettheimer* (exhibition catalogue). New York: Museum of Modern Art.

McCabe, James D. 1876. *The Illustrated History of the Centennial Exhibition.* Philadelphia, Chicago, and St.Louis: National Publishing Co.

Macdonald, Stuart. 1970. *The History and Philosophy of Art Education*. London: University of London Press.

Macht, Carol. 1976. *The Ladies, God Bless 'Em: The Woman's Art Movement in Cincinnati in the Nineteenth Century* (exhibition catalogue). Cincinnati: Cincinnati Art Museum.

Mackenzie, Tessa, ed. 1895. *The Art Schools of London*. London: Chapman and Hale.

Macmillan, James E. 1981. *Housewife or Harlot: The Place of Women in French Society 1870-1940*. New York and London: St. Martin's Press.

Macpherson, Gerardine Bate. 1878. *Memoirs of the Life of Anna Jameson*. Boston: Roberts Bros.

McPherson, Heather, and Douglas K. S. Hyland. 1990. *Marie Laurencin: Artist and Muse* (exhibition catalogue). Birmingham, AL: Birmingham Museum of Art.

Manners, Lady Victoria and George C. Williamson. 1924. *Angelica Kauffmann, R.A.: Her Life and Works*. London: John Lane.

Mannes, Myra. 1930. "The Embroideries of Marguerite Zorach." *International Studio* 95 (March), 29-33.

Marsh, Jan, and Pamela Gerrish Nunn. 1989. *Women Artists and the Pre-Raphaelite Movement*. London: Virago.

Marter, Joan. 1979. "Three Women Artists Married to Early Modernists: Sonia Delaunay-Terk, Sophie Tauber-Arp, Marguerite Thompson Zorach." *Arts Magazine* 54 (Sep), 88-95.

Mathews, Nancy Mowll. 1984. *Cassatt and Her Circle: Selected Letters*. New York: Abbeville.

Mayer, Dorothy Moulton. 1972. *Angelica Kauffmann, R.A., 1741-1807*. Gerrards Cross, Eng.: Colin Smythe.

Merritt, Anna Lea. 1900. "A Letter to Artists: Especially Women Artists." *Lippincott's Magazine* 65 (Jan-Jun), 461- 469.

Metropolitan Museum of Art. 1987. *In Pursuit of Beauty: Americans and the Aesthetic Movement* (exhibition catalogue). New York: Rizzoli.

Miller, Florence Fenwick. 1893. "Art in the Woman's Section of the Chicago Exhibition." *The Art Journal*, xv-xvi.

Mirbel, Lizinka de. 1830. "De la peinture du portrait," *Revue de Paris* 9, 91-99.

Mitchell, Marilyn Hall. 1978. "Sexist Art Criticism: Georgia O'Keeffe, A Case Study." *Signs* 3 (Spring), 681-87.

Modersohn-Becker, Paula. 1980. *The Letters and Journals of Paula Modersohn-Becker*. Translated and annotated by J. Diane Radycki. Metuchen, NJ, and London: Scarecrow Press.

————. 1983. *Paula Modersohn-Becker: The Letters and Journals*. Edited and translated by Günter Busch and Liselotte von Reinken. New York: Taplinger.

Montaiglon, Anatole de Courde de, ed. 1875-92. *Procès-verbaux de l'Académie Royale de Peinture et de Sculpture, 1648-1793*, 10 vols. Paris: J. Bauer.

Moore, George. [1910]. *Modern Painting*. New York: Brentanos.

Morris, Barbara. 1961. *The History of English Embroidery*. London: Victoria and Albert Museum/Her Majesty's Stationery Office.

————. 1963. *Victorian Embroidery*. New York: Thomas Nelson and Sons.

Morris, May. 1900. "Decorative Needlework" in *International Congress of Women, London, July 1899, Volume 4: Women in the Professions*. Edited by the Countess of Aberdeen. London: T. Fisher Unwin.

Moses, Claire Goldberg. 1984. *French Feminism in the Nineteenth Century*. Albany: State University of New York Press.

National Collection of Fine Arts, Smithsonian Institution, Washington, DC. 1973. *Marguerite Zorach: The Early Years 1908-20* (exhibiton catalogue). Essay by Roberta Tarbell. Washington, DC: Smithsonian Institution Press.

Naylor, Gillian. 1971. *The Arts and Crafts Movement*, Cambridge, MA: M.I.T. Press.

————. 1985. *The Bauhaus Reassessed*. New York: E. P. Dutton.

Neff, Wanda Fraiken. 1966. *Victorian Working Women*. Reprint of 1929 edition. London: Frank Cass.

Nemser, Cindy. 1975. *Art Talk: Conversations with Twelve Women Artists*. New York: Scribner.

Neumann, Eckhard, ed. 1970. *Bauhaus and Bauhaus People*. New York: Van Nostrand Reinhold Co.

"New York School of Design for Women." 1856. *The Crayon* 3 (Sep), 280-81.

Nochlin, Linda. 1980. "Florine Stettheimer: Rococo Subversive." *Art in America* 68 (Summer), 64-83.

Nolhac, Pierre de. 1912. *Mme. Vigée-LeBrun, peintre de la Reine Marie Antoinette*. Paris: Goupil.

Norman, Dorothy. 1973. *Alfred Stieglitz: An American Seer*. New York: Random House.

Novotny, Fritz. 1960. *Painting and Sculpture in Europe, 1780-1880*. Baltimore: Pelican History of Art.

Nunn, Pamela. 1978. "The Case History of a Woman Artist: Henrietta Ward." *Art History* 1 (Sep): 293-308.

————. 1987. *Victorian Women Artists*. London: Woman's Press.

Oakley, Ann. 1974. *Woman's Work: The Housewife Past and Present*. New York: Pantheon.

Oldcastle, John. 1879. "Our Living Artists: Elizabeth Butler (née Thompson)." *The Magazine of Art* 2, 257-262.

Omega. 1824. "Men and Women: A Brief Hypothesis Concerning the Difference Between Their Genius." *Blackwoods' Magazine* 16 (October), 387-94.

"Our Weekly Gossip." 1843. *Athenaeum* no. 839 (25 Nov), 1048-49.

Paine, Judith. 1975-76. "The Woman's Pavilion of 1876." *Feminist Art Journal* 4 (Winter), 5-12.

Parker, Rozsika. 1984. *The Subversive Stitch: Embroidery and the Making of the Feminine*. London: The Women's Press.

Parker, Rozsika, and Griselda Pollock. 1981. *Old Mistresses: Women, Art and Ideology*. New York: Pantheon.

Pelles, Geraldine. 1963. *Art, Artists and Society: Origins of a Modern Dilemma*. New York: Prentice Hall.

Pennell, Elizabeth Robins. 1918. "Art and Women." *The Nation* 106 (1 June), 663-64.

Perry, Gillian. 1979. *Paula Modersohn-Becker: Her Life and Work*. New York: Harper and Row.

Perry, Mrs. Aaron F. 1881. "Decorative Pottery of Cincinnati." *Harpers New Monthly Magazine* 62 (May), 834-45.

Petersen, Karen, and J. S. Wilson. 1976. *Women Artists: Recognition and Reappraisal from Early Middle Ages to the Twentieth Century*. New York: Harper and Row Colophon.

Petteys, Chris. 1985. *Dictionary of Women Artists: An Internatonal Dictionary of Women Artists Born Before 1900*. Boston: G. K. Hall.

Pevsner, Nikolaus. 1940. *Academies of Art Past and Present*. New York: Da Capo.

————. 1968. *The Sources of Modern Architecture and Design*. New York and Washington: Praeger.

Pinchbeck, Ivy. 1930. *Women Workers and the Industrial Revolution, 1750-1850*. London: Cass.

Pointon, Marcia. 1984. "Portrait Painting as a Business Enterprise in London of the 1780s." *Art History* 7 (June): 187-295.

Pollock, Griselda. 1988. *Vision and Difference: Femininity, Feminism, and the Histories of Art*. London and New York: Routledge.

Pope, Barbara Corrado. 1977. "Angels in the Devil's Workshop: Leisured and Charitable Women in Nineteenth Century Eng-

land and France" in *Becoming Visible: Women in European History*, edited by Renate Bridenthal and Claudia Koontz. Boston: Houghton Mifflin.

"Pottery and Art Industry for Women." 1871-72. *Victoria Magazine* 18, 456-8.

Prather-Moses, Alice Irma. 1981. *The International Dictionary of Women Workers in the Decorative Arts*. Metuchen, NJ, and London: Scarecrow Press.

[Prospectus]. 1858. *English Woman's Journal* 1 (March), 2.

Radycki, J. Diane. 1982. "The Life of Lady Art Students: Changing Art Education at the Turn of the Century." *College Art Journal* 42 (Spring), 9-13.

Raimes, Gaston de. 1889. "L'union des femmes peintres et sculpteurs." *L'artiste* année 59, t. 1, 195-203.

Redgrave, Richard, and Samuel Redgrave. 1981. *A Century of British Painters*. Ithaca, NY: Cornell/Phaidon.

Rendall, Jane. 1984. *The Origins of Modern Feminism: Women in Britain, France and the United States 1780-1860*. New York: Schocken Books.

Rensselaer, Susan van. 1963. "Harriet Hosmer." *Antiques* 84 (Oct), 424-28.

Rewald, John. 1973. *The History of Impressionism*. 4th edition. New York: New York Graphic Society and Museum of Modern Art.

Rigby, Elizabeth. 1895. *Journals and Correspondence of Lady Eastlake*, 2 vols. Charles Eastlake Smith, ed. London: John Murray.

Roditi, Edouard. 1961. *Dialogues on Art*. New York: Horizon Press.

Roget, John Lewis. 1891. *A History of the Old Water-Colour Society*. London: Longmans, Green and Co.

Roland-Michel, Marianne. 1980. "A Note on a Portrait of Madame du Barry." *Fenway Court*, 20-25.

Rosenfeld, Paul. 1921. "American Painting." *The Dial* 71 (Dec), 649-70.

———. 1932. "The World of Florine Stettheimer." *The Nation* 134 (4 May), 522-23.

Rossetti, Dante Gabriel. 1965. *Letters of Dante Gabriel Rossetti*, 6 vols. Glen Doughty and John Robert Wahl, eds. Oxford: Clarendon.

Rossi, Alice S., ed. 1974. *The Feminist Papers*. Reprint of New York: Columbia University Press, 1973. New York: Bantam.

Rouart, Denis, ed. 1950. *Correspondance de Berthe Morisot*. Paris: Quatre Chemins-Editart.

————. 1957. *The Correspondence of Berthe Morisot with her Family and Friends.* Translated by Betty W. Hubbard. London: Lund Humphries. Reprinted as *Berthe Morisot: The Correspondence with Family and Friends* with an introduction and notes by Kathleen Adler and Tamar Garb. Mount Kisco, NY: Moyer Bell, 1987.

Roworth, Wendy Wassyng. 1984. "Angelica Kauffmann's Memorandum of Paintings." *Burlington Magazine* 126 (Oct), 629-30.

"Royal Academy [6 parts]." 1859. *Athenaeum* no. 1637 (12 Mar), 361-62; no. 1639 (26 Mar), 421-22; no. 1640 (2 Apr), 452-53; no. 1641 (9 Apr), 486; no. 1642 (16 Apr), 517; no. 1643 (23 Apr), 549.

"Royal School of Art Needlework, South Kensington." 1875. *Art Journal*, 100.

Rubenstein, Charlotte Streiffer. 1982. *American Women Artists.* New York: G. K. Hall and Avon.

Ruskin, John. 1903-12. *The Works of John Ruskin*, 39 vols. Edited by E. T. Cook and Alexander Wedderburn. London and New York: George Allen and Longmans, Green.

"Salons." 1893. *Journal des femmes* 19 (June), 2-3.

Sandby, William. 1862. *The History of the Royal Academy of Arts*, 2 vols. London: Longmans, Green. Reprinted London: Cornmarket, 1970.

Schweiger, Werner. 1984. *Wiener Werkstätte: Design in Vienna.* New York: Abbeville Press.

Sherman, Claire Richter, with Adele M. Holcomb. 1981. *Women as Interpreters of the Visual Arts, 1820-1979.* Westport, CT: Greenwood.

Sigourney, Mrs. L. H. 1838. *Letters to Young Ladies.* New York: Harper and Bros.

Slusser, Jean Paul. 1923. "Modernistic Pictures Done in Wool." *Arts and Decoration* 18 (Jan), 30.

Smart, Mary. 1983-84. "Sunshine and Shade: Mary Fairchild MacMonnies Low." *Woman's Art Journal* 4 (Fall/Winter), 14-19.

"Society of Female Artists." 1857a. *Art Journal* (July), 215-16.

"Society of Female Artists." 1857b. *Athenaeum* no. 1548 (27 June), 825.

"Society of Female Artists." 1858. *Athenaeum* no. 1588 (3 Apr), 438-39.

"Society of Female Artists." 1863. *Art Journal* (May), 95.

Sparrow, Walter Shaw. 1976. *Women Painters of the World.* Reprint of 1905 edition. New York: Hacker Art Books.

Stanton, Theodore. 1910. *Reminiscences of Rosa Bonheur.* New York: Appleton. Reprinted New York: Hacker Art Books, 1976.

Steegmuller, Francis. 1963. *Apollinaire: Poet Among the Painters.* New York: Farrar, Straus.

Stewart, John. 1860. "Art Decoration: A Suitable Employment for Females." *Art Journal* (March), 70-71.

Stokes, Adrian. 1978. *The Critical Writings of Adrian Stokes.* London: Thames and Hudson.

Strachey, Ray. 1978. *The Cause: A Short History of the Women's Movement in Great Britain.* Reprint of 1928 edition. London: Virago.

Stranahan, Clara H. 1888. *A History of French Painting from Its Earliest to Its Latest Practice.* New York: Charles Scribner's.

Stuckey, Charles F., and William P. Scott. 1988. *Berthe Morisot: Impressionist* (exhibition catalogue). New York: Hudson Hills Press.

Sweet, Frederick A. 1966. *Miss Mary Cassatt: Impressionist from Philadelphia.* Norman: University of Oklahoma Press.

Taft, Lorado. 1903. *The History of American Sculpture.* New York: Macmillan.

Tapazio, Virgil W. 1963. "Art criticism in the Enlightenment." *Studies on Voltaire and the Eighteenth Century*, vol. 27. Geneva: Institut et Musée Voltaire.

Tarbell, Roberta K. 1980. *William and Marguerite Zorach: The Maine Years* (exhibition catalogue). Rockland, ME: William A. Farnsworth Library and Art Museum.

Tate, Robert S., Jr. 1968. "Petit de Bachaumont: His Circle and the Mémoires Secrets." *Studies on Voltaire and the Eighteenth Century*, vol. 65. Geneva: Institut et Musée Voltaire.

Taylor, Hilary. 1986. " 'If a Painter Be Not Fierce and Arrogant God Help Him': Some Women Art Students at the Slade." *Art History* 9 (June), 232-243.

"Third Annual Exhibition of the Society of Female Artists." 1859. *English Woman's Journal* 3 (March), 53-55.

Thomas, Clara. 1967. *Love and Work Enough: The Life of Anna Jameson.* Toronto: University of Toronto Press.

Thoré, Théophile. 1834. "L'Art Social et Progressif," *L'artiste* 8: 38-42.

Trapp, Frank. 1967. "A Mistress and a Master, Mme. Cavé and Delacroix." *College Art Journal* 27 (Fall), 40-59.

Truman, Benjamin Cummings. 1893. *History of the World's Fair.* Philadelphia: H. W. Kelley.

Tufts, Eleanor. 1984. *American Woman Artists Past and Present: A Selected Bibliography*. New York: Garland.

———. 1987. *American Women Artists 1830-1930*. (exhibition catalogue). Washington, DC: The National Museum of Women in the Arts.

Turgeon, Charles. 1907. *Le féminisme français*. Paris: L. Larose et Forcel.

Tyler, Parker. 1963. *Florine Stettheimer: A Life in Art*. New York: Farrar, Straus.

"Union des Femmes Peintres et Sculpteurs." 1882. *Chronique des arts et de la curiosité* (28 Jan), 27.

Usherwood, Paul. 1988. "Elizabeth Thompson Butler: The Consequences of Marriage." *Woman's Art Journal* 9 (Spring/Summer), 30-34.

Vaisse, Pierre. 1981. "Salons, expositions et sociétés d'artistes en France 1871-1914" in *Saloni, gallerie, musei e loro ifluenza sullo svilieppo dell'arte dei secoli XIX e XX*, ed. Francis Haskell, Atti del XXIV Congresso Internationale di storia dell'arte, 7. Bologna: CLUEB.

Vicinus, Martha, ed. 1972. *Suffer and Be Still: Woman in the Victorian Age*. Bloomington, IN: Indiana University Press.

Vigée-Lebrun, Elisabeth-Louise. 1869. *Souvenirs de Madame Vigée-Le Brun*, 2 vols. Paris: Charpentier.

———. 1879. *Souvenirs of Madame Vigée-Le Brun*. Translator unidentified. New York: R. Worthington.

———. 1903. *Memoirs of Elisabeth Vigée-Lebrun*. Translated by Lionel Strachey. New York: Doubleday, Page.

———. [1927]. *The Memoirs of Mme. Elisabeth Louise Vigée-Lebrun, 1785-1789*. Translated by Gerard Shelley. New York: George H. Doran.

Waller, Susan. 1983. "The Artist, the Critic, and the Queen." *Woman's Art Journal* 4 (Spring/Summer), 21-28.

Walton, William. 1897. "Cecilia Beaux." *Scribner's Magazine* 22 (October), 477-85.

Wardle, Patricia. 1970. *Guide to English Embroidery*. London: Her Majesty's Stationery Office/Victoria and Albert Museum.

Weeks, Charlotte. 1883. "Women at Work: The Slade Girls." *The Magazine of Art* 6, 324-29.

Weidner, Ruth Irwin. 1982. *American Ceramics Before 1930, A Bibliography*. Westport, CT: Greenwood Press.

Weimann, Jeanne Madeline. 1981. *The Fair Women*. Chicago: Academy.

Wein, Jo Ann. 1981. "The Parisian Training of American Women Artists." *Woman's Art Journal* 2 (Spring/Summer), 41- 44.

Weisberg, Gabriel. 1980. *Realism: French Painting and Drawing, 1830-1900* (exhibition catalogue). Cleveland: Cleveland Museum of Art and Indiana University Press.

Weiss, Peg, ed. 1981. *Adelaide Alsop Robineau: Glory in Porcelain* (exhibition catalogue). Syracuse: Syracuse University Press and Everson Museum of Art.

"What Field of Art Shall I Enter?" 1893. *Art Interchange* 5 (November), 125-26.

Wheeler, Candace. 1897. "Art Education for Women." *Outlook* 55 (2 Jan), 81-87.

———. 1918. *Yesterdays in a Busy Life*. New York and London: Harper.

White, Cynthia A., and Harrison C. White. 1965. *Canvases and Careers: Institutional Change in the French Painting World*. New York: Wiley.

Whitley, Jon. 1981. "Exhibitions of Contemporary Painting in London and Paris, 1760-1860" in *Saloni, gallerie, musei e loro ifluenza sullo svilieppo dell'arte dei secoli XIX e XX*, ed. Francis Haskell, Atti del XXIV Congresso Internationale di storia dell'arte, 7. Bologna: CLUEB.

Whitley, William. 1928. *Artists and Their Friends in England 1700-1799*. London: Medici Society. Reprinted London: B. Blom, 1968.

Wingler, Hans, ed. 1969. *The Bauhaus*. Cambridge, MA: M.I.T. Press.

Withers, Josephine. 1976. "Artistic Women and Women Artists." *College Art Journal*, 35 (Summer), 330-36.

"Women's Executive Committee." 1876. *New Century for Women* no. 1 (May 13), 4.

Wood, Sir Henry Trueman. 1913. *A History of the Royal Society of Arts*. London: J. Murray.

Woodring, Carl Ray. 1952. *Victorian Samplers: William and Mary Howitt*. Lawrence, KS: University of Kansas.

Woolf, Virginia. 1930. *Recent Paintings by Vanessa Bell* (exhibition catalogue). London: The London Artists' Association.

*The World's Congress of Representative Women*. 1894. May Wright Sewall, ed. Chicago and New York: Rand McNally.

Wyzewa, Teodor de. 1903. *Peintres de jadis et d'aujourd'hui*. Paris: Perrin et Cie.

Yeldham, Charlotte. 1984. *Women Artists in Nineteenth-Century France and England*, 2 vols. New York: Garland.

*Young Ladies' Treasure Book*. n.d. London: Ward.

Zorach, Marguerite. 1944. *Marguerite Zorach* (exhibition catalogue with artist's statement). New York: Knoedler Galleries, Nov. 6-25.

———. 1956. "Embroidery as Art." *Art in America* 44 (Fall), 50-51, 66-67.

Zorach, William. 1967. *Art is My Life*. Cleveland and New York: World.

# INDEX